FOLK ART'S MANY FACES

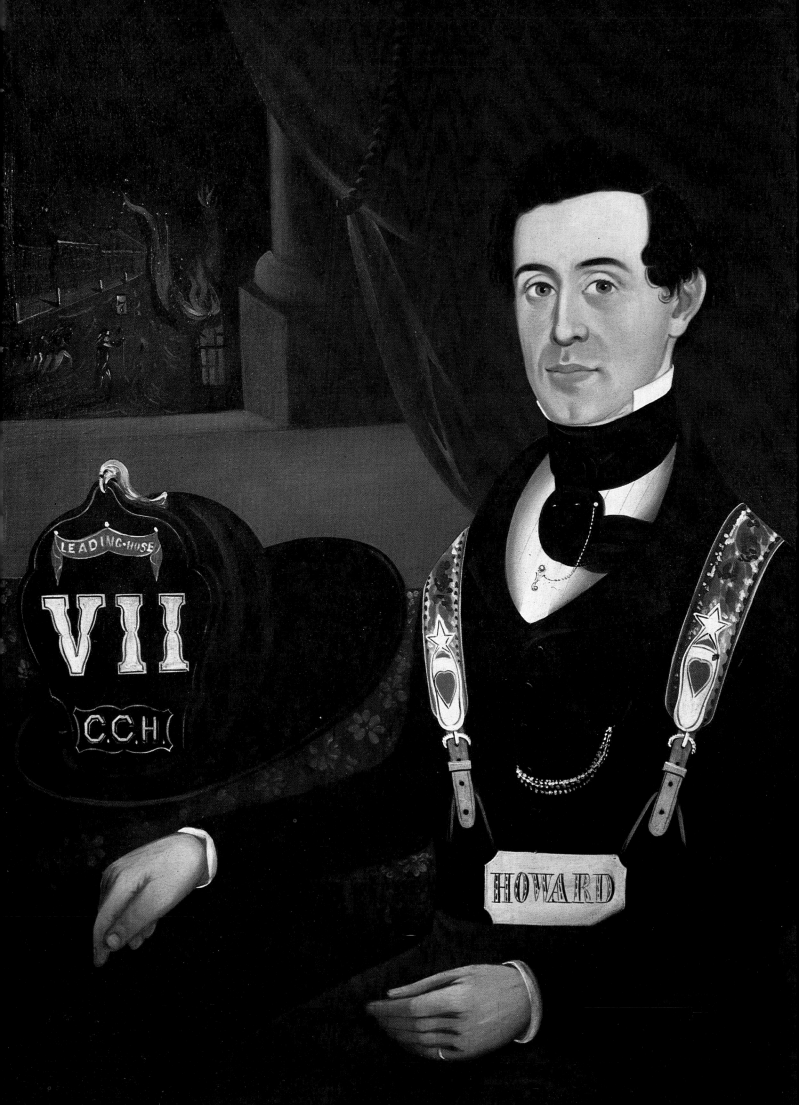

FOLK ART'S MANY FACES

❖

PORTRAITS IN THE NEW YORK STATE HISTORICAL ASSOCIATION

by

PAUL S. D'AMBROSIO

and

CHARLOTTE M. EMANS

❖

with introductory material by

DR. LOUIS C. *and* AGNES HALSEY JONES

NEW YORK STATE HISTORICAL ASSOCIATION
COOPERSTOWN, N.Y.
1987

This catalog was published with the aid of a grant from the National Endowment for the Arts in Washington, D.C., a federal agency

New York State Historical Association, Cooperstown, N.Y., 13326
Copyright ©1987 by the New York State Historical Association.

Printed in the United States of America.

Editor: Wendell Tripp

Design: C. W. Pike

Photography: Milo V. Stewart

Typesetting: Dupli Graphics Typographers
 Syracuse, New York

Printing: Salina Press
 Syracuse, New York

Folk Art's Many Faces is a publication of the Dixon Ryan Fox Fund of the New York State Historical Association.

ISBN: (Casebound—0-917334-14-0)
 (Perfectbound—0-917334-15-9)

Library of Congress Catalog Number: 87-61301

Cover, details (left to right):
20. *One Shoe Off*
31. *Gentleman with a High Collar*
144. *American Madonna and Child*
106. *John Wharf*

Frontispiece: 54. *The Fireman*

❖ TABLE OF CONTENTS ❖

❖ Preface and Acknowledgments ❖

This portrait volume, the first published catalog of the New York State Historical Association's renowned collection of American folk art, is envisioned as the first of a multi-volume work whose goal is to make information and images of the entire collection easily accessible to scholars and to the general public.

Nearly all of the catalog entries included in this volume were researched and written by Paul S. D'Ambrosio and Charlotte M. Emans. Several individual entries were supplied by Richard Miller and Jacquelyn Oak. Amy McKune authored the essay "The Gunn Legacy," which summarizes her recent research on these enigmatic and important collectors. The essay on the history of the folk art collection at Cooperstown was graciously supplied by Dr. Louis C. and Agnes Halsey Jones.

During the four years that went into the planning, research and production of *Folk Art's Many Faces,* a number of key staff members at NYSHA provided generous assistance and expertise. A. Bruce MacLeish, curator of collections, was instrumental in the early organization and fund raising which launched the project; Marianne Bez, associate in public relations, offered technical advice and assistance at each stage of the project; C. R. Jones, conservator, compiled conservation histories and condition reports for each portrait, and conserved a number of works prior to their inclusion in the catalog; Rose D. Vitzthum, curatorial assistant, typed hundreds of letters of inquiry and several versions of the catalog manuscript; Wendell Tripp, director of publications, painstakingly edited the manuscript and provided invaluable editorial advice; Milo V. Stewart, associate director, expertly photographed all of the portraits in the catalog; Kathleen D. Stocking, registrar, supplied technical data on many of the portraits cataloged; and Josephine E. Case meticulously proofread the entire manuscript. A group of folk art specialists read and provided comments on the finished manuscript, a panel of experts that included Dr. Louis C. and Agnes Halsey Jones, Joyce Hill and Beatrix T. Rumford.

The many museum professionals, librarians, genealogists, historians and others who aided this project are far too numerous to acknowledge individually here. Their contributions are cited in the notes to the text. Particular thanks are extended to Carolyn J. Weekley, director, and Barbara R. Luck, curator, of the Abby Aldrich Rockefeller Folk Art Center in Williamsburg, Virginia, who offered constant support, advice and use of their many resources.

Invaluable financial support for this catalog came from the National Endowment for the Arts, Washington, D.C., the A. Lindsay and Olive B. O'Connor Foundation, Hobart, N.Y., and the New York State Historical Association's Dixon Ryan Fox Fund.

The publication of this catalog marks a significant step in the further understanding and appreciation of the NYSHA collection. Many of the folk portraits included herein are being published for the first time; many other familiar likenesses are newly attributed to well known or recently discovered artists; and numerous portraits now have more complete bodies of information to enhance their historical importance. The once radical notion that these folk paintings deserve aesthetic acclaim is now widely accepted. This catalog reaffirms our belief that, in order to form a true picture of their place in American art and history, they require systematic scholarly attention.

PAUL S. D'AMBROSIO
ASSISTANT CURATOR

18 99

❖ Folk Art at Fenimore House ❖
A Historical Note

There were examples of American folk art at Fenimore House long before anyone classified them as such. They were called to mind one day in the autumn of 1948 when the curator and the director of the New York State Historical Association and The Farmers' Museum were going through the main building of the latter, discussing artifacts and exhibits. Suddenly their attention was focused on a handcrafted barley fork, a featherweight sculpture of flowing lines and hidden strength. This simple, commonplace tool was a thing of beauty. What had it meant to the artisan who made it, to the man who used it? At what point does the artifact become art? Was this folk art? If so, were there any other examples in the collections of the two museums?

The days that followed brought to light some interesting items: a handsomely curved cast iron plow; the polychromed wooden sculpture of a boy's head with the carver's name, "A. Ames," incised in the base; fine quilts and coverlets; a watercolor portrait of Mrs. William Cooper sitting in the wide front hall of the frontier mansion her husband built overlooking Lake Otsego.

The curator, Janet R. MacFarlane, had been trained as a painter and art historian; the director, Louis C. Jones, was a student of American folklore, among other disciplines, but neither had been much exposed to folk art. They turned to the library and found a few helpful volumes, especially those by Jean Lipman, the editor of *Art in America,* author of *American Primitive Painting* (1942) and the newly published *American Folk Art in Wood, Metal and Stone.* It was shortly agreed that a small gallery could be developed in Fenimore House to present examples of aesthetically satisfying objects created outside the academic tradition.

The chairman of the board of the two institutions, Stephen C. Clark Sr., was a distinguished collector of academic American paintings and French impressionists. A founder and trustee of the Museum of Modern Art, he had been aware of American folk art since Holger Cahill's major exhibit at that museum in 1932. He was also aware that most of that show came from the collection of his friend and fellow trustee, Mrs. John D. Rockefeller Jr. So he was by no means on unfamiliar ground when the director

discussed with him the possibility of a small new exhibit. He saw it as an extension of the concepts governing The Farmers' Museum, thereby tying that museum and Fenimore House closely together.

One day early in December, 1948, Mr. Clark called the director to ask if he would come to New York to join him in a visit to the widow of Elie Nadelman in Riverdale. The great Polish sculptor and his wife had already assembled and sold one collection of folk art. They were well started on a second when his death brought that chapter to a close. Lincoln Kirstein, an old friend of the Nadelmans and of Mr. Clark, joined the two men on the drive up the river. Kirstein's interest in American folk art went back to the 1920s at Harvard where he had been one of the moving spirits in a pioneering folk art show by the Society of Contemporary Arts in 1930.

The Nadelman house was overflowing with all kinds of folk art. For the green director, it was a baptism for which a few weeks of reading had not prepared him. On every side there were objects he had never thought of in the context of folk art. Mr. Clark went off by himself and after an hour or so he took the director aside and said, "Mr. Jones, if you could have twelve of these pieces for our collection, which would you choose?" The director felt there was far more at stake than twelve pieces of folk art. Rightly or wrongly he felt that his new career was in the balance. He took his time answering, weighing each choice as best he could, and finally selected twelve pieces. There was a silence and finally Mr. Clark said, "I agree with you on eleven of those. Let's buy thirteen."

Looking back on that original purchase, one can only marvel at the good fortune of having such excellent examples to form the cornerstone of the collection. They included a large circular painted campaign banner in support of Henry Clay and internal improvements; a life-sized trade sign of a dancing black man, which Paul Manship once called the best piece of carving done in America before 1850; a blue and white coverlet with a tree of life design and a brilliant Star of Bethlehem quilt in red and orange; a painted window shade from a New England inn, which included all the early symbols of the young America: Washington, Liberty, the eagle, liberty cap, the pine tree and broken symbols of tyranny. Among the other items from the Nadelmans' collection were two classical, polychromed heads of Apollo and Ceres attributed to Samuel Skillen or one of his kinsmen.

The new purchases and additional pieces rediscovered in the collections placed a burden on existing exhibit space in Fenimore House. In the lower level of the house, which had once been a privately owned mansion, was a dark, dank unused swimming pool. Harry Sinclair Zogbaum, the original architect of the house, was still in town and he took over the transformation of the area into one large gallery where the pool had been and at the foot of the stairs an introductory gallery. Through the winter of 1948–49, the staff researched the folk art and planned the new exhibits.

In 1948, the Association offered the first Seminars on American Culture, a two-week adult education program offered in July. As the planning for the 1949 Seminars began, everyone agreed that there should be a course on American folk art presented in the new gallery. The faculty comprised most of the thoughtful pioneers in the field: Nina Fletcher Little; Jean Lipman; Alice Winchester, the editor of *The Magazine An-*

tiques; Holger Cahill; Mary Allis, the Connecticut dealer; Edith Halpert, owner of the Downtown Gallery in New York where she sold both contemporary paintings and earlier folk art; Erwin Christensen, who was in charge of the *Index of American Design*. Decades later participants still remember that week as one in which new perspectives were presented at every class meeting.

Later that summer the director was invited to visit Jean and Howard Lipman at their home in Wilton, Connecticut. As at Nadelman's, every space seemed filled with folk art; wherever one turned there were lessons to be learned and fresh delights to be savored. The collection was very strong in wood carvings. It included, for example, an archetypical Julius Theodore Melchers cigar store Indian of great dignity, brilliantly carved. Even more fascinating was a very early cigar store figure of a young Indian woman carved, according to tradition, by a black slave named Job in Freehold, New Jersey, and reminding the knowledgeable of African sculpture. There were school girl art, watercolor portraits, two of Hicks's "Peaceable Kingdoms," and landscapes, seascapes, figureheads, overmantels and fireboards. Everything was in superb condition and one began to be aware of the limitless varieties comprised in the term "folk art."

In March of 1950 Mary Allis approached Mr. Clark to offer the entire Lipman collection for sale. He went to Wilton to see for himself and was as impressed as the director had been. The principals came to an agreement quickly. At about that time it dawned on the staff that the folk art collection had more than quadrupled and that they were now responsible for the display and interpretation of one of the major folk art collections in the country. More galleries were created from unneeded space adjacent to the long gallery; by Seminar time in 1950 a new exhibit was in place. The Lipman collection nicely complemented the earlier exhibit and the new rooms made it possible to show each item to advantage.

During the early 1950s a few purchases were made, a few gifts came in. The most important addition was the van Bergen overmantel. Painted in 1732, probably by John Heaton, the seven-foot-long overmantel features a view of the Marten van Bergen farm, near Catskill, some fifty miles south of Albany. It presents Marten's house, barn and outbuildings, with van Bergen and his family, relatives and servants in the foreground. The overmantel has come to be recognized as one of the nation's most significant pieces of folk art.

An analysis of the Fenimore House collection in the mid-fifties would have shown strength in all kinds of wood carvings, from cakeboards to figureheads, in mourning pictures, theorems, every sort of school girl art, and landscapes, farmscapes and seascapes. But in one major area, the collection was relatively weak: there were only a few portraits, mostly small watercolors. For many collectors, oil portraits were the most significant type of folk art. The reason for this position is uncertain but it may have been because family portraits had assumed an iconic role in those families that owned them. An oil painting fits into the normal household easier than a wooden Indian or a ship's figurehead.

Again it was Mary Allis, the indefatigable scholar-dealer, who brought about a major change in the composition of the Cooperstown collection. One morning in the spring of 1958 she learned that Mrs. William J. Gunn of Newtonville, Massachusetts, had died.

Miss Allis remembered that in 1931 she had met Mr. and Mrs. Gunn and learned that they were collecting folk paintings. She never met them again, though she did read, some years before 1958, of Mr. Gunn's death. With characteristic directness she located the estate lawyers, took a quick look at the approximately 600 primitive paintings stacked in the Gunns' barn. Some of them had been taken out of their frames, others cut from their stretchers; bird and bat droppings had dirtied many of them, but Miss Allis had seen enough to realize that while there was considerable dross there was a sizable number of superb paintings by master folk artists. She bought the whole collection.

Her next step was to see Stephen C. Clark. The end result was that 175 paintings were selected for Cooperstown and Miss Allis disposed of the balance. It is difficult to understand the rationale of the Gunns' collecting. Except for three canvases that were found in a closet in the house, all were stacked unprotected in the barn. Not a single note or listing was ever found. They seemed not to have known nor cared who the artists or sitters were. And yet, repeatedly, they came home with minor masterpieces.

About 60 percent of the paintings selected for retention were portraits and of those, a good half were of children. There is something touching about this childless couple selecting scores of children's portraits and then never looking at them again. There were, of course, other kinds of paintings—farmscapes, frontier townscapes, paintings based on prints or lithographs; paintings done on canvas, paper and wooden panels.

There was not the slightest evidence of who the artists were except for what could be read from the paintings themselves or from the writing on the back. In January 1959, a "conversational weekend" brought to Cooperstown a group of folk art authorities who wandered through the galleries of the second floor of Fenimore House where every space was filled with paintings from the Gunn collection. The harvest of ideas and suggestions were of tremendous value to the director and his wife, Agnes Halsey Jones, who together had been preparing a catalog, *New-Found Folk Art of the Young Republic,* for the eighty-odd paintings that were shown to the public in 1960.

The conservators, Sheldon and Caroline Keck, began the long process of cleaning and repairing the collection. Many of the artists are still unidentified, despite excellent recent research, but, on the other hand, such artists as John Brewster Jr. (with five paintings), the school of William Matthew Prior (with nearly a dozen attributions), Joseph Stock, Ruth Henshaw Bascom, Erastus Salisbury Field, Ammi Phillips and their peers had been hiding under the barn dirt of decades. Some new names were added to the roll of American folk artists: for example, A. Ellis, and, through later research, Samuel Miller and Samuel P. Howes.

The Gunns' portraits rounded out the Cooperstown collection, but its growth has continued. In 1979, through the will of Effie Thixton Arthur, the Association was left forty-odd pieces of carving: trade signs, walking sticks and weathervanes. No one at NYSHA had known Mrs. Arthur but it was later learned that she had been advised by Miss Allis to divide her collection among the Museum of American Folk Art in New York City, the Abby Aldrich Rockefeller Folk Art Center in Williamsburg, and Fenimore House.

In the acquisitions of recent years special emphasis has been placed on contemporary artists who have continued the earlier folk art traditions. Mrs. Stephen Clark

Sr. left the Association two of Grandma Moses's paintings of rural life. The Trustees recently bought a genre painting by the urban artist, Ralph Fasanella. Another urban artist whose work brightens the collection is Mario Sanchez, the Cuban-American painter of the folk life of Key West. The New England history painter, J. O. J. Frost is represented by scenes of the Revolution and of fishing off the Newfoundland coast. John Scholl, an inspired whittler, is represented with several excellent examples of his lively, exuberant carved "celebrations." One of the best of these was a gift of Jean and Howard Lipman. A very different mood is created in Edgar Tolson's stark, direct figures from the Book of Genesis. Two elderly black artists, Sister Gertrude Morgan and Clementine Hunter, are as different as Scholl and Tolson: Morgan paints her dreams and visions of her close communion with God and Jesus; Hunter, more of the earth earthy, reports everyday life on the plantation where she lives, its labors, its rituals, its rites of passage.

Over the years, as the collection has grown, so too have the supporting tools of research. The library of the Association has assembled the kind of reference shelves that are requisite for research in depth. A course in American Folk Art has been given to future museum professionals in the Cooperstown Graduate Program for nearly two decades. An archive of slides of folk art from all over the country has grown to approximately 30,000.

Probably the greatest change that has taken place in the field of folk art is to be found in the attitude of the museum public. Magazines like *Time, Life, Antiques, Art in America, Woman's Day* and scores of others have opened their pages to color photography of folk art. Advertisers find it useful in some of their handsomest presentations. Major shows, like the Whitney Museum's *Flowering of American Folk Art* in 1974, have been covered by all the media. Sister institutions like the Museum of American Folk Art and the Abby Aldrich Rockefeller Folk Art Center, with whom we have had a wonderfully cooperative relationship, have been major factors in creating an audience that is intelligently critical.

We remember two occasions that reflect these changes in popular taste. The central hall of Fenimore House contains a handsomely carved staircase, and one afternoon in 1960 during the exhibit of the Gunn collection two women came through the front door. They suffered from museum feet and tourist fatigue. The elder slumped down in an easy chair and said to the younger, "You go upstairs and see if it's worth the climb, I'm tired." Soon the younger was leaning over the rail and shouting down, "Don't bother to come up, it's nothin but pitchas." Twenty-two years later a comparable pair came in, also tired and hot. This younger woman too was sent upstairs on the same errand but when she leaned over the railing her voice was vibrant, "Myra, come on up. It's all folk art; you'll love it."

In the 1950s the public was very often puzzled by an exhibit of folk art, whereas today they take it in stride. In doing so the past becomes less strange. This is especially true of the portraits, whose faces from across the years reflect the same emotions that we ourselves have known.

LOUIS C. JONES
AGNES HALSEY JONES

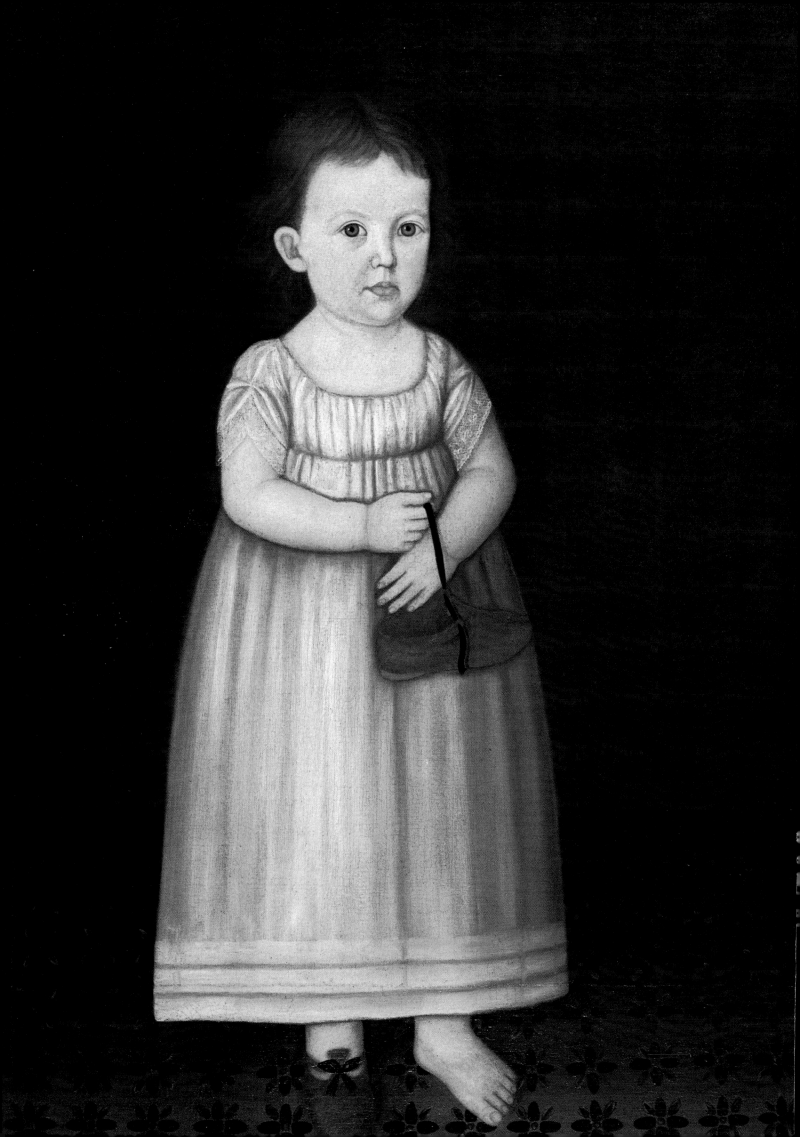

❖ The Gunn Legacy ❖

Stephen C. Clark's 1958 gift of 154 paintings from the collection of Mr. and Mrs. William J. Gunn was the crowning achievement in the early development of the folk art collection at the New York State Historical Association. Most of the paintings were portraits, which, as Louis C. and Agnes Halsey Jones point out in their essay "Folk Art at Fenimore House," added an essential dimension to the Association's folk art holdings. They include nearly all the portraits in the present catalog.

FACING PAGE
20. *One Shoe Off*

Because these paintings, and others collected by the Gunns, have become so well known to students of American folk art, it is easy to forget that their very existence was all but unknown till Mrs. Gunn died in 1957. Mr. and Mrs. Gunn went about their collecting, if not in deliberate secrecy, at least without publicity. When the collection became known, specialists in American folk art were amazed by its size and scope. The Gunns almost inevitably became figures of mystery. Who were they? Whence their interest in folk art? Why did their collection include so many portraits of children? Why did they store it unattended in an old barn? The Gunns left no statement to answer these or many other questions raised by students of the subject. Definitive answers are thus not possible, but sufficient evidence survives to support well-educated guesses and to bring the Gunns farther out of the shadows.

Marion and William Gunn were not the typical "couple next door" of American popular mythology. But neither were they reclusive eccentrics. They were strong-minded individuals who had the financial means to pursue their own interests, which featured the collecting of objects in several cultural areas including American folk art, and to do so without encouraging comment or interference. New England born, they were world travelers who met and married in Japan and whose home in Newtonville, Massachusetts, was a base from which they sallied forth on journeys near and far and in which they assembled the artifacts they had gathered.

Marion Raymond Gunn was born in Massachusetts in 1881, the daughter of Freeborn and Mary Porter Raymond. Freeborn, a patent lawyer with offices in Boston, established the family home in Newtonville, Massachusetts. Mary Raymond died in 1900 at the age of forty-eight. This had a profound effect on Marion, then in her late teens, who would always remember her mother as a great lady. She felt betrayed by the loss; she turned away from religion and stopped believing in the existence of God. Freeborn survived his wife by ten years, during which he and his daughter traveled around the world. This was the beginning of a lifetime spent in visiting and living in other cultures.[1]

William John Gunn was born in 1879 in Portland, Maine, the son of John and Katherine McLeod Gunn. He graduated from Harvard in the class of 1899, and in 1901–1902 was employed as a foreman at the Montana Ore Publishing Company in Butte, Montana. He then moved to Chicago to work as an advertising manager at the Kellogg Switchboard and Supply Company. He was also a teaching resident at Hull House.[2]

William's life changed drastically in 1906 when he learned that he had Bright's Disease, a kidney disorder. Although he knew that the disease was believed to be fatal, William did not learn until twenty years later that the doctors had predicted he would live

one and a half to five years if he took care of himself. Forty-three years later, in 1949, William wrote, "Now that I was saddled with an incurable disease, I decided it would be nice to see a little more of the world."[3] He spent the rest of his life traveling, working with the Red Cross during World War I and as a journalist. During one of his journeys, evidently, he met that other inveterate wanderer, Marion Raymond. The Gunns were married in Yokohama, Japan on May 6, 1914. When they returned to the United States they moved into Marion's house at 173 Otis Street in Newtonville.[4]

Though they lived here for the duration of their lives, the Gunns were never well known in the neighborhood. Mrs. W. Rupert Maclaurin, who grew up across the street, remembers the Gunns as little more than a presence. She relates that the children were given strict instructions never to go on the Gunns' property though they had "about three acres that looked simply gorgeous to play on." One strong memory is a note sent to her mother, Mrs. Carter, that asked "would Master Jim please practice his trumpet in the basement?"[5]

Other neighbors had a sketchy, and somewhat negative, view of the couple. When NYSHA acquired the paintings, Vice Director Frederick L. Rath Jr. contacted some neighbors for their reminiscences. He summarized these as follows:

The Gunns were antisocial at least as far as the immediate neighborhood was concerned. . . .it was Mrs. Gunn who was the more eccentric. . .upon occasion prior to his death Mr. Gunn would speak to the children of the neighborhood through the fence. . . .either before or after Mr. Gunn's death the number of fences increased. Mrs. Gunn literally barricaded herself on the property.[6]

Mrs. Maclaurin does not remember Mr. Gunn speaking to the children. The evidence suggests a couple who enjoyed their privacy and indicates that Mrs. Gunn was the more self-contained of the two.

A possible reason for this "unsocial" behavior is the extensive traveling in which the Gunns engaged. By 1939, the Gunns' travels included three trips around the world. On the eve of the second world war, they were in Bombay, India, considering which route to take home. Mr. Gunn's account reveals their passion for far away places:

I planned not to return to the United States for two years, but we shall return before that if we live. . . .we are too old for the program we laid out for ourselves in India. At first, it was going to be India, Burma, Siam, Java, returning by Afghanistan and Persia. We have travelled in all those countries—except Afghanistan. . . .This being our third winter in India together, we had hoped to make short work of the places we wanted to see and go to the other countries. . . .I think that we may still dare to go back to Europe as we did the last time, via the Persian Gulf, Irak, and Persia.[7]

The Gunns' intensive interest in other cultures is obvious. This influenced many of their activities throughout their lifetimes. After William died in 1952, Mrs. Gunn hired George Ivask, a Harvard Ph.D. candidate, to teach her Russian. Ivask, who wrote literary criticism and poetry, published an essay in 1959 which presented some details of the

life of Mrs. Gunn and offers insight into her personality. Ivask himself described Mrs. Gunn as "one of the most wonderful and puzzling persons I have ever met."[8]

When Ivask arrived at the Gunn house, he found an elderly woman in a house which he referred to as a museum. Mrs. Gunn was literally surrounded by possessions collected from all over the world. Noticing Soviet newspapers that Mrs. Gunn had been reading, Ivask asked why. Mrs. Gunn replied that they amused her, yet Ivask noticed they actually irritated her. It seems that Mrs. Gunn was hungry for any available information about ways of life which were foreign to her own.

During the lessons, Ivask encouraged her to read plays, such as Chekhov's *The Cherry Orchard* and plays by Ostrowski. The lessons brought on stories about their lives. Mrs. Gunn reminded Ivask of his Russian grandmother–both were solitary, eccentric, and still great ladies. Many of her stories were about her travels and her relationships with other people; the two often had philosophical discussions about life. Mrs. Gunn revealed herself to this young Russian, it would seem, as she never had to others in her life.

One activity that Mrs. Gunn did not reveal to others was her folk art collecting. Many people who knew the Gunns were unaware of the extent of this collection, which at the time of Mrs. Gunn's death, numbered over 600 pieces. The vast majority of the paintings were located in a barn on her property, although each of the three houses had a few pieces.[9]

The manner in which the Gunns collected is still a bit of a mystery. The story told is that the Gunns drove around every afternoon going to dealers and buying folk art. They were very secretive about their activities and did not like their names to be attached to their purchases. For this reason, they were never associated with collecting and were not known by other collectors.

Most of the dealers whom the Gunns patronized were dealers in antiques, who sold an occasional folk painting. Only one, Harry Stone of New York City, actually advertised himself as a dealer of primitive paintings.[10] One dealer, Charles D. Childs, remembers the Gunns and their trips to his gallery on Newbury Street in Boston: he describes Mrs. Gunn as "an extraordinary woman" and a "shrewd collector." He remembers that Mrs. Gunn was the collector, although her husband was always with her. Occasionally, Mr. Gunn would come in alone to purchase a present for his wife. Mr. Gunn was "a delightful man," somewhat under the control of his wife. Childs believes that Mr. Gunn had an allowance and didn't mind being supported by his wife.[11]

After Mrs. Gunn's death in November of 1957, her property was distributed to a large number of non-profit organizations. Two types of organizations, children's services and animal shelters, received a large portion of the estate. This is important because these interests related to the portraits which Mrs. Gunn had collected throughout her lifetime.

Although there is evidence that Mrs. Gunn was not especially friendly with the children in the neighborhood, I think it would be incorrect to say that she did not like children. Her bequests to Children's Hospital, Infant's Hospital, and the New England Peabody Home for Crippled Children suggest that she felt some concern for their well-being. Approximately one-third of the paintings listed in the appraisal are of children.

Bequests to the Massachusetts Society for the Prevention of Cruelty to Animals

and the Animal Rescue League of Boston are not surprising. At the time of her death, Mrs. Gunn had more than twenty cats living in her house. The cats were strays that had found their way to Mrs. Gunn and she had taken them in. Ivask relates a discussion he had with Mrs. Gunn about her cats:

> *Most of all I like dogs, but now I keep cats. I, of course, will soon go. Dogs would grieve for me, but cats will not cry, will live up their time....Neighbors thinking that Mrs. G. worshipped cats were bringing or stealthily abandoning kittens at her door....Finally the stray cats found the way to the house on their own.*[12]

This love of animals is also reflected in the collection: many of the portraits now in the NYSHA collection have animals in them.

The folk art collection was treated separately from the other collections by the terms of the will. Most of the art objects were sold at auction in New York City in 1958. The primitive paintings, on the other hand, were given to Grace Marr, a long-time servant of Mrs. Gunn, who directed that the paintings be offered for sale to a private dealer.

The lawyers contacted Robert Vose, the appraiser, for the name of a possible buyer. He contacted Winsor White, a good friend, to see if he was interested in purchasing the collection. White was interested, but apparently did not have sufficient capital to buy the collection at that time. He approached Mary Allis, another dealer from Connecticut, and she and White agreed to buy the collection of 630 paintings for $27,000. Apparently, Mary Allis paid for the entire collection and was therefore the sole owner after the purchase.[13]

As soon as she acquired the paintings, Mary Allis contacted Stephen Clark, who viewed a selection of paintings and agreed to buy the entire collection. Since the Gunn collection included so many portraits, it was a good opportunity to round out the NYSHA collection, which till then had so few. After Allis and Clark had chosen about 150 paintings, Allis sold the remainder to other museums and private collectors.[14]

A fresh view of the Gunns contradicts some of the stories which have been told about them in the past. Some observers would consider them eccentric: they certainly were reclusive, Mrs. Gunn especially so. But the evidence also indicates that the Gunns were thoughtful collectors. They purchased from many well known dealers as well as from smaller dealers in New England. Many of the pieces they purchased are now considered masterpieces and their foresight prevented the loss of many fine works of art. It is not too surprising, despite the wonder it has raised, that the Gunns stored the paintings in a barn. They owned such a vast number of paintings and other objects that their houses and outbuildings were all used for storage. They hung a substantial number of paintings in each house and stored numbers in attics, unused rooms and closets. During their years of active collecting, awareness of conservation was somewhat limited; it is unrealistic to expect the Gunns to have been aware of such measures.

The Gunns had a passion for collecting. This has been perhaps misunderstood because their other collections were sold separately and never associated with the folk art. Had all the collections been auctioned off together, we would have been less astounded

by the number of folk paintings in the Gunn collection. In comparison with the objects comprised in the rest of the estate, the size of the painting collection is less striking.

Whether viewed as outright eccentrics, which is doubtful, or as unsung heroes of American folk art, which is closer to the mark, Marion and William Gunn made indisputable and significant contributions to the holdings of the New York State Historical Association, and of other institutions. This catalog, and the Fenimore House exhibit that it accompanies, is a demonstration of their foresight and their good fortune. The portraits presented here offer continuing opportunity for the study of an art form and for an informed appreciation of one aspect of the American past. It is of some importance that we also be aware of the process by which the collection was created.

AMY MCKUNE

[1] Biographical information for Marion Raymond Gunn comes from *Newton City Directory* (Boston, Mass., Polk and Co., 1875–1952); Newton City Records, City Clerk's office, Newton, Mass.; interviews with John G. Brooks, Co-Executor of the Gunn estate, Boston, Mass., October 17, 1986 and November 6, 1986; George Ivask, "I am Going to Yucatan," in *Novyi Zhurnal [The New Review]* 57 (1959), pp. 61–81. English translation by Dr. William Walisko, State University College at Oneonta, December 1986, pp. 6–7, NYSHA files.

[2] Biographical information for William John Gunn is from *Harvard University Anniversary Reports* (Cambridge, Mass.: Harvard University Press, 1902, 1905, 1909, 1914, 1924, 1949, 1959); and "William John Gunn," Obituary, *Portland Press Herald*, March 10, 1952, p. 132.

[3] *Harvard University Anniversary Report* (1949), p. 352.

[4] *Harvard University Anniversary Report* (1924), p. 290.

[5] Mrs. W. Rupert Maclaurin, Lincoln, Mass., telephone interview with Amy McKune, December 10, 1986.

[6] Frederick L. Rath Jr., "Memorandum to Louis C. Jones," March 18, 1960, Gunn file, NYSHA.

[7] *Harvard University Anniversary Report* (1939), p. 109.

[8] George Ivask to Dr. Louis C. Jones, April 14, 1960, Gunn file, NYSHA; Ivask, "I am Going to Yucatan." For a biographical sketch of Ivask see Nikolai P. Poltoratzky, *Russian Emigré Literature: A Collection of Articles in Russian with English Resumés* (Pittsburgh, Pa.: University of Pittsburgh, 1972), p. 390.

[9] During the estate settlement, Mr. Robert Vose appraised the American folk art collection. His appraisal (which included the location of each painting) was included in the inventory for the entire estate prepared by Walter I. Nichols, Boston, Mass., pp. 74–95, Gunn file, John G. Brooks, Peabody and Arnold, Boston, Mass.

[10] Bessie J. Howard to Dr. Louis C. Jones, May 11, 1960, Gunn file, NYSHA. This letter includes a list of dealers from whom the Gunns purchased their paintings. Sixteen of the twenty-five were known to other dealers and collectors in the New England area. Harry Stone's advertisements appear in *Antiques* XLVII (May 1945), p. 297 and LVII (May 1950), p. 338.

[11] Charles D. Childs, Stow, Mass., telephone conversation with Amy McKune, November 19, 1986. The theory that the money came from Mrs. Gunn's family is supported by the probate information. Freeborn F. Raymond II left a large trust fund to his daughter, Marion. At the time of her death, it was valued in excess of $1,000,000.00. Marion's personal and real estate was valued at $246,552.26. William Gunn did not have a will recorded at the Probate Office. Probate information was from two sources: Marion R. Gunn Will and Inventory, Registry of Probate, Middlesex County, Cambridge, Mass.; and Gunn file, John G. Brooks.

[12] Ivask, "I am Going to Yucatan," English translation, p. 13.

[13] Winsor White and Mary Allis to John G. Brooks, May 9, 1958, Gunn file; Mary Allis, Southport, Conn., telephone conversation with Amy McKune, December 3, 1986.

[14] Mary Allis, Southport, Conn., telephone conversation with Amy McKune, September 25, 1986; Inventory of Gunn Collection, Gunn file, NYSHA.

❖ On the Use of the Catalog ❖

The portraits presented in this volume are separated into two groups: those whose painters have been identified and those whose creators remain unknown. Within the identified artist section the entries are arranged alphabetically by the artist's surname. The unidentified portraits are presented chronologically by date of creation. The catalog numbers assigned to each portrait in both sections follow their order of appearance in the catalog.

A biographical entry on each identified artist precedes the entries dealing with portraits by or ascribed to that artist. The artist's full name, or the fullest known version, is given as a heading. The use of quotation marks around the name of an artist denotes a tentative identification. The dates below this heading represent the artist's birth and death dates. Where these dates are not known, the artist's known dates of activity are given. Each biographical entry is a synopsis of the artist's life and an analysis of his particular painting style. When biographical data on an artist is scant, this commentary is incorporated into the painting entries.

Each painting entry, in both identified and unidentified artist sections, begins with the painting title. When known, the subject's name is the title; if the identification of the subject is speculative, the word "possibly" will precede the name. In the naming of the artist which appears beneath the title, certain qualifications such as "attributed to," "probably by," "possibly by" and "manner of" sometimes precede the artist's name, reflecting varying amounts of visual or documentary evidence linking the portrait to that artist. The artist's name is given without qualification only if the painting is signed. The portrait's place of origin is cited next, referring to the location where the likeness was executed. A date is then assigned to each portrait, based on documentary, visual or physical evidence. An approximate date is placed on undated works, allowing for a five-year time span in either direction. Each portrait's medium and support are given as precisely as possible, as are the dimensions of the support. Dimensions appear in inches and in centimeters, with height preceding width.

The commentary on each portrait summarizes the known information on the work, and describes its particular aesthetic qualities. The technical data that follows the commentary includes the content and location of contemporary inscriptions, marks and labels; a brief conservation history and description of each portrait's condition; the history of ownership from the earliest known owner up to the donor/seller of the work to NYSHA; the portrait's exhibition and publication histories. All citations to NYSHA research files refer to curatorial files maintained on each artist and painting.

The many exhibition catalogs, books and articles listed in the *Exhibited* and *Published* sections, and in the footnotes, will prove of interest to the reader with the desire to read more on the subject of American folk portraiture.

The author of each catalog entry is identified by his or her initials at the end of the commentary as follows:

Paul S. D'Ambrosio	–	PD'A	Richard Miller	–	RM
Charlotte M. Emans	–	CME	Jacquelyn Oak	–	JO

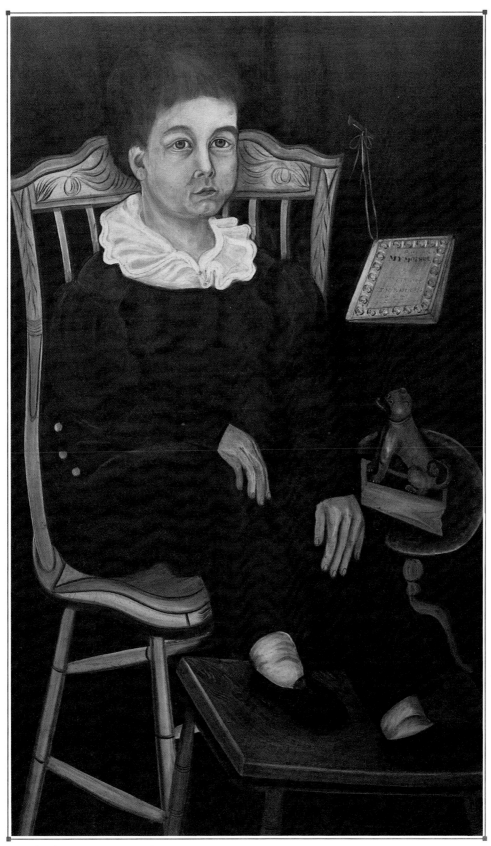

77. *Charles Mortimer French*

❖ Noah Alden ❖

(active 1830)

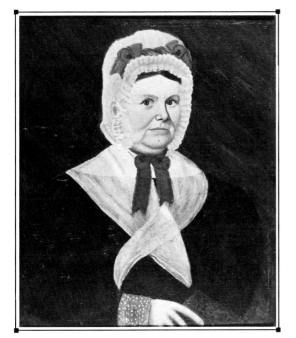

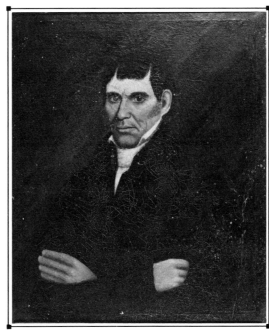

Noah Alden
Probably Massachusetts, 1830
Oil on canvas
28″ × 24″
(71.1 cm × 60.9 cm)

2. *Cintha J. Pierce*

1. *Silas Pierce*

1. **Silas Pierce** N-422.61

2. **Cintha J. Pierce** N-423.61

These likenesses of Silas and Cintha J. Pierce are among the mere handful of recorded portraits painted by Noah Alden.[1] The artist signed several canvases, sometimes noted when the subject was born, how much he charged for the completed portrait, and dated almost all specifically to 1830. Rendered in half-length frontal pose, both of these subjects turn slightly to the side, yet gaze back directly at the viewer. Characteristics of Alden's work include the dark line along the far side of the nose, curling around as it meets with the far eyebrow; the low forehead; the two-dimensional ear parallel with the picture plane; and the crudely drawn hands with stiff, rigid fingers.

Noah Alden was born on July 17, 1806.[2] He married Deborah Sherman of Middleboro, Massachusetts on May 13, 1832. The portrait of Prentis Crosby locates the artist in Bridgewater, a neighboring town of Middleboro, by November 1830.[3] CME

Inscriptions/Marks: In script, in red paint, on the verso of no. 1 is "Silas Pierce/Born June 26th 1772/Painted June 1830/By/Noah Alden [?]/Price $13.00." Modern inscription, in paint over pencil, on the verso of the lining canvas of no. 2 is "Miss Cintha J. Pierce 1793/Pinxt June 1800 [sic]/By Noah Alden."

Condition: The surface of no. 1 was cleaned in 1986 by the NYSHA conservator, but was not lined

to correct the cupping of the paint layer. At an undetermined date, no. 2 was lined, cleaned, inpainted and varnished. The surface is flat now and the varnish has very slightly yellowed.

Provenance: Mr. and Mrs. William J. Gunn, Newtonville, Mass.; Miss Mary Allis, Fairfield, Conn.; Mr. Stephen C. Clark Sr., Cooperstown, N.Y.

[1] The portraits of Jeremiah and Sarah C. Kelley and Obadiah Sampson are owned by the Fruitlands Museums, Harvard, Mass.; the portraits of Mr. and Mrs. Bump are privately owned and are illustrated in *Antiques Gazette* I (August 1, 1974); the portraits of Prentis and Sarah S. C. Crosby are privately owned and are illustrated in the untitled catalog for the C. G. Sloan and Co., sale no. 704, October 6–9, 1977, as lot no. 1455 and lot no. 1455a, on p. 184.

[2] Anne Nicholson (American Antiquarian Society) to NYSHA, September 2, 1986.

[3] The portrait is privately owned and is illustrated in the untitled catalog for the C. G. Sloan and Co., sale no. 704, October 6–9, 1977, as lot no. 1455 and lot no. 1455a, on p. 184.

❖ John James Trumbull Arnold ❖

(1812–ca. 1865)

John James Trumbull Arnold is an artist about whom few facts are known, although an ever increasing body of work ascribed to him provides some insights into his life and career.

Arnold was born on September 29, 1812 in Reading Township, Adams County, Pennsylvania. He was one of eight children and the only son of Dr. John B. and Rachel Weakley Arnold.[1] By 1841, he was active as an artist, advertising his skills as portrait and miniature painter and as teacher of penmanship. The majority of likenesses signed by or attributed to Arnold, some thirty-five at present, date from the 1850s. They have been traced largely to Pennsylvania, particularly York County, although several from West Virginia have been documented. The particulars of Arnold's later years are still unknown. He is believed to have died shortly after the Civil War, having "drunk himself into an early grave."[2]

Arnold retained his distinctive style long after the popularization of the daguerreotype and other photographic processes, at a time when most folk portraitists were mimicking the realism of the new technology in order to compete with the camera for commissions. From his known body of work, a consistently flat, linear quality is evident in the rendering of hands and faces, as well as soft grayish shades of brown in facial features, individually delineated eyelashes and smoothly painted eyebrows. His portraits of adults are usually marked by a half-length, seated pose, with the head slightly tilted and the right arm stiffly resting on a chair or a table. In contrast, his portraits of children often depict the subject in a full-length frontal pose with one hand pointing and the other hand closed in a small fist. PD'A

[1] *Adams County Historical Society Newsletter* (Gettysburg, Pa.) 9 (May 1982), p. 1. This artist is currently the subject of research by Dr. Milton Flower.

[2] Much of the biographical information on the artist is from Beatrix T. Rumford, ed., *American Folk Portraits: Paintings and Drawings from the Abby Aldrich Rockefeller Folk Art Center* (Boston, 1981), pp. 39–41, and George C. Groce and David H. Wallace, *The New-York Historical Society's Dictionary of Artists in America, 1564–1860* (New Haven, 1957), p. 13. A combination self-portrait and advertisement for portraits, miniatures and penmanship is signed "J. J. T. Arnold" and is owned by the Abby Aldrich Rockefeller Folk Art Center, Williamsburg, Va. Five portraits have been found depicting members of the Withers family from Summit Point, Jefferson County, Virginia, now West Virginia, and all are dated 1849. The portraits are privately owned. A portrait of a gentleman from Romney, West Virginia, dated April 1853, is also privately owned. Rumford, *American Folk Portraits*, p. 40.

3. *Baby in a Pink Dress* N-383.61

This well composed portrait contains a series of diagonal lines, formed by the legs and arms of the chair and the outlined folds of the dress, that effectively lead the viewer's eye to the point of intersection at the child's softly modeled face.

As in other portraits of children by Arnold, the composition is frontal and full-length with the arms of the subject jutting out stiffly from the body. Hands are posed characteristically with a finger on one hand pointing and the other hand held in a stubby fist. The flatly rendered facial features, which are modeled in grayish brown tones, the mottled, reddish brown painted surface of the chair, the necklace around the neck of the child, the lace along the neckline of the dress, and the wide part in the hair are similar to details in other known works by Arnold. Individually painted eyelashes, a hallmark of Arnold's artistic style, do not appear in this portrait. PD'A

Condition: In 1962, Caroline and Sheldon Keck cleaned the surface, inpainted a few small damages, and applied protective varnish. At an unknown date previous to that work, the painting was lined with fabric and glue, and losses around the head and in the dress were inpainted.

Provenance: Mr. and Mrs. William J. Gunn, Newtonville, Mass.; Miss Mary Allis, Fairfield, Conn.; Mr. Stephen C. Clark Sr., Cooperstown, N.Y.

Exhibited: "Folk Art From Cooperstown," Museum of American Folk Art, New York, N.Y., March 21–June 6, 1966; untitled exhibition, New York State Teachers Association, Elnora, N.Y., March 27–April 1, 1967; "American Folk Art," Anglo-American Art Gallery, Louisiana State University, Baton Rouge, La., February 15–April 30, 1968.

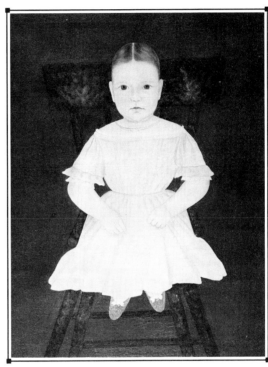

Attributed to John James Trumbull Arnold
Probably Pennsylvania, Maryland, Virginia or West Virginia, ca. 1850
Oil on canvas
29¼″ × 22⅛″
(74.3 cm × 56.2 cm)

3. *Baby in a Pink Dress*

4. *Lady in a White Cap in a Stenciled Chair* N-430.61

This likeness of an unidentified woman is typical of Arnold's portraits of adults, illustrating the stiff, two-dimensional treatment of anatomy that marks his style. The composition, pose, tilted head, softly shaded flesh tones and the individually painted eyelashes all place this portrait clearly within Arnold's attributed body of work. Also typical of the artist's style is the hand draped over the chair rail and seemingly disconnected from the arm, and flatly delineated fingers held together and bent as if soft and malleable. The dark color scheme is alleviated by the woman's white bonnet, lace collar and the bright yellow painted stencil decoration on the chair. Her smiling expression is a rarity in folk portraiture. PD'A

Attributed to John James Trumbull Arnold
Probably Pennsylvania, Maryland, Virginia or West Virginia, ca. 1850
Oil on canvas
30⅛″ × 25″
(76.5 cm × 63.5 cm)

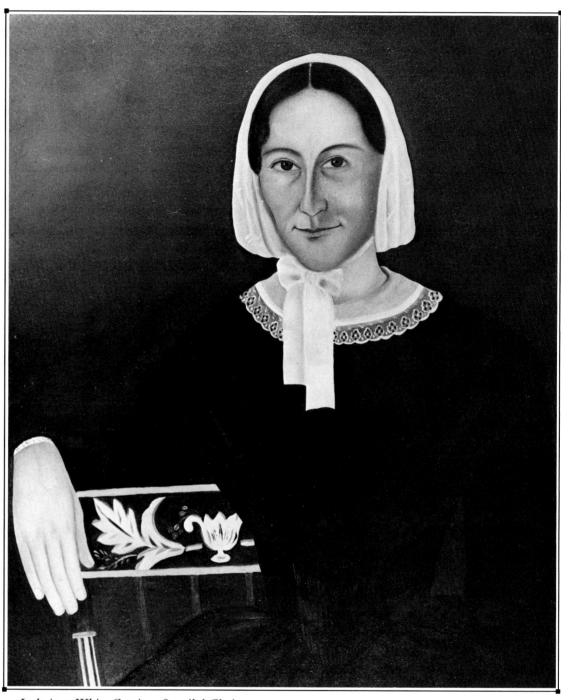

4. *Lady in a White Cap in a Stenciled Chair*

Inscriptions/Marks: Printed on a paper label fragment on the right member of the frame is "...CHE...NGS/Looking G.../of eve.../...oLD Frames p..."

Condition: Conservation treatment by Caroline and Sheldon Keck in 1961 included removing a patch, improving several old repairs, cleaning and lining. The painting was put on a new stretcher and several small losses were filled and inpainted.

Provenance: Mr. and Mrs. William J. Gunn, Newtonville, Mass.; Miss Mary Allis, Fairfield, Conn.; Mr. Stephen C. Clark Sr., Cooperstown, N.Y.

❖ Calvin Balis ❖

(ca. 1817–after 1856)

Owing to this artist's practice of signing his canvases with only his first initial and last name, he was, for many years, an obscure figure known only as "C. Balis." Recent research has identified him as Calvin Balis, probably the son of Calvin and Sally Cogswell Balis of Whitestown, New York, adjacent to Utica. In addition, the discovery of over thirty paintings from the vicinity of Whitestown, as well as some written documentation, has brought Balis's life and career more into focus.[1]

Balis's earliest known painting, a portrait of Smith Dewey, dated 1834 and signed "C. Balis, Jr.", indicates that he had begun his career as an artist by the age of seventeen.[2] By 1845, he was working in neighboring Madison County, as a notice in the Hamilton, New York *Democratic Reflector* of January 29 states that he had "taken a room over W. H. Williams' Jewelry Store" to paint portraits. At that time, he claimed to have had ten years' experience. On February 19 another notice was published in this newspaper, announcing the completion by Balis of four portraits of local residents.

By 1850, the artist had returned to Whitestown where his name appears in the New York federal census as a thirty-three-year-old portrait painter living with his wife and four children. The family is again listed in the 1855 New York state census and then mysteriously disappears. The popularity of photography and the subsequent decline in painted portrait commissions may have forced the artist to abandon portraiture for more profitable pursuits elsewhere, as no paintings by Balis have been recorded dating after 1856.

The vast majority of works signed by or attributed to Balis are portraits, although three paintings depicting genre and historical subjects have been documented.[3] His painting style remained remarkably consistent well after the introduction of photographic techniques had increased the demand for more naturalistic portraiture. The technically accomplished portrait of Daniel Eels, dated 1846, suggests that Balis was capable of painting in a more polished, "academic" manner.[4] In general, his sitters are posed in a murky, fantasy-like landscape with cliffs, lakes and attenuated trees.[5] Faces appear distinctly placid, with large, dark eyes, small, unsmiling mouths, and hands typically tapered with long slender fingers in flame-shaped forms. PD'A

[1] Pioneering information on C. Balis was published in Agnes Halsey Jones's catalog for the NYSHA exhibition "Rediscovered Painters of Upstate New York, 1700–1875," June 14–September 15, 1958, p. 25. For more information on the artist and a checklist of known works, see Cynthia Sutherland, "The Search for the Elusive C. Balis," *The Clarion* (Fall 1984), pp. 54–61.

[2] This portrait is privately owned and is listed in Sutherland, "The Search for the Elusive C. Balis," as checklist no. 23 on p. 61. This is the only known instance in which the artist used a panel support.

[3] See *ibid.*, checklist no. 12, no. 17 and no. 18.

[4] This portrait is owned by the Munson-Williams-Proctor Institute, Utica, N.Y., and is listed *ibid.* as checklist no. 9 on p. 61.

[5] One notable exception to the standard background technique is the large double portrait of George and Emma Eastman, which is dominated by a lavish and accomplished rendering of their father's house, shop, gardens and surrounding landscape. This portrait is owned by the William Rockhill Nelson Gallery of Art, Kansas City, Mo., and is illustrated *ibid.* as fig. 1 on p. 54.

5. *Charles Thomas Bowen* N-222.59

Many of the stylistic features that typify Balis's portrait work are evident in this somber likeness. The sitter's rigid pose, large, dark eyes, compressed mouth and small, tapered hands are all hallmarks of this artist's style. Also typical is the murky landscape with the attenuated trees in the background. Balis invariably depicted young male sitters in white trousers, a practice which served to lighten his otherwise dark compositions.

Charles Thomas Bowen was born February 26, 1838 in Oneida County, New York, the son of Thomas and Susan Juliette Newkirk Bowen. After the death of his father in 1838, Charles and his mother moved to her parents' home in Washington Mills, New York. The following year, his mother remarried and moved away with her husband. Charles stayed behind in Washington Mills to be raised by his grandparents. In May of 1861, the subject married Catherine Lillian Hammond. During the Civil War, Bowen served in the infantry, rising to the rank of sergeant. Afterwards, he returned to his wife in Washington Mills where he died of tuberculosis in 1874. He is buried in Forest Hill Cemetery in Utica, New York.[1] PD'A

Calvin Balis
Probably Washington Mills,
New York, 1850
Oil on fabric
34⅛″ × 28″
(86.7 cm × 71.1 cm)

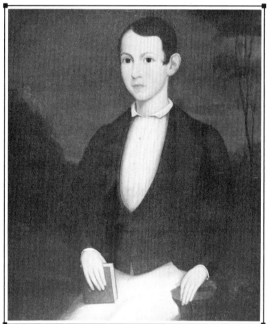

5. *Charles Thomas Bowen*

Inscriptions/Marks: Painted in script on the verso is "C. T. Bowen/AEt 12./C. Balis/Pinxit/Sept. 1850."

Condition: In 1959, Caroline and Sheldon Keck consolidated the flaking paint, mended tears in the canvas, lined the painting, and cleaned the surface. It was put on a new stretcher and extensive losses were inpainted.

Provenance: Mrs. Edward K. Cassedy (Capitola Bowen), Schenectady, N.Y. (descendant of the sitter).

Published: Cynthia Sutherland, "The Search for the Elusive C. Balis," *The Clarion* (Fall 1984), p. 59, illus. as fig. 7 on p. 59.

[1] All biographical information on the subject is from NYSHA research files, and was supplied by the donor, Mrs. Cassedy, who was a daughter of the sitter.

❖ Lucius Barnes ❖

(1819–1836)

6. *Martha Barnes* N-59.61
7. *Martha Barnes, Aged 96* N-350.61

These two portraits of Martha Barnes are among seven known likenesses of the subject believed to have been drawn by her grandson, Lucius Barnes. Born on August 1, 1819

in Middletown, Connecticut, the artist was the son of Elizur and Clarissa Bacon Barnes. At about age four, he was afflicted with a spinal disease which left him with the use of only his hands and toes. Confined to a wheelchair for most of his life, Barnes drew these portraits of his ninety-six-year-old grandmother when he was probably fifteen years old. He died two years later on September 9, 1836.[1] It has not been determined why Barnes painted so many portraits of his grandmother, but the remains of a portrait bound inside a copy of John Cookson's book on Mrs. Barnes entitled *The Memoir of Martha Barnes, Late of Middletown, Connecticut* (1834) suggests that some of these nearly identical drawings may have served originally as frontispiece illustrations to this text.[2]

Barnes always depicted his grandmother in profile wearing wire-framed oval glasses, a long-sleeved black dress, a shawl with a decorative border and a white cap held in place with a black bow. In these two portraits, Mrs. Barnes is drawn standing on a mound-like formation holding a cane in one hand and smoking a pipe. In other examples, she is drawn seated on a chair reading a book, and in one instance, reading the Bible.[3]

Martha Barnes was probably born on June 17, 1738, the second daughter of Thomas and Martha Miller Atkins of Middletown, Connecticut. On March 23, 1758, she married Jabez Barnes, a sailor. About 1780, her husband was lost at sea or died of a fever in the West Indies, leaving Martha with eight children to raise. She died in Middletown on October 10, 1834 at the age of ninety-six. Martha Barnes was remembered by John Cookson as a strong-willed and devoutly religious woman who was absent from Sunday church service only two half-days during the last twenty years of her life.[4] CME

Inscriptions/Marks: In ink in script below no. 7 is "Martha Barnes Aged 96." No watermarks found.

Condition: The paper on no. 6 is cockled and unevenly yellowed. An acid-free mat and backing have been placed in the frame. Treatment by the NYSHA conservator in 1983 included float washing and sun-bleaching no. 7 in calcium carbonate solution to reduce water spots, yellowed paper, and a dark brown stain at bottom left. An acid-free mat and backing replaced the former backing.

Provenance: Mr. and Mrs. Howard Lipman, Wilton, Conn.; Mr. Stephen C. Clark Sr., Cooperstown, N.Y.

Exhibited: "Primitives," Harry Stone Gallery, New York, N.Y., 1942, no. 7 only; untitled exhibition, The Century Association, New York, N.Y., January-February 1952, no. 7 only; "American Primitive Watercolors," Smithsonian Institution, Washington, D.C., 1965, and exhibition catalog, no. 7 on p. 4.

Published: Jean Lipman, *American Primitive Painting* (New York, 1969), no. 7 only, illus. as no.

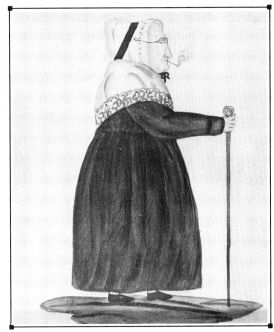

6. *Martha Barnes*

**Attributed to
Lucius Barnes**
Probably Middletown, Connecticut, probably 1834
Watercolor on wove paper
6⅝″ × 5¹¹/₁₆″
(16.8 cm × 14.4 cm)

35 on p. 51.

Attributed to
Lucius Barnes
Probably Middletown,
Connecticut, probably 1834
Watercolor on wove paper
6½″ × 4¼″
(16.5 cm × 10.8 cm)

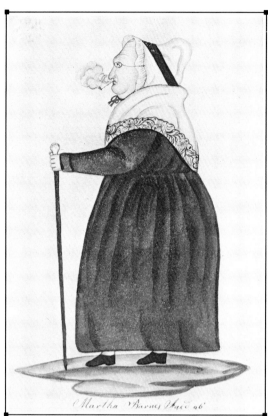

7. *Martha Barnes, Aged 96*

[1] All biographical information on the artist and portrait subject is from Mrs. Arthur B. Schultz (The Middlesex County Historical Society) to NYSHA, May 30, 1985.

[2] This book is owned by the Connecticut Historical Society, Hartford, Conn.

[3] This portrait is owned by the Danbury Scott-Fanton Museum and Historical Society, Danbury, Conn.

[4] According to both George N. Barnes, *Barnes Genealogies including a Collection of Ancestral Genealogical and Family Records and Biographical Sketches of Barnes People* (Ohio, 1904), p. 195 and John Cookson, *Memoir of Mrs. Martha Barnes, Late of Middletown, Connecticut* (Middletown, Conn., 1834), p. 9, Martha Barnes was born on June 17, 1739. However, her age was recorded on three of the portraits as ninety-six years old, which suggests that her birthdate was 1738.

❖ Ruth Henshaw Bascom ❖
(1772–1848)

Ruth Henshaw Bascom was born on December 15, 1772, the eldest of ten children of Colonel William and Phebe Swan Henshaw of Leicester, Massachusetts. At the age of seventeen, Bascom began a journal which she maintained for fifty-seven years, from 1789 through 1846. The journal presents her daily activities as schoolgirl, wife, stepmother and most significantly as portrait painter. In it, she recorded making over one thousand portraits for money, services in kind or simply as tokens of affection.[1]

On February 14, 1804, the artist married Dr. Asa Miles, a surgeon who lived in Westminster, Massachusetts. After only a year of marriage, Bascom was left a widow and returned to her family's home in Leicester. In January of 1806, she married the Reverend Ezekiel Bascom, a minister of the Congregational Church in Gerry, now Phillipston, Massachusetts. Mrs. Bascom assumed her varied roles as minister's wife, caretaker of her husband's daughter and orphaned nephew, church record keeper, librarian, summer school teacher, hat maker and artist.

By 1819, Bascom was filling her journal with specific comments about her portrait work. These entries indicate that she was drawing an average of twelve likenesses a year. Unfortunately, no renderings from this period have been found to document her early

portrait work. In January of 1821, the Bascoms moved to Ashby, Massachusetts where the Reverend Bascom became pastor of the local Congregational Church. By 1828, the artist's level of productivity had increased significantly, as she was now averaging about forty portraits a year. She also began noting in her journal when she bought art supplies including crayons, paper, frames, and glass. The artist also began traveling to areas outside Ashby, making portraits of friends and relatives whom she visited in Cambridge Port, Boston and Athol. Bascom's involvement in portraiture had thus progressed from a hobby to a profession.

In 1832, the Reverend lost his parish at Ashby as a result of an illness which forced him to spend the winter months in Savannah, Georgia. Mrs. Bascom stayed behind and lived with various relatives and friends in towns throughout Massachusetts including Belchertown, Hadley, Northampton, Gill, Bernardston, Greenfield, Worcester and Leicester and in parts of Maine. In 1839, with the Reverend's health somewhat improved, the couple went to live in Fitzwilliam, New Hampshire, where the Reverend Bascom died in 1841. Mrs. Bascom later returned to Ashby where she continued to make portraits until at least 1846. She died in 1848 at the age of seventy-six.

To date 185 portraits by Bascom have been recorded, all rendered in life-size profile.[2] The artist preferred a bust-length format for her adult subjects while choosing to depict children in half-length and three-quarter length poses. Bascom followed a four-part process to render her portraits accurately and with a sense of aesthetic appeal. First, the artist captured in pencil the shadowed outline of the person which was cast on the wall by a light source. Such details as the subject's facial features and clothing were recorded with pencil. Then, without need for the sitter to be present, Bascom colored in the picture using pastel crayons. Finally, backgrounds were filled in with solid color, although sometimes the artist included stylized landscape scenes or finished corners of the paper with stylized swagged drapery. At other times, the artist made necklaces, earrings and glasses of gold foil paper and pasted individual locks of hair to the paper. She often executed these features separately and then applied them later to the composition, using a collage-like technique. Bascom maintained a personal relationship over the years with many of her subjects and, in some cases, with their portraits as well. She mended tears in the paper, altered profiles as the subject aged, and even altered costumes to reflect changing styles. CME

[1] All biographical information on the artist is from Mary Eileen Egan, "Ruth Henshaw Bascom, New England Portraitist" (Honors Thesis, College of the Holy Cross, Worcester, Mass., 1980); this journal is owned by the American Antiquarian Society, Worcester, Mass.

[2] Lois S. Avigad to NYSHA, February 4, 1987. Bascom's work is the subject of continuing research by Ms. Avigad.

8. *Content Chamberlain* N-113.61
9. *Eliezur Chamberlain* N-114.61

Bascom extended the portrait of Content Chamberlain at the top of the drawing with a small strip of paper which resulted in a more successfully balanced portrait composition.[1] In the lower portion to the right of Mrs. Chamberlain's likeness, the artist drew stylized green pine trees with brown trunks, a seemingly light-hearted motif she included in several compositions. The green shading beside both portraits was a technique em-

Attributed to Ruth Henshaw Bascom
Probably Bernardston, Massachusetts, 1837
Pastel and pencil on wove paper
18⅞″ × 14″
(47.9 cm × 35.6 cm)

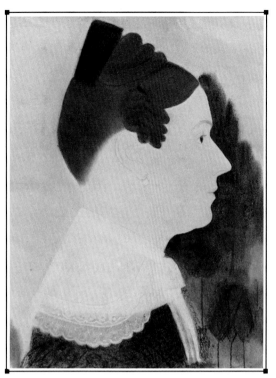

8. *Content Chamberlain*

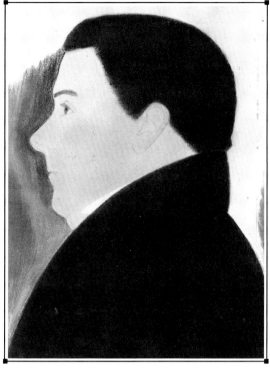

9. *Eliezur Chamberlain*

ployed by the artist to separate the profile from the blue background and to lend further definition to it.

Content Chamberlain was born on January 10, 1788 to Mary and Samuel Pickett Jr., of Greenfield, Massachusetts. On September 2, 1807 in Greenfield, she announced her intention to marry Eliezur Chamberlain of Durham, Connecticut, who was born in September 1786. The couple resided in Bernardston, Massachusetts where they had a daughter, Mary M. Chamberlain, who was born in June 1808 and died, unwed, on April 5, 1878.[2] Content Chamberlain died on June 27, 1862 at the age of seventy-four.[3]
CME

Inscriptions/Marks: Penciled in script on the backing board of no. 8 is "Mary Chamberlain/born June 1808/died April 5, 1878." Penciled in script vertically along the left side of the backing board of no. 9 is "Eliezur Chamberlain" and in ink in script at the lower left corner is "April 1837/Aged 50 – Last September." The primary support of no. 8 bears the watermark of a six-point star. No watermark found on no. 9.

Condition: The paper is slightly cockled on no. 8. An acid-free mat and backing were placed in the frame in 1987. No. 9 shows no record of previous conservation. The paper is slightly cockled at left and right edges.

Provenance: Mr. and Mrs. Howard Lipman, Wilton, Conn.; Mr. Stephen C. Clark Sr., Cooperstown, N.Y.

Exhibited: "Identified American Primitives," Harry Shaw Newman Gallery, New York, N.Y., November 15–30, 1950; "Primitives," Union College Art Gallery, Schenectady, N.Y., March 1951.

[1] Information recorded in modern hand on the backing board of this portrait indicates that the subject is Mary Chamberlain, wife of Eliezur Chamberlain. However, Mrs. Chamberlain's name was Content and Mary was their daughter. This portrait of Mrs. Chamberlain is more probably a likeness of Content than Mary as Bascom makes reference in three separate journal entries to rendering Mrs. Chamberlain's portrait and only cites an evening spent with Miss Chamberlain. The journal is owned by the American Antiquarian Society, Worcester, Mass.

[2] Jerome E. Anderson (New England Historical and Genealogical Society) to NYSHA, June 6, 1986.

[3] Mary Pat Brigham (Vermont Historical Society) to NYSHA, April 14, 1986. Erroneous information recorded on a modern typed paper label attached to the backing board of Mrs. Chamberlain's portrait states that the couple lived in Brattleboro, Vt.

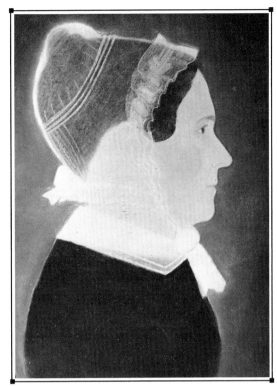

10. *Elizabeth Hastings Henshaw*

Ruth Henshaw Bascom
Leicester, Massachusetts, 1839
Pastel and pencil on wove paper
19″ × 13⅞″
(48.2 cm × 35.2 cm)

10. **Elizabeth Hastings Henshaw**
N-259.61

11. **Horatio Gates Henshaw** N-260.61

Bascom used pencil not only to draw the outline of her portraits, but also to bring greater definition to facial features and clothing details. She depended on this medium to highlight portions of the portrait of Elizabeth Hastings Henshaw as graphite is visible on the pastel surface, specifically at the knot tied under the subject's chin and on the bow at the back of her bonnet. With rather limited means, Bascom further distinguished Henshaw's bonnet by using deliberate, solid strokes of white pastel crayon around the outside edges to define its form within the portrait composition. She also used this color effectively to create a rhythmic play of line from the pattern created by the bonnet's ruffled edges.

The portrait depicting the artist's brother, Horatio Gates Henshaw, is one of Bascom's more compelling character studies. From the heavy, lined brow, to the strongly contoured nose and tightly pursed lips, this likeness successfully conveys the mature appearance of a fifty-year-old man. The brightly colored, ruddy complexion of his cheeks as well as the sinuous locks of hair curling forward on the brow, sweeping up at the side of his face and on the nape contribute to making this portrait a dynamic study. Bascom noted rendering this likeness in her journal entry for July 4, 1839. "I painted on brother Gates likeness...." On July 19, she wrote, "went over to brothers to tea/and framed his likeness."

Born on March 28, 1791, Elizabeth Hastings Henshaw was the daughter of Benjamin and Rebecca Clark Hastings of Watertown, Massachusetts. On March 28, 1816, she married Horatio Gates Henshaw who was born on September 21, 1788 to William and

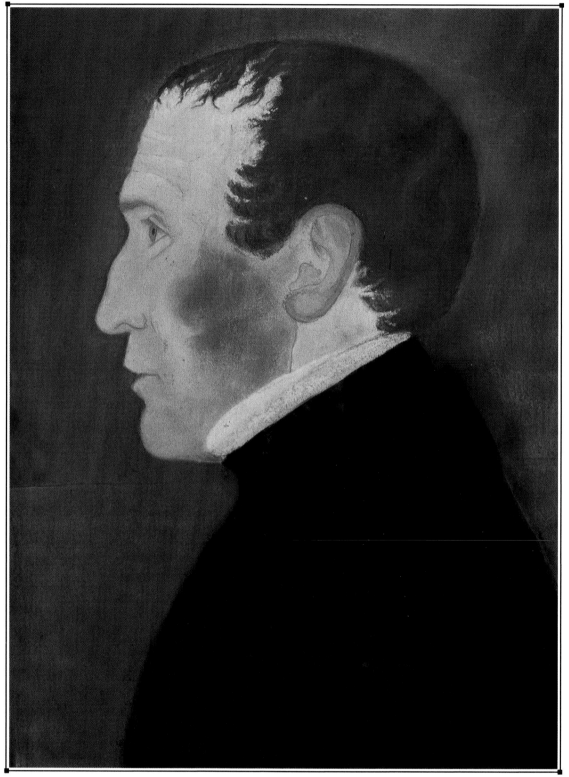

Ruth Henshaw Bascom
Leicester, Massachusetts, 1839
Pastel and pencil on wove paper
19" × 13 7/8"
(48.2 cm × 35.2 cm)

11. *Horatio Gates Henshaw*

Phebe Swan Henshaw of Leicester, Massachusetts.[1] As a young man, Henshaw had apprenticed to a storekeeper and soon opened his own business in New Worcester. By 1825,

Henshaw and his wife had returned to Leicester where they raised three girls. Henshaw worked for about twenty years as a cashier at the Leicester Bank and served for thirty years as a justice of the peace. For a time, he also maintained a trading business in town under the firm name, Henshaw and Willard. Horatio Gates Henshaw died on May 7, 1860 in Leicester, his wife in 1866. CME

Inscriptions/Marks: Inscribed in pencil on the verso of no. 11 is "Horatio Gates Henshaw Esq./of Leeicester[sic]-born Sept. 21. 1788./Sketched July 1839./by R. Henshaw Bascom." Inscribed in pencil on the inside of the backing board is "Horatio Gates Henshaw Esq./Leicester July 1839." No watermarks found.

Condition: At some time in the past, no. 10 was dry-mounted to a sheet of illustration board, apparently with very little loss of pigment. It is still firmly attached. In 1983, the NYSHA conservator put the portrait in a new acid-free mat and backing. The paper is slightly cockled on no. 11. An acid-free mat and backing were placed in the frame in 1987.

Provenance: Mr. and Mrs. William J. Gunn, Newtonville, Mass.; Miss Mary Allis, Fairfield, Conn.; Mr. Stephen C. Clark Sr., Cooperstown, N.Y.

Exhibited: NYSHA, "New-Found Folk Art of the Young Republic," 1960, and exhibition catalog, no. 52A and no. 52B, pp. 24–25 and illus. as fig. 52A and fig. 52B.

[1] Cinthia A. Walden (American Antiquarian Society) to NYSHA, May 14, 1985; Marie E. Lamoureux (American Antiquarian Society) to NYSHA, May 2, 1986.

12. *Eliza Jane Fay* N-288.61

Bascom's fondness for rounded forms is echoed in the curvilinear folds of Eliza Jane's dress, her scallop-edged collar, and the outline of her hair swept up behind her ear pierced with a daisy-like earring. A particularly sensitive likeness, this portrait of Eliza Jane Fay is unusual for the artist as the subject's body is drawn in almost three-quarter view. The artist chose this perspective to better display the subject's locket which is inscribed, "In Mem[ory of] Geo. Washingt[on]." During the Victorian era in America, women and young girls often wore mourning jewelry such as this piece commemorating the death in 1799 of the first president of the United States.

Born on March 25, 1832 in Fitzwilliam, New Hampshire, Eliza Jane Fay was the only child of Benjamin Fay and his first wife Abigail Ross Fay. On September 20, 1854, she married David Lyman Laws, originally of Westminster, Massachusetts. The couple settled in Boston where they raised four children. She died in Boston on April 29, 1899.[1] CME

Inscriptions/Marks: Penciled in script at the base of the monument pictured in the locket is "In Mem[ory of] Geo. Washingt[on]" and below the portrait is "Eliza Jane Fay/Fitzwilliam N.H./Aged 8 years & 4 months. 1840." Penciled in script on the verso at the bottom is "Eliza ^Jane^ Fay/Fitzwilliam/July 1840." No watermark found.

Condition: An acid-free mat and backing were placed in the frame by the NYSHA conservator in 1983.

Provenance: Mr. and Mrs. William J. Gunn, Newtonville, Mass.; Miss Mary Allis, Fairfield, Conn.; Mr. Stephen C. Clark Sr., Cooperstown, N.Y.

Exhibited: NYSHA, "New-Found Folk Art of the Young Republic," 1960, and exhibition catalog, no. 53A, pp. 24–25 and illus as fig. 53A.

[1] All biographical information on the subject is from the Fitzwilliam Historical Society, N.H. to NYSHA, November 22, 1976.

**Attributed to Ruth
Henshaw Bascom**
Fitzwilliam, New Hampshire,
1840
Pastel and pencil on laid paper
17¾" × 12⅞"
(45.1 cm × 32.7 cm)

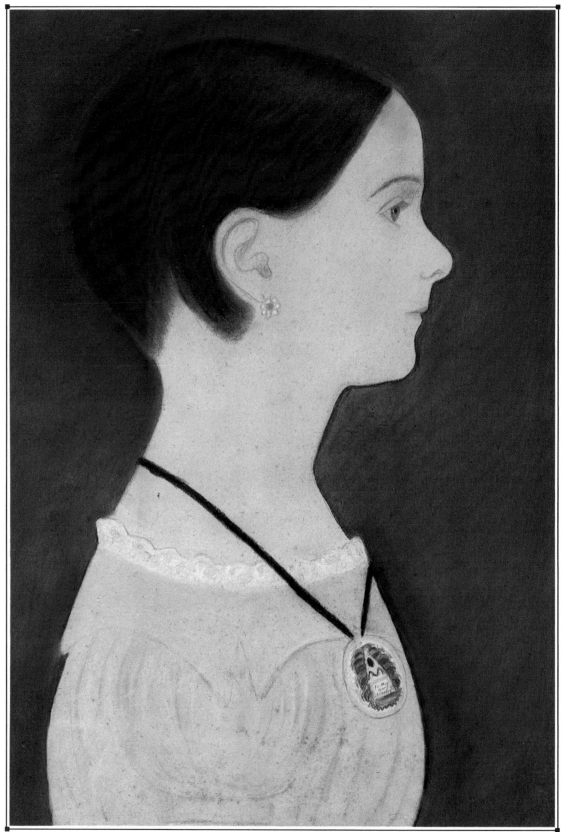

12. *Eliza Jane Fay*

13. *Charles Lewis Bingham* N-287.61

Bascom's renderings of children are among her most sensitive and imaginative interpretations. Here, the artist convincingly portrays Charles Lewis Bingham as a healthy baby boy. From Bingham's full, double chin and no neckline, to his oversized ears and round body, this likeness evinces youth and vitality. The rattle held in the subject's hand probably served to entertain the sitter while his likeness was being drawn. However, the prop also served conveniently as a decorative device for Bascom and is found in some of her other portraits of children. The inclusion of the subject's right arm and hand in the composition is an unusual feature of this artist's work.

Born in about 1844, Charles Lewis Bingham was probably the son of Rebecca and Charles Bingham of Fitchburg, Massachusetts.[1] According to the federal census record for 1850, Charles's father worked as a railroad agent. Such a transient lifestyle may explain the lack of information on this family found in Fitchburg. CME

Inscriptions/Marks: Penciled in script on the verso at the lower right corner is "Charles Lewis Bingham/Fitchburg/Taken at Ashby/May 1844/by R. H. Bascom." No watermark found.

Condition: The paper is slightly cockled at top right along the edge. An acid-free mat and backing have been placed in the frame.

Provenance: Mr. and Mrs. William J. Gunn, Newtonville, Mass.; Miss Mary Allis, Fairfield, Conn.; Mr. Stephen C. Clark Sr., Cooperstown, N.Y.

Exhibited: NYSHA, "New-Found Folk Art of the Young Republic," 1960, and exhibition catalog, no. 53B, pp. 24–25, and illus. as fig. 53B; "Small Folk: A Celebration of Childhood in America," Museum of American Folk Art, New York, N.Y., December 12, 1980–February 1, 1981.

Published: Sandra Brant and Elissa Cullman, *Small Folk: A Celebration of Childhood in America* (New York, 1980), illus. as fig. 58 on p. 39.

[1] All biographical information is from Eleanora F. West (Fitchburg Historical Society) to NYSHA, July 9, 1986.

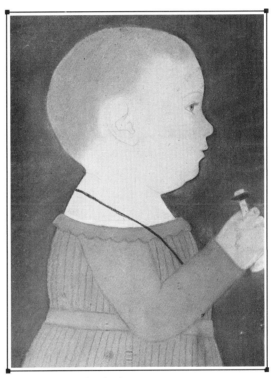

13. *Charles Lewis Bingham*

Ruth Henshaw Bascom
Ashby, Massachusetts, 1844
Pastel and pencil on wove paper
16″ × 12″
(40.6 cm × 30.5 cm)

❖ Zedekiah Belknap ❖

(1781–1858)

Zedekiah Belknap was born on March 8, 1781 in Ward, now Auburn, Massachusetts, the son of Zedekiah and Elizabeth Wait Belknap. When he was thirteen years old his family relocated to a twenty-five acre farm in Weathersfield, Vermont. While his brothers and sisters tended the farm, Belknap went on to pursue divinity studies at Dartmouth

College in Hanover, New Hampshire, where he was graduated in 1807. A biography published in *Sketches of the Alumni of Dartmouth College* states that he "preached a few years, but was never ordained, his only employment known to us was that of a portrait painter." While portraiture seems to have been Belknap's only occupation, a Belknap family genealogy asserts that he served as chaplain in the War of 1812. On April 30, 1812, he married Sophia Sherwin in Waterville, Maine. Their marriage was soon terminated, as Belknap's alumni records at Dartmouth College indicate that she left him after seeing his limping relatives, who were victims of a hereditary hip disease.[1]

Whether or not the young portraitist received formal art instruction has not been determined. He began painting at least by 1807, signing and dating in that year portraits of John, Xperience and Sarah Carpenter, all of New Hampshire.[2] Belknap's artistic career took him throughout Vermont, New Hampshire and Massachusetts, as he traveled in search of portrait commissions. The more than 170 portraits currently ascribed to Belknap illustrate the stylistic changes he underwent during the course of his career. His early portraits exhibit an effort to render his subjects in a naturalistic manner.[3] However, he soon developed a bold, decorative style that allowed him to execute portraits with greater speed and efficiency. This style is marked by bright colors and a decorative use of costume details, stylish hair and various accessories, all of which served to compensate for the artist's inability to render anatomy. Belknap consistently outlined the flesh tones with heavy, dark lines, and paid particular attention to the thick reddish outline of the nose. Also typical of the artist's work are the reddish ears rendered flat against the picture plane. For most of his career, Belknap painted full-size oil portraits on wood panels, on most of which he first scored the surface with diagonal lines. This practice enabled the paint to adhere to the wood while lending a canvas-like texture to the finished surface. With his paintings on canvas Belknap often chose a coarsely woven material, stretching it in such a manner as to create a diagonal twill configuration. Belknap's later portraits are somber, naturalistic likenesses which reveal the influence of the daguerreotype on his painting style. His latest signed and dated likeness is the portrait of Rufus Holman, inscribed on the back "Portrait of Rufus Holman/at 71 yrs. Aug. 13th 1848/Z. Belknap pinxt/Nov. 1848."[4] This portrait was painted at about the time Belknap moved back to the family farm in Weathersfield.

Falling on hard times, Belknap entered the Chester Poor Farm in 1857 and remained there until his death on June 8, 1858. He is buried, with several members of his family, in the Aldrich graveyard in Weathersfield. Belknap experienced many tragedies in his life, including the crippling physical effects of a hereditary disease suffered by members of his family, his marriage to a woman who abandoned him soon thereafter, and his inability to remain solvent, as a result of which he spent the last year of his life in a poorhouse. Despite these unhappy circumstances, he developed his artistic skills without the benefit of extensive training and created portraits of timeless beauty and visual appeal. PD'A

[1] All biographical information on the artist is from Elizabeth R. Mankin, "Zedekiah Belknap," *Antiques* CX (November 1976), pp. 1055–1066.

[2] The portraits are privately owned and are illustrated in *Antiques and the Arts Weekly* (Newtown, Conn.), July 29, 1977, p. 42.

[3] An example is the portrait of Joseph Stone, signed and dated at lower left "Zedekiah Belknap/1810." The portrait is privately owned and is illustrated in Mankin, "Zedekiah Belknap," as fig. 1 on p. 1056.

[4] The portrait is privately owned and is illustrated in Mankin, "Zedekiah Belknap," as fig. 20 on p. 1066.

14. *Portrait of a Young Woman* N-427.61

Many of the stylistic traits that typify Zedekiah Belknap's work are evident in this half-length portrait of a seated young woman. The sitter's hard-edged facial features and rigid stylized body characterize the bold, decorative style developed by the artist to enable him to more rapidly execute portraits. Contributing to the aesthetic appeal of the portrait composition are embellishments such as the woman's stylish curls, sheer lace collar and jewelry as well as the floral decoration on the chair. The shawl framing the body of the sitter was a device commonly used by Belknap in his portraits of female subjects. PD'A

Condition: In 1963, Caroline and Sheldon Keck cleaned the panel and set down cleaving paint in the face. Small fills and inpainting were needed and an extra support panel was loosely attached to the back.

Provenance: Mr. and Mrs. William J. Gunn, Newtonville, Mass.; Miss Mary Allis, Fairfield, Conn.; Mr. Stephen C. Clark Sr., Cooperstown, N.Y.

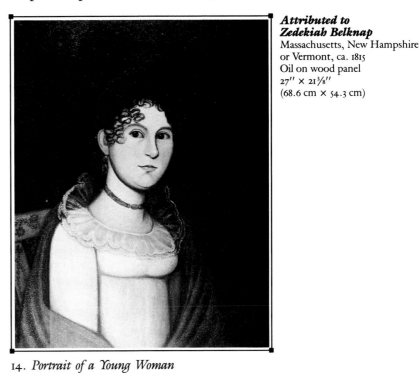

Attributed to
Zedekiah Belknap
Massachusetts, New Hampshire or Vermont, ca. 1815
Oil on wood panel
27″ × 21⅜″
(68.6 cm × 54.3 cm)

14. *Portrait of a Young Woman*

15. *Two Children with a Basket of Fruit* N-447.61

In this arresting double portrait, Belknap symmetrically arranged figures around a shared basket of fruit, thus creating a composition of unusual balance and harmony. The strong outlines along the young sitters' pleasingly round facial features and tubular arms are characteristic of this artist's work, as Belknap consistently employed dark, concentrated lines of color to define three-dimensional form. Enhancing the visual appeal of the children's faces are their large eyes, full cheeks and mouths, pudgy noses and flat, reddish ears—all telling features of Belknap's hand. Their dresses are embellished with decorative elements such as the zig-zag and lace-edged collars. The playful treatment of the ringlets of hair on the head of the child at the right also adds to the portrait's overall visual appeal, and the basket of fruit is a compelling arrangement of shapes and forms. The large pieces of fruit are outlined in dark, yet colored in light, making them soft and round in a manner that echoes the children's features. Each grape is given highlighted form by the application of individual dabs of white paint. In addition, the artist captured the rhythmic quality of the woven basket design as he forcefully rendered its scalloped uprights in a repetitive pattern. PD'A

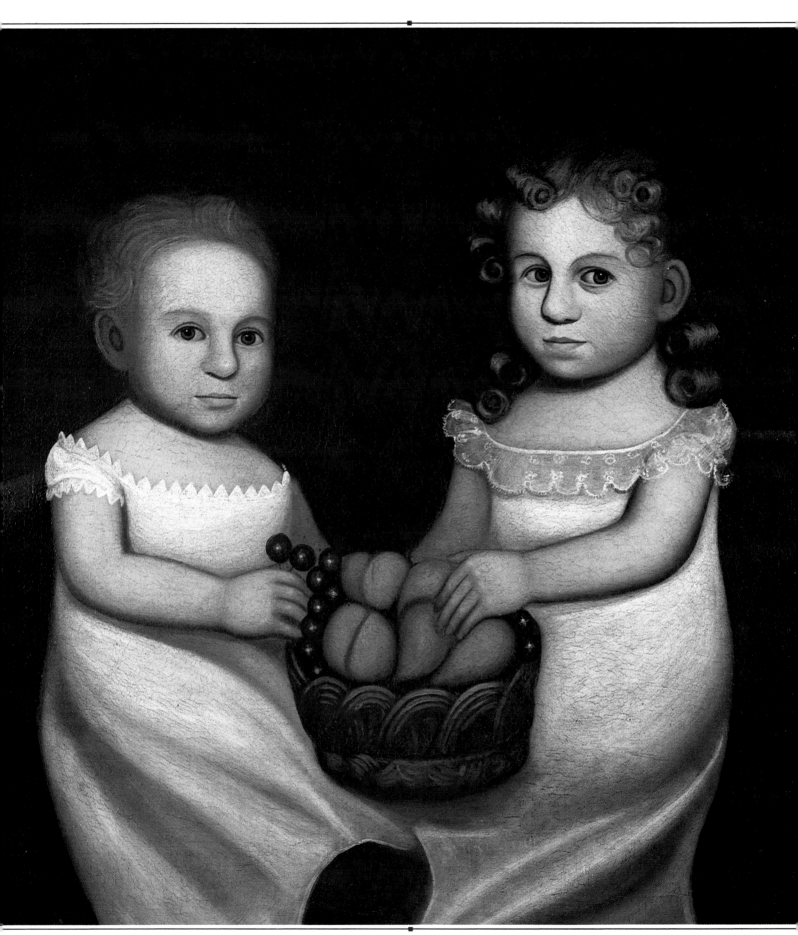

15. *Two Children with a Basket of Fruit*

Condition: The painting was cleaned, lined and put on a new stretcher in 1961 by Caroline and Sheldon Keck. The cupping paint film was treated and many stress cracks and other small losses were inpainted.

Provenance: Mr. and Mrs. William J. Gunn, Newtonville, Mass.; Miss Mary Allis, Fairfield, Conn.; Mr. Stephen C. Clark Sr., Cooperstown, N.Y.

Exhibited: "Child's World," Schenectady Museum, Schenectady, N.Y., January 2–May 9, 1972; "Portraits of Zedekiah Belknap," the Abby Aldrich Rockefeller Folk Art Center, Williamsburg, Va., May 9–June 26, 1977.

Published: Elizabeth R. Mankin, "Zedekiah Belknap," *Antiques* CX (November 1976), illus. as plate VIII on p. 1066.

FACING PAGE
Attributed to Zedekiah Belknap
Massachusetts,
New Hampshire
or Vermont, ca. 1830
Oil on canvas
27¼″ × 27¼″
(69.2 cm × 69.2 cm)

❖ John Brewster Jr. ❖
(1766–1854)

Present-day admirers of American folk portraiture marvel at the aesthetic success achieved by painters who overcame technical limitations as well as life's sometimes tragic circumstances. The artist John Brewster Jr. clearly stands out among these painters as one whose disadvantages did not prevent him from creating portraits of lasting beauty.

Brewster was born in Hampton, Connecticut on May 30/31, 1766 to Dr. John and Mary Durkee Brewster.[1] A deaf-mute from birth, he was encouraged at an early age to cope with his disability by learning to read and write. His talent for painting was recognized early and fostered through a period of artistic studies under an experienced portrait painter, the Reverend Joseph Steward (1753–1822). By the early 1790s, Brewster had begun his professional career as a portrait painter, executing full-length likenesses of members of his family and local people. By 1796, he had relocated to Buxton, Maine, where he lived with his younger brother, Royal Brewster, between periods of itinerancy. Throughout his successful artistic career Brewster traveled widely in Connecticut, Maine, Massachusetts and eastern New York state.

In April, 1817, Brewster enrolled in the first class at the Connecticut Asylum for the Education and Instruction of Deaf and Dumb Persons, in Hartford. At fifty-one, he was the oldest of seven classmates and one of the few students to be self-supporting. As he apparently had learned to use sign language in his youth, and already had many years of practical experience in non-verbal communication, his course of instruction was no doubt more advanced than that of his younger classmates. He remained at the Asylum until early in 1820, when he returned to Maine to continue his career as a portraitist. Brewster died in Buxton, Maine on August 13, 1854 at the age of eighty-eight, having achieved in his long life an admirable measure of artistic and financial success as well as personal independence.

To date, over one hundred likenesses have been ascribed to Brewster, providing a basis for establishing characteristics of his painting style. He is known for his unusually delicate and sensitive renderings, with his sitters' faces painted with clear, precise brushwork and given serene expressions. In his early portraits, Brewster attempted only a minimal amount of facial modeling. As his painting style developed, however, he described flesh tones with more vigor, employing heavier shading to achieve greater naturalistic depth.

Brewster painted full-length portrait compositions until about 1805, when he turned to executing half-length and bust-length likenesses on a standard canvas size of 30 inches by 25 inches. The artist also began at this time to inscribe his name and the date in pencil on the stretcher. Throughout his career Brewster consistently advertised his skills as a painter of portrait miniatures on ivory, an aspect of his artistic output which recent research has begun to address.[2] PD'A

[1] The biographical information on this artist is from Nina Fletcher Little, "John Brewster, Jr., 1766–1854: Deaf-Mute Portrait Painter of Connecticut and Maine," *Connecticut Historical Society Bulletin* 25 (October 1960), pp. 97–103.

[2] The portrait of Benjamin Apthorp Gould is inscribed, in ink on paper affixed to the back of the ivory, "Benj. Gould, Jr. Taken by Mr. John Brewster Jr./Oct. 1809." The portrait is privately owned and is illustrated in Joyce Hill, "Miniatures by John Brewster, Jr.," *The Clarion* (Spring/Summer 1983) as fig. 1 on p. 49.

Attributed to
John Brewster Jr.
Probably Massachusetts,
ca. 1800
Oil on canvas
30″ × 40″
(76.2 cm × 101.6 cm)

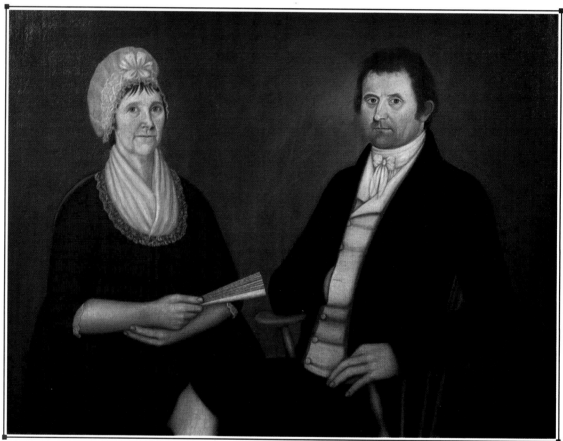

16. *Deacon Eliphaz Thayer and his Wife, Deliverance*

16. *Deacon Eliphaz Thayer and his Wife, Deliverance* N-271.61

In this serene and intimate double portrait, Brewster depicted Mr. and Mrs. Thayer comfortably seated in Windsor chairs, with direct gazes that are a hallmark of his painting style. The artist's characteristically sensitive and subtle modeling of both sitters' faces conveys a strong sense of their individual personalities. Employing his standard poses, Brewster depicted Mr. Thayer sitting, legs crossed, with his right hand tucked into his vest, and Mrs. Thayer with her arms folded at her waist, holding a closed fan. His placement of

their overlapping bodies lends an unusual informality and intimacy to this portrait. Costume details are precisely rendered, as evident in Mrs. Thayer's lace-edged bonnet and collar, and in the heavily shadowed folds of Mr. Thayer's white shirt and cravat. At an undetermined time the original appearance of the portrait was altered somewhat, as it was cut down along the lower edge. It is possible that Brewster originally depicted the Thayers in full-length poses.

Eliphaz Thayer was born in Braintree, Massachusetts on March 14, 1762, to Isaih and Sarah White Thayer.[1] He served in the Revolutionary War in three different companies, stationed part of the time at West Point, New York and in Rhode Island. His wife, Deliverance, the daughter of James and Deborah Arnold Thayer, was born in 1762. The couple announced their intention to marry on March 29, 1782 and afterward settled in Braintree, building a house at 475 Liberty Street in 1794. Eliphaz was reportedly a deacon in the First Congregational Church in Braintree until 1811, when he and his wife joined the Union Congregational Church. Deliverance died in 1821 and Eliphaz on December 29, 1848. PD'A

Inscriptions/Marks: Printed in capital letters in ink on paper fragment formerly attached to the verso, and currently attached to the backing, is "DEACON ELIPHAZ THAYER'S HOUSE, 1785/LIBERTY AND MIDDLE STS. BRAINTREE" above a pencil sketch of a house; printed in capital letters in ink on a second paper fragment, formerly attached to the verso and currently attached to the backing, is "PORTRAIT OF/DEACON ELIPHAZ THAYER AND HIS WIFE/DELIVERANCE DAUGHTER OF JAMES AND DEBORAH/ARNOLD THAYER — AND GREAT/GREAT GRANDAUGHTER OF JOHN ALDEN AND PRISCILLA MULLENS."

Condition: At an unknown date, three holes were patched with fabric and glue. The bottom of the picture was cut off and placed on a re-used stretcher. In 1958, Caroline and Sheldon Keck removed the patches and mended the damage correctly. The remaining design on the bottom tacking edge was reclaimed and the canvas was lined and placed on a new stretcher. A complete cleaning was followed by filling and inpainting numerous small losses.

Provenance: Mr. and Mrs. William J. Gunn, Newtonville, Mass.; Miss Mary Allis, Fairfield, Conn.; Mr. Stephen C. Clark Sr., Cooperstown, N.Y.

Exhibited: Untitled exhibition, Albright-Knox Art Gallery, Buffalo, N.Y., May 8–15, 1959; NYSHA, "New-Found Folk Art of the Young Republic," 1960, and exhibition catalog, pp. 27–28, no. 56, illus. as fig. 56; "John Brewster, Jr.," Connecticut Historical Society, Hartford, Conn., November 6–December 31, 1960; untitled exhibition, Addison Gallery of American Art, Andover, Mass., March 4–April 3, 1961; "Folk Art from Cooperstown," Museum of American Folk Art, New York, N.Y., March 21–June 6, 1966; "Twenty-five Artists and Their Works," the Abby Aldrich Rockefeller Folk Art Collection, Williamsburg, Va., May 10–July 11, 1971.

Published: *Christian Science Monitor,* April 19, 1966, p. 8; Nina Fletcher Little, "John Brewster, Jr., 1766–1854: Deaf-Mute Portrait Painter of Connecticut and Maine," *Connecticut Historical Society Bulletin* 25 (October 1960), p. 108, illus. as fig. 24 on p. 124; A. Bruce MacLeish, "Paintings in the New York State Historical Association," *Antiques* CXXVI (September 1984), illus. as plate III on p. 591.

[1] Biographical information on these sitters is from Nina Fletcher Little, "John Brewster, Jr., 1766–1854: Deaf-Mute Portrait Painter of Connecticut and Maine," *Connecticut Historical Society Bulletin* 25 (October 1960), p. 108, and Ronald F. Frazer (Braintree Historical Society) to NYSHA, November 11, 1984.

17. *Francis O. Watts with Bird* N-265.61

Brewster achieved one of his most successful compositions in this depiction of young Francis O. Watts standing in a tranquil landscape. The sitter's serene face and large, expressive eyes exhibit the particularly sensitive manner in which the artist painted young portrait subjects. The child's transparent dress and the bird perched on his finger tied with a string effectively communicate the fragility and innocence of childhood. Enhancing the serenity and calmness of this likeness are the subdued blue-gray palette and the flat, converging planes of the landscape with three stylized trees. Brewster originally portrayed Francis O. Watts wearing bright red shoes, the remnants of which are still visible. However, the artist painted them over in black, probably to avoid interrupting the harmony of the overall color scheme.

Francis Osborne Watts was born in 1803, the son of Francis and Mehitable Lord Watts of Kennebunkport, Maine.[1] Enrolled in Harvard College in Cambridge, Massachusetts at the age of fifteen, he was admitted to the Bar in 1825. He married Caroline Goddard of Kennebunkport, and in 1851 became the first president of the newly established Young Men's Christian Association. He died in 1860. PD'A

Inscriptions/Marks: A modern inscription on the verso of the panel to which the canvas is glued reads "Francis O. Watts by John Brewster, 1805/ Signed on stretcher."

Condition: At an unknown date, the canvas was attached to a piece of plywood and scattered losses were inpainted. Treatment in 1959 by Caroline and Sheldon Keck included reattaching small loose spots in two corners, removing darkened inpaint and replacing with new inpainting. In 1966, an auxiliary support was added to the reverse to correct a warp and a small damage at the top edge was repaired.

Provenance: Mr. and Mrs. William J. Gunn, Newtonville, Mass.; Miss Mary Allis, Fairfield, Conn.; Mr. Stephen C. Clark Sr., Cooperstown, N.Y.

Exhibited: NYSHA, "New-Found Folk Art of the Young Republic," 1960, and exhibition catalog, pp. 27 and 28, no. 57, illus. as fig. 57; "John Brewster, Jr.," Connecticut Historical Society, Hartford, Conn., November 6–December 31, 1960; untitled exhibition, Addison Gallery of American Art, Andover, Mass., March 4–April 3, 1961; "Childhood Long Ago," The IBM Gallery, New York, N.Y., February 1–March 6, 1965; "Folk Art from Cooperstown," Museum of American Folk Art, New York, N.Y., March 21–June 6, 1966.

Published: Nina Fletcher Little, "John Brewster, Jr., 1766–1854: Deaf-Mute Portrait Painter of Connecticut and Maine," *Connecticut Historical Society Bulletin* 25 (October 1960), p. 108, illus. as fig. 26 on p. 125; A. Bruce MacLeish, "Paintings in the New York State Historical Association," *Antiques* CXXVI (September 1984), pp. 591 and 592, illus. as fig. 1 on p. 593; Anita Schorsch, *Images of Childhood: An Illustrated Social History* (New York, 1979), illus. as fig. 9 on p. 22.

[1] Biographical information on the sitter is from Nina Fletcher Little, "John Brewster, Jr., 1766–1854: Deaf-Mute Portrait Painter of Connecticut and Maine," *Connecticut Historical Society Bulletin* 25 (October 1960), p. 108.

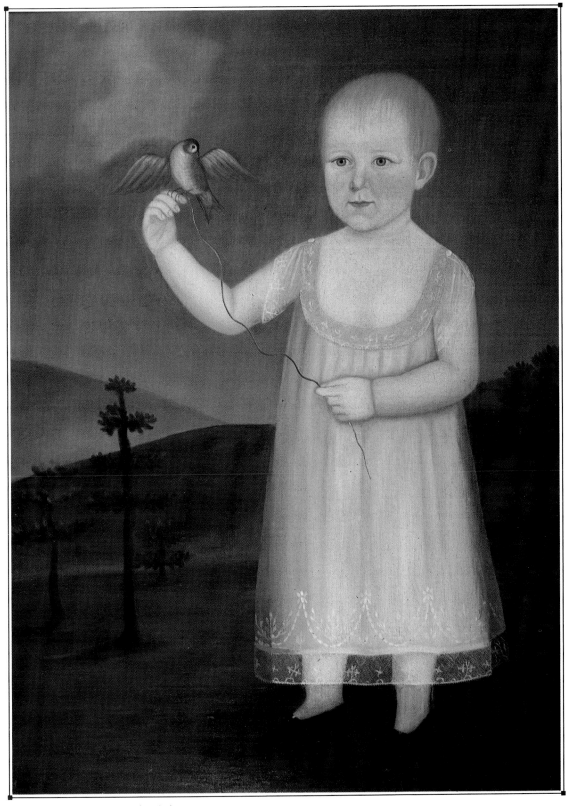

John Brewster Jr.
Probably Maine, 1805
Oil on canvas,
mounted on wood panel
35⅜" × 26⅜"
(89.8 cm × 67 cm)

17. *Francis O. Watts with Bird*

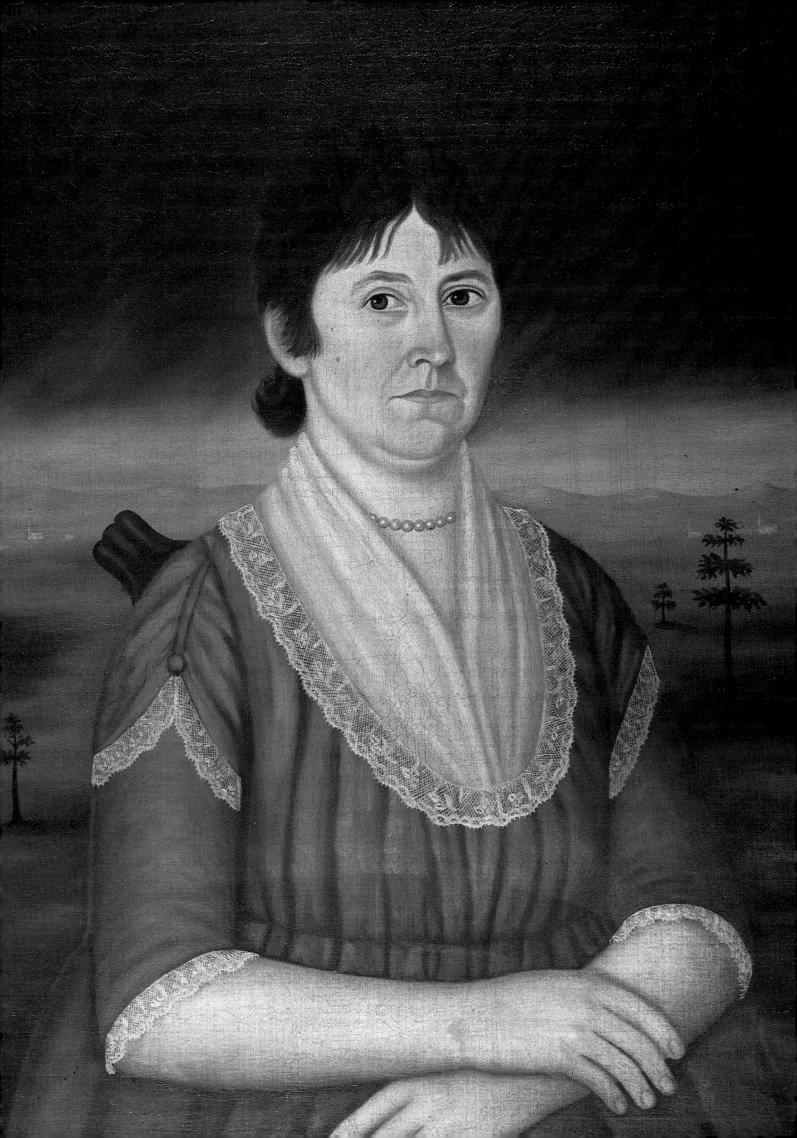

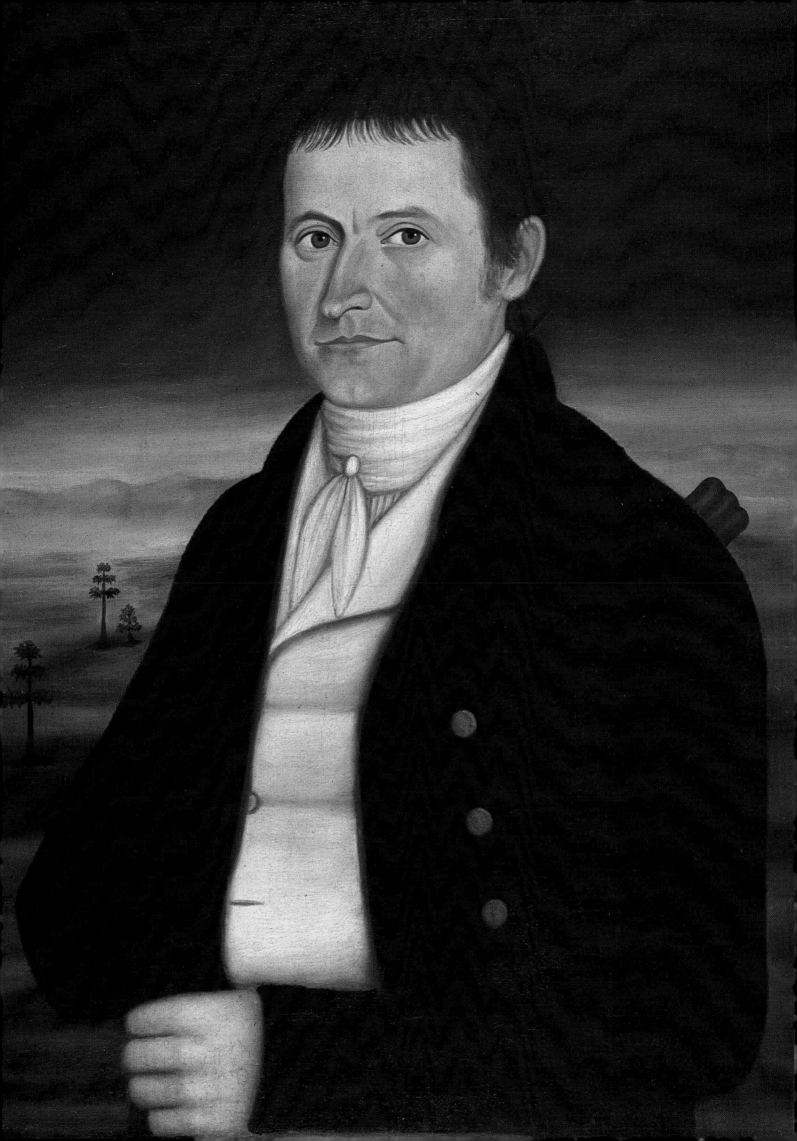

18. **Gentleman in a Landscape** N-268.61 (1)

19. **Lady in a Landscape** N-268.61 (2)

In this pair of portraits, Brewster created a dramatic composition by depicting the sullen-faced sitters against a vast and open landscape. Both subjects exhibit the penetrating gazes and precise rendering of facial features for which the artist is known. The short, stubby fingers of the lady and the awkwardly closed fist of the gentleman betray Brewster's inability to define hands. He often depicted adult male subjects with one hand tucked into their vests, perhaps to avoid the obvious difficulties of executing it convincingly. The inclusion of the grooved ear of the country Chippendale chair, visible over the near shoulder of both sitters, recalls a similar treatment in a number of Brewster's earlier portraits.[1] The landscape in the background, composed of barren terrain leading to a distant mountain range under a darkened sky, is an unusual departure for Brewster, who typically placed his subjects in an interior scene, against a neutral background or in a more intimate outdoor setting. Near the distant horizon of the lady's portrait are several tiny white structures, some of them church-like in appearance, which, with the oddly stylized trees, are the only embellishments to the landscape. PD'A

PAGES 46–47
18. *Gentleman in a Landscape*
19. *Lady in a Landscape*
Attributed to John Brewster Jr.
New England or New York state, ca. 1805
Oil on canvas
28¾″ × 23¾″
(73 cm × 60.4 cm)

Condition: Both paintings had been cut down in size and were tacked to their stretchers from the front. In 1959, Caroline and Sheldon Keck lined and cleaned them and put them on new stretchers. Cleaning revealed only very tiny losses, which were filled and inpainted.

Provenance: Mr. and Mrs. William J. Gunn, Newtonville, Mass.; Miss Mary Allis, Fairfield, Conn.; Mr. Stephen C. Clark Sr., Cooperstown, N.Y.

Exhibited: NYSHA, "New-Found Folk Art of the Young Republic," 1960, and exhibition catalog, pp. 27 and 28, no. 58 and no. 59, illus. as fig. 58 and fig. 59; "John Brewster, Jr.," Connecticut Historical Society, Hartford, Conn., November 6–December 31, 1960; untitled exhibition, Addison Gallery of American Art, Andover, Mass., March 4–April 3, 1961.

Published: Nina Fletcher Little, "John Brewster, Jr., 1766–1854: Deaf-Mute Portrait Painter of Connecticut and Maine," *Connecticut Historical Society Bulletin* 25 (October 1960), p. 107, illus. as fig. 20 and fig. 21 on p. 123; Nina Fletcher Little, "John Brewster, Jr., 1766–1854: Deaf-mute itinerant portrait painter," *Antiques* LXXVIII (November 1960), no. 19 only, illus. on p. 462.

[1] The 1795 portraits of Mr. and Mrs. James Eldredge, which exhibit a similar treatment of the Chippendale chair, are owned by the Connecticut Historical Society, Hartford, and are illustrated in Jean Lipman and Tom Armstrong, eds., *American Folk Painters of Three Centuries* (New York, 1980), on p. 19.

20. **One Shoe Off** N-231.61

This likeness is one of the best loved works in the folk art collection at Cooperstown. In expressing the delicate physical features and playful innocence of childhood, few folk painters were equal to John Brewster Jr., who achieved remarkable success at communicating these attributes in this young sitter. The child's expressive face, with its tiny nose, cupid's-bow mouth and large eyes, and the casual manner in which the shoe is held by the shoelace in the right hand, make this an endearing and pleasingly informal portrait. Brewster apparently placed the red shoe in the sitter's hand as an afterthought, since traces of red paint are visible on the bare left foot. This fortunate alteration not only adds to the portrait's charm, but also utilizes the bright red color of the shoe to balance the somber-colored composition and lead the viewer's eye upward to the child's face.

The patterned floor is an embellishment Brewster often employed in his portraits of children, and the stenciled design in this likeness appears to be amusingly mimicked in the tied bow of the sitter's right shoe. PD'A

Inscriptions/Marks: Penciled in script on the upper member of the stretcher is "John Brewster, Jr. Pinxit June 4th, 1807."

Provenance: Mr. and Mrs. William J. Gunn, Newtonville, Mass.; Miss Mary Allis, Fairfield, Conn.; Mr. Stephen C. Clark Sr., Cooperstown, N.Y.

Exhibited: NYSHA, "New-Found Folk Art of the Young Republic," 1960, and exhibition catalog, pp. 27 and 28, no. 60, illus. as fig. 60; "John Brewster, Jr.," Connecticut Historical Society, Hartford, Conn., November 6–December 31, 1960; untitled exhibition, Addison Gallery of American Art, Andover, Mass., March 4–April 3, 1961; untitled exhibition, Roberson Center for the Arts and Sciences, Binghamton, N.Y., November 1–December 15, 1961; untitled exhibition, Union College Art Gallery, Schenectady, N.Y., January–March 1962; "Childhood Long Ago," The IBM Gallery, New York, N.Y., February 1–March 6, 1965.

Published: George R. Clay, "Children of the Young Republic," *American Heritage* XI (April 1960), illus. on p. 53; Suzette Lane and Paul D'Ambrosio, "Folk art in the New York State Historical Association," *Antiques* CXXIV (September 1983), illus. as plate IV on p. 520; Nina Fletcher Little, "John Brewster, Jr., 1766–1854: Deaf-Mute Portrait Painter of Connecticut and Maine," *Connecticut Historical Society Bulletin* 25 (October 1960), p. 125, illus. as fig. 25 on p. 125; "The Paintings" [New York State Historical Association issue], *Antiques* LXXV (February 1959), illus. on p. 166.

Condition: At an unknown date this painting was lined with new fabric. It was cleaned, small losses were inpainted and a protective varnish was applied.

20. *One Shoe Off*

John Brewster Jr.
New England or New York state, 1807
Oil on canvas
34 7/8" × 24 7/8"
(88.6 cm × 63.3 cm)
FULL COLOR REPRODUCTION
ON PAGE 14.

❖ J. Brown ❖
(active 1806–1808)

Seven signed portraits provide the only conclusive data that document this artist's travels through Massachusetts between 1806 and 1808. Brown's earliest known portraits, dated 1806, depict General Samuel and Hannah Douglas Sloane of Williamstown. In January of 1808, Brown was in nearby Cheshire, painting the complex and ambitious likenesses of Calvin and Mercy Barnes Hall. By late February, the artist had ventured eastward to Franklin, where he painted William and Erastus Emmons. The most recently discovered

signed portrait painted by J. Brown depicts young Henry Turner and places the artist in Plymouth at about this same time.[1]

J. Brown's portraits are known for several characteristics of artistic style and painting technique. Sitters are depicted with clear, angular facial features which convey a strong sense of individuality and character. Their faces have an aged, tired appearance which is caused by the gray ground layer showing through the thinly painted facial area. Anatomical proportions are distorted, and the artist had particular difficulty in rendering hands, which is perhaps the reason why he turned to painting more simple bust-length likenesses. Clothing details and accessories are meticulously painted and embellish Brown's otherwise simple compositions. Evident in several portraits is a lightening of the reddish brown background around the head and shoulders of the sitters, a rather sophisticated means of drawing attention to the subject's face. In addition, a number of likenesses include a painted spandrel in each corner, which frames the sitter in an oval surround, a popular academic convention for this period. PD'A

[1] The information on this artist is from Nancy A. Kelley, "J. Brown: Search for an Artist's Identity," unpublished paper, State University of New York College at Oneonta, 1986. The Sloane portraits are privately owned; the portraits of Calvin and Mercy Barnes Hall are owned by the Abby Aldrich Rockefeller Folk Art Center, Williamsburg, Va.; the portrait of William Emmons is owned by Bertram K. and Nina Fletcher Little; the portrait of Erastus Emmons is privately owned and is illustrated in *American Folk Art from the Collection of Peter Tillou, Litchfield, Connecticut,* catalog for Sotheby's sale no. 5375, lot no. 16, October 26, 1985. Portraits attributed to J. Brown include: NYSHA's portrait of Laura Hall (see no. 21); the portrait of Clarissa Childs, owned by the Abby Aldrich Rockefeller Folk Art Center, Williamsburg, Va.; the portraits of Obadiah and Lavinia Latham, privately owned.

21. *Laura Hall* N-10.52

FACING PAGE
Attributed to J. Brown
Cheshire, Massachusetts, 1808
Oil on canvas
72″ × 36″
(182.9 cm × 91.5 cm)

Brown painted this stunning likeness of Laura Hall while in Cheshire, Massachusetts to paint portraits of her parents, Calvin and Mercy Barnes Hall. The subject stands with one hand resting on a rod-back Windsor chair, while the other hand holds a closed book at her side. The artist included a variety of carefully painted adornments, such as the delicately embroidered bodice, sleeves and shirt of Laura's white Empire gown, her hair combs, earrings, brooch, ring and star-like buckles on her slippers. Laura's gracefully outlined gown, her frenetically rendered tight ringlets, and the subtly lightened reddish brown background are all artistic devices employed by Brown to direct attention to the subject's realistically modeled face. However, her elongated legs, shortened, misshapen right hand, curiously splayed feet, and the awkwardly foreshortened chair, betray the artist's difficulties with anatomy and perspective. The strong similarities in composition between the portrait of Laura Hall and the two full-length likenesses of Harriet Leavens (1815) and Harriet Campbell (1816) by Ammi Phillips (1788–1865) suggest that Phillips may have seen Brown's work while traveling through the same territory painting portraits.[1]

The daughter of Calvin and Mercy Barnes Hall, Laura Hall was born on May 31, 1787 in Cheshire, Massachusetts. On January 14, 1810 she married Ambrose Kasson, an attorney from North Adams. The couple moved to Syracuse, New York, in 1816, where Kasson directed a seminary, and by 1833 they had relocated to Deerfield, New York, where the couple operated a modest farm with their seven children. Ambrose Kasson died on October 20, 1855, and Laura Hall Kasson on July 24, 1869.[2] PD'A

Condition: At an unknown date this painting was lined with a primed canvas and paste adhesive. At that time, a hot iron caused some slight damage to the paint in the proper left shoulder and the lower right section of the gown. In 1957, Caroline and Sheldon Keck removed surface grime and yellowed varnish. Flyspecks and other tiny losses were inpainted and a protective varnish was applied.

Provenance: John G. Kasson, Utica, N.Y. (descendant of the sitter).

Exhibited: "Art of the Pioneer," M. Knoedler & Co. Gallery, New York, N.Y., April 11–May 5, 1956; NYSHA, "Rediscovered Painters of Upstate New York, 1700–1875," June 14–September 15, 1958, and exhibition catalog, illus. as fig. 23 on p. 29; "Art Across America," Munson-Williams-Proctor Institute, Utica, N.Y., September 1960–January 1961; "Ammi Phillips 1788–1865," Connecticut Historical Society, Hartford, Conn., October 31, 1965–February 1, 1966; "Folk Art from Cooperstown," Museum of American Folk Art, New York, N.Y., March 21–June 6, 1966.

Published: Mary Black and Jean Lipman, *American Folk Painting* (New York, 1966), illus. as fig. 45; Barbara C. and Lawrence B. Holdridge, *Ammi Phillips: Portrait Painter 1788–1865* (New York, 1969), illus. on p. 20; "The Paintings" [New York State Historical Association issue], *Antiques* LXXV (February 1959), illus. on p. 172.

¹ Barbara C. and Lawrence B. Holdridge, *Ammi Phillips: Portrait Painter 1788–1865* (New York, 1969). The portrait of Harriet Leavens is owned by the Fogg Art Museum, Harvard University, Cambridge, Mass., and is illustrated as catalog no. 23 on p. 22. The portrait of Harriet Campbell is privately owned and is illustrated as catalog no. 24 on p. 23.

² Nancy A. Kelley, "J. Brown: Search for an Artist's Identity," unpublished paper, State University of New York College at Oneonta, 1986, pp. 24–26.

21. *Laura Hall*

❖ Joseph Goodhue Chandler ❖

(1813–1884)

Joseph Goodhue Chandler was an artist who, like many folk portrait painters of his day, produced works of far greater appeal in the years prior to the widespread popularization of photography than in those that followed.

Born on October 8, 1813 in South Hadley, Massachusetts, Joseph was the second child and oldest son of Captain David (1770–1838) and Clarissa Goodhue Chandler.[1] His father was a farmer, postmaster, tavern keeper and successful land speculator.

Joseph was trained as a cabinetmaker in his youth, and followed this trade for a number of years before traveling to Albany, New York, some time between 1827 and 1832, to study painting under William Collins (1787–1847). Although the nature of this training is not known, it is evident from Chandler's early works that he was a painter of some skill and talent.

The earliest of his portraits date from 1837 and are mainly of his immediate family, though it does not appear that he was able to support himself solely with portraiture at this time. In 1838, after Captain David Chandler died, Joseph bought his brother's share of the small farm and, like his father, became successful in land speculation.

On October 14, 1840 Joseph married Lucretia Ann Waite (1820–1868) of Hubbardston, Massachusetts, who was herself a locally established painter. During the next ten years Joseph embarked on a career as an itinerant portrait painter, working mostly in northwestern Massachusetts. Most of his known portraits were executed during this time.

In 1852 Joseph and Lucretia moved to Boston and established a studio at 69 Bedford Street, where they stayed for eight years. There they apparently enjoyed some success, and frequently collaborated on portraits, with Lucretia providing many of the finishing touches. It was probably she who became better known in Boston, as is evidenced by the 1856 Boston Athenaeum exhibition of her work. In 1860 the Chandlers moved back to Hubbardston, where Joseph purchased a farm, and lived there the rest of their lives.

Joseph Goodhue Chandler's most appealing works date from the period 1837–1852, when his portraits of adults were direct and vigorous despite anatomical inaccuracies and his portraits of children were lively and engaging. His sojourn in Boston, where he was exposed to the works of numerous academic artists, undoubtedly influenced him to change his style to more realistically modeled portraits in somber colors.

Photography also exerted an influence on his later work, and many of his portraits from this period, especially those of such prominent persons as Daniel Webster and Captain John Fremont, were probably taken from photographs. His portraits from the 1870s, whether taken from life or photographs, mirror the realism of the photographic image and are generally devoid of the personality and charm of his earlier work.

Chandler also painted still lifes, street scenes and landscapes in his later career, though few have been located. His last known painting was a landscape done in Baldwinsville, Massachusetts, in early 1882. He died on October 27, 1884. PD'A

[1] The biographical data for this entry is from John W. Keefe, "Joseph Goodhue Chandler (1813–1884): Itinerant Painter of the Connecticut River Valley," *Antiques* CII (November 1972), pp. 849–854.

22. *Dr. Joseph Goodhue Aged 81 Years* N-186.65

Dr. Joseph Goodhue (1764–1849), the maternal grandfather of the artist, was a surgeon in the United States Army at Fort Constitution, New Hampshire, before moving to Deerfield.[1] He was apparently painted at least three times by Chandler, twice in May of 1844 in nearly identical poses.[2]

This portrait illustrates the combination of technical skill and naiveté that marks much of Chandler's early work. The subtle shading and coloring of Dr. Goodhue's face and the competent treatment of the eyeglasses and book are evidence of an accomplished hand, although the sitter's pose and the position of his left arm appear stiff. As in many of Chandler's portraits of adults the palette is dark and somber, and the composition heavy. PD'A

Inscriptions/Marks: Painted in script on the verso is, "Painted for Dr. Joseph C. Goodhue aged 81 years/by J. G. Chandler May 1844."

Condition: No record of previous conservation. The canvas is very slack on the strainer with draws in all four corners. There are four small punctures–top left, left center, right center and bottom center. There is a yellowed coat of varnish on the surface.

Provenance: Found near New Haven, Conn.; Mrs. Agnes Halsey Jones, Cooperstown, N.Y.

[1] Suzanne L. Flint (Historic Deerfield, Inc.) to NYSHA, October 17, 1984.

[2] An 1837 portrait of Dr. Joseph Goodhue is in the collection of Historic Deerfield, Inc., and is illustrated in John W. Keefe, "Joseph Goodhue Chandler (1813–1884): Itinerant Painter of the Connecticut River Valley," *Antiques* CII (November 1972), as fig. 2 on p. 850. The Brick Church in Deerfield owns the May 1844 portrait, which is nearly identical to the NYSHA portrait.

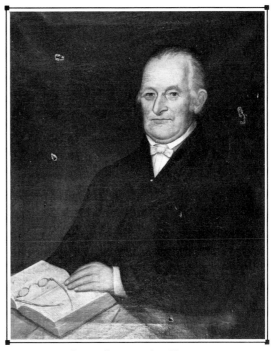

Joseph Goodhue Chandler
Deerfield, Massachusetts, 1844
Oil on canvas
36″ × 29″
(91.5 cm × 73.7 cm)

22. *Dr. Joseph Goodhue Aged 81 Years*

❖ Winthrop Chandler ❖
(1747–1790)

Born on April 6, 1747 Winthrop Chandler was the son of Jemima and William Chandler, a prominent surveyor and farmer. The youngest of ten children, the artist grew up on Chandler Hill in Connecticut. At his father's death in 1754, Chandler took Samuel McClellan, his brother-in-law, as his lawful guardian. This arrangement may have been assumed so that Chandler might legally apprentice to a trade, a practice common at this time for a youth of about fourteen. In his book *The History of Worcester* published in 1862, William Lincoln lends further insight into Chandler's early years noting that "He [Chandler] studied the art of portrait painting in Boston." Exactly when or how the art-

ist began his career remains speculative. However, the diversity of his work, which ranged from gilding, carving, drafting and house painting to portrait and landscape painting, suggests that he received at least an introduction to the principles of fine art and craftsmanship.[1]

By 1770, the artist was living in Woodstock, Connecticut, near Chandler Hill. His earliest known portraits, dated 1770, are of his neighbors the Reverend Ebenezer and Martha Devotion.[2] The subjects' piercing eyes, tightly pursed lips, beetling brows and strongly modeled faces are all characteristic features of Chandler's portrait work.

On February 17, 1772, the artist married Mary Gleason, a daughter of the Reverend Charles and Bethiah Scarsborough Gleason of Dudley, Massachusetts. Returning to Chandler Hill that same year, the couple resided on thirty-three acres of land where they raised seven children. Unlike many artists of the day, Winthrop Chandler did not travel in search of commissions, but remained at home where he sought clientele among his family, friends and acquaintances. Never a financially secure individual, Chandler may have rendered portraits in return for debts incurred, since many unpaid promissory notes have been found in the estates of those whose likenesses he painted.

Since Chandler did not sign any of his extant paintings, all attributions to his hand are based on documentary evidence that relates the artist to the painting, on family tradition or on stylistic similarities.[3] Of the approximately sixty paintings thus ascribed to Chandler, almost one-fourth are lesser known landscape scenes rendered in oil on panel or canvas. In these scenes, houses are often individually painted in bright colors; architectural details are outlined in white, while doors are painted in solid black; men and women are depicted in brightly colored clothing. Chandler approached this genre with his usual precision, careful to draw scenes accurately, yet without regard for shaded form.

With the exception of a possible apprenticeship in Boston and about five years in Worcester, Winthrop Chandler lived his entire life on Chandler Hill. Towards the end of his painting career, the artist's portrait style evolved, probably reflecting many years' experience and exposure to stylistic conventions. A self-portrait rendered about 1789 depicts the artist in a bust-length, three-quarter view.[4] A single light source cast from the left onto the figure highlights the near side of the face, yet throws the far side into shadow. This manipulation of light lends a measure of directness and immediacy reminiscent of Chandler's American academic contemporaries who sought to convey individuality and realism in their character studies. The inclusion of the painted oval spandrel in this portrait is almost always a signature of the artist's bust-length portraits. Winthrop Chandler died on July 29, 1790 at the age of forty-three. CME

[1] All biographical information on the artist is from Nina Fletcher Little, "Recently Discovered Paintings by Winthrop Chandler," *Art in America* 36 (April 1948), pp. 81–97; Little, "Winthrop Chandler," *Art in America* 35 (April 1947), pp. 77-168.

[2] The portraits are owned by the Brookline Historical Society, Brookline, Mass.

[3] A clause contained in the will of Judge Ebenezer Devotion, drawn on November 2, 1827, states "The seven Family Pictures painted by Chandler must be divided as justly as possible among my four surviving children," which provided the key for Little's identification of the artist's name and a known body of work from which other portraits could be attributed. See Little, "Winthrop Chandler," p. 81.

[4] The portrait is owned by the American Antiquarian Society, Worcester, Mass.

23. *New England Man*

24. *New England Woman*

23. **New England Man** N-295.61 (1)

24. **New England Woman** N-295.61 (2)

While these portraits are the only known likenesses in pastel attributed to Winthrop Chandler, the skill with which he executed them suggests this was not the first time the artist employed this medium. Chandler successfully conveyed a forthright appearance as the sitters are drawn with somber expression, determined gaze and angular facial features. From the adeptly modeled flesh tones so markedly visible in the man's face to the sculptural quality of the woman's bonnet, her translucent fichu and neatly combed hair, Chandler's work evinces a refined style. However, the artist sometimes betrayed a struggle to reconcile a three-quarter view with the two-dimensional limitations of the canvas or paper. For instance, in the portrait of the woman, the artist rendered slightly askew some of her facial features as the nose appears parallel to the face and the mouth seems too horizontal to create the illusion of recessed space required for this composition. CME

Attributed to
Winthrop Chandler
Probably Connecticut or
Massachusetts, ca. 1780
Pastel on laid paper over canvas
21⁵⁄₁₆" × 15½"
(53.5 cm × 39.4 cm)

Inscriptions/Marks: Watermark in the primary support, "DAC" followed by a cluster of grapes and leaves.

Condition: When Caroline and Sheldon Keck examined these pastels in 1958, they found that both had been water-damaged at one time, resulting in

dark stains which had worked up the paper about half-way from the bottom. The worst stains were overpainted with new pastel, mats and backings were added and dust seals were put on the frames. In 1986, the NYSHA conservator retouched a few spots where the stains had reappeared, cleaned the frames and renewed the mats and dust seals.

Provenance: Mr. and Mrs. William J. Gunn, Newtonville, Mass.; Miss Mary Allis, Fairfield, Conn.; Mr. Stephen C. Clark Sr., Cooperstown, N.Y.

Exhibited: NYSHA, "New-Found Folk Art of the Young Republic," 1960, and exhibition catalog, no. 2 and no. 3, p. 13, illus. as fig. 2 and fig. 3.

❖ Justus Dalee ❖
(active ca. 1826–ca. 1848)

25. *Profile of Man in Black Suit* N-33.85

This miniature of an unidentified man is one of at least eighty-six such recorded watercolor-on-paper profiles signed by or attributed to the artist Justus Dalee.[1] Defining the subject's face in watercolor, the artist then rendered facial features in pink, drew the coat, vest and tie in black, and outlined the suit collar and lapels with glazed highlights. In keeping with hair fashions of the period, Dalee also delineated individual sections of the man's hair with smooth, meticulous brushstrokes. This special treatment was a feature particularly suited to profile portraiture and proved a successful focus for his work.

Typewritten notes attached to a portrait miniature of Van Buren Da Lee and two other portraits record the subjects as members of the Beauregard family, descendants of the Da Lee and Minten families of New Orleans.[2] This information indicates the possible, yet unproven, origins of the artist Justus Dalee. Like many artists, Dalee kept a sketchbook which he entitled "EMBLEMATICAL FIGURES, May 29, 1826. Representations To PLEASE THE EYE."[3] The pages are filled with drawings of floral compositions, stylized portraits, some based on print sources, and standing female figures dressed in elegant, fashionable costumes. On one page, he signed his name "Justus Dalee. Professor of Penmanship."

In 1830, the artist was probably living in Troy, New York as a "Justus Daly" is listed in the census records and a "Justus Dailey" is recorded at 107 North Second Street in the *Troy Directory for the Year 1830*. By 1834, he was in Cambridge and West Troy, New York where he rendered at least seven known family records. Using a printed register for these records, Dalee drew in decorative details with watercolor and listed in a column the names of parents and their children, leaving space across the paper for their birth, marriage and death dates. Accompanying the *Isaac C. Gunnison Family Record* are portrait miniatures of six family members.[4] The likeness of Mrs. Gunnison is inscribed on the back "J. Dalee 1835," making these portraits by the artist the earliest thus recorded. Drawn completely in profile from the hips up, their faces are rendered with stylized features and their bodies are drawn in solid forms lacking clear definition. Unlike these renderings, Dalee's likenesses from the late 1830s present the sitter's face in profile, but the body in full, frontal view. The portrait of Lydia Coffin of Troy is typical as Dalee drew her facial features with linear definition and accented her profiled face with a headband, hair combs and two ringlets of hair.[5] In his later work, dating from about 1840, Dalee

began drawing portraits exclusively in profile. It was perhaps the influence of photography in the 1840s which led him to enclose these likenesses in oval spandrels, in the manner of daguerreotypes framed in spandreled cases. While over the years changes in costume and hairstyles are evident in Dalee's portraits, his work remains at a consistently high level of technical skill and artistic ability.

By 1840, the artist was in a new location far west of Troy as the portrait of Isaac Post is inscribed "Taken in Rochester in June 1840."[6] The *King's Rochester City Directory* for 1841 lists a "Justus Da Lee" as a "Side Portrait Painter" living at 17 Adams. During this period, Dalee also may have traveled in search of work, as one portrait is inscribed "Taken in Cabotville, July 26, 1842" (now Chicopee, Massachusetts), and another depicts Sarah Baldwin of Berea, Ohio.[7] By 1843, he was in Rochester again, where he drew a likeness of Isaac Post's little boy.[8] By 1847, he was living in Buffalo, New York, where he is listed in the 1847–48 *Commercial Advertiser Directory* as a "portrait painter" living at "h caroline nr tupper." Interestingly, a Richard Dalee, also a portrait painter, is listed at the same address. While the *Directory* records Justus Dalee as a resident through 1849, he is listed thereafter as a grocer living at "cor carolina and seventh h." CME

Inscriptions/Marks: No watermark found.

Condition: No record of previous conservation. The paper is slightly yellow, with a darker spot at bottom right. The top 1/3 margin has been cut off, along the oval. There is a small tear at left center. Some surface dirt and fingerprints are visible and the black has been abraded slightly in the coat.

Provenance: Mrs. Maurice Osterhoudt, Phoenix Mills, N.Y.

[1] For a checklist of extant portraits, see NYSHA research files.

[2] The portrait of Van Buren Da Lee is owned by the Abby Aldrich Rockefeller Folk Art Center, Williamsburg, Va.; the other two portraits are privately owned.

[3] The sketchbook is owned by the Walters Art Gallery, Baltimore, Md.

[4] The *Isaac Gunnison Family Record* and six Gunnison portraits are privately owned.

[5] The portrait is privately owned.

[6] The portrait is owned by the Rochester Museum and Science Center, Rochester, N.Y.

[7] The portraits are privately owned. The 1830 federal census record lists a Justus Daly as a resident of Scioto County, Ohio.

[8] The portrait is owned by the Rochester Museum and Science Center, Rochester, N.Y.

Attributed to Justus Dalee
Probably New York state,
ca. 1840
Watercolor with glazed highlights and ink on bristol board
2 15/16" × 2 5/8"
(7.5 cm × 6.7 cm)

25. *Profile of Man in Black Suit*

❖ Robert Darling ❖

(active 1835)

26. *Child in a Yellow Chair* N-248.61

The artist Robert Darling is known exclusively for his signature on this rather unassuming portrait of a child. Only one other likeness, also of a child, has been ascribed to his hand as it shares several stylistic characteristics with this portrait.[1] Both subjects are seated on yellow chairs decorated with green paint and are rendered with a directness and simplicity of presentation common among folk portraits. Their faces have dark, expressive eyes, rounded nostrils, proportioned ears, flushed cheeks and closely cropped hair. However, the crudely drawn paw-like hands, unconvincingly hidden behind sprigs of red roses, betray Darling's uneven artistic abilities. CME

Robert Darling
United States, 1835
Oil on canvas
23¼″ × 19½″
(59.1 cm × 49.5 cm)

26. *Child in a Yellow Chair*

Inscriptions/Marks: Early NYSHA records indicate that the inscription, "Painted by/Robert Darling/March th14, 1835." once appeared on the verso, but the lining now obscures such an inscription.

Condition: In 1959, Caroline and Sheldon Keck removed this painting from its stretcher and lined it. The tacking edges were lined flat because evidence showed they were part of the original design before the canvas was cut down. Surface dirt, old varnish, and overpaint were removed. Losses were filled and inpainted and a protective varnish was applied after placement on a new stretcher.

Provenance: Mr. and Mrs. William J. Gunn, Newtonville, Mass.; Miss Mary Allis, Fairfield, Conn.; Mr. Stephen C. Clark Sr., Cooperstown, N.Y.

Exhibited: NYSHA, "New-Found Folk Art of the Young Republic," 1960, and exhibition catalog, p. 29, no. 62, illus. as fig. 62.

[1] The portrait entitled *Child in a Yellow Painted Chair* is privately owned and is illustrated in the catalog for the exhibition, "American Folk Painting, Selections from the Collection of Mr. and Mrs. William E. Wiltshire III," The Virginia Museum, Richmond, Va., November 29, 1977–January 8, 1978, illus. as fig. 35 on p. 76.

❖ Joseph H. Davis ❖

(active 1832–1837)

No vital records, advertisements or directory listings have been found documenting the life of Joseph H. Davis, artist of over one hundred and sixty watercolor portraits of southern New Hampshire and Maine residents.[1] Among the known five that he signed with his name, the likeness of Batholomew Van Dame is inscribed, "Joseph H. Davis/Left

Hand/Painter."[2] Several theories have been proposed concerning the identity of this artist. Davis may have been the legendary "Pine Hill Joe" of Newfield, Maine, a man remembered as a farmer and an incurable wanderer who was always dabbling with paints and earned only $1.50 for each portrait rendered.[3]

From the extant portraits, it appears that Davis's artistic career spanned a mere six years, from 1832 through 1837. His earliest known likenesses depict subjects from Lebanon, Berwick and North Berwick, Maine, as well as some residents from Sommerset and Dover, New Hampshire. By 1835, Davis was seeking portrait work almost exclusively in New Hampshire where he drew subjects from several towns including Farmington, Dover, Epping, Deerfield and Strafford. No portraits dated after 1837 have been found to suggest that Davis continued to work as an artist.

A pleasing sense of orderly composition, rigorous design and scrupulous detail characterize Davis's work in watercolor. Employing a standardized format, Davis posed subjects, seated or standing, in lavish interior scenes decorated with profusely grained, painted furniture and lively patterned carpets. He occasionally depicted children in outside views and flanked them with flowers, birds and butterflies. Consistently drawing his portraits in rigid profile, Davis posed figures facing each other, with outside shoulders turned slightly back in order to reveal more of the silhouette and to lend an illusion of depth to the scene. Facial features are individualized and well defined, although hands are drawn disproportionately small and feet appear too slight to support the individuals.

CME

[1] For further information on the artist and checklist of his portrait work, see the catalog for the exhibition "Three New England Watercolor Painters," Art Institute of Chicago, Chicago, Ill., November 16, 1974–September 1, 1975, pp. 22–41, pp. 57–65, and errata and addenda.

[2] The portrait is currently unlocated and is illustrated in Frank O. Spinney, "Joseph H. Davis, New Hampshire Artist of the 1830's," *Antiques* XLIV (October 1943), as fig. 1 on p. 177.

[3] See catalog "Three New England Watercolor Painters," p. 22.

27. *Joseph and Sarah Ann Emery* N-323.61

In this portrait of Joseph and Sarah Ann Emery, traces of pencil appear along the edges of the right side of the table, vertically through the center of the vase, and within the area of the inscription at the bottom of the composition. These outline markings indicate that Davis initially sketched his likenesses in pencil and afterwards filled in the areas of the images with watercolor. The artist seemingly devised his compositions this way to determine order and balance. However, this architectural, geometric approach resulted in severe regularity to Davis's work. Further evidence of the artist's preliminary work is found in the portrait of Trueworthy Chamberlain and Wife. A rough outline sketch of Mrs. Chamberlain was drawn by Davis on the verso of the piece and apparently discarded as unsuccessful.[1]

The elaborately ornamented ink inscriptions appearing along the bottom borders of many of Davis's portraits record information about the subjects such as their names, birthdates and ages at the time the portraits were completed. Joseph Emery was born on July 4, 1808, the son of James and Hannah Dunn Emery of Limerick, Maine. On June 12, 1836, he married Sarah Ann Libbey, who was born on September 19, 1815 to Ira

and Fanny Libbey of North Berwick, Maine. The couple resided in Limington, Maine where they raised five children. Joseph died on March 11, 1866 and Sarah Ann followed on September 5, 1873. A discrepancy appears in the biographical information cited here, as church records indicate that the subjects were not married until 1836, two years after Davis is believed to have rendered this portrait. According to a published Emery family genealogy, Davis also incorrectly cited the couple's ages. Joseph Emery would have been twenty-six in 1834 and Sarah Ann nineteen.[2] CME

Attributed to Joseph H. Davis
Probably Limington, Maine, 1834
Watercolor with glazed highlights and pencil on wove paper
13¹³⁄₁₆″ × 13¹³⁄₁₆″
(35.1 cm × 35.1 cm)

27. *Joseph and Sarah Ann Emery*

Inscriptions/Marks: In ink in script in the margin below the portrait is "Joseph Emery./Aged, 25/& 2 months./1834/Sarah Ann. Emery./Aged-/20 years./-1834-". Watermark found in primary support, "A[?]IES/PHI[?]LA."

Condition: In 1970, Per Guldbeck removed a pulp board backing and adhesive residue. Small tears were mended with Japanese tissue and wheat starch paste and an acid-free mat and backing were prepared.

Provenance: Mr. and Mrs. Howard Lipman, Wilton, Conn.; Mr. Stephen C. Clark Sr., Cooperstown, N.Y.

Exhibited: "Identified American Primitives," Harry Shaw Newman Gallery, New York, N.Y., November 15–30, 1950; "Primitives," Union College Art Gallery, Schenectady, N.Y., March 1951; untitled exhibition, The Century Association, New York, N.Y., January-February 1952; "American Primitive Art," White Chapel Art Gallery, London, England (an exhibition organized by the Smithsonian Institute and U.S. Information Service, Washington, D.C.), June 3–July 3, 1955, and exhibition catalog, no. 42 on p. 12; "American Primitive Art," Brussels International Exhibition, Brussels, Belgium, 1958; "Art in Maine," Colby College Art Museum, Waterville, Maine, April 1963–January 1964; "Folk Art From Cooperstown," Museum of American Folk Art, New York, N.Y., March 21–June 6, 1966; "Three New England Watercolor Painters," Art Institute of Chicago, Chicago, Ill., November 16, 1974–September 1, 1975, and exhibition catalog, checklist no. 11 on p. 28, and illus. as fig. 11 on p. 29.

Published: James Thomas Flexner, "The Cult of the Primitives," *American Heritage* VI (February 1955), p. 38; Louis C. Jones, "The Cooperstown Idea, History for Everyman," *American Heritage* III (Spring 1952), p. 38; Jean Lipman and Alice Winchester, *Primitive Painters in America* (New York, 1950), illus. on p. 99; Gertrude A. Mellon and Elizabeth F. Wilder, eds., *Maine and Its Role in American Art 1740–1963* (Waterville, Me., 1963), illus. on p. 49; Frank O. Spinney, "Joseph H. Davis, New Hampshire Artist of the 1830's," *Antiques* XLIV (October 1943), checklist no. B3 on p. 180.

[1] The portrait, which is privately owned, and the sketch on the verso are illustrated in the catalog for the exhibition "Three New England Watercolor Painters," as fig. 7 on p. 27.

[2] Margot McCain (Maine Historical Society) to NYSHA, July 22, 1985.

Attributed to Joseph H. Davis
Probably New Hampshire, 1835
Watercolor, pencil and ink
on heavy wove paper
11¹³⁄₁₆″ × 9¹¹⁄₁₆″
(30 cm × 24.6 cm)

28. *Mary D. Varney*

28. *Mary D. Varney* N-198.51

This portrait of lovely twenty-one-year-old Mary D. Varney is one of several single-figure compositions of young women by Davis. Other than the information recorded by Davis below the drawing, little is known about Varney except that she was the child of Miles and Jane Varney who were married in Rochester, New Hampshire, on October 7, 1807.[1]

CME

Inscriptions/Marks: In ink in script in the margin below the portrait is, "Mary D. Varney. Born Decem^br.20^th.1814. Painted at the Age of 21, 1835." Watermark in the primary support, upper left, "J. RO[?]."

Condition: The paper is slightly cockled. There is a 1½″ irregular tear from the top edge, just in front of the face. An acid-free mat and backing have been placed in the frame.

Provenance: Mrs. Mable Smith, Larchmont, N.Y.

Published: Gail and Norbert H. Savage and Esther Sparks, *Three New England Watercolor Painters* (Chicago, 1974), checklist no. 91 on p. 63.

[1] C. W. Tibbets, ed., *The New Hampshire Genealogical Record,* 7 vols., (New Hampshire, 1903–1910), vol. 6, p. 24.

Attributed to
Joseph H. Davis
Probably Maine or
New Hampshire, ca. 1835
Watercolor with glazed
highlights and pencil
on heavy wove paper
11¾″ × 17¾″
(29.8 cm × 45.1 cm)

29. *Separate Tables*

29. *Separate Tables* N-290.61

Davis's clientele included military officers, farmers, lawyers, schoolmasters and clergymen. In this group portrait of a handsome couple and their two children, Davis placed many refinements of a middle-class society on the tables, including a top hat, two books, a vase of flowers, a quill pen with inkstand and writing paper. Although he sought to record true likenesses, the portraits themselves do not seem to convey the sense of character found in the work of more skilled artists. Husband and wife are stiffly posed, as they gaze unblinkingly into each other's eyes, while their dutifully silent children gather by them. Just as Davis included symbols of a family's role in society, he seems to have made the subjects themselves symbols of refined New Englanders. CME

Inscriptions/Marks: No watermarks found.

Condition: In 1983, emergency treatment by the NYSHA conservator was necessary because of water damage to the object. The lower half of the paper and backing were wet. The entire sheet was washed in deionized water, stains were reduced and a new mat and backing of acid-free material were made.

Provenance: Mr. and Mrs. William J. Gunn, Newtonville, Mass.; Miss Mary Allis, Fairfield, Conn.; Mr. Stephen C. Clark Sr., Cooperstown, N.Y.

Exhibited: "The Lives and Ages of Men and Women," the Albright-Knox Art Gallery, Buffalo, N.Y., May 8–15, 1959; NYSHA, "New-Found Folk Art of the Young Republic," 1960, and exhibition catalog, p. 29, no. 63, illus. as fig. 63; "Folk Art From Cooperstown," Museum of American Folk Art, New York, N.Y., March 21–June 6, 1966;

"Early American Folk Art," Rensselaer County Historical Society, Troy, N.Y., October 31–November 28, 1967; "Child's World," Schenectady Museum, Schenectady, N.Y., January 2–May 9, 1972.

Published: Gail and Norbert H. Savage and Esther Sparks, *Three New England Watercolor Painters* (Chicago, 1974), checklist no. 104 on p. 64.

30. *The Azariah Caverly Family* N-61.61

While Davis's compositions varied little, the artist sought to personalize his portraiture by presenting subjects surrounded with objects special to them. *The Dover Gazette and Strafford Advertiser,* held in the hand of Azariah Caverly, was a politically inspired newspaper voicing democratic views.[1] The detailed drawing seen on the table at the left and the carpenter's square held in his son George's hand suggest that Azariah may have been involved in the field of architecture, engineering or carpentry. Davis often included the family home in a small painting in the background of the interior scene, thus creating a miniature within a miniature.

This portrait of the Azariah Caverly family is one of six attributed to Davis and depicting Caverly relatives from New Hampshire.[2] Azariah Caverly was the son of Lieutenant John and Betsey Boodey Caverly, prominent residents of Barrington, New Hampshire. He was born on December 28, 1792 and married his first wife Sally Adams on May 12, 1816. The couple had five children. On January 23, 1832, Caverly married his second wife, Eliza Tasker, who is depicted in this portrait. She was born on June 4, 1812. Residing in Strafford, New Hampshire, Azariah and Eliza Caverly had four children. George A. and Sarah Jane, the two eldest, are also depicted. Research indicates that Caverly was a farmer and a Captain in the militia who served as commander of the Strafford Light Infantry Company. Described as a man "full of aspirations; ingenious and frugal," Caverly died on December 14, 1843, the result of an injury received when his carriage was overturned by a frightened horse. Eliza Caverly died on May 30,1870.[3]

George A. Caverly, their son, was born on January 28, 1833. He married Martha Boodey on May 16, 1854. After his father's death in 1843, George inherited his family's homestead where he and his wife raised their six children. He died in Strafford in 1916 at the age of ninety-three.[4] Sarah Jane Caverly was born on December 15, 1835 and died on September 16, 1865. CME

Inscriptions/Marks: Inscribed in ink in the margin below the portrait is "Azariah Caverly. Aged 44. Dec^ember 28^th 1836. George A. Caverly. Aged 3 years./January 28^th 1836/Sarah Jane. Caverly. Aged 7 months/July 15^th 1836/Eliza Caverly. Aged 24. June 4^th 1836." Printed in ink at the top of the newspaper is "DOVER GAZETTE./and Strafford Advertiser." Watermark found in center support, "OH."

Condition: Treatment by Per Gulbeck in 1966 included removing surface dirt and lightening stains on the two bottom corners. The watercolor was protected with an acid-free mat and backing.

Provenance: Mr. and Mrs. Howard Lipman, Wilton, Conn.; Mr. Stephen C. Clark Sr., Cooperstown, N.Y.

Exhibited: "Identified American Primitives," Harry Shaw Newman Gallery, New York, N.Y., November 15–30, 1950; "Art of the Pioneer," M. Knoedler & Co. Gallery, New York, N.Y., April 11–May 5, 1956, and exhibition catalog, checklist no. 27; "Folk Art," Roberson Memorial Art Gallery, Binghamton, N.Y., September 15, 1966–April 1, 1967; "Three New England Watercolor Painters," Art Institute of Chicago, Chicago, Ill., November 16, 1974–September 1, 1975, and exhibition catalog, p. 26, no. 5, p. 57, no. 7, and illus. as fig. 5 on p. 26.

[1] William Copeley (New Hampshire Historical Society) to NYSHA, July 26, 1985.

[2] The other five portraits depicting members of the Caverly family are as follows: the portrait of Asa and Susanna Caverly is privately owned and is illustrated in the catalog for the exhibition, "Three New England Watercolor Painters" (see *Exhibited*) as fig. 4 on p. 25; the portrait of Everitt and John Hoit Caverly is owned by the Museum of Fine Arts, Boston, Mass. and is illustrated *ibid.* as fig. 6 on p. 27; the portrait of Elder John Caverly and Family is privately owned and is listed *ibid.* as checklist no. 10 on p. 57; the portrait of John Caverly and Seth W. Caverly is privately owned.

[3] Robert Boody Caverly, *Genealogy of the Caverly Family* (Lowell, Mass., 1880), pp. 81–82.

[4] Copeley (NHHS) to NYSHA, July 26, 1985.

Attributed to Joseph H. Davis
Probably Strafford, New Hampshire, July 1836
Watercolor with glazed highlights, pencil and ink on wove paper
10 15/16″ × 14 15/16″
(27.7 cm × 37.9 cm)

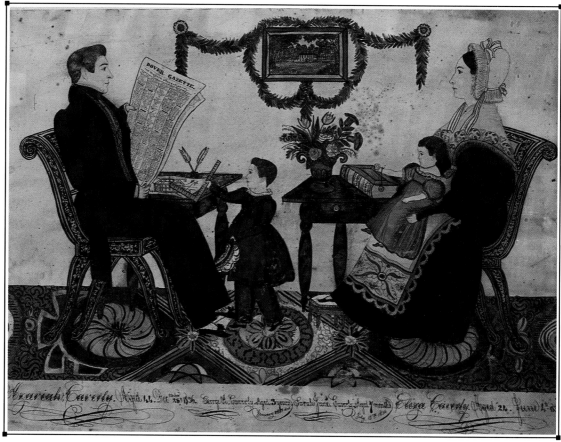

30. *The Azariah Caverly Family*

❖ A. Ellis ❖

(active ca. 1830)

31. ***Gentleman with a High Collar*** N-304.61
32. ***Lady with a Nosegay*** N-305.61

Many folk painters relied on their instinctive sense of design and color to create appealing likenesses despite their lack of technical proficiency. The degree of their ability to depict subjects realistically varied widely from one artist to another. For this reason, folk portraits ranged from nearly academic renderings to almost totally abstract configurations. For the most part, the works of A. Ellis represent the latter end of this scale, their linear definition exhibiting the decorative qualities that typify the most successful folk portraits.

A. Ellis is an artist whose life and artistic career are almost completely obscure, despite recent research which has determined that the artist may have worked in the Readfield-Waterville area of central Maine.[1] Many of the fifteen works currently ascribed to Ellis on the basis of their comparison with the Association's signed portraits have been found in central Maine or portray sitters known to have lived in that region.[2] The artist is best known for portraits executed in oil on panel with the occasional use of pencil to outline details. The extreme linear quality and bright, solid areas of color evident in Ellis's work suggest that the artist may have been more experienced in decorative painting than portraiture. This is apparent in *Gentleman with a High Collar* and *Lady with a Nosegay,* which are lively depictions of subjects but devoid of naturalistic form owing to the artist's inability to render anatomy accurately. The stylized faces of these subjects, drawn partly with pencil, show no sign of shading to achieve form and contour. Noses are depicted in profile and outlined with a single, thick line of paint as a continuation of one eyebrow. In addition, the artist rendered these sitters with wide open eyes, eyelids highlighted with thick white paint, an unfocused gaze, softly flushed cheeks and, in the gentleman's portrait, a mottled, undefined ear. The gentleman's formless hand and the remarkably flat quality of the lady's bent left arm are further evidence of this artist's inability to define anatomical features.

Ellis's rhythmic, linear technique is apparent in the way the artist divided the lady's brown hair into sections by using white paint to separate her curls. The zig-zag pattern of her dress outlined against the neutral background and the stylized treatment of her belt lend to the portrait an abstract quality of the kind so admired by modern eyes. The gentleman's portrait exhibits an appealing repetition of rolling waves of line along the outline of the shoulders and hair. The artist peculiarly aligned the mouth with the collar so that the effect created is a single unbroken line across the face forming a U-shaped chin. PD'A

PAGES 66–67
31. *Gentleman with a High Collar*
32. *Lady with a Nosegay*
A. Ellis
Possibly Maine, ca. 1830
Oil and pencil on wood panel
26⅝″ × 22″
(67.6 cm × 55.8 cm)
27″ × 21⅛″
(68.6 cm × 53.7 cm)

Inscriptions/Marks: In chalk in script on the verso of no. 31 is "A.E.", and in penciled script at the lower center are approximately twenty lines of a small, indecipherable inscription; in chalk in script on the verso of no. 32 is "A. Ellis."

Condition: The two panels were cleaned and a few damages inpainted by Caroline and Sheldon Keck in 1959. The backs were coated to minimize further warping of the wood.

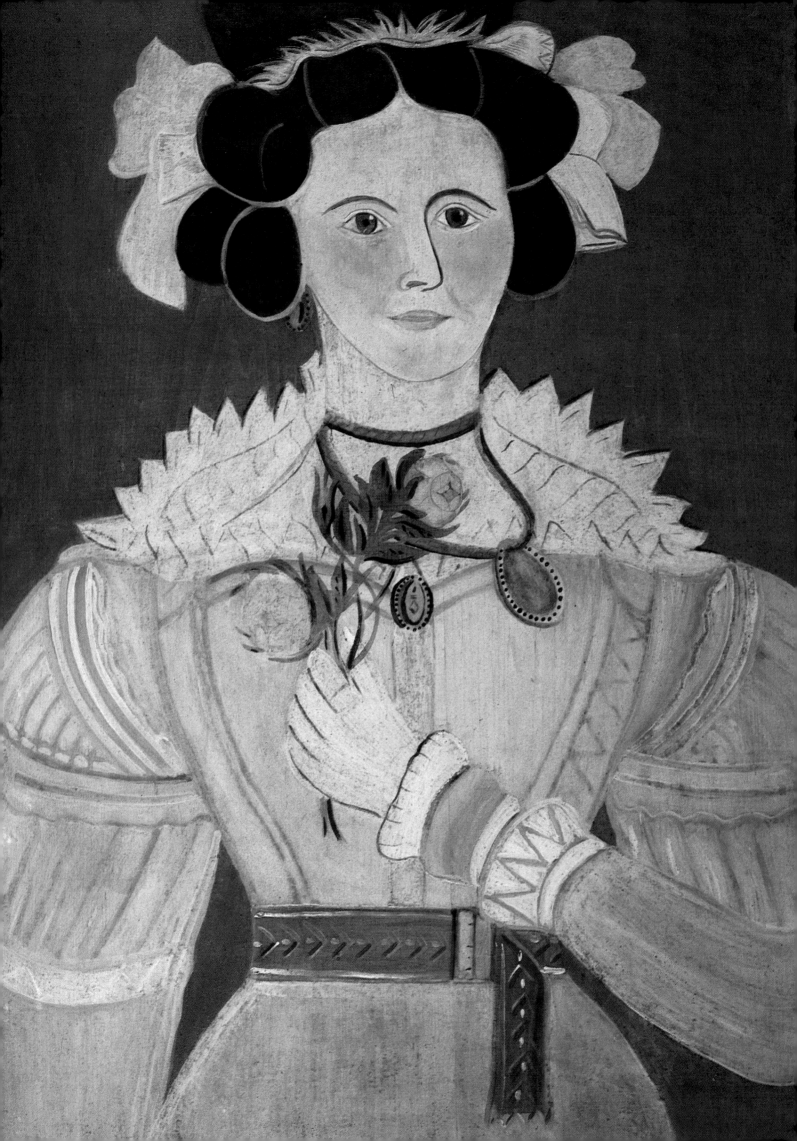

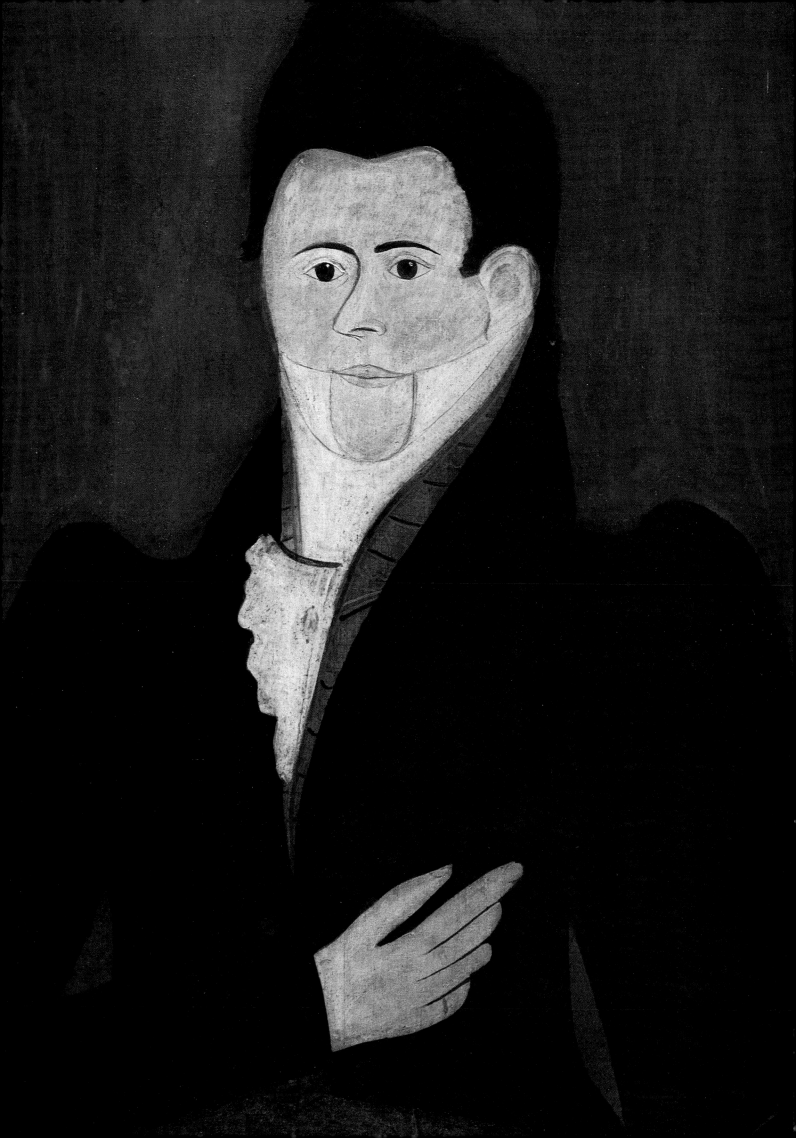

Provenance: Mr. and Mrs. William J. Gunn, Newtonville, Mass.; Miss Mary Allis, Fairfield, Conn.; Mr. Stephen C. Clark Sr., Cooperstown, N.Y.

Exhibited: NYSHA, "New-Found Folk Art of the Young Republic," 1960, and exhibition catalog, p. 30, no. 64 and no. 65, illus. as fig. 64 and fig. 65; untitled exhibition, The Century Association, New York, N.Y., January 2–February 15, 1961.

Published: Sheila McDonald, "Who Was A. Ellis? And why did he or she paint all those pictures?," *Maine Antique Digest* XI (April 1981), illus. on p. 27-A.

¹ This research is summarized in Sheila McDonald, "Who Was A. Ellis? And why did he or she paint all those pictures?," *Maine Antique Digest* XI (April 1981), pp. 26-A and 27-A. Known likenesses attributed to A. Ellis include portraits of Angeline Sherburne, Clementine Sherburne and a portrait of a boy and his dog, owned by the Maine State Museum, Augusta, and illustrated *ibid.* on p. 26-A; a portrait of Mr. Tiffen of East Kingston, N.H., owned by the Museum of Fine Arts, Boston, Mass., and illustrated *ibid.*, on p. 27-A; portrait of Albert G. Gilman and a young lady in blue, privately owned and illustrated in the catalog for the exhibition "Nineteenth Century Folk Painting: Our Spirited National Heritage, Works of Art from the Collection of Mr. and Mrs. Peter Tillou," William Benton Museum of Art, University of Connecticut, Storrs, Conn., April 23–June 3, 1973, as fig. 49 and fig. 50; portraits of Mr. Titcomb and Mrs. Titcomb, privately owned and illustrated in the catalog for the exhibition "Where Liberty Dwells: 19th Century Art by the American People, Works of Art from the Collection of Mr. and Mrs. Peter Tillou," Albright-Knox Art Gallery, Buffalo, N.Y., January 17–February 22, 1976, as fig. 34 and fig. 35; and portraits of Diantha Atwood Gordon, David Hudson and Electa Kendell Hudson, all privately owned. A recently discovered pair of portrait miniatures in watercolor on paper depicting Rufus and Rosaline Linton are inscribed in ink on the verso with the names of the sitters and "Feb. 1821/A. Ellis." These portraits are privately owned.

❖ James Sanford Ellsworth ❖
(1802/3–1874?)

By the early nineteenth century, the portrait miniature in watercolor on paper had become popular. This medium met the demands of a growing middle class population for economical, efficient and aesthetically pleasing portraits prior to the widespread use of commercial photography. To date, over 260 such portrait miniatures in watercolor on paper and twelve portraits in oil on canvas painted by James Sanford Ellsworth have been recorded, suggesting his popularity with his clients. Whether he was painting likenesses of farmers, mill owners, lumbermen, country squires, churchmen, blacksmiths, or their wives and children, Ellsworth's strength lay in his uncommon ability to capture a reflection of character and individuality.

Evidence suggests the artist was born in Connecticut in 1802 or 1803 to John and Huldah Ellsworth, and was baptized in West Harland, Connecticut, on June 26, 1807. James S. Ellsworth married Mary Ann Driggs on May 23, 1830 in Hartford, Connecticut. On November 15, 1829, six months prior, Miss Driggs had given birth to their baby boy. Their marriage appears to have been troubled, for in 1833 Mrs. Ellsworth filed for divorce on the grounds of desertion and was granted a divorce on January 17, 1839.¹

Details are vague concerning the whereabouts of Ellsworth directly after he left his wife. H. W. French, an art historian of the late nineteenth century, writes in his book, *Art and Artists in Connecticut,* that Ellsworth left Connecticut "for the West." Efforts to substantiate this claim have proven inconclusive. However, Ellsworth soon reappears in the East by 1835, as one portrait miniature dated 1835 has been found to document his return.² From 1835 until about 1855, Ellsworth traveled throughout Connecticut and eastern Massachusetts rendering portraits in watercolor on paper and oil on canvas. He also painted miniatures of Mary Wood Closson of Charlestown, New Hampshire, Susan-

nah Storms Barthol of Yawpo, New Jersey, Margaret Douglas Bottum of South Shaftesbury, Vermont, and Dr. Lucius Marcellus Wheeler of East Greenwich, Rhode Island.[3]

Although Ellsworth is perhaps best known for his portrait miniatures in watercolor, twelve full-scale portraits in oil on canvas painted by him have been recorded. The portrait of Mrs. William Henry Harrison, dated May 1, 1843, is the earliest known portrait in oil painted by Ellsworth.[4] In these paintings, the artist depicted subjects in halflength with torsos slightly turned to create an illusion of depth. However, unlike his lively and decorative portrait miniatures in watercolor, Ellsworth's oils are somber renditions of New Englanders clad in heavy, dark clothing with faces and hands worked in pale flesh tones.

In a letter to Governor Edwin Denison Morgan, dated August 28, 1861, Ellsworth mentioned his recent travels through Pennsylvania, the edge of Ohio, and into parts of New York. His reasons for these travels are not known and no portraits have been found to document further work during this period. According to French, he spent his last days in an almshouse in Pittsburgh, Pennsylvania where he died in 1874.[5] CME

[1] Except where noted, all biographical information on the artist included here is from the catalog for the exhibition "The Paintings of James Sanford Ellsworth: Itinerant Folk Artist, 1802–1873," the Abby Aldrich Rockefeller Folk Art Center, Williamsburg, Va., October 13–December 1, 1974, pp. 4–6.

[2] H. W. French, *Art and Artists in Connecticut* (1879; reprint ed., New York, 1970), p. 72; the portrait is privately owned and is illustrated in the catalog "The Paintings of James Sanford Ellsworth: Itinerant Folk Artist, 1802–1873," as A27 on p. 59.

[3] The portrait of Mary Wood Closson is owned by Old Sturbridge Village, Sturbridge, Mass., and is illustrated in the catalog "The Paintings of James Sanford Ellsworth," as 99 on p. 50; the portrait of Susannah Storms Barthol is privately owned and is illustrated *ibid.* as A53 on p. 53; the portrait of Margaret Douglas Bottum is privately owned and is illustrated *ibid.* as A65 on p. 71; the portrait of Dr. Lucius Marcellus Wheeler is owned by the Rhode Island Historical Society Library, Providence, R.I., and is illustrated *ibid.* as A157 on p. 99.

[4] The portrait is owned by the Connecticut Valley Historical Museum, Springfield, Mass., and is illustrated *ibid.* as 6 on p. 17.

[5] French, *Art and Artists,* p. 73.

33. *Noah Clark*

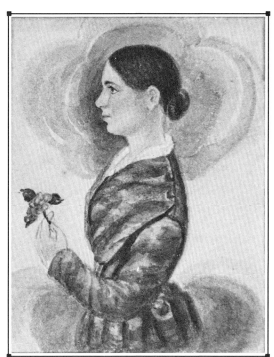

34. *Martha Clark Parkins [Perkins?]*

James Sanford Ellsworth
Probably Connecticut, ca. 1840
Watercolor on
heavy wove paper
3⅛″ × 2¾″
(7.9 cm × 7 cm)

33. *Noah Clark* N-64.61 a
34. *Martha Clark Parkins [Perkins?]* N-64.61 b

Although donor's information states that the portrait subjects Noah Clark and Martha Clark Parkins [Perkins?] were from Norwich, Connecticut, efforts to locate them in state records have proven inconclusive. CME

Inscriptions/Marks: Printed in black watercolor below both portraits is "-Ellsworth. Painter.-"; inscribed in pencil on the verso of no. 33 is "Noah Clark"; in black ink at the upper left is the number "6" and in pencil upside-down in the lower left is "H1199." Inscribed in pencil on the verso of no. 34 is "Martha Clark/Parkins [Perkins?]"; in black ink at the upper left is the number "5," and in pencil upside-down in the lower left, is "H1199." No watermark found on no. 33. The primary support of no. 34 bears the partial watermark "[?]ES[?]PS".

Condition: Because of minor foxing and discoloring of the paper, the watercolors had surface dirt removed, were washed to reduce the yellowing and were placed in acid-free mats and backings by the NYSHA conservator in 1983.

Provenance: Found in Norwich, Conn.; Claire Pinney, Stafford Springs, Conn.; Mr. and Mrs. Howard Lipman, Wilton, Conn.; Mr. Stephen C. Clark Sr., Cooperstown, N.Y.

Exhibited: "Identified American Primitives," Harry Shaw Newman Gallery, New York, N.Y., November 15–30, 1950; "Primitives," Union College Art Gallery, Schenectady, N.Y., March 1951; untitled exhibition, The Century Association, New York, N.Y., January-February 1952; "James S. Ellsworth: American Miniature Painter," Connecticut Valley Historical Museum, Springfield, Mass., September 13–October 9, 1953; "The Paintings of James Sanford Ellsworth, Itinerant Folk Artist, 1802–1873," the Abby Aldrich Rockefeller Folk Art Center, Williamsburg, Va., October 13–December 1, 1974, and exhibition catalog, p. 42, no. 76 and no. 77, and illus. as fig. 76 and fig. 77 on p. 43.

Published: Jean Lipman, "James Sanford Ellsworth, A Postscript," *Art in America* 32 (April 1944), checklist no. 22 and no. 23 on p. 102; Lucy B. Mitchell, "James Sanford Ellsworth, American Miniature Painter," *Art in America* 41 (Autumn 1953), checklist no. 76 and no. 77 on p. 179; Julia D. Sophronia Snow, "King versus Ellsworth," *Antiques* XXI (March 1932), illus. as fig. 5 on p. 120, no. 33 only.

Attributed to
James Sanford Ellsworth
Probably Massachusetts,
ca. 1845
Watercolor with glazed highlights on wove paper
3⅜″ × 2¾″
(8.6 cm × 7 cm)

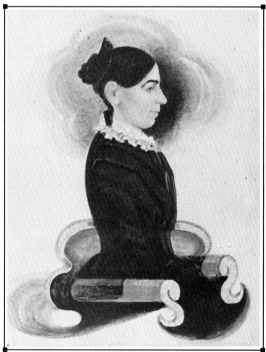

35. *Lady from Amherst*

35. *Lady from Amherst* N-65.61

Inscriptions/Marks: No watermark found.

Condition: No record of previous conservation. The paper has been attached to a backing of yellow paper with paste or glue. An acid-free backing and mat was placed in the frame by the NYSHA conservator in 1987.

Provenance: Found in Amherst, Mass.; Harry Stone, New York, N.Y.; Mr. and Mrs. Howard Lipman, Wilton, Conn.; Mr. Stephen C. Clark Sr., Cooperstown, N.Y.

Exhibited: "James S. Ellsworth: American Miniature Painter," Connecticut Valley Historical Museum, Springfield, Mass., September 13–October 9, 1953; "The Paintings of James Sanford Ellsworth, Itinerant Folk Artist, 1802–1873," the Abby Aldrich

Rockefeller Folk Art Center, Williamsburg, Va., October 13–December 1, 1974, and exhibition catalog, p. 44, no. 82, illus. as fig. 82 on p. 45.

Published: Lucy B. Mitchell, "James Sanford Ellsworth, American Miniature Painter," *Art in America* 41 (Autumn 1953), checklist no. 82 on p. 180.

36. *Lady of the Folts Family of Albany* N-66.61

This likeness is one of only a few portraits drawn by James Sanford Ellsworth depicting subjects who are believed to have lived in New York state. A pleasing sense of pattern and design is created as the artist skillfully employed line and color to render the subject's striped dress and shawl in shades of blue and rose. The pink paper visually complements the picture and is one of several paper colors he employed. The artist's inclusion of both hands is unusual for his profile work. Only one other example is known to exist.[1] CME

Inscriptions/Marks: Printed in black watercolor under the drawn oval is "-Ellsworth, Painter.-". No watermark found.

Condition: Poor quality backing materials were replaced with an acid-free mat and backing in 1980 by the NYSHA conservator.

Provenance: Harry Stone, New York, N.Y.; Mr. and Mrs. Howard Lipman, Wilton, Conn.; Mr. Stephen C. Clark Sr., Cooperstown, N.Y.

Exhibited: "Identified American Primitives," Harry Shaw Newman Gallery, New York, N.Y., November 15–30, 1950; untitled exhibition, The Century Association, New York, N.Y., January-February 1952; "James S. Ellsworth: American Miniature Painter," Connecticut Valley Historical Museum, Springfield, Mass., September 13–October 9, 1953; "The Paintings of James Sanford Ellsworth, Itinerant Folk Artist, 1802–1873," the Abby Aldrich Rockefeller Folk Art Center, Williamsburg, Va., October 13–December 1, 1974, and exhibition catalog, p. 40, no. 73, illus. as fig. 73 on p. 41; "American Painting Around 1850," Utah State Museum of Fine Art, Salt Lake City, Utah, and exhibition catalog, plate 35; "American Folk Painters of Three Centuries," Whitney Museum of American Art, New York, N.Y., February 26–May 13, 1980.

Published: Jean Lipman, "James Sanford Ellsworth, A Postscript," *Art in America* 32 (April 1944), checklist no. 11 on p. 102; Jean Lipman and Tom Armstrong, eds., *American Folk Painters of Three Centuries* (New York, 1980), illus. on p. 72;

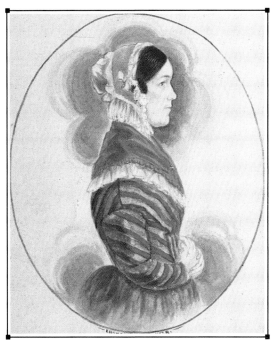

James Sanford Ellsworth
Probably New York, ca. 1845
Watercolor with white wash
on pink wove paper
4⅜″ × 3⅛″
(11.1 cm × 7.9 cm)

36. *Lady of the Folts Family of Albany*

Lucy B. Mitchell, "James Sanford Ellsworth, American Miniature Painter," *Art in America* 41 (Autumn 1953), checklist no. 73 on p. 179.

[1] Lucy B. Mitchell to NYSHA, June 5, 1985; the portrait of Calista Howard is privately owned and is illustrated in the catalog "The Paintings of James Sanford Ellsworth: Itinerant Folk Artist, 1802–1873," as A100 on p. 81.

James Sanford Ellsworth
Probably New England, ca. 1850
Watercolor on laid paper
3″ × 2¾″
(7.6 cm × 7 cm)

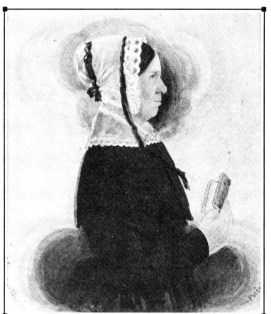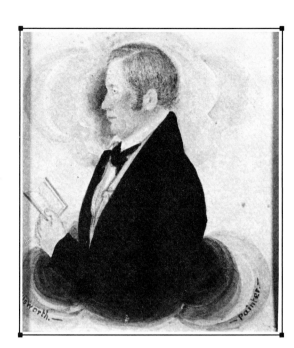

37. Red-Haired Gentleman and His Wife

37. *Red-Haired Gentleman and His Wife* N-67.61 a & b

Ellsworth's skill in drawing faces is illustrated in these portraits. Personality is suggested through delicate modeling and a sensitive use of color. Ellsworth probably spent most of his time and attention working on faces, as the bodies and hands of his subjects are less skillfully rendered and in a more stylized manner. Unusually large, glove-like hands often appear in his miniatures as he struggled to represent their correct proportion and form. Ellsworth tried to solve this problem by portraying his subjects holding books, flowers and occasionally fans, and by including only one of the sitter's hands.

In many of his portraits in watercolor, Ellsworth included imaginative, aureole clouds at the base of the figures. He also included similar stylized, cloud-like formations around the heads and shoulders of the subjects, thus providing an effective contrast between the figures and the light background. CME

Inscriptions/Marks: On both, printed in black watercolor at the bottom left corner is "-Ellsworth.-". On both, printed in black watercolor at the bottom right corner is "-Painter.-". No watermarks found.

Condition: Surface dirt was removed from these two pieces and new mats and backings were prepared by the NYSHA conservator in 1983.

Provenance: Frederick Fairchild Sherman, Westport, Conn.; Mr. and Mrs. Howard Lipman, Wilton, Conn.; Mr. Stephen C. Clark Sr., Cooperstown, N.Y.

Exhibited: "Primitives," Union College Art Gallery, Schenectady, N.Y., March 1951; untitled exhibition, The Century Association, New York, N.Y., January-February 1952; "James S. Ellsworth: American Miniature Painter," Connecticut Valley Historical Museum, Springfield, Mass., September 13–October 9, 1953; "The Paintings of James Sanford Ellsworth, Itinerant Folk Artist, 1802–1873," the Abby Aldrich Rockefeller Folk Art Center, Williamsburg, Va., October 13–December 1, 1974, and exhibition catalog, p. 43, no. 79 and no. 80, illus. as fig. 79 and fig. 80 on p. 43.

Published: Jean Lipman, "American Primitive Portraiture, A Revaluation," *Antiques* XL (September 1941), illus. as fig. 4 on p. 144; Jean Lipman and Alice Winchester, *Primitive Painters in America* (New York, 1950), illus. on p. 69; Lucy B. Mitchell, "James Sanford Ellsworth, American Miniature Painter," *Art in America* 41 (Autumn 1953), checklist no. 79 and no. 80 on p. 180.

38. *Cornelia Wilkinson Cotrell* N-69.61

Cornelia Wilkinson Cotrell was the daughter of Dr. Jabez Wilkinson. In 1836, she married Edgar Cotrell of Albany, New York who was born in 1804 and died in 1878.[1] CME

Inscriptions/Marks: No watermark found.

Condition: Treatment by the NYSHA conservator in 1976 included removing a cellophane tape mend and repairing a tear. Surface dirt was removed and a new mat and backing were prepared.

Provenance: Mr. and Mrs. Howard Lipman, Wilton, Conn.; Mr. Stephen C. Clark Sr., Cooperstown, N.Y.

Exhibited: "James S. Ellsworth: American Miniature Painter," Connecticut Valley Historical Museum, Springfield, Mass., September 13–October 9, 1953; "The Paper of the State," Museum of American Folk Art, New York, N.Y., April 9–June 2, 1976; "The Paintings of James Sanford Ellsworth, Itinerant Folk Artist, 1802–1873," the Abby Aldrich Rockefeller Folk Art Center, Williamsburg, Va., October 13–December 1, 1974, and exhibition catalog, p. 44, no. 81, and illus. as fig. 81 on p. 45.

Published: Jean Lipman, "James Sanford Ellsworth, A Postscript," *Art in America* 32 (April 1944), checklist no. 12 on p. 102; Lucy B. Mitchell, "James Sanford Ellsworth, American Miniature Painter," *Art in America* 41 (Autumn 1953), checklist no. 81 on p. 180.

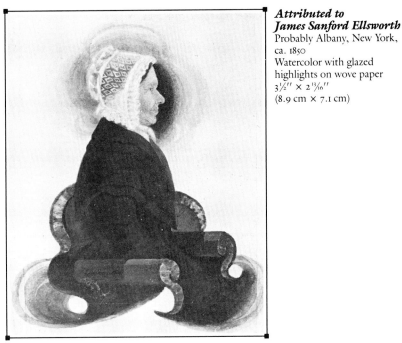

38. *Cornelia Wilkinson Cotrell*

Attributed to James Sanford Ellsworth
Probably Albany, New York, ca. 1850
Watercolor with glazed highlights on wove paper
3½″ × 2¹³⁄₁₆″
(8.9 cm × 7.1 cm)

[1] Thomas P. Hughes, *American Ancestry: Giving the Name and Descent, in the Male Line, of Americans Whose Ancestors Settled in the United States, Previous to the Declaration of Independence, A.D. 1776,* 12 vols., (Albany, 1887), vol. I, p. 17.

39. *Jennie Post of Guilford* N-112.61

The charcoal-colored background in this portrait of Jennie Post is an unusual departure for Ellsworth.[1] The artist successfully lightened the portrait by detailing a white scalloped lace collar and skillfully modeled white bonnet to separate the face from the dark background. The hand that holds a hymnal book is also highlighted, thus drawing attention to the lower portion of the picture and balancing the composition. CME

Inscriptions/Marks: Printed in ink on the verso of the center support is "J. S. Ellsworth. Painter." No watermark found.

Condition: An acid-free backing has been placed in the frame.

Provenance: Henry Walters; Frederick Fairchild Sherman, Westport, Conn.; Mr. and Mrs. Howard Lipman, Wilton, Conn.; Mr. Stephen C. Clark Sr., Cooperstown, N.Y.

Exhibited: "Identified American Primitives," Harry Shaw Newman Gallery, New York, N.Y., November 15–30, 1950; "Primitives," Union College Art Gallery, Schenectady, N.Y., March, 1951; "James S. Ellsworth: American Miniature Painter," Connecticut Valley Historical Museum, Springfield, Mass., September 13–October 9, 1953; "The

James Sanford Ellsworth
Probably Connecticut, ca. 1850
Watercolor on laid paper
2⁷/₁₆″ × 2⁷/₈″
(6.2 cm × 7.3 cm)

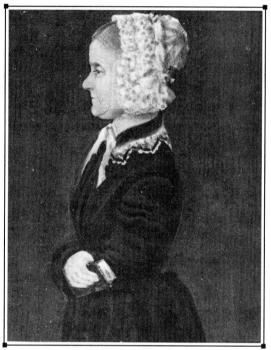

39. *Jennie Post of Guilford*

Paintings of James Sanford Ellsworth, Itinerant Folk Artist, 1802–1873," the Abby Aldrich Rockefeller Folk Art Center, Williamsburg, Va., October 13–December 1, 1974, and exhibition catalog, p. 42, no. 78, illus. as fig. 78 on p. 43; "American Folk Painters of Three Centuries," Whitney Museum of American Art, New York, N.Y., February 26–May 13, 1980.

Published: Jean Lipman, *American Primitive Painting* (London, 1942), p. 21, illus. as fig. 38 on p. 54; Jean Lipman and Tom Armstrong, eds., *American Folk Painters of Three Centuries* (New York, 1980), illus. on p. 73; Jean Lipman and Alice Winchester, *Primitive Painters in America* (New York, 1950), illus. on p. 70; Lucy B. Mitchell, "James Sanford Ellsworth, American Miniature Painter," *Art in America* 41 (Autumn 1953), checklist no. 78 on p. 180; Frederick Fairchild Sherman, *Early Connecticut Artists and Craftsmen* (New York, 1925), illus. on p. 36; Sherman, "Miniature by J. S. Ellsworth," *Art in America* XI (June 1923), p. 209; Sherman, "Substantiation for Miss Snow," *Antiques* XXII (July 1932), p. 4.

¹Although donor's information states that the portrait subject, Jennie Post, was from Guilford, Connecticut, efforts to locate her in state records have proven inconclusive.

40. *Unidentified Gentleman and His Wife* N-68.61 a & b

Ellsworth relied upon several compositional formats. In this pair of portrait miniatures, he posed the couple facing each other in the same handmade frame separated by a thin wooden strip. They are seated on matching, fanciful chairs upholstered in brightly colored green fabric with yellow wood. Variations of these imaginative chairs, painted in orange, red, yellow or green, are found in many of Ellsworth's other miniatures, and lend rhythm and color to his compositions. CME

Inscriptions/Marks: Inscribed in ink on the verso of the Gentleman is "8" and penciled directly underneath is "H1199." Printed in ink on the verso of his Wife is "8/J.S. Ellsworth. Painter/March 12th. 1852." and penciled directly under the inscribed "8" is "H1199." No watermarks found.

Condition: Acid-free backings have been placed in the double frame.

Provenance: Found in New London, Conn.; Frederick Fairchild Sherman, Westport, Conn.; Mr. and Mrs. Howard Lipman, Wilton, Conn.; Mr. Stephen C. Clark Sr., Cooperstown, N.Y.

Exhibited: "F. F. Sherman Memorial Exhibition," Walter Vincent Smith Art Gallery, Springfield, Mass., April 1941, and exhibition catalog, no. 94 and no. 95; "Primitives," Harry Stone Gallery, New York, N.Y., 1942; "Identified American Primitives," Harry Shaw Newman Gallery, New York, N.Y., November 15–30, 1950; untitled exhibition, The Century Association, New York, N.Y., January–February, 1952; "James S. Ellsworth: American Miniature Painter," Connecticut Valley Historical Museum, Springfield, Mass., September 13–October 9, 1953; "The Paintings of James Sanford

Ellsworth, Itinerant Folk Artist, 1802–1873," the Abby Aldrich Rockefeller Folk Art Center, Williamsburg, Va., October 13–December 1, 1974, and exhibition catalog, p. 40, no. 74 and no. 75, illus. as fig. 74 and fig. 75 on p. 41.

Published: Theodore Bolton, *Early American Portrait Painters in Miniature* (New York, 1921), no. 1 and no. 2 on p. 47; Jean Lipman, *American Primitive Painting* (London, 1942), p. 21, illus. as fig. 38 on p. 54; Lipman, "American Primitive Portraiture, A Revaluation," *Antiques* XL (September

1941), illus. as fig. 4 on p. 144; Lipman, "James Sanford Ellsworth, A Postscript," *Art in America* 32 (April 1944), checklist no. 20 and no. 21 on p. 102; Jean Lipman and Alice Winchester, *Primitive Painters in America* (New York, 1950), illus. on p. 70; Lucy B. Mitchell, "James Sanford Ellsworth, American Miniature Painter," *Art in America* 41 (Autumn 1953), checklist no. 74 and no. 75 on p. 179; Frederick Fairchild Sherman, "Three New England Miniatures," *Antiques* IV (December 1923), illus. as fig. 4 and fig. 5 on p. 276.

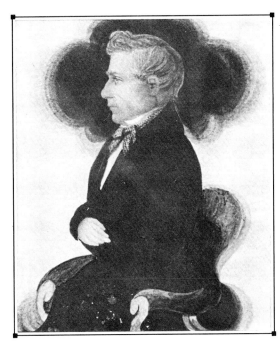

James Sanford Ellsworth
Probably New England, 1852
Watercolor on wove paper
3⅛″ × 2⅝″
(7.9 cm × 6.7 cm)

40. *Unidentified Gentleman and His Wife*

❖ Alexander Hamilton Emmons ❖
(1816–1884)

41. *Boy of the Reed Family* N-70.61 a
42. *Girl of the Reed Family* N-70.61 b

Alexander Hamilton Emmons was born on December 12, 1816 to Noadiah and Elizabeth Emmons of East Haddam, Connecticut. A house painter by trade, Emmons's interest in portraiture emerged when he made a sketch of a fellow worker which bore a close resemblance to the subject. Encouraged by his success at achieving this likeness, he began drawing portrait miniatures in watercolor on bristol board.[1] To date, only a small number of Emmons's miniatures have been recorded to document his early, unschooled work. The two modestly rendered profile portraits depicting a boy and girl of the Reed Family demonstrate the artist's sensitive appreciation of his subjects' appearance. Em-

mons meticulously recorded their facial features with delicate lines and employed stippled brush strokes of color to add contour and form to their portraits. By outlining faces in dark tones of red or black and flanking shoulders in stippled surrounds, Emmons offset these profiles against their neutral ground.

At age eighteen, Emmons married his first wife, Mary A. Wilson of Norwich, Connecticut on October 8, 1835.[2] For a short time, he resided in Norwich where he began painting half-length portraits of local citizens in oil on canvas. By 1841, he was advertising his services for "Portrait and Miniature Painting" in the *Norwich Courier,* stating that "having recently had the benefit of instruction from many of the first artists of our country, he would invite the public to call and judge for themselves as to his abilities as an artist." By 1843, he had moved to Hartford, Connecticut where he opened his first studio and commenced business as a landscape and portrait painter, as well as an instructor of pupils in art.

In 1848, he returned to Norwich where he received a commission from Charles Johnson, president of the Old Norwich Bank, to paint thirty-two portraits of prominent men of the community. Emmons received twenty-five dollars per portrait or a total of eight hundred dollars for this work, which he completed in three years. Mr. Johnson is believed to have solicited Emmons, not only because he desired to preserve the likenesses of men honored and respected in the community, but also to provide subjects for a painter whose work he admired and for someone whom he wished to encourage.[3]

Emmons spent most of his artistic career painting portraits in the vicinity of Norwich, Connecticut. However, he occasionally traveled outside the area for other commissions. In a letter to his brother dated March 15, 1849, Emmons stated he would be unable to attend his wedding and ". . .regret it much but I have pledged my word to be in N York the first of April to paint two heads. . . ." On January 24, 1853, Emmons married his second wife, Elizabeth English, also of Norwich.[4]

In 1868, the artist made an extended tour through Europe visiting art galleries and studying works of art by Old Masters. Upon returning to Norwich, Emmons showed considerable development in his painting style and technique, the result of his foreign travels. He died in Norwich on October 28, 1884 at the age of sixty-eight and was buried with his palette and brushes according to his request.[5] CME

Inscriptions/Marks: Printed in watercolor below no. 41 is "A. H. Emmons Del." Printed in pencil on the frame's probably modern wood backing of no. 42 is "A. H. Emmons/del." No watermarks found.

Condition: The boy's portrait is slightly yellowed. It has been pieced out at the top edge to fill the frame. The girl's portrait is unevenly yellowed and has been attached to a backing sheet at the corners. There is an irregular loss of paper (insect-eaten) in the dress below the necklace and another hole in the hair. A paper patch covers these and a piece of black fabric has been attached to the reverse with sealing wax to fill the hole where it extends into the dress. There is a spot of adhesive at the top left.

Provenance: Frederick Fairchild Sherman, Westport, Conn.; Mr. and Mrs. Howard Lipman, Wilton, Conn.; Mr. Stephen C. Clark Sr., Cooperstown, N.Y.

Published: Frederick Fairchild Sherman, "American Miniatures by Minor Artists," *Antiques* XVII (May 1930), no. 41 only, illus. as fig. 8 on p. 424; Sherman, "Three New England Miniatures," *Antiques* IV (December 1923), no. 42 only, illus. as fig. 6 on p. 276.

[1] Except where noted, biographical information on the artist is from David J. Corrigan (Museum of Connecticut History) to NYSHA, November 8, 1984.

[2] Vital records, Connecticut State Library, Hartford, Conn.

[3] Marie E. Noyes (The Slater Memorial Museum) to NYSHA, June 27, 1985.

[4] A. H. Emmons to brother, March 15, 1849, the Connecticut Historical Society, Hartford, Conn.

[5] Vital records, Connecticut State Library, Hartford, Conn.

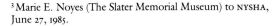

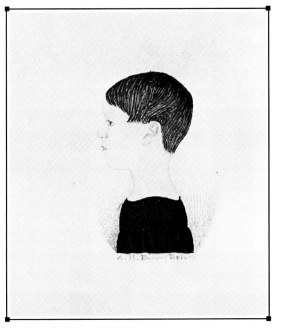

41. *Boy of the Reed Family*

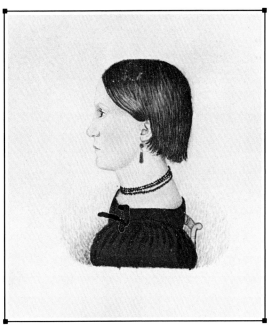

42. *Girl of the Reed Family*

FAR LEFT
Alexander Hamilton Emmons

LEFT
Attributed to Alexander Hamilton Emmons
Probably Connecticut, ca. 1835
Watercolor with glazed highlights on bristol board
4″ × 3½″
(10.2 cm × 8.9 cm)

❖ J. Evans ❖
(active 1827–1834)

Two signed portraits, *Woman in a Garden* and *Family of Four,* both inscribed "J. Evans, Painter," provide the basis for attributing over twenty portraits to this elusive artist. A rendering of Sarah Jane Pennell dated November 16, 1827 is the earliest likeness ascribed to J. Evans.[1] From 1830 through 1833, the artist worked in and around Portsmouth, New Hampshire, generally venturing no further than thirty-five miles for commissions. While Evans continued to draw portraits of subjects living in southeastern New Hampshire, from 1833 through 1834 the artist was also executing portraits in the Boston-Roxbury area of Massachusetts. Until further discoveries are made, nothing else is known of Evans's life, not even the artist's gender.

The artist expressed a fondness for controlled pattern and meticulous detail, especially in his portraits of women. Floral-embroidered and lace-decorated aprons and collars, stylishly coiffed hair with tortoise-shell combs and diminutive hands holding such ladylike accessories as purses and handkerchiefs all lent fashion and elegance to Evans's portrait compositions.

As in the portrait of the Christian children, drawn about 1831, the artist's early work betrays an inability to convey perspective, as one child is drawn standing and the other

sitting on the top edge of an elaborately patterned floor covering.[2] In the portrait *Family of Four*, dated 1832, Evans appears to have learned how to convey depth in a portrait scene as these figures illustrate a more convincing interpretation of spatial relationships. In most group portraits, the artist positioned subjects facing each other in compositions reminiscent of English conversation pieces. However, Evans's likenesses are not particularly engaging as no individuals seem to successfully communicate with eye contact. CME

[1] For information on the artist and a checklist of portrait work, see the catalog for the exhibition, "Three New England Watercolor Painters," Art Institute of Chicago, Chicago, Ill., November 16, 1974–September 1, 1975, pp. 10–21 and p. 56; the portrait *Woman in a Garden* is privately owned and is illustrated *ibid.* as fig. 20 on p. 20; the portrait

Family of Four is owned by the National Gallery of Art, Washington, D.C.; the portrait of Sarah Jane Pennell is privately owned and is illustrated *ibid.* as fig. 8 on p. 15.

[2] The portrait of the Christian children is privately owned and is illustrated *ibid.* as fig. 5 on p. 12.

43. *Unidentified Gentleman* N-110.61

Rendered in watercolor without the use of pencil, this unidentified gentleman stands on a grassy knoll facing left with his body drawn in three-quarter view and his face in profile. Evans often represented men in this pose with the subject's weight on the left leg, the left arm bent and resting on the rounded hip and the right hand holding a beaverskin top hat. The pale blue of the gentleman's gloves and the pink in the striped lining of the hat were accent colors often employed by Evans. Other distinguishing characteristics include the slightly protruding upper lip, the subtle, complementary coloration of fleshtones and the well defined facial features. CME

Attributed to J. Evans
Probably New Hampshire or
Massachusetts, ca. 1833
Watercolor with glazed
highlights on heavy wove paper
10″ × 8 ⁷⁄₁₀″
(25.4 cm × 30.5 cm)

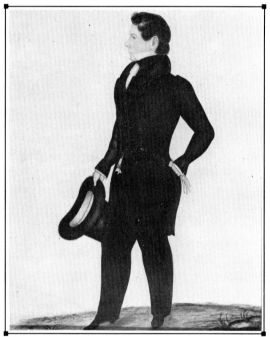

43. *Unidentified Gentleman*

Inscriptions/Marks: The primary support bears the watermark "J. Whatman [1823?] or [1833?]" for the Maidstone, Kent, England firm operated by the Hollingworth brothers between 1806 and 1859.

Condition: The paper has faint yellow stains along the left edge and a band at bottom left. An acid-free backing and mat have been placed in the frame.

Provenance: Mr. and Mrs. Howard Lipman, Wilton, Conn.; Mr. Stephen C. Clark Sr., Cooperstown, N.Y.

Exhibited: Untitled exhibition, The Century Association, New York, N.Y., January-February 1952; "Three New England Watercolor Painters," The Art Institute of Chicago, Chicago, Ill., November 16, 1974–September 1, 1975, and exhibition catalog, p. 21, no. 19, p. 56, no. 25, illus. on p. 20.

Published: Norbert and Gail Savage, "J. Evans, Painter," *Antiques* C (November 1971), illus. as fig. 8 on p. 786.

❖ Erastus Salisbury Field ❖

(1805–1900)

For ninety-five years, the artist Erastus Salisbury Field lived in and around western Massachusetts, venturing no farther than two hundred miles from home to earn a living painting portraits. Born in Leverett on May 19, 1805, the artist and his twin sister were named for their parents, Erastus and Salome Field. As a youth, Field first exhibited an interest in art when he began sketching likenesses of relatives. Encouraged by his family, in 1824 he traveled to New York City where he studied with the artist and inventor Samuel F. B. Morse (1791–1872). This tutelage was brief and Field returned to Leverett in 1825. Under Morse's guidance, however, he learned painting techniques that later influenced his portrait style and was exposed to an art world which affected and probably encouraged his professional painting career.[1]

By late summer of 1826, Field was traveling across western Massachusetts and eastern New York visiting with friends and relatives while painting their portraits. In 1828, he painted a likeness of Biel Le Doyt from Worcester, his only known signed and dated rendering from this early period of activity.[2] The skillfully blended tones of color appearing in the background, the softly defined outline of the subject's head, and the gray undercoat on the canvas are all typical elements Field probably derived from his study with Morse. The subject's short waist, narrow shoulders, long arms and awkwardly rendered hands are other features commonly found in Field's early portraits.

On December 29, 1831, Field married Phebe Gilmur of Ware, Massachusetts. The couple had only one child who was born on November 6, 1832 in Monson. Not one to stay in the same place, Field continued to seek commissions by traveling from one town to the next in western Massachusetts and as far south as Hartford, New Haven and New Canaan, Connecticut. By 1835, Field's portrait style had changed somewhat, reflecting his experimentation with artistic conventions and his ability to find solutions to technical problems. His likenesses conveyed more assured brushwork, softer modeled facial features and more rapidly executed costume details than his earlier work. As in the portraits of his brother and sister-in-law, Stillman and Aurilla Field Field, subjects typically gaze at the viewer with their faces shaded and highlighted in a pointillist application of gray and pink paint.[3] Their ears are elfinlike forms and their square fingertip hands seem to have only two knuckles. Black or gray paint is used to express the negative space of lacework. The backgrounds of these canvases are rendered with dark tones of gray paint along the edge to lighter shades toward the center, thus creating billowing cloudlike effects around sitters' heads and shoulders.

From 1841–1843, the artist again resided in New York City where he is listed in the New York Directory as "portrait painter" and later as "artist." However, few paintings can be dated to this second New York City period. By 1854, Field had returned to Massachusetts where he took a studio in Palmer. His portraits of these town residents are different from those of previous commissions as they evince the artist's introduction to photography, which he probably learned while living in New York City. In fact, Field began to use his own photographic images as sources for larger portrait compositions–posing sub-

jects, photographing them and then transferring the images to canvas with paint and brush. With the death of his wife in 1859, Field and his daughter moved to Plumtrees, near the artist's native Leverett. In about 1865, Field again painted likenesses of Mr. and Mrs. Stillman Field.[4] Posed squarely in the center of the canvas, their faces are accurately executed with smooth, easy brushstrokes; although this time the portraits seem stilted and lifeless as they were drawn not from life but from the photographic image. The immense empty space hanging over the sitters' heads and around their shoulders contributes to the boldness of these likenesses.

With the introduction of photography and the subsequent decline in commissions for painted portraits, Field turned to alternative subject matter for his compositions. He painted large exotic pictures of great buildings in foreign lands, a panorama depicting an imaginary trip around the world, religious scenes, such as *The Garden of Eden,* and historical narratives including Field's great epic work, *The Historical Monument of the American Republic* which he completed about 1867.[5] Field continued to paint in his later years. He executed his last known painting about five years before his death on June 28, 1900.

CME

FACING PAGE
44. *Girl in Yellow Dress with Doll*
Attributed to Erastus Salisbury Field
Probably Massachusetts, ca. 1838
Oil on canvas
42⅕₆" × 24⅝₆"
(106.8 cm × 62.4 cm)

[1] All biographical information on the artist is from the catalog for the exhibition "Erastus Salisbury Field: 1805–1900," the Museum of Fine Arts, Springfield, Mass., February 5–April 1, 1984.

[2] The portrait is owned by the National Gallery of Art, Washington, D.C.

[3] The portraits are privately owned and are illustrated in the catalog for the exhibition "Erastus Salisbury Field: 1805–1900," as fig. 21 and fig. 22 on p. 24.

[4] The portraits are privately owned and are illustrated *ibid.* as fig. 39 and fig. 40 on p. 37.

[5] One of two similar versions of *The Garden of Eden* is owned by the Museum of Fine Arts, Boston, Mass., the other is owned by the Shelburne Museum, Shelburne, Vt.; *The Historical Monument of the American Republic* is owned by the Museum of Fine Arts, Springfield, Mass.

44. *Girl in Yellow Dress with Doll* N-234.61

Lingering over costume details and decorative accessories, Field painted this delightful likeness with the attention he reserved for youthful sitters. Rendered in full-length, this subject fills the canvas as she holds out a pretty doll in her left hand and stands on a boldly patterned carpet painted in colors of gold, red, blue and burnt sienna. From the diagonal lines on the bodice and skirt which seem to converge at the waist, to the rhythmic, sculptural swirls of paint on the sleeves, and the dabs of blue and yellow for the child's two-strand necklace, Field executed this portrait with an expressive short-hand style. The lacework pattern at her neckline and along the bottom edges of her pantaloons was created with lines of white paint and dots of gray, and her knuckles were suggested by a pointillist application of tiny dots of pink paint, all significant features of Field's portrait work. CME

Condition: At an unknown date, this canvas was lined and extensively overpainted with oil colors. In 1959, Caroline and Sheldon Keck cleaned the painting and removed the then-darkened overpaint. Numerous losses were filled and inpainted and protective varnish was applied. The old lining was not removed, but a new stretcher replaced the older damaged one.

Provenance: Mr. and Mrs. William J. Gunn, Newtonville, Mass.; Miss Mary Allis, Fairfield, Conn.; Mr. Stephen C. Clark Sr., Cooperstown, N.Y.

Exhibited: NYSHA, "New-Found Folk Art of the Young Republic," 1960, and exhibition catalog, no. 66 on p. 30, illus. as fig. 66; untitled exhibi-

tion, The Century Association, New York, N.Y., January 2–February 15, 1961; untitled exhibition, Roberson Center for the Arts and Sciences, Binghamton, N.Y., November 1–December 15, 1961; untitled exhibition, Union College Art Gallery, Schenectady, N.Y., January–March 1962; "Erastus Salisbury Field: 1805–1900," the Abby Aldrich Rockefeller Folk Art Collection, Williamsburg, Va., January 20–March 17, 1963, and exhibition catalog, checklist no. 77; "Folk Art from Cooperstown," Museum of American Folk Art, New York, N.Y., March 21–June 6, 1966; "Folk Art," Roberson Center for the Arts and Sciences, Binghamton, N.Y., September 15, 1966–April 1, 1967.

Published: George R. Clay, "Children of the Young Republic," *American Heritage* XI (April 1960), p. 53.

FACING PAGE
Attributed to
George Freeman
Cooperstown, New York, 1816
Watercolor on wove paper
17 1/16″ × 22 3/8″
(43.3 cm × 56.8 cm)

❖ George Freeman ❖
(1789–1868)

George Freeman was born on April 21, 1789, the fifth child of Skiff and Mary Freeman of Mansfield, Connecticut. A sickly boy, Freeman was limited in his ability to help on the family farm and passed the time by teaching himself to draw and paint. By 1808 he had left Connecticut to live with his sister in Lisle, New York. Freeman traveled from there to Albany, Schenectady and Utica in search of his first portrait commissions. In June of 1813, he opened a studio at 65 Maiden Lane in New York City and is listed as "miniature painter" in *Longworth's New York City Directory* for 1813–14. On August 23, 1815, he married Lydia Burr at the Second Dutch Reformed Church in Albany, New York.[1] By late 1816, Freeman and his wife left the United States for Montreal where he advertised his services as "Miniature painter" in the November 18 issue of the *Montreal Gazette*.[2]

Although lacking the training of an academic artist, Freeman appears to have been aware of trends in cultural taste and sought to achieve in his portraiture the skill and sophistication of academic artists. In 1817, he left Canada for England where he hoped to receive instruction in painting from European masters. While his instructors are not known his style and technique evolved dramatically as he learned the conventions favored in European portraiture at the time. Maintaining a studio in Bath, Freeman traveled throughout England establishing a reputation for painting attractive and accomplished portrait miniatures on ivory of English nobility and royalty. By the time he returned to America in 1841, Freeman had exhibited paintings at the Royal Academy of Art in London, had become the first American to paint a portrait of Queen Victoria, and during an interim visit to America, was commissioned to paint a portrait of President Martin Van Buren.[3]

By 1843, George Freeman had moved to New York City where, until 1849, he is listed as "artist" in the *New-York City and Co-Partnership Directory*. In search of further portrait work, Freeman subsequently traveled to several major cities including Philadelphia, Hartford, Boston, Newport, Baltimore, Richmond and Cincinnati. The years 1841–1850 were Freeman's most prolific period as an artist in America, thus establishing his professional reputation on two continents. George Freeman died in Hartford, Connecticut on March 7, 1868, leaving a known body of work numbering close to 100 portraits painted over a span of sixty years. CME

45. *Elizabeth Fenimore Cooper*

[1] Mormon Genealogical Research Center, New York, N.Y.

[2] Except where noted, all biographical information on the artist has been summarized from Wilma Keyes, *George Freeman, Miniaturist, 1789–1868* (Storrs, Conn., 1980).

[3] Neither portrait has been located. The last known source of the portrait of Queen Victoria was King Edward VII, in 1908. See Keyes, *Freeman*, pp. 27, 29, 30.

45. *Elizabeth Fenimore Cooper* N-145.77

With the exception of the artist's earliest recorded likenesses of members of his family, George Freeman sought to attract only prosperous or well known clients. During the summer of 1816, in search of portrait work through central New York, he stopped in Cooperstown to draw this ambitious and accomplished portrait of Elizabeth Fenimore Cooper, widow of Judge William Cooper (1754–1809) and mother of novelist James Fenimore Cooper (1789–1851). The portraits of two other prominent Cooperstown residents, Catherine A. Russell and Rensselaer W. Russell, also are believed to have been drawn by Freeman during this visit.[1] These renderings and the appearance of the artist's name

cited in the October 3, 1816 issue of the Cooperstown *Watch Tower* among those people with letters remaining at the post office are the only evidence of the artist's visit to town.

While little is known of Freeman's early artistic training, the considerable ability with which he created the illusion of depth in this composition suggests that Freeman had more than a casual understanding of drafting techniques. Like many portraitists, he probably based the interior scene on visual observation of the room rather than exact measurements. It is therefore not surprising that the walls in this scene are not parallel, as Freeman must have struggled to reconcile reality with a pleasing composition.

Using short, precise brushstrokes, Freeman adeptly contoured Mrs. Cooper's facial features to render this compelling portrait of a mature woman. The sculpted folds of her dress, created by the artist's experienced use of cross-hatch markings and dark lines of blue watercolor, skillfully communicate her imposing figure. Seated on a chair in the main hall of her home, Otsego Hall, Mrs. Cooper is depicted by Freeman as a woman of taste and refinement. Her appearance and disposition are portrayed in a manner similar to a later description of her recalled by a granddaughter:

> . . .*She always wore sleeves to the elbow, or a little below, with long gloves. She took great delight in flowers, and the south end of the long hall was like a greenhouse in her time. She was a great reader of romances. She was a marvelous housekeeper, and beautifully nice and neat in all her arrangements.*[2]

To the right of Mrs. Cooper, located in the shadow at the base of her chair, appears the curious pentimento of a drawn outline of a cat curled up by her feet. The flowering plant at Mrs. Cooper's knee, the gauze-wrapped chandelier, and the chintz fabric covered sofa are interior details included by Freeman to interpret this rendering as a summer scene. Interestingly, inclement weather conditions experienced during this particular summer could explain why the large plants potted in boxes with handles located at the far end of the hall were not carried outside.[3]

Elizabeth Fenimore Cooper was born on June 11, 1751 to Richard and Hannah Allen Fenimore of Rancocas, New Jersey. On November 12, 1774, she married William Cooper in Burlington, New Jersey. The couple resided in Pennsylvania until 1780, when they returned to Burlington where William Cooper became involved in land speculation. While living there, Elizabeth Cooper gave birth to eleven of their twelve children. In 1790, William Cooper moved the family and their household including five servants and two slaves to Cooperstown, the village he founded in the wilderness of central New York. There, the couple lived for almost twenty years, residing at Otsego Hall, the home Cooper had built for his family. Elizabeth Fenimore Cooper died on September 13, 1817 and is buried in Christ Church Cemetery in Cooperstown.[4]

The black man portrayed standing in the doorway to the far left of the scene is Joseph Stewart. Born a slave, Stewart worked as the Coopers' free servant for over twenty years. Among Cooper family members, he was known as "the Governor," a name bestowed by William Cooper's sons. He died in July 1823 and is buried in the Cooper family plot in Cooperstown. CME

Inscriptions/Marks: In ink in script on the right center of the frame's wood backing is "A representation of the hall of the mansion house of the late William/Cooper Esqr. [illegible] also a perfect likeness of his widow Mrs. Elizabeth/Cooper together with her shrubbery in the south end of the hall. Also/the likeness of their old servant Joseph Stewart generally known/by the name of Governor. [P]ainted by Mr. [] Freeman/in the summer of 1816——". Written by George Pomeroy, Mrs. Cooper's son-in-law, in ink in script along the lower left of the frame's wood backing is "1846 This picture, at our deceased/we bequeath it to our daughter Mrs. Georgiann Keeses [Keese] at her death – to her son G. Pomeroy Keese/G.P." No watermark found.

Condition: Extensive treatment of the watercolor was undertaken at the Cooperstown Graduate Program for the Conservation of Historic and Artistic Works in 1976. A thick coat of discolored shellac was removed. Four layers of the five-ply support were removed in order to flatten the piece and permit stain removal. Small damages were repaired and a mat and backing were devised to protect the paper while preserving inscriptions on the frame and backing. The gilt frame appears to be original to the painting but was cut down slightly at an unknown date.

Provenance: Dr. Henry S. F. Cooper, New York, N.Y. (descendant of the sitter).

Exhibited: "American Art from Alumni Collections," Yale University Art Gallery, New Haven, Conn., April 25–June 16, 1968, and exhibition catalog, illus. as no. 60.[5]

Published: James Franklin Beard, ed., *The Letters and Journals of James Fenimore Cooper,* 6 vols., (Cambridge, Mass., 1960), vol. I, illus. as plate IV; Charlotte M. Emans, "Instead of Roses and Buttercups, There Were Snow and Ice," *Heritage* 2 July/August 1986), p. 20 and on back cover; Elizabeth Donaghy Garrett, "The American Home," *Antiques* CXXVIII (December 1985), illus. as plate V on p. 1218; Wilma Keyes, *George Freeman, Miniaturist, 1789–1868* (Storrs, Conn., 1980), p. 58, illus. on p. 17.

[1] The portraits are privately owned and are illustrated in the catalog for the NYSHA exhibition "Rediscovered Painters of Upstate New York," June 14, 1958–February 28, 1959, as fig. 38 and fig. 39 on p. 43.

[2] As quoted in James Fenimore Cooper, *The Legends and Traditions of a Northern County* (New York and London, 1921), p. 202.

[3] In Cooperstown, and in fact across much of America, temperatures plummeted during these months creating unseasonably cool weather, unprecedented snowfall and killing frost in June, July and August. For further information see C. Edward Skeen, " 'The Year Without a Summer': A Historical View," *Journal of the Early Republic,* 1 (Spring 1981), pp. 51–67.

[4] Except where noted all biographical information on Mrs. Cooper is from Wayne W. Wright, "The Cooper Genealogy," unpublished paper in NYSHA Library, pp. 8–9. This source and published genealogies indicate that Mrs. Cooper was born on June 11, 1752. However, the tombstone inscription records her age at death as sixty-six, making her year of birth 1751. Wright and published genealogies cite Mrs. Cooper's death date as September 15, 1817. However, her tombstone inscription records the date as September 13, 1817.

[5] With the exception of those illustrations published prior to NYSHA's acquisition of the portrait, all photographs reproduced to date are actually illustrations of a mid-nineteenth century copy of Freeman's portrait of Elizabeth Fenimore Cooper and not the original portrait. However, information cited with the erroneous image reproduced is correct for the original portrait and is therefore included under *Published.* The copy is privately owned and is illustrated in Clifford L. Lord, *The Museum and Art Gallery of the New York State Historical Association* (Cooperstown, 1942), on p. 20.

❖ John M. Gall ❖

(active 1839)

46. *Lurissa Cooke* N-48.41

The only known painting by John M. Gall, this likeness of Lurissa Cooke does not appear to be the artist's first attempt at portraiture. With red paint, he distinctly outlined the woman's facial features, highlighted her eyelids, the right side of her nose, her left nostril and the corners of her mouth. In her hands, she holds a vaguely defined landscape scene or drawing and an implement of an undetermined variety. The drapery in the background and the column to the left are pleasing compositional devices that frame the subject and further define the canvas.[1] CME

John M. Gall
United States, 1839
Oil on canvas
30½″ × 25½″
(77.5 cm × 64.8 cm)

46. *Lurissa Cooke*

Inscriptions/Marks: Painted in script on the verso at the bottom right is "John M. Gall/Painter/1839."

Condition: No record of previous conservation. The canvas is slack on its strainer and has wrinkled because of uneven priming and partial wetting at an unknown date. There is some flake loss of paint along the left edge and across the bottom. The old varnish layer is very yellow.

Provenance: Mrs. Bruce Phillips, Oneonta, N.Y.

Published: Clifford L. Lord, *The Museum and Art Gallery of the New York State Historical Association* (Cooperstown, 1942), illus. on p. 37.

[1] A portrait of Erastus Cooke, the sitter's husband, by an unidentified artist is owned by NYSHA, see no. 130.

❖ Deborah Goldsmith ❖

(1808–1836)

Deborah Goldsmith was born in North Brookfield, New York on August 14, 1808, the youngest child of Richard and Ruth Minor Goldsmith. Following the popular activity for young ladies, in 1826, at the age of nineteen, Deborah began a friendship album, filling it with poems that she and her friends selected from the works of such English poets as Pope, Goldsmith and Shakespeare. This album, together with another she began in 1829, included drawings by Deborah of pictorial scenes based upon prints, and floral vignettes, as well as a few watercolor portraits of her friends and relatives.[1]

Unlike most other young women of the nineteenth century who demonstrated an interest in art, Deborah Goldsmith sought work as a professional portrait painter. She traveled to towns throughout central New York, including Brookfield, Hamilton,

Lebanon, Toddsville, Hartwick, Hubbardsville and possibly Cooperstown, in search of work. The majority of her commissions came from relatives and family friends. Whether she was drawing in watercolor on paper, or ivory, or painting in oil on panel, Deborah's portrait work provided her with a means to contribute to the economic support of herself and members of her family.[2]

A naive inability to record anatomical features accurately is evident in Goldsmith's earliest portraits; eyes are suggested by almond-shaped forms; noses appear flat and two-dimensional; lips are tightly drawn and pursed; jowls seem swollen and hands are rendered disproportionately small. Her later work, however, reveals an increased understanding of anatomy and proportion. Goldsmith's sensitivity to the subject's appearance becomes more evident as she began to employ line and shadow to create more naturalistic likenesses.

Although her output spanned a period of over ten years, Goldsmith's chosen technique for drawing the figure and placing it within the composition remained consistent, with little stylistic change. Her two known group portraits, *Mr. and Mrs. Lyman Day and Daughter Cornelia* and *The Talcott Family,* drawn almost ten years apart, illustrate her passion for pattern and design as she rendered these sitters in highly detailed interior settings.[3]

On December 27, 1832, Deborah Goldsmith married George Addison Throop whom she met while painting his portrait and those of members of his family. After she married, it appears that Goldsmith no longer sought portrait commissions, but remained at home attending to her duties as wife and mother of two children.[4] After a lengthy illness, she died on March 16, 1836 at the age of only twenty-seven. CME

[1] Both albums are privately owned and are reproduced on microfilm at the Archives of American Art, Washington, D.C.

[2] All biographical information on the artist included here is from Sandra C. Shaffer, *Deborah Goldsmith, 1808–1836: A Naive Artist in Upstate New York* (East St. Louis, Ill., 1975); and from Addison James Throop, ed., *The Ancestral Charts of George Addison Throop, Deborah Goldsmith, many historically interesting letters from The Old Traveling Bag* (East St. Louis, Ill., 1934).

[3] The Day family portrait is privately owned and is illustrated in the catalog for the NYSHA exhibition, "Rediscovered Painters of Upstate New York," June 14–September 15, 1958, as 40 on p. 45; the Talcott family portrait is owned by the Abby Aldrich Rockefeller Folk Art Center, Williamsburg, Va.

[4] After her marriage, Deborah Goldsmith painted a small number of portraits depicting members of her immediate family including the portrait of her daughter Cordelia Throop Cole which is privately owned and is illustrated in Jean Lipman, "Deborah Goldsmith, Itinerant Portrait Painter," *Antiques* XLIV (November 1943), as fig. 6 on p. 229 and a self-portrait dated 1833 which is privately owned and is illustrated in Shaffer, *Deborah Goldsmith,* on the cover.

47. *Permilia Forbes* N-103.68

The artist's sensitivity to feminine qualities is evident in this attractive portrait of Permilia Forbes Sweet. Goldsmith included decorative details such as Permilia's single lock of hair on her forehead, her tortoise shell comb, her earrings and necklace, and the floral border on her shawl. As with most of her single figure portraits, Goldsmith drew Permilia in a half-length, frontal pose, with her head slightly turned to the subject's right. The crosshatch markings in the background are reminiscent of miniature work on ivory, but this was also a technique used by Goldsmith in a few of her watercolor portraits on paper.

Cemetery records reveal that Permilia Forbes Sweet was the first wife of Jeremiah Sweet of North Brookfield, New York, who was a farmer and sawmill owner. She was born in April 1810, and died in September 1849.[1] CME

47. *Permilia Forbes*

Inscriptions/Marks: No watermark found.

Condition: The paper has yellowish brown spots around all four edges, the result of glue or tape applied to the reverse. An acid-free mat and backing have been placed in the frame.

Provenance: Robert Palmiter, Bouckville, N.Y. (descendant of the sitter).

Published: Sandra C. Shaffer, *Deborah Goldsmith, 1808–1836: A Naive Artist in Upstate New York* (East St. Louis, Ill., 1975), checklist no. 61 on p. 38.

[1] Howard D. Williams to NYSHA, July 17, 1985; Isabel M. Bracy to NYSHA, May 30, 1985.

48. *Lady and Gentleman* N-326.61 a & b

Goldsmith's lack of skill at drawing anatomy makes her portraiture seem occasionally awkward. Eyes are rendered disproportionately large, while ears seem small and are sometimes placed low on the head. The woman's expressive face is unusual for Goldsmith since she drew most of her subjects with a fixed, somber gaze. A characteristic of Goldsmith's work is her use of a blue wash to shade and contour faces and hands. The newspaper and book held in the claw-like hands of these sitters are typical props she employed to disguise her struggle to draw realistic hands.

Although her work shows evidence of a maturing style and technique, Goldsmith consistently had difficulty with perspective. In these portraits, she attempted to create an illusion of depth by lowering the subject's right shoulder so that it might recede into the background. However, the device is unconvincing, as the resulting portraits appear somewhat distorted. CME

FACING PAGE
***Attributed to
Deborah Goldsmith***
Probably North Brookfield,
New York, ca. 1832
Watercolor on wove paper
5⅞″ × 5⁄₁₆″
(14.9 cm × 12.9 cm)

***Attributed to
Deborah Goldsmith***
Possibly Madison, New York,
ca. 1832
Watercolor on wove paper
6³⁄₁₆″ × 5″
(15.7 cm × 12.7 cm)
6¹⁄₁₆″ × 5⁄₁₆″
(15.4 cm × 12.9 cm)

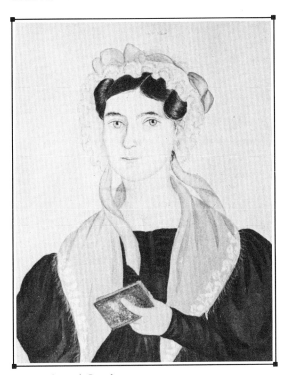
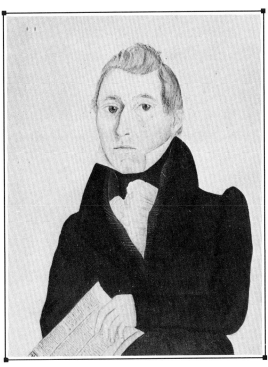

48. *Lady and Gentleman*

Inscriptions/Marks: Printed in watercolor at the top of the gentleman's newspaper is "M[?]". Penciled in script along the top of the frame backing of the lady is "Made/Curtis Cady Madison, NY./1834." Penciled in script on the top of the frame backing of the gentleman is "Cady maker/Curtis Cady/maker/Madison Jan. 10, 1834." Primary support of the lady bears the watermark "s & AB[?]" probably for the Suffield, Conn. firm known as the Eagle Mill which operated from 1816 until 1877. No watermark found on the gentleman's portrait.

Condition: The paper supports are slightly brittle and yellowed around the edges. There are only slight abrasion losses of paint in the dark areas. In 1975, the NYSHA conservator removed surface dirt, matted and backed both pieces with acid-free material.

Provenance: Mr. and Mrs. Howard Lipman, Wilton, Conn.; Mr. Stephen C. Clark Sr., Cooperstown, N.Y.

Exhibited: "Identified American Primitives," Harry Shaw Newman Gallery, New York, N.Y.,

November 15–30, 1950; untitled exhibition, The Century Association, New York, N.Y., January-February 1952; NYSHA, "Rediscovered Painters of Upstate New York, 1700–1875," June 14–September 15, 1958, and exhibition catalog, illus. as no. 41 on p. 45; "The Paper of the State," Museum of American Folk Art, New York, N.Y., April 9–June 2, 1976, and exhibition catalog, checklist no. 148.

Published: Richard I. Barons, *The Folk Tradition: Early Arts and Crafts of the Susquehanna Valley* (Binghamton, N.Y., 1982), p. 40, illus. as fig. 45 and fig. 46 on p. 39; Sandra C. Shaffer, *Deborah Goldsmith, 1808–1836: A Naive Artist in Upstate New York* (East St. Louis, Ill., 1975), checklist no. 59 and no. 60 on p. 38.

❖ William H. Graham ❖

(active 1850)

William H. Graham
Probably New England, ca. 1845
Oil on canvas
25 5/16″ × 20 5/16″
(64.3 cm × 51.6 cm)
24 5/16″ × 20 1/16″
(61.8 cm × 51 cm)

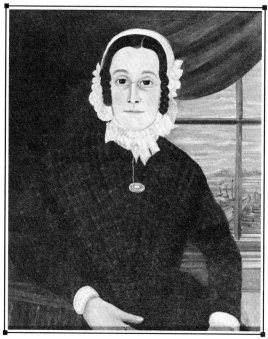

49. *Lady with Bonnet and Glasses*

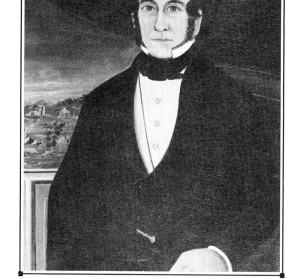

50. *Man in Black*

49. **Lady with Bonnet and Glasses** N-403.61
50. **Man in Black** N-404.61

William H. Graham was born in England about 1815 and appears in federal census records for 1850 as an artist residing in Belfast, Maine. The same census lists his wife Rebecca, who was born in Maine, and their two children. Belfast's *Republican Journal* of January 15, 1850, carried an advertisement for Graham as a "fancy and ornamental painter" living at "no. 8 phenix row." On March 22, 1850, the artist exhibited portraits at the Waldo Agricultural Society fair held that year in Belfast.[1]

Using thinly applied paint, Graham outlined and contoured the subjects' facial features in brown, highlighted the noses in white, and rendered the lips and cheeks with a distinctive salmon-colored paint.[2] The careful positioning of the rather formless hands at the bottom of the canvas with only the lady's thumb and fingernail articulated, betrays

the artist's effort to avoid painting hands. Graham painted these portraits in somber colors, using black for the man's coat and vest, black and brown for the lady's checker-patterned dress and hunter green for the drapery. The lady's brooch, ring and necklace, and the man's watch fob and shirt buttons are all rendered in bright gold paint which helps to individualize the subjects and relieve the dark mood of the portraits. The skillfully rendered scenes through the windows behind the sitters suggest that Graham may have been a more experienced painter of landscapes than portraits. CME

Inscriptions/Marks: Painted in script on the verso of no. 49 is "Painted by Wm. H. Graham." Painted in script on the verso of no. 50 is "Painted by W. H. Graham."

Condition: These two paintings were cleaned, lined and put on new stretchers in 1961 by Caroline and Sheldon Keck. A very few small losses were filled and inpainted. Evidence of fading pigments was found at the edges of no. 49.

Provenance: Mr. and Mrs. William J. Gunn, Newtonville, Mass.; Miss Mary Allis, Fairfield, Conn.; Mr. Stephen C. Clark Sr., Cooperstown, N.Y.

Exhibited: "Primitive Art," Albion College, Albion, Mich., November 24–December 16, 1965, no. 49 only.

[1] Census data is from Jane E. Radcliffe (Maine State Museum) to NYSHA, May 24, 1985; Andrew E. Kuby Jr. (Belfast Museum) to NYSHA, September 23, 1985.

[2] The artists William Matthew Prior and Sturtevant J. Hamblin were painting portraits in Maine during the early nineteenth century. Similarities between Graham's artistic style and that of the Prior-Hamblin group suggest that Graham may have seen examples of their portrait work. For examples of Prior's portrait work, see cat. no. 79 through no. 84 and for examples of Hamblin's portrait work, see cat. no. 52 through no. 56.

❖ Benjamin Greenleaf ❖
(1769–1821)

Born in Hull, Massachusetts, on January 13, 1769, Benjamin Greenleaf was the first child of John and Mary Goold Greenleaf. The artist married Miss Abigail Greenleaf-Rhoades (Rhodes?) on November 20, 1799, in Dorchester, Massachusetts. There is no known record indicating they had children. On January 10, 1821, Benjamin Greenleaf died of apoplexy in Weymouth, Massachusetts, three days before his fifty-second birthday.[1]

Greenleaf probably received the vast majority of his commissions through recommendations since most of his portrait subjects were interrelated through marriage. Further evidence of his popularity are the many portraits of prominent citizens who could have afforded to be discriminating when choosing an artist.

Of the fifty-six paintings by Greenleaf identified to date, approximately one-third present the subject in three-quarter pose with the remainder dominated by bust-length profiles.[2] Among his earliest existing paintings, dating from 1803, are three portraits of the Goolds, members of Greenleaf's mother's family who lived in Hull, Hingham and Weymouth, Massachusetts.[3] These portraits and three others document Greenleaf's only known work in oil on panel or canvas.[4] Probably from contacts made by his family, Greenleaf secured further commissions from residents of these surrounding areas. By 1810, he was also painting portraits in oil on glass, the medium for which he is best known. Inscriptions written by Greenleaf on the backing boards of these glass paintings document his subsequent travels across parts of New England in search of portrait work. By

1813, he was taking business in Hopkinton, Hanover and Concord, New Hampshire, where again he painted his own distant relatives as well as portraits of local residents. From 1816 to 1818, Greenleaf painted his greatest number of portraits, depicting subjects from Bath, Paris, Portland, Bridgton and Phippsburg, Maine. The portrait of Henry Bromfield McCobb dated May 15 or 16, 1818 is his latest known work.[5]

Greenleaf's painting technique reflects an ability to reverse and to translate his subject's appearance to glass and at the same time capture the spirit of the individual's character. With a firm brushstroke, Greenleaf highlighted facial features first, employing line rather than shadow to create depth and volume in faces. Eyes and nostrils are well delineated with prominent, dark brushstrokes; lips are painted thin and tightly pursed with a diagonal line drawn at the corners of the mouth; the negative space of the earlobe forms a heart-like shape; and the chin is filled out round and full. These stylized methods enabled Greenleaf to produce portraits quickly and effectively.

Particularly with his female subjects, Greenleaf was successful at creating individual likenesses by including personal accessories such as hair ornaments, earrings, necklaces and brooches. Other details make his portraits dynamic and serve as effective compositional devices. Locks of hair fall forward framing the face; masses of curls pile high on the head with a sense of decorative rhythm; and ruffles follow along necklines and ladies' bonnets to soften the images. Using thinly applied paint, Greenleaf completed the background with vigorous, short strokes, thus giving pattern and texture to even the solid areas of his portraits. CME

[1] All biographical information on the artist is from Arthur B. and Sybil B. Kern, "Who was Benjamin Greenleaf?," *Antiques World* III (September 1981), pp. 38–47.

[2] See Kern and Kern, "Who was Benjamin Greenleaf?," pp. 45–47, and Arthur B. and Sybil B. Kern, "Benjamin Greenleaf: Nineteenth Century Portrait Painter," *The Clarion* (Spring/Summer 1985), pp. 45–47 for checklists of recorded works.

[3] The portrait of Jacob Goold is privately owned and is illustrated in Kern and Kern, "Who was Benjamin Greenleaf?," p.

39; the portraits of Robert Goold and Mary Lincoln Goold are privately owned and are illustrated in Kern and Kern, "Benjamin Greenleaf," as fig. 2 on p. 40 and fig. 3 on p. 41.

[4] The portrait of *Lady in White Mop Cap* is owned by the National Gallery of Art, Washington, D.C.; the portrait of Dr. Cotton Tufts is owned by the Countway Library of Medicine, Harvard Medical School, Cambridge, Mass.; the portrait of James Wheelock is privately owned.

[5] The portrait is privately owned.

51. *Mrs. Lydia Waterman* N-36.61

While this likeness is one of Greenleaf's more modest portraits, it still conveys a sense of the sitter's personality, which is so characteristic of his work. Greenleaf painted this bust-length profile of seventy-four-year-old Lydia Waterman by using soft brushstrokes and starkly contrasting pigments of black, white, brown and ochre. The horizontal lines of the bonnet's ruffle, the black ribbon wrapped around to hold the bonnet in place, as well as the rhythmically sculpted cap of the bonnet, all lend pattern and movement to this rather somber portrait.

Lydia Lincoln Waterman was born in Hingham, Massachusetts, on March 9, 1736 to Josiah and Susanna Lincoln. She married Thomas Waterman on December 9, 1762. The couple resided on Fort Hills Street in Hingham, where they had five children. Records indicate that Thomas Waterman served briefly in the militia as a private during the Revolutionary War. Lydia Lincoln Waterman died at the age of eighty on August 3, 1812, eight years after the death of her husband.[1] CME

Inscriptions/Marks: Penciled in script on a piece of paper glued to the center of the frame's wood backing is "Painted by Benjn. Greenleaf/February 5, 1810/Mrs. Lydia Warterman [sic] Aged 74."[2]

Condition: A number of blistered and flaking spots were treated by the NYSHA conservator in 1985. A resin-solvent mixture was applied to consolidate the loose paint. No inpainting was done and there are some very small flake losses in the white cap.

Provenance: Horace W. Davis, Pittsfield, Mass.; Mr. and Mrs. Howard Lipman, Wilton, Conn.; Stephen C. Clark Sr., Cooperstown, N.Y.

Exhibited: "Art of the Pioneer," M. Knoedler and Co. Gallery, New York, N.Y., April 11–May 5, 1956, and exhibition catalog, checklist no. 17.

Published: Arthur B. and Sybil B. Kern, "Who was Benjamin Greenleaf?," *Antiques World* III (September 1981), checklist no. 9 on p. 45; Jean Lipman, "Benjamin Greenleaf, New England Limner," *Antiques* LII (September 1947), illus. as fig. 3 on p. 196.

[1] All biographical information on the subject is from Arthur B. Kern to NYSHA, November 5, 1984.

[2] Greenleaf's spelling "Warterman" is a slip of the pen. See Donald Lines Jacobus, *The Waterman Family* (New Haven, Conn., 1939), p. 143.

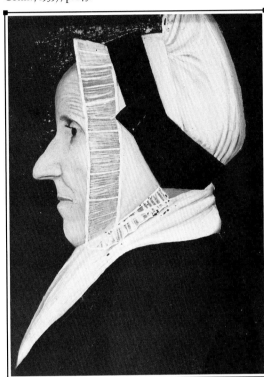

Benjamin Greenleaf
Probably Hingham, Massachusetts, 1810
Oil on glass
13³⁄₁₆″ × 10⅛″
(33.5 cm × 25.7 cm)

51. *Mrs. Lydia Waterman*

❖ Sturtevant J. Hamblin ❖
(active 1837–1856)

Only recently have art historians learned to distinguish portraits painted by Sturtevant J. Hamblin from those painted by William Matthew Prior. Now, the term "Prior-Hamblin School" refers mainly to works by as yet unidentified hands that closely resemble paintings by Prior, Hamblin, William Kennedy and George Hartwell.[1]

Sturtevant J. Hamblin belonged to a Portland, Maine family that had worked as painters and glaziers for several previous generations. Hamblin's grandfather, George Hamblin, apprenticed as a painter and glazier in Barnstable, Massachusetts, and continued to follow that trade after he moved to Gorham, Maine in 1763. Sturtevant's father, Almery Hamblin, worked with his four sons, Joseph G., Nathaniel, Eli and Sturtevant J. in a painting business in Portland. The Hamblin sons' names appear sporadically in the Portland city directories from 1823 until 1841.

Sturtevant's sister, Rosamond, married William Matthew Prior in 1828, and by 1834 the Priors were residing with his brother-in-law, Nathaniel Hamblin, of Green Street in Portland. Soon Prior moved to his own home where, by 1839, Joseph G. and Sturtevant J. also had moved. Three of the Hamblin brothers bought a farm in Scarborough,

Maine, in 1838. But after Eli died there suddenly in 1839, the remaining two Hamblins and the Priors moved to Boston. They lived together during the year 1841 at Nathaniel Hamblin's house at 12 Chambers Street.

Between 1841 and 1856, Sturtevant J. Hamblin worked as a portrait painter while he lived with the Priors on Marion Street and at other East Boston addresses. By 1856, he and his brother Joseph were in the "gent's furnishings" business. He apparently had given up portrait painting and would follow this new occupation for the next ten years.[2]

At first glance, the similarities between the portraits painted by Sturtevant J. Hamblin and those by William Matthew Prior appear so strong as to render them indistinguishable. But upon closer examination, differences appear that allow Hamblin's stylistic traits to emerge. Unlike Prior's quickly rendered faces with their painterly white highlights, Hamblin's faces are painted with more restrained brushwork and highlights that contrast less with the overall fleshtones. Hamblin painted pointed, tapering hands, while Prior's are often heavier and more rounded. Hamblin's portraits often include a wider assortment of props than do Prior's, as well as occasional background landscapes that lend depth to the shallow spaces he created.

Although Hamblin did not promote his work through advertising as effectively as Prior, the attractive likenesses he produced found a ready market that sustained him for approximately fifteen years while he worked in the Boston area. RM

[1] For a discussion of William W. Kennedy and his paintings, see no. 61. George Hartwell also painted in Boston, Mass.

[2] The biographical information in this entry is from Nina Fletcher Little, "William M. Prior, Traveling Artist, And His In-Laws, the Painting Hamblens," *Antiques* LII (January 1948), pp. 44–48, and Beatrix T. Rumford, ed., *American Folk Portraits: Paintings and Drawings from the Abby Aldrich Rockefeller Folk Art Center* (Boston, 1981), pp. 112–117.

52. *Three Children* N-235.61

This solidly triangular composition exhibits many of the characteristics of Hamblin's two-dimensional, inexpensive painting style. The three young sitters gaze directly at the viewer, their wide eyes accentuated by whitish highlighting under the eyebrows. The left child's prominent ears are similar to other known frontal portraits of children by Hamblin. The salmon pink coloration of the faces, and the bold, dark outlining of the sitters' costumes, arms and tapered hands are also found in numerous other portraits by this artist.[1] A stylistic trait shared by both Hamblin and Prior is the manner in which the youngster at the center holds the open book. PD'A

Condition: In 1966, Caroline and Sheldon Keck corrected the improper framing of this painting, which had caused damage. Small edge losses were filled and inpainted and the piece was inserted correctly in the frame.

Provenance: Mr. and Mrs. William J. Gunn, Newtonville, Mass.; Miss Mary Allis, Fairfield, Conn.; Mr. Stephen C. Clark Sr., Cooperstown, N.Y.

Exhibited: NYSHA, "New-Found Folk Art of the Young Republic," 1960, and exhibition catalog, p. 19, no. 27, illus. as fig. 27; untitled exhibition, The Century Association, New York, N.Y., January 2–February 15, 1961; "Childhood Long Ago," The IBM Gallery, New York, N.Y., February 1–March 6, 1965; "Folk Art from Cooperstown," Museum of American Folk Art, New York, N.Y., March 21–June 6, 1966.

[1] For related examples, see the signed portrait of *Woman and Child by a Window* and the attributed likeness, *The Younger Generation,* owned by the National Gallery of Art, Washington, D.C.

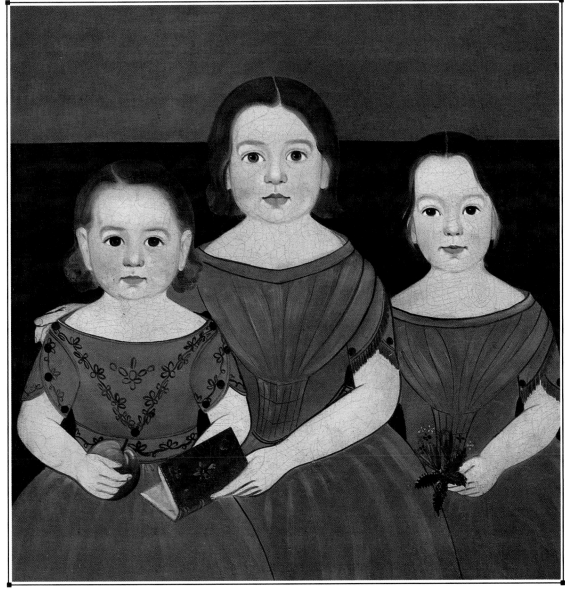

Attributed to
Sturtevant J. Hamblin
Probably Massachusetts,
ca. 1845
Oil on canvas
27⅛″ × 27″
(68.9 cm × 68.6 cm)

52. *Three Children*

53. *Child in Red with Whip* N-388.61

The strong symmetry of this portrait and the pyramidal composition are stylistic devices that appear frequently in Sturtevant J. Hamblin's work.[1] Others include the boldly outlined fingers that taper toward the extended index finger and the vivid primary palette. The child's bright expression and the painting's decorative appeal make it one of Hamblin's most satisfying likenesses. RM

Condition: In 1986, the NYSHA conservator cleaned the painting and lined it with new fabric. Two small areas of inpaint at bottom left and top center were replaced and a new stretcher was provided.

Provenance: Mr. and Mrs. William J. Gunn, Newtonville, Mass.; Miss Mary Allis, Fairfield, Conn.; Mr. Stephen C. Clark Sr., Cooperstown, N.Y.

[1] See *Three Children*, no. 52, for a similar example.

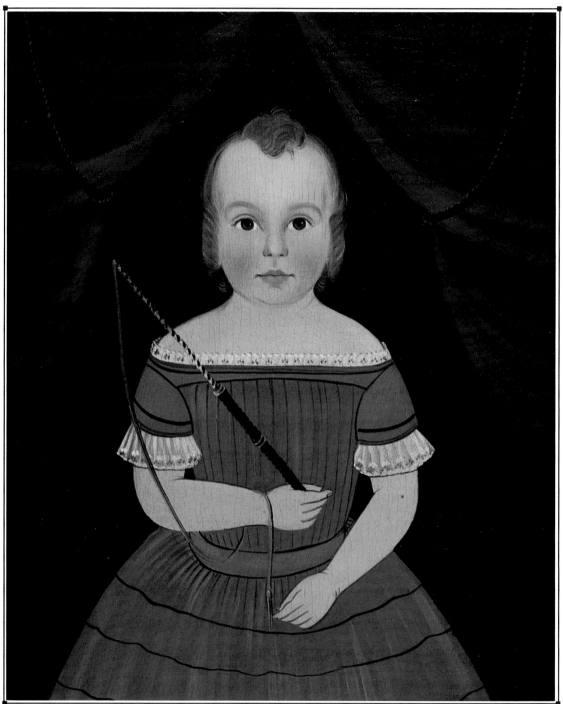

Attributed to
Sturtevant J. Hamblin
Probably Massachusetts,
ca. 1845
Oil on canvas
27″ × 22″
(68.6 cm × 55.9 cm)

53. *Child in Red with Whip*

54. *The Fireman* N-263.61

This colorful, elaborate portrait of a volunteer fireman in civilian clothes is an excellent example of Sturtevant Hamblin's most polished painting style. The sitter's face is modeled in gray under the eyes and around the mouth, and his cheeks and lips are colored in a light salmon pink. A line of light brown paint outlines the flesh tones at the collar,

jawline and nape. Hamblin retained the stiff, tapered hands that characterize his "flat" portraits, yet added contours to this area by shading between the fingers and at the joints. In this instance, the dark, bold lines that Hamblin typically used to outline hands are feathered to suggest three-dimensional form. Light blue veins are visible on the backs of his hands, enhancing their realistic texture. Despite the artist's somewhat accomplished rendering of flesh tones, the sitter's overall appearance is stiff and two-dimensional and the table top visible to the subject's right is tilted vertically. These features underscore the artist's emphasis on linear forms even in his most developed portraits.[1]

This likeness exhibits many colorful details including the fireman's large, wide-brimmed helmet, decorated suspenders, engraved belt buckle and jewelry, as well as the red upholstered chair and green patterned tablecloth. The background scene depicts a volunteer company responding to a fire. This type of pictorial representation of a sitter's occupation, and the swagged drapery and column, were academic conventions assimilated by numerous folk portraitists.

The sitter has not been identified conclusively, although the letters "C.C.H." on his helmet probable represent his initials. The Roman numeral seven on his helmet and the word "Howard" on his belt buckle refer to his volunteer fire company, Howard No. 7, which operated in Boston on Franklin Place from 1848 to 1852. The words "Leading Hose," printed on the helmet's front indicate that the sitter was a Leading Hoseman, a senior line fire fighter whose job it was to carry the hose into the burning building or to supervise those who did.[2] PD'A

Inscriptions/Marks: Painted in print on the front of the sitter's helmet are "LEADING HOSE", "VII", and "C.C.H."; painted in print on the sitter's belt buckle is "HOWARD"; painted on the lighted signal lamp in the background scene is "7."

Condition: Conservation by Caroline and Sheldon Keck in 1959 included removing dirt and yellowed varnish, replacing an old mend at lower left, filling and inpainting minor losses around the edges at lower right, as well as lining and placing on a new stretcher.

Provenance: Mr. and Mrs. William J. Gunn, Newtonville, Mass.; Miss Mary Allis, Fairfield, Conn.; Mr. Stephen C. Clark Sr., Cooperstown, N.Y.

Exhibited: NYSHA, "New-Found Folk Art of the Young Republic," 1960, and exhibition catalog, pp. 18–19, no. 25, illus. as fig. 25; untitled exhibition, The Century Association, New York, N.Y., January 2–February 15, 1961; untitled exhibition, Roberson Center for the Arts and Sciences, Binghamton, N.Y., November 1–December 15, 1961; untitled exhibition, Union College Art Gallery, Schenectady, N.Y., January-March 1962; untitled exhibition, Museum of American Folk Art,

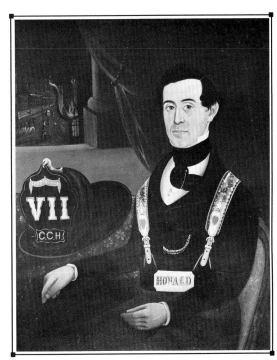

54. *The Fireman*

Attributed to Sturtevant J. Hamblin
Probably Boston, Massachusetts, ca. 1850
Oil on canvas
36″ × 29″
(91.5 cm × 73.7 cm)
FULL COLOR REPRODUCTION AS FRONTISPIECE

New York, N.Y., October 5–November 18, 1962; "The Flowering of American Folk Art, 1776–1876," Whitney Museum of American Art, New York, N.Y., February 1–September 15, 1974.

Published: Jean Lipman and Alice Winchester, *The Flowering of American Folk Art, 1776–1876* (New York, 1974), illus. as fig. 32 on p. 36.

[1] This portrait was attributed to Hamblin in Beatrix T. Rumford, ed., *American Folk Portraits: Paintings and Drawings from the Abby Aldrich Rockefeller Folk Art Center* (Boston, 1981), p. 115, no. 86, footnote 2.

[2] Stephen Heaver Jr. (Fire Museum of Maryland, Inc.) to NYSHA, March 14, 1986.

55. *Child Holding Eyeglasses* N-298.61

This stark portrait of a small, fragile child gently pulling a pair of eyeglasses out of its case includes distinctive attributes of Sturtevant Hamblin's painting style. The youngster's face exhibits the gray shading and white highlights which are common to the artist's work. Perhaps the most crucial features in the attribution of unsigned portraits to Hamblin are the heavy, dark outlines of the arms and hands, and the formation of hands which taper smoothly to the index finger.[1] These characteristics are clearly evident in this likeness. PD'A

Attributed to Sturtevant J. Hamblin
Probably Massachusetts,
ca. 1850
Oil on canvas
27″ × 22″
(68.6 cm × 55.9 cm)

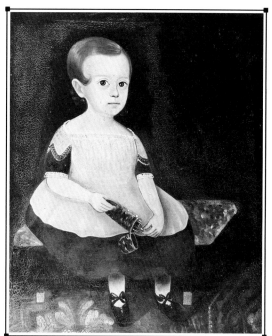

55. *Child Holding Eyeglasses*

Condition: Layers of yellowed varnish and dirt were cleaned off by Caroline and Sheldon Keck in 1959. An old glue lining was found sound and retained. New varnish was applied. No attempt was made to inpaint the extensive traction crackle which was caused by an underlying layer.

Provenance: Mr. and Mrs. William J. Gunn, Newtonville, Mass.; Miss Mary Allis, Fairfield, Conn.; Mr. Stephen C. Clark Sr., Cooperstown, N.Y.

Exhibited: NYSHA, "New-Found Folk Art of the Young Republic," 1960, and exhibition catalog, p. 21, no. 36, illus. as fig. 36; "Child's World," Schenectady Museum, Schenectady, N.Y., January 2–May 9, 1972.

[1] Donald R. Walters to NYSHA, February 1, 1984.

56. *Boy with Book in a Rocking Chair* N-382.61

A number of stylistic traits in this portrait point to Sturtevant J. Hamblin as the probable artist. The young boy's face exhibits large eyes, subtle white highlighting under the eyebrows, and salmon pink facial color. Also, the sketchy, tapered outline of the left hand, and the light, glossy highlights on the book, costume and rocking chair are reminiscent of the artist's fluid painting style.[1] PD'A

Condition: At some time before the picture was acquired, it was lined with fabric and glue and put on a narrow modern stretcher. In 1962, Caroline and Sheldon Keck removed some overpaint and cleaned and varnished the surface. No filling or inpainting was done.

Provenance: Mr. and Mrs. William J. Gunn, Newtonville, Mass.; Miss Mary Allis, Fairfield, Conn.; Mr. Stephen C. Clark Sr., Cooperstown, N.Y.

[1] Donald R. Walters to NYSHA, February 1, 1984.

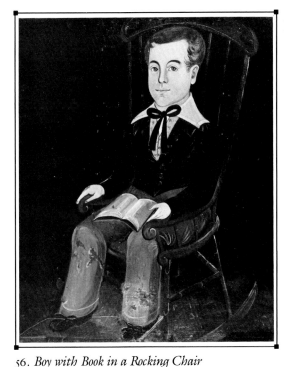

56. *Boy with Book in a Rocking Chair*

**Probably by
Sturtevant J. Hamblin**
Probably Massachusetts,
ca. 1850
Oil on canvas
34″ × 28″
(86.4 cm × 71.1 cm)

❖ Milton William Hopkins ❖
(1789–1844)

In 1982, initial research for an exhibition of the work of folk painter Noah North (1809–1880) revealed that many portraits attributed to North were the work of a previously unknown but closely related artist, Milton William Hopkins. Subsequent research reconstructed Hopkins's life and documented his activities as an ornamental painter, portraitist and art instructor. Hopkins's advertisements indicating that he taught portrait painting, the strong stylistic similarity between his work and that of North and the geographic proximity of the two men suggest a mentor/student relationship.

Milton Hopkins was born on August 1, 1789 in Harwinton, Litchfield County, Connecticut, the son of Hezekiah and Eunice Hubbel Hopkins. In 1802, he relocated with his parents and seven siblings to Pompey Hill, New York, where his father took over the operation of a tavern. Hopkins married Abigail Pollard of Guilford, Connecticut about 1809. She died at an undetermined date prior to 1817, after which the artist married his second wife, Almina Adkins, also of Guilford. Shortly thereafter, he moved with Almina and his eight-year-old son from his first marriage to Le Ray, Jefferson County, New York, joining members of his wife's family.

A visual analysis of Hopkins's work clearly shows that he was familiar with academic portrait traditions, but no solid evidence of formal art instruction has yet come to light. Since he was traveling throughout Connecticut from about 1810 until about 1820, he may have seen the work of Joseph Steward (1753–1822) or Reuben Moulthrop

(1763–1814), among others. Hopkins's portraits relate most directly to those of artist Ammi Phillips (1788–1865) and it has been suggested, though not documented, that Phillips may have influenced Hopkins early in his career. The artist also may have been acquainted with the portraits of Abraham G. D. Tuthill (1776–1843), as many parallels exist in their lives.[1] Tuthill studied in London with Benjamin West (1738–1820) and later executed at least twelve portraits of prominent residents of the Watertown, New York area in the 1820s. During the same period, Hopkins worked in Evans Mills, adjacent to Watertown, and may have seen some of Tuthill's likenesses. In the mid-1820s, Tuthill worked in the canal towns of New York, as far west as Buffalo. Hopkins also worked in the same towns, including Albion, where he had moved in late 1823. In the late 1820s, Tuthill painted in Batavia, twenty miles south of Albion and six miles from Noah North's home in Alexander. A group of five family portraits, recently given by descendants of the sitters to the Genesee Country Museum in Mumford, New York, include two painted by Hopkins and/or North and three painted by Tuthill.

Hopkins and North have been traced through advertisements and land transactions from the New York counties of Genesee and Orleans to Ohio City (Cleveland), Columbus and Cincinnati, Ohio, ca. 1836–1844. It has been traditionally assumed that the reason for their move from upstate New York was to secure additional portrait commissions in the newly settled West. A closer investigation of their personal lives, however, has shown that other social issues contributed to their relocation. Always active in the progressive Presbyterian church, about 1830 Hopkins embraced the temperance, anti-Masonic and abolitionist movements. Many of his sitters in New York and Ohio shared similar concerns. It is interesting to speculate that Hopkins was offered portrait commissions by those active in the movements to subsidize him as a reform spokesman. The artist died of pneumonia while visiting his farm in Williamsburg, Ohio, on April 24, 1844. He was buried at Williamsburg until about 1863, when his children moved his body to Spring Grove Cemetery in Cincinnati.

Using paintings by Hopkins and North as a case study, one can trace the development of a distinct style of non-academic portraiture from its antecedents in the work of Connecticut painters of the late eighteenth century to its interpretation by nineteenth-century artists of the American frontier. Further investigation of the lives and work of painters such as Hopkins and North will help clarify and delineate the role of the folk artist in American life.[2] JO

[1] See David Tatham, *Abraham Tuthill: Portrait Painter of the Young Republic* (Watertown, N.Y., 1983), pp. 5–20.

[2] The biographical information on this artist was researched and written by Jacquelyn Oak, registrar, Museum of Our National Heritage, Lexington, Mass.

57. *Unidentified Man* N-21.71

This likeness, with the extensive documentation linking it to Milton Hopkins, prompted the re-evaluation of the body of work once ascribed to Noah North.[1] Now one of seven known portraits signed by Hopkins, it exhibits many stylistic traits linking Hopkins's work so closely to that of North, his student. The subject is seated on a hitchcock-type stenciled chair with one arm draped over the top rail, a pose frequently employed by

both artists in their portraits of adult male sitters.[2] The inclusion of the chair recalls that both Hopkins and North were active in ornamental painting, and that Hopkins was also a chair maker and gilder. The clearly defined facial features, prominent ear with a D-shaped inner area, highlighted pupils, square, blunt fingernails and the muted brown background are stylistic features in the work of both painters. However, this sitter's well modeled face gives him a more three-dimensional, naturalistic quality than is evident in North's portraits. As research progresses, this characteristic may prove vital in attributing more unsigned portraits to Milton W. Hopkins. PD'A

Milton William Hopkins
Albion, New York, 1833
Oil on canvas
30″ × 25⅞″ (76.2 cm × 65.7 cm)

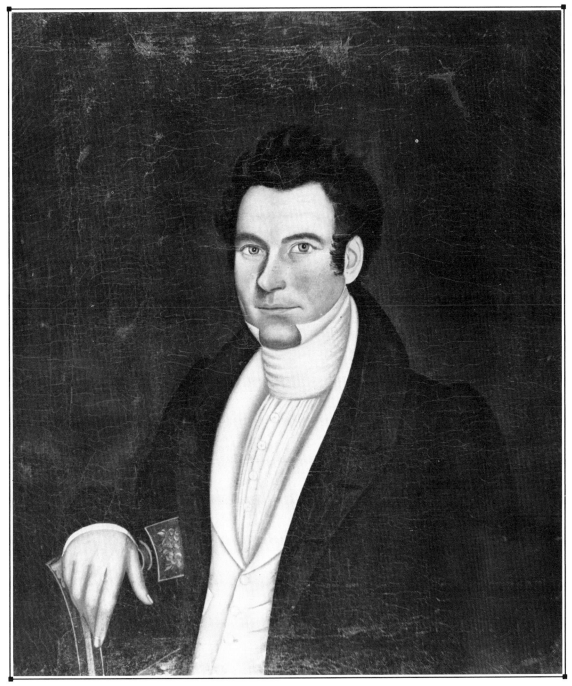

57. *Unidentified Man*

Inscriptions/Marks: Painted in print in block letters on the lower margin of the verso is "Taken March 1833 at Albion"; painted in script on the verso at the lower right is "M.W. Hopkins" followed by an illegible mark; penciled in script on the lower member of the strainer is "M.W.H."; printed on a label formerly attached to the verso, now in NYSHA Special Collections, is "Portrait Painting./M.W. HOPKINS,/LIMNER,/Will pursue his Profession in this place for a short time./Ladies and Gentlemen/are respectfully invited to call at his room and examine specimens of his work./ T. C. Strong's Print, Albion."

Condition: Conservation treatment was done in 1975 at the Cooperstown Graduate Program for the Conservation of Historic and Artistic Works. The canvas was infused with wax-resin adhesive and lined with glass fabric. The surface was cleaned, losses were filled and inpainted, and new varnish was applied. The lined painting was mounted on a new expansion bolt stretcher and the paper label was cleaned and repaired for reattachment to the back of the canvas.

Provenance: Bertram K. and Nina Fletcher Little, Brookline, Mass.

[1] Information for this entry is from Jacquelyn Oak (Museum of Our National Heritage) to NYSHA, August 13, 1986. The lives and artistic careers of Milton Hopkins and Noah North are the subject of continuing research by Ms. Oak.

[2] Closely related to this portrait are: the portrait of Dewitt Clinton Fargo, inscribed on the verso "No. 11 By Noah North/Mr. Dewitt Clinton Fargo/Who died July 7th 1833/AE 12 years," privately owned and illustrated in Nancy C. Muller and Jacquelyn Oak, "Noah North (1809–1880)," *Antiques* CXII (November 1977), as plate 1 on p. 940; and the portrait of Elijah Talcott Miller, by Hopkins or North, owned by the Memorial Art Gallery of the University of Rochester, Rochester, N.Y. See also no. 119, *Gentleman in a Yellow Vest,* by an unidentified artist.

❖ Samuel P. Howes ❖

(1806–1881)

Only recently has Samuel P. Howes emerged from total obscurity to be recognized as a talented and prolific folk painter.[1] Now credited with a body of work numbering over fifty paintings, Howes is acknowledged as an important and long-standing member of his adopted community of Lowell, Massachusetts, where he lived and worked for most of his life.[2]

According to data published in obituaries and a death record, the artist was probably born on June 25, 1806 in Plympton, Plymouth County, Massachusetts. A number of these obituaries mention his involvement in divinity studies before turning to painting as a career.

Howes's name first appears in the Boston city directory for 1829, listed as a "painter" residing at Lewis's Wharf, and appears regularly through 1832. On two occasions, in 1833 and 1834, Howes exhibited portraits at the Boston Athenaeum's Annual Art Exhibition. Given the large number of professional artists working in Boston during the 1830s, it seems likely that Howes was exposed to some level of artistic training during his residence there. His early stylistic development, however, remains undocumented as no paintings from this period have been found. While living in Boston, Howes married Martha Averill on April 3, 1832 and had two sons by her.

By late 1835, Howes was in Lowell, Massachusetts, a booming industrial town which must have seemed an attractive place for the young painter to look for portrait commissions. The first account of his arrival there appeared in an advertisement in the *Journal and Weekly Bulletin* of September 25, 1835, in which Howes stated his intention of "stop-

ping in this town for a few days" to paint full-size likenesses for ten to thirty dollars and miniatures for six to twenty-five dollars. Within a few weeks he had settled into a studio in the Mansur building at the corner of Central and Lowell Streets, where he was to stay for the next ten years. The fact that Howes chose to stay in Lowell suggests that the business climate of the city was living up to his expectations. Howes was married for the second time on November 10, 1844 to Catherine Bennett, an operative who worked in the textile mills. Their marriage record indicates that he was divorced from his first wife.

By the mid-1840s, the daguerreotype was quickly replacing the painted portrait as the preferred means of achieving a likeness. This development undoubtedly prompted Howes to turn his attention to the popular and profitable new trade. He began advertising his services for taking daguerreotype likenesses in late 1845 at his new studio at 112 Merrimack Street, a location that he would occupy for the next forty-five years. In 1847, he began listing his occupation in the Lowell city directory as both "daguerreotypist and portrait painter." Howes advertised his daguerreotype business extensively in local newspapers from 1845 to 1865 and in a more aggressive manner than his portrait painting.

In his later career, Howes increasingly turned to painting historical figures and non-portrait subjects. His most notable rendering of a historical figure is the large-scale *Washington at Dorchester Heights* which was completed by late 1845.[3] However, his most ambitious artistic project was the *Historical Panorama of the American Republic,* completed in early 1852.[4] Howes also painted portraits of a number of national heroes during the 1860s, including Ulysses S. Grant, William T. Sherman and Abraham Lincoln.[5] The known portraits of Lincoln reflect the more naturalistic style that marks Howes's later work, the result of an attempt to imitate the realism of the photographic image. According to an article appearing in the Lowell *Weekly Journal* of May 12, 1865, on several occasions Howes painted portraits directly from photographs, although it was noted he preferred to paint from life. The portrait of Grace Lawrence (ca.1870) is the latest known likeness painted by Howes and illustrates how his painting style was influenced by photography as it is rendered in a more subdued, realistic manner than any of his earlier portraits.[6]

Information regarding Howes's later career comes from several published obituaries, two of which cite his involvement in landscape painting.[7] One obituary states that in later life, Howes had given up photography to return to painting. This notion is supported by the city directories which list him only as a "portrait painter" after 1865. He apparently painted portraits until very late in life, as a notice in the September 3, 1879 issue of the Lowell *Vox Populi* discusses a recently finished example.

Howes died of peritonitis on February 25, 1881. In his obituaries, he was remembered as a well-known resident of Lowell and a fixture in the business community. The Lowell *Morning Mail* of February 26, 1881 summed up Howes's character succinctly by stating "Mr. Howes was a gentleman of more than average intelligence, somewhat eccentric in his habits but of good conduct and conscientious in his dealings with his fellow citizens."

Samuel P. Howes's painting style is remarkably consistent and easily recognizable. His sitters are often portrayed in half-length, seated poses with stiff, upright postures, triangular sloping shoulders, long, attenuated arms with a "rubbery" bend to them and

a draped hand tapering to the index finger or extending to both the index and middle fingers. Facial features are equally distinct, marked by an awkward turn of the nose, with heavy shading on the far side, an upward arch to the lines that describe the eyelids and vertically elongated irises. Other characteristics include a full, cupid's-bow mouth and ears which are delineated with smoothly curving areas of shadow. In his early portraits dating from the middle to the late 1830s, Howes's palette is rather muted. By 1839, he began to add brighter colors to his canvases, especially using red in drapery and uphol-stery details. PD'A

[1] All biographical information for this entry is from the catalog for the exhibition "Samuel P. Howes: Portrait Painter," Whistler House Museum, Lowell, Mass., April 6–May 31, 1986, pp. 1–5.

[2] Two signed 1839 portraits form the basis for attributing this body of work to Howes. They are the portrait, *Man Reading Zion's Herald*, owned by the Heritage Plantation of Sandwich, Inc., Sandwich, Mass., and the portrait, *Child with Cat*, privately owned. They are illustrated *ibid.* on p. 14 and p. 32.

[3] This portrait is owned by the Pollard Memorial Library, Lowell, Mass. Its dimensions are 96″ × 72″.

[4] *The Historical Panorama of the American Republic* was advertised in Lowell newspapers from January through June of 1852. According to the Lowell *Daily Journal* and *Courier,* of May 11, 14, 25 and 28, 1852, Howes completed the work with the help of an artist known only as Mr. Barnes. Exhibited in Wentworth's Hall in Lowell, the panorama depicted the history of America from the landing of Christopher Columbus in 1492 to the Battle of New Orleans in 1812. Howes narrated the show, accompanied by a pianist and a singer who entertained the audience while the scenes were moved.

[5] Two portraits of Lincoln, painted by Howes shortly after the President's assassination in 1865, are presently owned by the City of Lowell. One of these is illustrated in the catalog for the exhibition "Samuel P. Howes: Portrait Painter," on p. 28.

[6] This portrait is owned by the Essex Institute, Salem, Mass. and is illustrated *ibid.* on p. 29. Also in the Institute's collection is a 1925 letter from the sitter identifying Howes as the painter of her portrait.

[7] A recently discovered landscape, signed on the strainer, "S.P. Howes, Lowell," is owned by the Boxford Historical Society, Boxford, Mass.

Attributed to Samuel P. Howes
Probably Lowell, Massachusetts, ca. 1845
Oil on canvas
30″ × 25″
(76.2 cm × 63.5 cm)

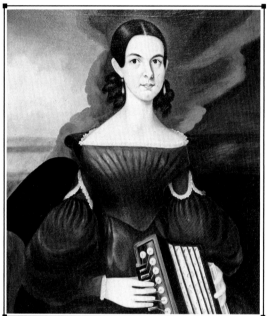

58. *Miss York of Concord, N.H.*

58. *Miss York of Concord, N.H.* N-428.61

This cheerful portrait of a young woman holding a button accordion illustrates many stylistic traits that characterize Howes's work. The sitter's strongly modeled features include the turned nose, cupid's-bow mouth, smoothly painted ear and elliptical irises, that are trademarks of his painting style. Also evident are the triangular sloping shoulders, stylized torso and long, attenuated arms, which often have the greatest decorative impact in Howes's depictions of women. Miss York's right hand appears wooden and less lifelike than is typical for Howes as he attempted to position it as if she were playing the instrument. The Empire sofa appears in many of Howes's portraits and may have been one of his studio props. The red drapery and a window vista in the background are devices often employed by Howes to embellish his portraits.

Identified only by the inscription on the stretcher, Miss York may have been one of the thousands of young women who emigrated to Lowell, Massachusetts from rural communities throughout New England seeking work in the flourishing textile mills. PD'A

Inscriptions/Marks: Penciled in script upside down on the upper member of the original stretcher is "Miss York of Concord, N.H." and "Dr. York of Concord, N.H."

Condition: The painting was lined with new linen, cleaned, and a few small losses of pigment were inpainted by the NYSHA conservator in 1986. It was also revarnished and mounted on a new expansion-bolt stretcher.

Provenance: Mr. and Mrs. William J. Gunn, Newtonville, Mass.; Miss Mary Allis, Fairfield, Conn.; Mr. Stephen C. Clark Sr., Cooperstown, N.Y.

Exhibited: "Samuel P. Howes: Portrait Painter," Whistler House Museum, Lowell, Mass., April 6–May 31, 1986, and exhibition catalog, no. 35, illus. on p. 26.

❖ Samuel Jordan ❖
(1803/4–after 1831)

59. *Woman and Man Holding Bible* N-389.61
60. *Double Portrait* N-390.61

The search for biographical data on the elusive "Samuel Jordan of Boston" has to date uncovered only sparse references to him in an 1831 diary to complement the three known portraits and one memorial executed by him in that same year. Excerpts from the diary include casual references to "Sam Jordan" and "Mr. Jordan, the portrait painter," and one more insightful entry, dated June 12, 1831, which reads "Called in Col. Tucker's – saw Sam Jordan's portraits – don't think they look very natural, or at least most of them."[1] The diary indicates that for at least the first six months of 1831 Jordan was painting in the Plaistow, New Hampshire area, where he stayed for a time at Tucker's Tavern.

The sitters in both of these double portraits remain unidentified, with the Bible in no. 59 remaining the only personalizing element that may provide a clue.[2] The elaborately decorative treatment of the women's bonnets, the pursed lips, the man's stubby fingers in no. 59 and the awkward treatment of his arm all seem to be typical features of Jordan's painting style. The faces show a convincing sense of presence and personality except for the woman in no. 59 whose mis-aligned features appear somewhat substandard for this artist's work. PD'A

Inscriptions/Marks: Painted in print at the left center of no. 59 is "Samuel Jordan/pinxit/1831"; painted in print on the spine of the book held by the gentleman is "Holy Bible"; painted in print at the left center of no. 60 is "S. Jordan pinxit/1831."

Condition: At an unknown date, no. 59 was coated on the verso with shellac and some minor losses were inpainted. In 1962, Caroline and Sheldon Keck cleaned the painting, lined it with new fabric, and placed it on a new stretcher. Some small spots of old inpainting were replaced and some were painted over because of the difficulty of removing them. No. 60 received blows which are evidenced by circular crack patterns and slight paint cupping. There are fifteen small punctures which have been mended with adhesive tape on the reverse. Some of the paint losses around these mends have been inpainted without fills.

Provenance: Mr. and Mrs. William J. Gunn, Newtonville, Mass.; Miss Mary Allis, Fairfield, Conn.; Mr. Stephen C. Clark Sr., Cooperstown, N.Y.

Exhibited: Untitled exhibition, Briarcliff College Museum of Art, Briarcliff Manor, N.Y., October 2–November 1, 1974, no. 59 only.

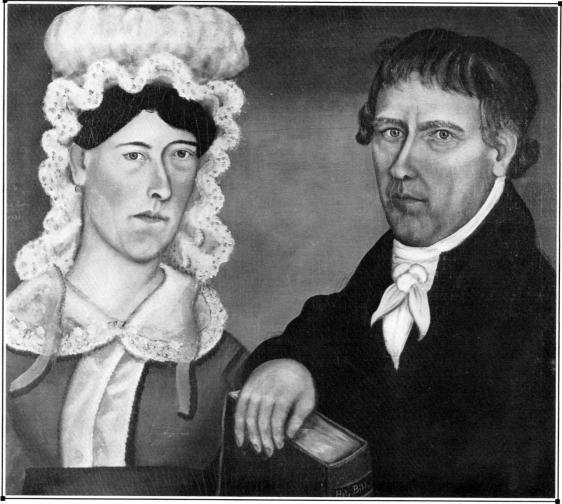

Samuel Jordan
Possibly Plaistow,
New Hampshire, 1831
Oil on canvas
23″ × 28½″
(58.4 cm × 72.4 cm)

59. *Woman and Man Holding Bible*

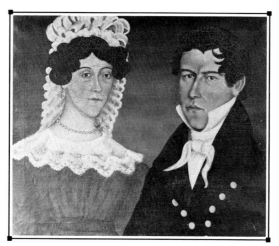

60. *Double Portrait*

[1] Ruth G. Manchester to NYSHA, December 13, 1983. The diary of Isaac Watts Merrill (1803–1878) is owned by the Haverhill Public Library, Haverhill, Mass. The portrait of *Young Man Seated* is inscribed "S. Jordan/pinxit/1831" and is owned by the Abby Aldrich Rockefeller Folk Art Center, Williamsburg, Va.; the *Eaton Family Memorial,* owned by the National Gallery of Art, Washington, D.C., is inscribed on the verso "Painted AD 1831 in Plaistow, N. Hamshire [sic]/by Samuel Jordan-." Below this is an inscription in Greek letters which reads "Samuel Jordan of Boston/painter AD 1831/Aged 27/in God's Name/Adieu." A cloudlike flair encircles these inscriptions, and to the left is a shooting star and a tilted cross, underneath which there is written, also in Greek lettering, "Christ our Trust."

[2] Gregory Laing (Haverhill Public Library) to NYSHA, October 26, 1984. The entry for March 24, 1831 in the Isaac Merrill diary reads: "Mr. Jordan is painting M.F. Peaslee and his wife's portrait. He boards there." Moses Flint Peaslee (1801–1868) was the son of Elder Ruben Peaslee (1777–1846), a Methodist preacher, and it is possible (given the Bible used as a prop in no. 59) that these men and their wives are the subjects of the two NYSHA double portraits.

❖ William W. Kennedy ❖

(1818–after 1870)

William W. Kennedy was born in New Hampshire in 1818.[1] Inscribed portraits indicate that from 1845 through 1847, he worked as a portrait painter in New Bedford, Massachusetts, Ledyard, Connecticut and Berwick, Maine. In late 1849 or early 1850, the artist moved his family from Massachusetts to Maryland, as the 1850 federal census for that state lists him as a portrait painter living with his wife, Julia, and three children, Fred W., Walter and Julia. The 1851 Baltimore city directory cites Kennedy's address as 229 Light Street where the family remained through 1853. From 1856 to 1871, he moved four times within the city, never remaining longer than four years at one address.[2] Since records do not indicate where the artist lived for the years 1861–1863, 1865, 1866 and 1869, life for the Kennedy family in Baltimore may have been a period of instability.

Except for William Matthew Prior and Sturtevant J. Hamblin, Kennedy is probably the best known of the portrait painters referred to as the "Prior-Hamblin School." Although no direct link has been found between Kennedy and this stylistically related group, his work bears strong similarities to both Prior's and Hamblin's paintings. These consistencies include the artist's occasional use of tapering fingers that resemble Hamblin's, a connecting of eyebrows and nose that Hamblin sometimes employed, as well as the generally flat images for which Prior and Hamblin are best known. Since Kennedy worked in Massachusetts at the same time as these artists, and since Prior was working in Baltimore a few doors from the East Monument Street address where Kennedy was located from 1856 to 1859, the opportunity for contact was possible.

Kennedy generally painted seated, half-length views of sitters on canvas or academy board. His props included books, roses, rattles, baskets of flowers and occasional background landscapes. His portraits, especially those of children, generate a dignity and warmth whose appeal is undiminished after one hundred and forty years. RM

[1] The biographical information for this entry is from Beatrix T. Rumford, ed., *American Folk Portraits: Paintings and Drawings from the Abby Aldrich Rockefeller Folk Art Center* (Boston, 1981), pp. 138–139.

[2] From 1856–1859, Kennedy lived at 227 East Monument Street; in 1860 and 1864, 82 West Baltimore Street; 1867–1868, 75 Chew Street; and 1870–1871 at 257 West Fayette Street.

61. *Brother and Sister Sharing a Book* N-247.61

This delightful double portrait exhibits several characteristics that readily distinguish it as the work of William W. Kennedy and not that of William Matthew Prior nor Sturtevant J. Hamblin. Kennedy's drawing of anatomical features is consistant in all his work. His most recognizable stylistic traits, evident in this likeness, include the children's steeply sloping shoulders; their squared noses that are blocky with prominent flat ridges; their fat, curving fingers; and their small, pursed lips which are separated by a dark reddish-brown line. RM

Condition: This painting was treated by Caroline and Sheldon Keck in 1958. The canvas was lined with new fabric and cleaned. Small losses were filled and inpainted and protective varnish was applied. It was placed on a new stretcher.

Provenance: Mr. and Mrs. William J. Gunn, Newtonville, Mass.; Miss Mary Allis, Fairfield, Conn.; Stephen C. Clark Sr., Cooperstown, N.Y.

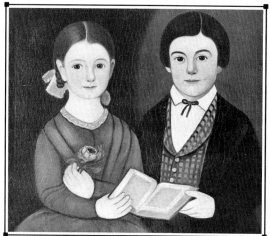

61. *Brother and Sister Sharing a Book*

Attributed to
William W. Kennedy
Probably New England, ca. 1845
Oil on canvas
20″ × 24″
(50.8 cm × 61 cm)

Exhibited: NYSHA, "New-Found Folk Art of the Young Republic," 1960, and exhibition catalog, p. 20, no. 26, illus. as fig. 26; untitled exhibition, The Century Association, New York, N.Y., January 2–February 15, 1961.

❖ Jacob Maentel ❖
(1763–1863)

Born on June 15, 1763 in Kassel, Germany, Jacob Maentel immigrated to America and married Catherine Weaver of Baltimore, Maryland. An individual of varying talents and occupations, Maentel is believed to have worked as a physician, a secretary, a farmer and served as a soldier under Napolean and in the War of 1812. It is as an artist, however, that he has received his greatest recognition and acclaim today, since over 200 watercolor portraits have been attributed to him. These likenesses depict his friends, family and acquaintances who lived in Lancaster, York, Dauphin, Berks and Lebanon counties, Pennsylvania and Posey County, Indiana.[1]

Interestingly, Maentel was already forty-four years old when, in 1807, he drew his earliest attributed portrait depicting Mary Koss. Many of the artist's early likenesses follow a simple compositional format. Subjects are drawn in full-length profile with their arms pinned closely to their bodies as they stand on grassy knolls. However, Maentel was soon drawing much more elaborate portraits as he began integrating the subjects with complex background scenes. For instance, in about 1812 he drew the likeness of military officer General Schumacker who stands dressed in full uniform reading a battle-field map while regiments of soldiers meet for combat in the distance.[2] The dynamic composition, dramatic color choices and the individualized facial features are characteristic of this more developed portrait style.

By 1822, the Maentels were living in Harrisburg, Pennsylvania where they had a daughter Louisa and later a son William. The family remained in the area for many years, having two more children who were born in nearby Schaefferstown in 1826 and 1828. By 1828, Maentel had altered his portrait formula, as he began depicting subjects in full, frontal view. One of only four signed portraits, the likeness of Johannes Zartmann, dates from this year and provides the link between the artist's early profile work and these later Pennsylvania portraits.[3] Maentel continued to depict subjects standing outside with

foreshortened landscape scenes or domestic views behind them. However, he also began drawing individuals in ornately decorated interior scenes filled with busily patterned floor coverings, wallpaper and painted furniture.

In about 1838, the Maentels started westward to make a new home in Texas, but their journey abruptly ended in New Harmony, Indiana when a family member became ill. The family probably decided to settle in the area because of their acquaintance with many residents from Pennsylvania. Although Maentel probably stayed close to home, he may have traveled sometimes in search of portrait work. The 1841 portrait of Jonathan Jaquess of neighboring Poseyville is in fact the only signed Indiana likeness recorded.[4] The portrait of Elizabeth Preston with her niece and nephew, Elizabeth Ann and Frank Crum, puts the artist across the state line in nearby Palmyra, Wabash County, Illinois.[5] Two landscape firescreens also have been recorded from Indiana, one a seascape and the other a farm scene.[6] Painted in oil, these canvases include such elements as house structures, horses, and sailing ships, which are reminiscent of background details in Maentel's portrait compositions. The 1850 federal census for Indiana lists a Jacob Maentel as a ninety-five year old painter living with his daughter Louisa, son-in-law, Thomas Mumford, and their three children. The artist died on April 28, 1863, only two months before his 100th birthday. CME

[1] Biographical information on the artist is from Valerie Redler, "Jacob Maentel: Portraits of a Proud Past," *The Clarion* (Fall 1983), pp. 44–55; and Josephine Elliott to NYSHA, February 1985.

[2] The portrait is owned by the National Gallery of Art, Washington, D.C.

[3] The portrait is owned by the Philadelphia Museum of Art, Philadelphia, Pa.

[4] The portrait is owned by the Abby Aldrich Rockefeller Folk Art Center, Williamsburg, Va.

[5] The portrait is privately owned and is illustrated in Betty I. Madden, *Art, Crafts, and Architecture in Early Illinois* (Urbana, Ill., 1974), p. 84.

[6] The firescreens are owned by The New Harmony Workingmen's Institute, New Harmony, Ind.

62. *Pennsylvania Gentleman* N-81.61 (1)
63. *Pennsylvania Lady* N-81.61 (2)

Rendered in full-length profile, these two likenesses are typical of Maentel's early Pennsylvania portrait style. Women wear Empire-cut gowns, have tiny feet, and often hold a flower or purse in their hand. Men wear dark suits with tails, stand rigidly with their legs slightly bent at the knees, and sometimes hold a top hat in their hand. Likewise, the artist carefully delineated subjects' facial features with heavy eyebrows over thickly fringed eyelashes, darkened lower eyelids, emphasized nostrils and pronounced chin lines. CME

Inscriptions/Marks: No watermarks found.

Condition: The paper supports are cockled, with some uneven yellowing, due to old backing adhesive near the edges. The Gentleman's portrait has a 2½″ tear at the bottom left. The portrait of his wife has a small hole and 3″ tear at top right near the edge. Both were placed in acid-free mats and backings by the NYSHA conservator in 1976.

Provenance: Mr. and Mrs. Howard Lipman, Wilton, Conn.; Mr. Stephen C. Clark Sr., Cooperstown, N.Y.

Exhibited: Untitled exhibition, The Century Association, New York, N.Y. January-February 1952; "American Primitive Art," The Museum of Fine Arts, Houston, Tex., January 1956, and exhibition catalog, checklist no. 21; "Portfolio of Ameri-

Attributed to
Jacob Maentel
Probably Pennsylvania,
ca. 1815–1820
Watercolor
with glazed finish on smooth
laid paper
11″ × 4½″
(28 cm × 11.4 cm)
11″ × 4⅞″
(28 cm × 12.4 cm)

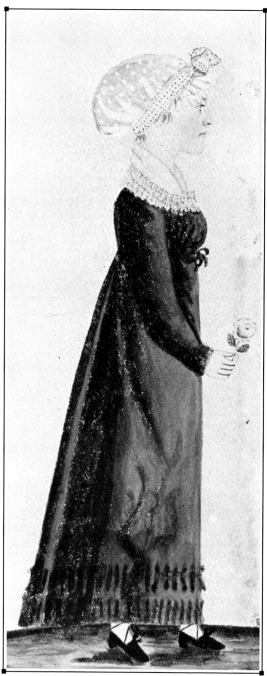

63. *Pennsylvania Lady*

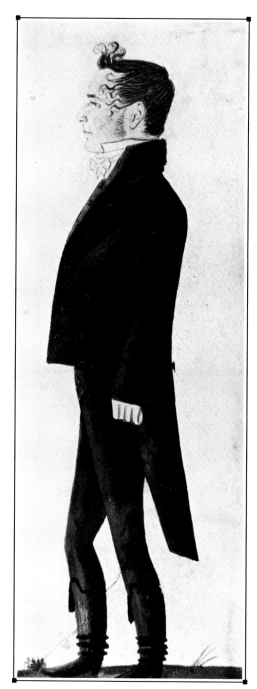

62. *Pennsylvania Gentleman*

can Primitive Watercolors," the Abby Aldrich
Rockefeller Folk Art Collection, Williamsburg,
Va., October-December 1963.

64. **Boy with Bird** N-82.61

Inscriptions/Marks: Penciled in script on the
verso is "C[?]ssolyvann". No watermark found.

Condition: No record of previous conservation.
The paper is slightly cockled along the left edge,

and is slightly yellow. An acid-free backing has been placed in the frame.

Provenance: Mr. and Mrs. Howard Lipman, Wilton, Conn.; Mr. Stephen C. Clark Sr., Cooperstown, N.Y.

Exhibited: "From the Cradle," The New-York Historical Society, New York, N.Y., November 1948; untitled exhibition, The Century Association, New York, N.Y., January-February 1952; "American Primitive Art," The Museum of Fine Arts, Houston, Tex., January 1956, and exhibition catalog, checklist no. 26; "Art of the Pioneer," M. Knoedler and Co. Gallery, New York, N.Y., April 11–May 5, 1956, and exhibition catalog, checklist no. 33; "Portfolio of American Primitive Watercolors," the Abby Aldrich Rockefeller Folk Art Collection, Williamsburg, Va., October-December 1963; "Turning in the Wind: Jacob Maentel A Folk Art Whodunit," Museum of American Folk Art, New York, N.Y., May 5–August 30, 1965.

Published: Mary C. Black, "A Folk Art Whodunit," *Art in America* 53 (June 1965), p. 103; Louis C. Jones and Marshall B. Davidson, "American Folk Art," *The Metropolitan Museum of Art Miniatures* (New York, 1953), illus. as fig. 9.

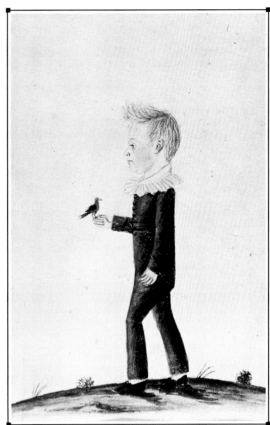

Attributed to Jacob Maentel
Probably Pennsylvania, ca. 1815–1820
Watercolor on wove paper
10½" × 8¼"
(26.7 cm × 21 cm)

64. *Boy with Bird*

❖ Samuel Miller ❖

(ca. 1807–1853)

This elusive artist was initially identified by an inscription on the verso of the portrait of Emily Moulton, owned by the Currier Gallery of Art, Manchester, New Hampshire, reading "Painted in 1852 by Mr. Miller who lived on the south corner of Pearl and Bartlett Streets, Charlestown, Mass., USA." According to a recently discovered death certificate, Miller was born in Boston to Robert and Ann Miller. He died of heart disease in Boston on October 18, 1853 at the age of forty-six. The Charlestown city directory for 1852 lists Samuel Miller as a portrait painter living at 70 Bartlett Street, and two years later lists his widow, Mrs. Samuel Miller, living at 68 Bartlett Street.[1]

A least sixteen other portraits with stylistic similarities to the portrait of Emily Moulton have been ascribed to Samuel Miller. Most are full-length portraits of children, although three are half-length and three-quarter length portraits of adults. These works are marked by stiff, flatly delineated figures, bold colors, carefully painted costume details, the frequent inclusion of family pets and thin, stylized trees and flowers. Faces have large, almond-shaped eyes with individually painted eyelashes, full cheeks and prominent ears with a D-shaped inner area. The flesh tones betray a bluish underpaint which Miller probably used to prime his canvas. PD'A

[1] Biographical information is from an unpublished paper, in NYSHA research files, by Laura Roberts, State University of New York College at Oneonta, 1977, pp. 1–2 and a telephone conversation with Pat Drummond, January 22, 1987. This artist is the subject of continuing research by Ms. Drummond. The recorded portraits are: *Emily Moulton; Child with a Rocking Horse,* owned by the National Gallery of Art, Washington, D.C.; *Young Girl with Flowers* and *Boy with Book and Dog,* owned by the Fine Arts Museums of San Francisco, Calif.; *Boy with Whip and Dog,* privately owned and illustrated in Sotheby Parke Bernet, Inc., *Americana: American*

Paintings and Prints, catalog for sale no. 4479M, lot no. 31., November 21, 1980; *Anna in Blue* and *Ophelia in Red,* privately owned and illustrated in *Antiques and The Arts Weekly* (Newtown, Conn.), July 24, 1981, p. 58; portraits of a man and a woman, unlocated and illustrated in the catalog for Christie's sale no. 5734, lot no. 137, October 13, 1984; *Girl with Basket of Flowers and Cat,* unlocated and illustrated in *Antiques* LVI (October 1949), p. 238; *Lady with Flowers,* privately owned and illustrated in *The Clarion* (Winter 1983–84), p. 22; *Julie Ruggles,* privately owned.

65. *Picking Flowers* N-255.61
66. *Walking the Puppy* N-256.61
67. *Girl in a Green Dress* N-385.61

FACING PAGE
65. *Picking Flowers*
Attributed to Samuel Miller
Probably New England, ca. 1845
Oil on canvas
44½" × 27½"
(113 cm × 69.9 cm)

By altering the positions of the subjects' stiff arms to accommodate different props or activities, Miller produced only slight variations on the flat, frontal pose he preferred in his full-length portraits of children. In *Picking Flowers* and *Walking the Puppy,* faces are rendered in a stylized manner characteristic of the artist's work, as eyes are large, eyelashes individually painted and cheeks full. The former likeness exhibits the prominent ears with the shaded, D-shaped inner area common in Miller's portraits. However, the facial modeling in *Girl in a Green Dress* suggests the artist's ability to render faces more proficiently, perhaps as a result of time and experience. The minimally modeled forearms and the misshapen closed hands with similar D-shaped shaded areas, hallmarks of Miller's artistic style, are identical in each of the three likenesses.

All three pictures include the active, playful pets that enliven many of Miller's works. *Picking Flowers* and *Walking the Puppy* exhibit the artist's characteristically colorful, detailed background scenes, including the distinctively stylized foliage, nearly identical finches, vaguely suggested hills, a body of water and a stylized one and one-half story structure. Miller's interiors are rendered with solid areas of color defining the walls and floor, and typically include a drapery swag, tassel and a window revealing a brightly colored landscape vista. A variety of props and accessories further embellishes the likenesses, including the basket of flowers, cup, spoon and coral necklaces. The meticulously rendered lacework and embroidery of the costumes adds greatly to their visual appeal. PD'A

Condition: Treatment on no. 65 by Caroline and Sheldon Keck in 1958 included the repairing of a puncture in the cat's paw, flattening the cupped paint film and removing dirt, spots of house and frame paint and fly specks. The canvas was infused, lined and put on a new stretcher. Losses were filled and inpainted. In 1958, Caroline and Sheldon Keck cleaned and lined no. 66, inpainted losses and placed it on a new stretcher. An old glue lining was removed from no. 67 by Caroline and Sheldon Keck in 1962. The depth of the seam in the original canvas support was reduced and a new fabric lining attached. Old losses were filled and inpainted after a complete cleaning and the paint-

ing was placed on a new stretcher. In 1976, the NYSHA conservator set down small areas of loose paint at bottom left and across the dress just below the hand.

Provenance: Mr. and Mrs. William J. Gunn, Newtonville, Mass.; Miss Mary Allis, Fairfield, Conn.; Mr. Stephen C. Clark Sr., Cooperstown, N.Y.

Exhibited: NYSHA, "New-Found Folk Art of the Young Republic," 1960, and exhibition catalog, no. 66 and 65 only, p. 20, no. 32 and no. 33, illus. as fig. 32 and fig. 33; untitled exhibition, The Century Association, New York, N.Y., January 2–February

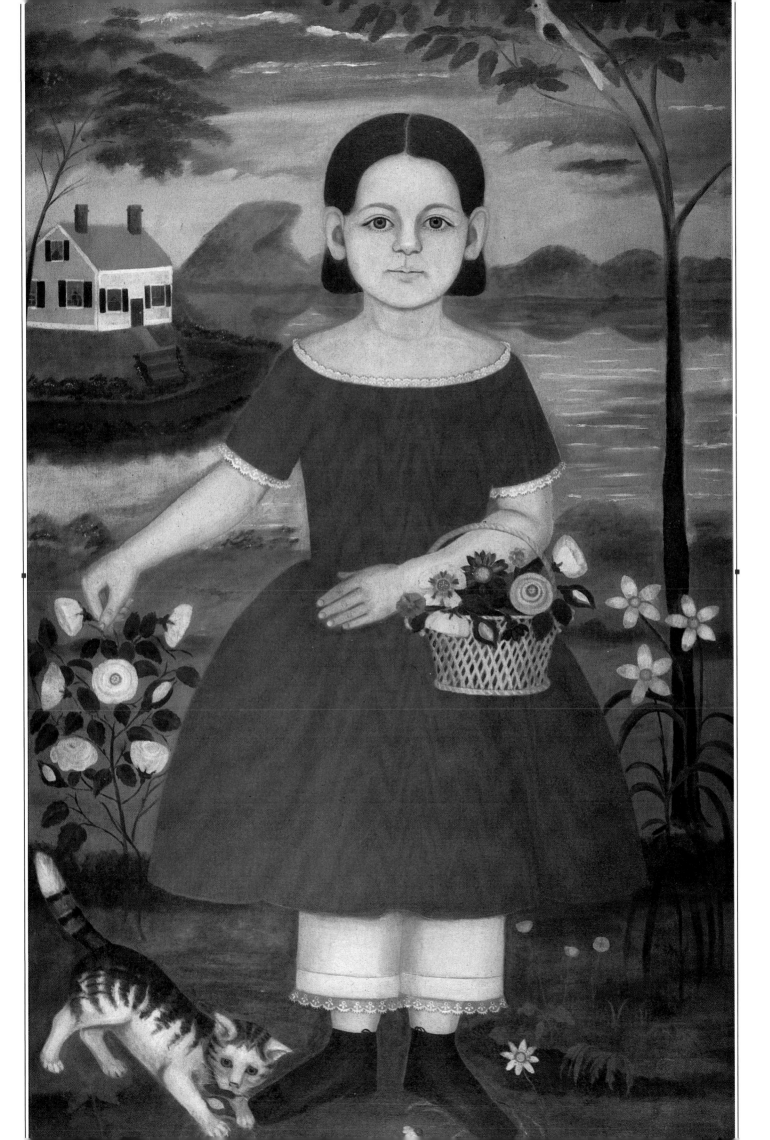

15, 1961, no. 65 only; untitled exhibition, Rober-
son Center for the Arts and Sciences, Bing-

hamton, N.Y., November 1–December 15, 1961, no.
65 only; untitled exhibition, Union College Art

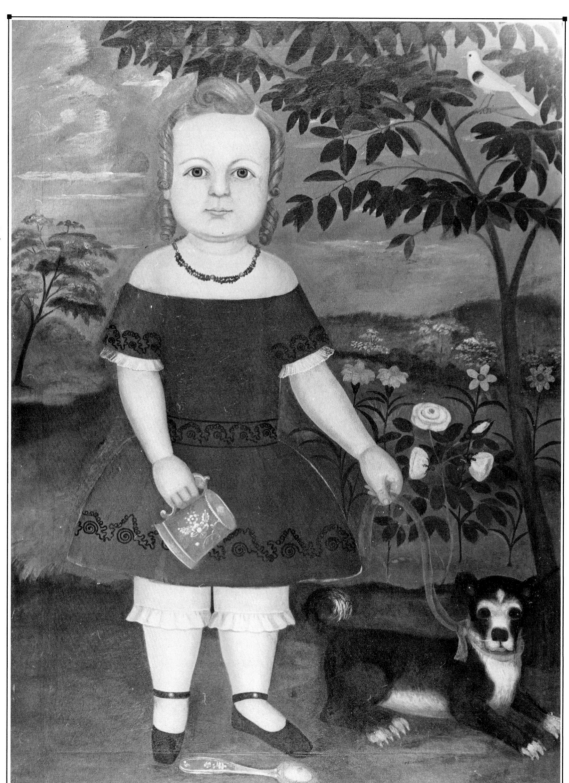

Attributed to
Samuel Miller
Probably New England, ca. 1845
Oil on canvas
36¼" × 26¾"
(92.1 cm × 68 cm)

66. *Walking the Puppy*

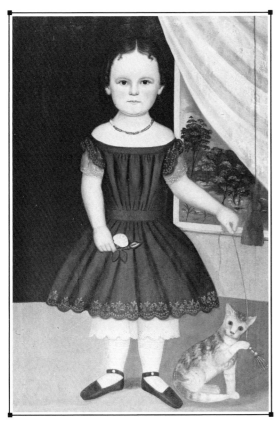

67. *Girl in a Green Dress*

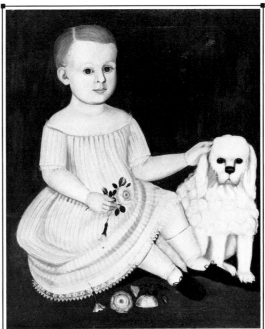

FAR LEFT
***Attributed to
Samuel Miller***
Probably New England, ca. 1845
Oil on canvas
40⅞″ × 27⅛″
(103.8 cm × 68.9 cm)

LEFT
***Attributed to
Samuel Miller***
Probably New England, ca. 1845
Oil on canvas
28¾″ × 23¾″
(73 cm × 60.4 cm)

68. *Child with Dog and Roses*

Museum, Schenectady, N.Y., January-March 1962, no. 65 only; "Childhood Long Ago," The IBM Gallery, New York, N.Y., February 1–March 6, 1965, no. 65 only; "Cat in American Folk Art," Museum

of American Folk Art, New York, N.Y., December 22, 1975–March 15, 1976, no. 65 only.

Published: Mary Black and Jean Lipman, *American Folk Painting* (New York, 1966), no. 65 only, illus. as fig. 116 on p. 131; Bruce Johnson, *American Cat-alogue* (New York, 1976), no. 65 only, illus. as fig. 23; Anita Schorsch, *Images of Childhood: An Illustrated Social History* (New York, 1979), no. 65 only, illus. as Plate XII on p. 106.

68. *Child with Dog and Roses* N-384.61

This portrait is attributed to Samuel Miller on the basis of stylistic similarities to his other known works. The child is placed in a dark interior setting defined only by the maroon colored wall and green painted floor. Miller's likenesses usually include much more decorative embellishment. The harsh, solid areas of color are softened, however, by the flowers in the child's hand and at its feet, by the carefully painted lace edges of the striped dress, and the rhythmically patterned curls of the dog's hair. As in many of Miller's portraits, a bluish underpaint is visible in the flesh tones of the sitter. PD'A

Condition: Conservation treatment in 1962 by Caroline and Sheldon Keck included removing an old glue lining, consolidating the paint and relining with new fabric. Old fills, repairs and darkened inpainting were replaced with new materials.

Provenance: Mr. and Mrs. William J. Gunn, Newtonville, Mass.; Miss Mary Allis, Fairfield, Conn.; Mr. Stephen C. Clark Sr., Cooperstown, N.Y.

Exhibited: "Early American Folk Art," Rensselaer County Historical Society, Troy, N.Y., October 31–November 28, 1967; "Child's World," Schenectady Museum, Schenectady, N.Y., January 2–May 9, 1972; "The All-American Dog–Man's Best Friend in Folk Art," Museum of American Folk Art, New York, N.Y., November 16, 1977–April 2, 1978.

Published: *The All-American Dog–Man's Best Friend in Folk Art* (New York, 1977), illus. on p. 31.

69. *Georgey* N-429.61

FACING PAGE
69. *Georgey*
Attributed to Samuel Miller
Probably New England, ca. 1845
Oil on canvas
44⅛" × 31⅞"
(112.1 cm × 81 cm)

Miller portrayed this young subject in a well-developed interior with not only the artist's standard red drapery, and window view, but also a decorative, patterned floor and fluted moulding. Georgey sits in a rocking chair with his legs crossed stiffly, holding an open book revealing an illustration of a bird. The boy's large almond-shaped eyes, full cheeks and prominent ear relate closely to Miller's signed portrait of Emily Moulton. Among the decorative touches embellishing this portrait are the sparkling buttons on the boy's suit, created by the application of a single dab of white paint from which thin white lines radiate. Visible in the colorful landscape are a cow, a calf and a curious tramp-like figure who walks with a cane and carries a white sack slung over his shoulder. The ornate book cover bears the name "Georgey" from which the portrait's present title is derived. PD'A

Inscriptions/Marks: Printed in paint on the book cover is "Georgey/[illegible word]."

Condition: At an unknown date, this canvas was lined with fabric and glue to repair several rips and excessive repaint was added. In 1962, Caroline and Sheldon Keck removed the old lining, reduced the thickness of an original seam in the canvas and relined with new fabric. A new stretcher was added and losses were filled and inpainted.

Provenance: Mr. and Mrs. William J. Gunn, Newtonville, Mass.; Miss Mary Allis, Fairfield, Conn.; Mr. Stephen C. Clark Sr., Cooperstown, N.Y.

❖ Sheldon Peck ❖
(1797–1868)

In 1913, William R. Plum, a long-time resident of Lombard, Illinois, wrote, "Our early settlers were largely Eastern people. . . . Among them were Sheldon Peck, a Methodist from Vermont and an artist by profession, as well as a sign painter and much interested in the temperance cause. He also wrote a great deal of poetry, some of which, at least, was of merit."[1] Although none of his poetry has been found, the portraits painted by Sheldon Peck provide clues to his life and travels as a folk portrait painter.

Only recently have the facts surrounding Peck's life and career emerged from obscurity. To date, about sixty portraits have been attributed to him documenting an artistic career that began in Vermont about 1820, continued after he moved to New York state in 1828 and matured in Illinois between 1837 and his death in 1868.

Sheldon Peck was born in Cornwall, Vermont, on August 26, 1797, the ninth of eleven children of Elizabeth Gibbs Peck and Jacob Peck, a farmer and blacksmith.[2] Nothing is known of Peck's youth and no records have been found to suggest he ever received formal art instruction. Like many other folk portraitists, he may have observed an itiner-

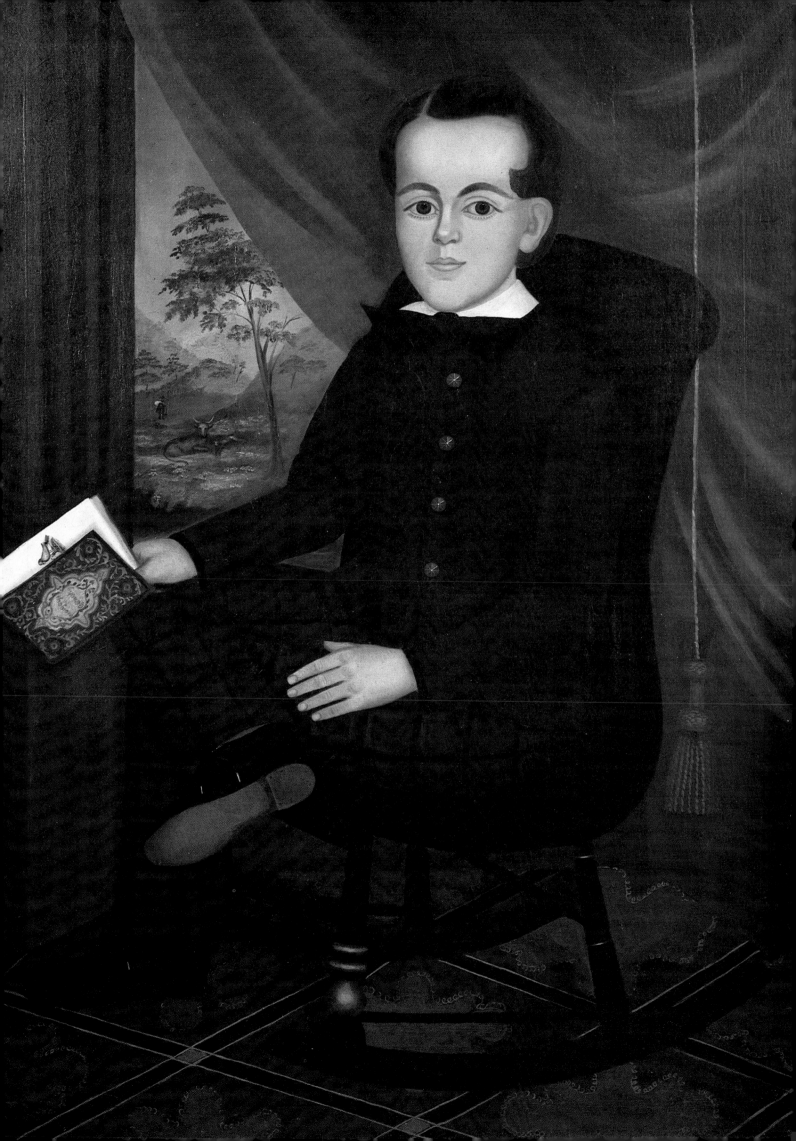

ant painter at work or he may have been self-taught. Since none of the portraits found thus far are signed, attributions to Sheldon Peck are based upon several early Vermont portraits depicting the artist's brother Alanson Peck and his wife, Mary Parker Peck, and a double-portrait of the artist's parents, Jacob and Elizabeth Gibbs Peck.[3] These contain stylistic elements that Peck would retain and elaborate upon throughout his painting career: stiff, formal poses; dour expressions; crisp, sensitively drawn faces; detailed presentation of costume, furniture and personalizing accessories. In fact, the skill with which Peck painted the decorated chairs in his portraits suggests that, from the beginning of his career, he probably supplemented his income from portrait work with ornamental painting.

Peck married Harriet Corey of Bridport, Vermont, on September 15, 1824. The couple remained in Vermont until 1828 when they moved to Jordan, Onondaga County, New York. Jordan was a prosperous village situated along the Erie Canal. Jordan's close proximity to the canal and the many travelers who passed through the village provided opportunities that were surely not overlooked by a portrait painter in search of commissions.

Peck's New York portraits reflect his growing proficiency as an artist and his increased awareness of the conventional poses and props used by countless other portraitists. The decorative quality of his work increased as he added background landscapes, books, flowers, tables, bowls of fruit and architectural columns to his repertoire of props. However, his painting technique changed little from his Vermont period; he painted the portraits on wood panels with thin paint and smooth, controlled brushwork.

By 1835, Peck had prospered enough from his farming and portrait business to purchase fifty acres of land near Jordan for $1500. But in August 1836, he sold this property and left New York for Illinois. An announcement placed by Hezekiah Gunn, the Jordan village physician, in the *Onondaga Standard* may put Peck's abrupt departure into context:

> *Be it known to all people, that one Sheldon Peck and Harriet his wife, not having the fear of God before their eyes, being instigated by the devil, have with malice aforethought most wickedly hired, flattered, bribed or persuaded my wife Emeline, to leave me without just cause or provocation. It is supposed that said Peck has carried her to some part of the state of Illinois. This is therefore to forbid all persons harboring or trusting my wife Emeline, for I will pay no debts of her contracting.*[4]

Since Emeline Gunn's name does not appear in any Illinois census entries for the Peck household, she either stayed with the family for only a short time or did not accompany them as far as Illinois.

Peck arrived in Chicago early in 1837. Within months of his arrival, a financial panic resulted in a severe economic depression. Since a portrait was a luxury that probably few could afford, Peck moved again, this time twenty miles west of Chicago to the part of the village of Babcock's Grove that is now known as Lombard. There he resumed farming and portrait painting among neighbors that included several families who had come to Illinois a few years earlier from Onondaga County, New York. Peck may already have known these people and this may partially explain his motivation for moving west.[5]

In Illinois during the 1840s, Peck's portraits underwent a radical stylistic transformation. He probably effected these changes in order to remain competitive with photography which was beginning to affect his portrait trade. While Peck continued to paint half-length, single portraits, about 1845 he began to paint full-length figures seated or standing in stage-like sets that resemble those used by early photographers. Painted on canvas instead of wood panels, these paintings often include multiple figures. Peck's mastery of ornamental detail is apparent in the tromp l'oeil grain-painted frames he painted on many of these canvases.[6]

Illinois census data and Chicago business directories reveal how Peck's occupational emphasis changed during the thirty years he lived in the state. The 1840 census cites Peck as "employed in agriculture." By 1850, he apparently turned over the operation of his farm to an elder son since that year's census lists him as a "portrait painter." A Chicago business directory of 1854–1855 lists him as an ornamental painter with a studio at 71 Lake Street.[7] Peck apparently stopped portrait painting and moved, for a time, back to Chicago where he probably painted signs and decorated furniture. The 1860 census, the last in which Peck's name appears, lists him as "artist."

Sheldon Peck died of pneumonia in Babcock's Grove on March 19, 1868, leaving ten children and an estate valued at $9000. He and his wife, Harriet, are buried in Lombard Cemetery where a stone obelisk marks their grave. RM

[1] Newton Bateman, ed., *Historical Encyclopedia of Illinois and History of Du Page County* (Chicago, 1913), p. 718.

[2] All biographical information is from Marianne Balazs, "Sheldon Peck," *Antiques* CVIII (August 1975), pp. 273–284, and Richard Miller, "Six Illinois Portraits Attributed to Sheldon Peck," *Antiques* CXXVI (September 1984), pp. 614–617.

[3] The portraits are privately owned and illustrated in Balazs, "Sheldon Peck," as fig. 2 on p. 273, and as plates I and II on p. 274.

[4] *Onondaga Standard*, November 9, 1836.

[5] These included the Babcock, Dodge and Churchill Families. See Miller, "Six Illinois Portraits," p. 614.

[6] For an example, see *David Crane and Catherine Stolp Crane*, illustrated in Balazs, "Sheldon Peck," p. 279.

[7] Hall's *Chicago Business Directory* (Chicago, 1855), p. 217.

70. ***Andrews Preston*** N-65.85

71. ***Elizabeth Ann Ferris Preston*** N-64.85

Andrews and Elizabeth Ann Ferris Preston's steady gazes, unyielding expressions and confident poses project independent, strong-willed personalities that typify Sheldon Peck's most successful portraits. It is difficult for modern viewers to understand why his sitters found these intense images appealing, but their decorative qualities and Peck's ability to capture an acceptable likeness must have provided great satisfaction for his middle-class, upstate New York clientele.

The contrast between the artistic quality of the sitters' faces and of their clothing suggests that Peck drew the faces from life and added costumes and backgrounds later.[1] This kept the sitting time to a minimum. The Prestons are modeled with crisply defined areas of highlight and shadow that give a planar, faceted quality to their faces. This differs sharply from the loose, almost expressionistic, handling of Elizabeth Ann's dress where Peck convincingly captured the play of light on dark green, velvet-like material. The light blue background of Andrews's portrait is similarly painted. Peck employed a wide brush

PAGES 120–121
Attributed to Sheldon Peck
Probably Cato, New York, ca. 1830
Oil on wood panel
28⅛" × 25¹¹⁄₁₆"
(71.3 cm × 65.3 cm)
27¹⁵⁄₁₆" × 25⁵⁄₁₆"
(71 cm × 64.3 cm)

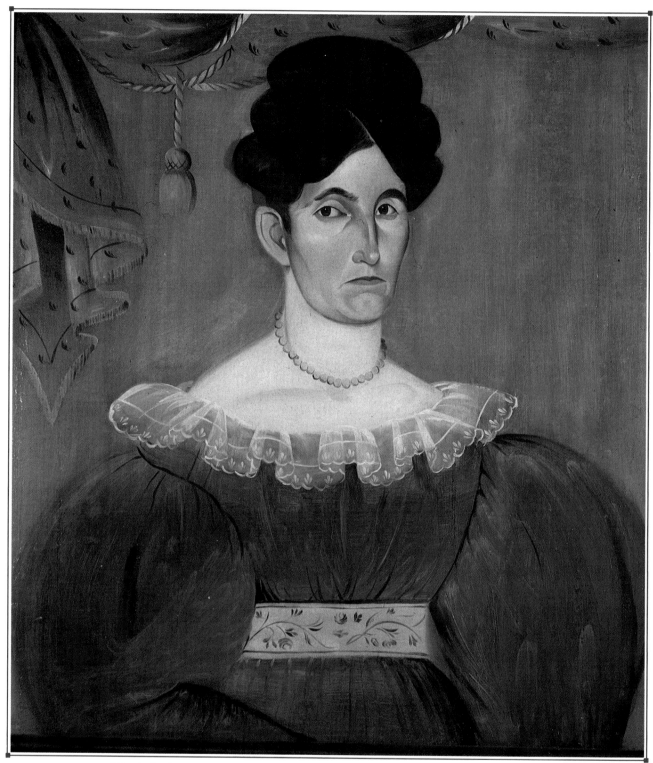

71. *Elizabeth Ann Ferris Preston*

in a vertical motion and applied paint so thinly that the wood support shows through as do the places where he stopped to reverse direction.

sitter's personality, though it is unsophisticated in its lack of modeled form or shaded contour. In 1815, Peckham and his brother, Samuel H. Peckham, advertised their services for "House, Sign and Ornamental Painting. ALSO Gilding, Glazing and Varnishing," in the May 17 issue of the *Hampshire Gazette*, published in Northampton, Massachusetts.[3] In about 1817, the artist painted one of his most extraordinary and complex portraits depicting sixteen members of the Peckham-Sawyer family of Bolton.[4] His ambitious handling of the interior setting, filled with furnishings of the period, and the overlapping, multiple figures dressed in elaborate clothes of the day, reveals a maturing competence which continued to develop throughout his painting career.

The 1830s and 1840s appear to have been Peckham's most prolific period as an artist. Painting primarily in Worcester County, Peckham's work included portraits of his sister-in-law's family, the Adamses, and the family of his brother, Reverend Samuel H. Peckham.[5] While visiting his brother in Haverhill, Peckham executed a portrait of local resident John Greenleaf Whittier.[6] Years later, Whittier commented in a letter about the occasion and remarked on Peckham's artistic ability. "I only recall sitting for him two or three times, but how it looked I have no idea. If it was a good picture it was a miracle, for the Deacon was eminently artless." However, this portrait of Whittier proved to be a strong, compelling likeness, attesting to the artist's proficient hand, as it evinces in paint the personality and drama of the sitter's appearance. Likewise, Peckham's portraits of children, such as the posthumous likeness of Mary L. Edgell painted about 1830, or the likeness of the Raymond Children painted about 1838, illustrate the artist's characterization of children as doll-like figures, crisply outlined in compositions using bold, bright colors and strong decorative patterns.[7] Two genre scenes in oil on board have been recorded which are inscribed "R. Peckham."[8] One depicts a family experiencing the evils of drink, the other scene presents a happy sober family going to church. Quite the devout individual, it is not surprising that Deacon Peckham should use his artistic abilities to communicate messages of religion and temperance.

After his wife's death on February 7, 1842, Peckham soon took a second wife, Mahalath Griggs of Brimfield, announcing their intention to marry on April 1, 1843.[9] In response to controversy resulting from his stand on slavery, Peckham resigned his church position in 1842, and was officially excommunicated in 1850. Peckham moved his family to Worcester but returned to Westminster in 1862, to be reinstated in the church when Congress passed the Emancipation Proclamation. He died on June 29, 1877 at the age of ninety-two. CME

[1] Except where noted, all biographical information on the artist is from Ann Howard, "Notes on Deacon Robert Peckham," unpublished paper, 1978, NYSHA research files. For further discussion of the artist's work, see Dale T. Johnson, "Deacon Robert Peckham: Delineator of the 'Human Face Divine,'" *The American Art Journal* XI (January 1979), pp. 27–36.

[2] Georgia Brady Bumgardner, "The Early Career of Ethan Allen Greenwood," *Itinerancy in New England and New York,* The Dublin Seminar for New England Folklife–Annual Proceedings for 1984 (Boston University, 1986), p. 221; the portrait of James Humphreys Jr. is privately owned and is illustrated in the catalog for the exhibiton, "Where Liberty

Dwells: 19th-Century Art by the American People, Works of Art from the Collection of Mr. and Mrs. Peter Tillou," Albright-Knox Art Gallery, Buffalo, N.Y., January 17–February 22, 1976, as fig. 20.

[3] Catherine Fennelly to NYSHA, September 14, 1960.

[4] The portrait is owned by the Museum of Fine Arts, Boston, Mass.

[5] Both portraits of John and Oliver Ellis Adams are privately owned and are illustrated in the catalog for the exhibition, "Where Liberty Dwells," as fig. 28 and fig. 29; the portrait of the children of Oliver Adams is privately owned and is illustrated in Johnson, "Deacon Robert Peckham," as fig. 1 on p.

28; the portraits of Samuel H. Peckham, his wife Sarah C. Peckham, and that of their children Horace L., John S. and Sarah E. Peckham are privately owned and are illustrated in "18th and 19th Century Naive Art," *The Kennedy Quarterly* XVI (January 1978), as fig. 48 on p. 51, fig. 49 on p. 52 and fig. 50 on p. 53.

[6] The portrait is owned by the John Greenleaf Whittier Home, Amesbury, Mass.

[7] The portrait of Mary L. Edgell is owned by the Whitney Museum of American Art, New York, N.Y.; the portrait of the Raymond Children is owned by the Metropolitan Museum of Art, New York, N.Y.

[8] Both scenes are owned by the Worcester Historical Museum, Worcester, Mass.

[9] Vital records, Westminster, Mass.

Attributed to Deacon Robert Peckham
Probably Massachusetts,
ca. 1836
Oil on cardboard
32½" × 26⅛"
(82.6 cm × 66.4 cm)

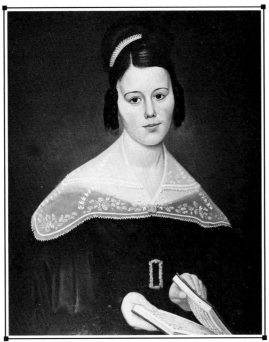

73. *Mrs. William Cowee with Music*

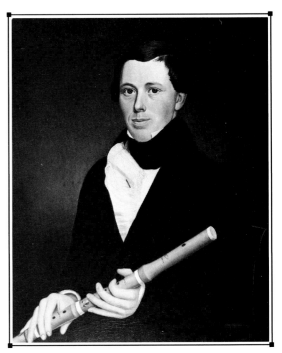

72. *William Cowee with Flute*

72. ***William Cowee with Flute*** N-300.61

73. ***Mrs. William Cowee with Music*** N-301.61

The skill with which Peckham rendered these portraits supports the evidence that he had some academic training. With the exception of the subject's flesh tones, their brown hair, the woman's dark brown eyes and the tawny background, these two portraits are painted almost exclusively in black and white. The contrasting effect proves successful as the woman's carefully decorated white collar and the man's white shirt ruffle draw the viewer's eye to their faces and away from their somber black clothing. Peckham characteristically modeled the facial features to convey three-dimensional form and highlighted the pupils with a single dab of white paint placed slightly off center in the top right of each iris. An unusual feature of Mrs. Cowee's portrait is the artist's pronounced delineation of her skull, conveyed by shaded contour at her temples. Curiously, with this exception, he seems to have reserved this technique for his portraits of children. Peckham adeptly foreshortened Mrs. Cowee's left hand as she holds open a music book, and convincingly painted Mr. Cowee's hands so that he wraps his fingers dexterously around his flute.

When acquired, these portraits were thought to be likenesses of Mr. and Mrs. Wil-

liam Cornee. This identification was based upon somewhat illegible inscriptions appearing on pieces of paper once attached to the backing boards of these portraits, but no longer extant. Research indicates, however, the subjects are more likely to be Mr. and Mrs. William Cowee, as a son named William was born on February 12, 1805 to James and Susanna Cowee of Gardner, Massachusetts, a town located near Westminster.[1] William's cousin Susan Cowee Doty, her husband, Timothy Doty, and their child were also painted by Peckham about the time these portraits were rendered.[2] The prevalence of the Cowee name throughout this area of Massachusetts, the absence of a William Cornee in local records, and the similarities in spelling between Cowee and Cornee all seem to substantiate this theory. CME

Inscriptions/Marks: Inscribed on a piece of paper once attached to the backing board of no. 72 is "Wm. Cowee"(?) and inscribed on a second piece of paper also once attached to this backing board is "Painted by Deacon Peckham of Westminster 1836." Inscribed on a piece of paper once attached to the backing board of no. 73 is "Painted by Deacon Peckham of Westminster 1836." These three pieces of paper are unlocated.

Condition: Conservation treatment by Caroline and Sheldon Keck in 1958 included flattening the warped supports, repairing a break in Mr. Cowee's portrait at lower right, cleaning, minor inpainting, and varnishing. Both were put on solid supports held in place with lip-over molding. In 1984 NYSHA's conservator removed surface dirt from both paintings and revarnished Mrs. Cowee.

Provenance: Mr. and Mrs. William J. Gunn, Newtonville, Mass.; Miss Mary Allis, Fairfield, Conn.; Mr. Stephen C. Clark Sr., Cooperstown, N.Y.

Exhibited: NYSHA, "New-Found Folk Art of the Young Republic," 1960, and exhibition catalog, pp. 32–33, no. 74 and no. 75, and illus. as fig. 74 and fig. 75; untitled exhibition, The Century Association, New York, N.Y., January 2–February 15, 1961; "Music in the American Home," Daughters of the American Revolution Museum, Washington, D.C., October 1, 1984–January 31, 1985.

Published: Dale T. Johnson, "Deacon Robert Peckham: Delineator of the 'Human Face Divine,' " *The American Art Journal* XI (January 1979), no. 73 only, illus. as fig. 7 on p. 36; Laurence Libin, *American Musical Instruments in the Metropolitan Museum of Art* (New York, 1985), no. 72 only, illus. as fig. 49 on p. 69; A. Bruce MacLeish, "Paintings in the New York State Historical Association," *Antiques* CXXVI (September 1984), illus. as fig. 3 and fig. 4 on p. 594.

[1] This theory was proposed and documented in Howard, "Notes on Deacon Robert Peckham" (NYSHA research files), p. 15. Biographical information on the subject is from Irene Mattila (Forbush Memorial Library) to NYSHA, July 3, 1986.

[2] The portrait of the Doty Family is owned by the Forbush Memorial Library, Westminster, Mass.

❖ Ammi Phillips ❖
(1788–1865)

Few American folk artists have received greater recognition and acclaim than Ammi Phillips, painter of over five hundred known likenesses that span a period of nearly sixty years. Born on April 24, 1788 in Colebrook, Connecticut, the artist was the youngest son of Milla and Samuel Phillips Jr. At about age twenty-three, he began painting portraits of subjects who lived in Stockbridge and Sheffield, Massachusetts. Rendered in half-length, three-quarter pose, the signed portrait of tavern owner Gideon Smith of Stockbridge is one of his earliest paintings and is dated 1811.[1] Smith's awkwardly flat head, the dark lines of paint on his face, which indicate advanced years, and the somber canvas background

are some stylistic features of Phillips's earliest known work. On March 18, 1813, the artist married Laura Brockway of Schodack, New York. The couple lived for a time in Troy, New York, but soon resettled in Rhinebeck, in Dutchess County.[2]

Referred to as Phillips Border Period, the portraits dating from about 1812 through 1819 are named for the artist's itinerant path up and down the New York, Massachusetts, and Connecticut state lines. Gaining introductions from one household to the next, Phillips painted portraits of several area families including the Dorrs, Leavenses and the Slades. Painted in three-quarter length, the portraits of Cyrus and Mary Eddy Spicer are typical of this period.[3] A master of contrast with color, Phillips rendered the sitters' clothing in black so that their figures would appear crisply outlined against the large rectangular pale gold backgrounds. Their pinkish, pearly gray flesh tones, tightly pursed lips, side-long looking eyes, gangly, wooden-like arms and large hands are also Border Period characteristics.

The 1820s proved a transitional period for the artist, as he was experimenting with painting techniques to create likenesses that as a group have been termed his Realistic work. Phillips began executing sitters' portraits so that their bodies filled the composition in bust or three-quarter length poses. He also used light and dark tonal effects more consistently now, as he painted facial features in colors that starkly contrasted with the new dark gray velvet-like backgrounds. Throughout this period, traveling far from Rhinebeck in search of commissions, Phillips executed portraits of residents in Dutchess, Orange and Columbia counties, New York.

In February 1830, Phillips's wife died in Rhinebeck, leaving him to care for five children. He was soon married again—on July 15, 1830 to Jane Ann Caulkins of Northeast, New York. After 1831, the family moved to the Amenia, New York area where Phillips found portrait commissions in the neighboring towns of Clermont, Rhinebeck, Germantown, Northeast and Pine Plains. The artist no longer ventured very far for work, but remained close to home, traveling within this rural society. In 1836, Phillips moved his family across the state border to Kent and Sharon, Connecticut where his productivity increased significantly as he painted portraits of entire families including the Ten Broecks and the De Witts. The Kent Period is the name ascribed to this style of portraits dating from 1829 to 1838. During these years, as Phillips neared fifty, he no longer approached work with the same vigor and inventiveness he had employed as a youthful, enterprising portrait artist eager to distinguish himself in his trade. He relied instead upon formula methods and stock gestures, using shortcuts to achieve quick, effective likenesses. As in the portrait of Catherine M. Ten Broeck De Witt, Phillips painted female subjects in forward-leaning poses. The likeness of her husband William Henry De Witt is also typical of Phillips's Kent Period portraits of men as he rendered the subject seated on a stenciled chair with one arm draped over the back and seemingly detached from the body.[4] The artist tried to gloss over many of these anatomical problems by painting subjects in dark clothing and using a flat, dark background.

In about 1838, Phillips returned to Amenia, but continued to travel in search of commissions to towns including Fishkill, New York in 1843 and soon thereafter to Colebrook, Connecticut. His portraits of the period from about 1840 to 1862 express

different aesthetic values than his previous work, as the exacting images made by the recently invented camera progressively seem to have influenced his painting style. Like the portrait of Edwin Harmon Tangdon, dated 1862, these likenesses are accurate, linear interpretations of the sitters' appearance.[5] Characterized by bold forms and vivid colors, the compositions express a vitality that is remarkably consistent throughout most of the artist's later years. After ten years in Northeast, Dutchess County, New York, the artist moved to Curtisville, New York in 1860 where he died on July 11, 1865. CME

[1] The portrait is privately owned and is illustrated in the catalog for the exhibition "Ammi Phillips: Portrait Painter 1788–1865," Museum of American Folk Art, New York, N.Y., October 14–December 1, 1968 as cat. no. 1 on p. 21.

[2] All information on the artist is from *ibid.*, pp. 9–18. For further discussion, see Barbara and Larry Holdridge, "Ammi Phillips, limner extraordinary," *Antiques* LXXX (December 1961), pp. 558–562.

[3] The portraits are privately owned and are illustrated in Sotheby Parke Bernet, *Americana: American Paintings and Prints,* sale no. 4479M, November 21, 1980, lot #41.

[4] The portraits are privately owned and are illustrated in Sotheby Parke Bernet, *Important Americana,* sale no. 5429, January 1968, lot #431.

[5] The portrait is privately owned and is illustrated in the catalog for the exhibition, "Nineteenth-Century Folk Painting: Our Spirited National Heritage, Works of Art from the Collection of Mr. and Mrs. Peter Tillou," The William Benton Museum, University of Connecticut, Storrs, Conn., April 23–June 3, 1973, as fig. 139.

74. *Mother and Child in Gray Dresses* N-267.61

The artistic flavor of Phillips's Realistic Period is no better represented than in this portrait of a mother and child. He cleverly expressed his appreciation for juxtapositions of light and dark color by painting the sitters in white-gray dresses that contrast sharply with the dark gray background. A single light source from the left of the canvas casts the sitters into partial shadow. The left side of the woman's face, her neckline and the far side of her sleeves as well as the baby's left side are all painted in darker tones of color, which lend depth and volume to the composition. The artist conveyed his delight with fabrics as he painted the woman's dress with rays of light falling on her sleeves and drenched her fichu in more light making the material appear shimmering and transparent. Other characteristic features include the three-quarter length pose that seems to fill the canvas, the subjects' tubular arms, and the distinctive red paint used to outline their fingers and define their knuckles. Of particular note, the woman's awkwardly positioned and elongated arms, which encircle the child, betray Phillips's as yet undeveloped painting technique. CME

PAGE 128
74. *Mother and Child in Gray Dresses*
Attributed to Ammi Phillips
Probably New York state, ca. 1825
Oil on canvas
33⅞" × 27⅞"
(86 cm × 70.8 cm)

Condition: The painting was lined before 1958 with canvas and glue, but a bulge developed below the child's ear resulting in some separation. In 1959, Caroline and Sheldon Keck repaired the separating lining, cleaned the entire front surface and filled and inpainted minor losses.

Provenance: Mr. and Mrs. William J. Gunn, Newtonville, Mass.; Miss Mary Allis, Fairfield, Conn.; Mr. Stephen C. Clark Sr., Cooperstown, N.Y.

Exhibited: NYSHA, "New-Found Folk Art of the Young Republic," 1960, and exhibition catalog, no.

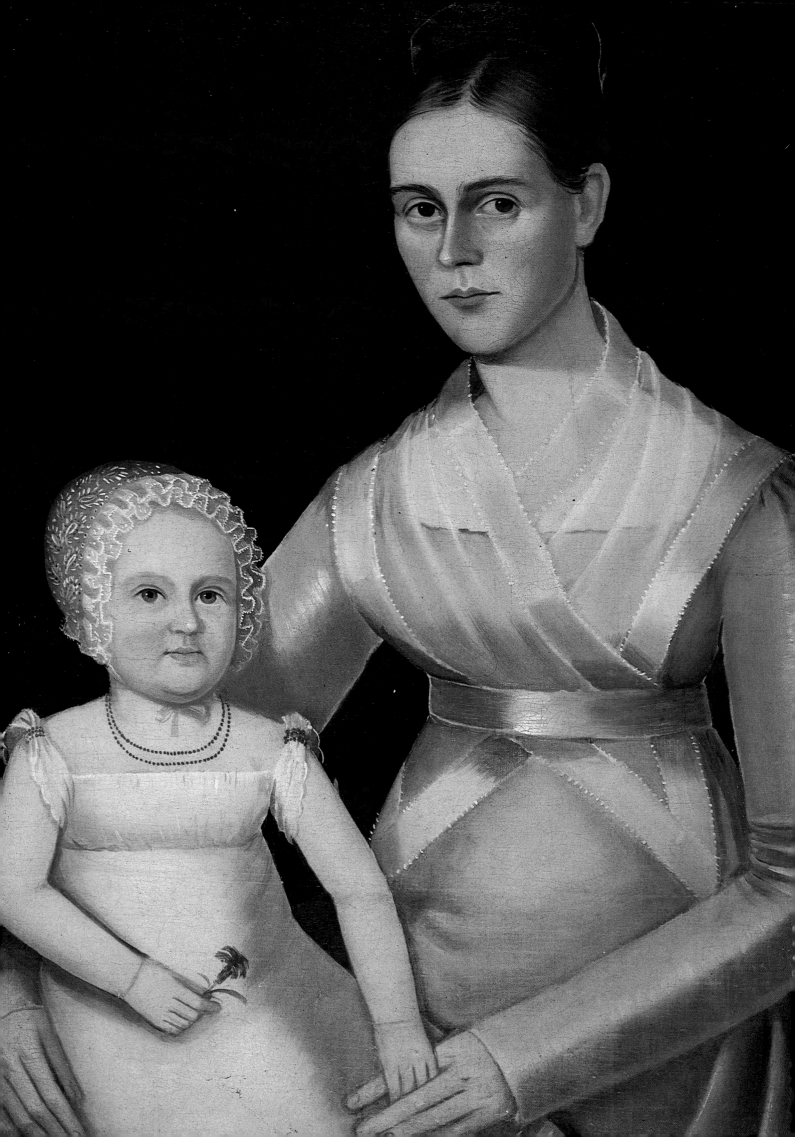

II on pp. 14–15 and illus. as fig. II; "Non-Academic Paintings of Rensselaer County, A Bicentennial Exhibition," the Rensselaer County Historical Society, Troy, N.Y., May 12–June 20, 1975, and exhibition catalog, illus. as no. 16.

Published: Louis C. Jones, "Three Eyes on the Past: Fifty Years of Folklife," *Museum News* 65 (December 1986), illus. on p. 24; A. Bruce MacLeish, "Paintings in the New York State Historical Association," *Antiques* CXXVI (September 1984), illus. as plate I on p. 590.

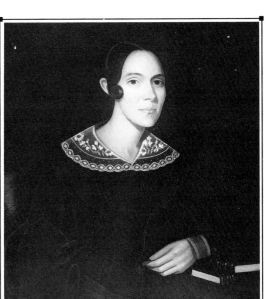

Attributed to Ammi Phillips
Probably Fishkill, New York, ca. 1845
Oil on canvas
33 ⅝″ × 28″
(85.4 cm × 71.1 cm)

76. *Elizabeth Phillips Storm*

75. *John Curry Storm*

75. *John Curry Storm* N-23.82
76. *Elizabeth Phillips Storm* N-1.83

Strong, dynamic likenesses, the Storm portraits evince an angular appearance as lines and forms cross one another in planar compositions of color and pattern. Mrs. Storm's long, oval-shaped face is counterbalanced by the three individualized sections of her hair; the triangular formation of her neck is reinforced by the scallop-edged lace collar; and the brown books at her side are scattered in pleasing disarray. From the fine gray lines of paint outlining the subjects' clothing against the dark brown background to the red paint around their fingers and the blue on the back of their hands to denote veins, Phillips relied upon simple lines of color for definition of complex forms.

The son of John and Jane Hilleka Storm, John Curry Storm was born on November 5, 1807 and baptized at the Dutch Reformed Church in Hopewell, Dutchess County, New York. He married Elizabeth Phillips who was born in 1806 to Elias and Maria Wilde Phillips of East Fishkill. The family lived for a time in East Fishkill where Mr. Storm worked as a farmer. He died on June 19, 1850 and is buried in the Evergreen Cemetery in Owego, Tioga County.[1] CME

Condition: Both paintings were on their original strainers, and no previous treatment appears to have been undertaken. In 1982–1983, the NYSHA conservator cleaned and varnished both paintings, lined them with new linen attached with a heat-seal adhesive, and put them on new stretchers. A

2″ tear at Mr. Storm's left was mended and in-painted.

Provenance: Mr. and Mrs. Clayton E. Weber, Brookdale, N.Y. (Mrs. Weber is a descendant of the sitters).

[1] Mrs. Jean D. Worden, *First Reformed Church, Hopewell, Dutchess County, New York* (Franklin, Ohio, 1981), p. 197; Mrs. E. Everett Thorpe, "Evergreen Cemetery, Owego Twp.," *Tree Talks* II (June 1971), 114 Tioga 36; *Commemorative Biographical Record of Dutchess County, New York* (Chicago, 1897), p. 690; J. Wilson Poucher, M.D. and Helen Wilkinson Reynolds, eds., *Old Gravestones of Dutchess County, New York*, 2 vols., (Poughkeepsie, N.Y., 1924), vol. 2, p. 58. Elizabeth Phillips worked a sampler in 1827 which is owned by NYSHA.

❖ Asahel Powers ❖
(1813–1843)

Well over seventy likenesses have now been ascribed to Asahel Powers, an artist whose bold, energetic painting style is greatly admired by modern viewers. Born on February 28, 1813, Powers was the eldest of seven children of Asahel Powers Jr. and Sophia Lynde Powers of Springfield, Vermont.[1] His earliest known portrait, probably depicting Dr. Joel Green, and dated February 28, 1831, indicates that the artist was painting in a highly original style as early as his eighteenth birthday.[2] By 1835, he seems to have entered into a business partnership, as several portraits dating from that time are inscribed "Powers & Rice." The inscriptions may refer to the bookseller, writer and publisher Daniel Rice, also of Springfield. Rice's role in this joint venture has not been determined; however, the partnership is believed to have lasted only one or two years.[3]

Powers traveled westward to New York state in 1839, where he worked in Clinton and Franklin counties painting portraits of fellow Vermont citizens who had also migrated. Clinton County records note the existence of a wife, Elizabeth M. Powers, who for an undetermined reason does not appear to have followed Asahel to Olney, Richland County, Illinois where he moved with his parents in 1841. Powers died in Illinois on August 20, 1843. No portraits depicting Illinois subjects have been documented to indicate that Powers pursued portraiture after leaving New York.

For most of his career, Powers painted in a style marked by loose, swirling lines, bold, black outlines, gray shading, multiple perspective and painstaking attention to detail. He painted in oil on wood panel until the mid-1830s, when he switched to painting on canvas. Powers consistently placed his adult subjects close to the picture plane in half-length and three-quarter length poses, while depicting children in full-length either standing or seated. His earliest portraits are distinctive for their vibrant, stylized backgrounds, created by a series of swirling lines behind the sitters in a manner that most resembles drapery.

By the late 1830s, the artist was painting in an increasingly proficient and realistic manner, probably the result of several years' experience and observation. In addition, he also must have recognized the emerging preference for naturalistic portraits brought on by the realism of the popular daguerreotype. This technically proficient later style reveals little of the vigor, individuality or creativity for which Powers's earlier work is so admired. PD'A

[1] Except where noted, the information on this artist is from Nina Fletcher Little's catalog that accompanied the exhibition "Asahel Powers: Painter of Vermont Faces," Abby Aldrich Rockefeller Folk Art Collection, Williamsburg, Va., October 14–December 2, 1973, pp. 7–12.

[2] This portrait is owned by the Springfield Art and Historical Society, Vt., and is illustrated *ibid.* as no. 8 on p. 19.

[3] See Beatrix T. Rumford, ed., *American Folk Portraits: Paintings and Drawings from the Abby Aldrich Rockefeller Folk Art Center* (Boston, 1981), p. 175. Powers was signing his name alone again in 1836, although a recently discovered portrait of a member of the Griswold-Field family of Springfield, Vermont, is said to be dated "June 23/1837." A modern, typed label accompanying the portrait ascribes it to "Powers and Rice." This discovery warrants further research, as it implies that the Powers and Rice partnership was intermittent during the years 1836 and 1837. The portrait is owned by the Smithsonian Institution, Washington, D.C.

77. *Charles Mortimer French* N-39.61

This full-length portrait of six-year-old Charles Mortimer French is one of Powers's more intriguing and successful compositions. The artist's keen instinct for composition and color more than compensate for his unfamiliarity with naturalistic anatomy and perspective, and work to create a painting of extraordinary vitality. The back and seat of the bright yellow-painted chair in which French is seated are at impossible angles, as is the small table top on which the squeak toy precariously rests. Of further visual interest is the top of the painted footstool, which has an unnatural curvature seemingly to accommodate the sitter's feet. The result is a vigorous, chaotic group of interactive forms. The loose painting style of Powers's early career is evident throughout the portrait, particularly in the sitter's baggy suit and thickly painted face and hands. The heavy gray shading of the boy's features contributes to his haggard, aged appearance.

Charles Mortimer French was born probably in Vermont in 1826 or 1827. He died in Floyd County, Iowa on January or June 11, 1859, at the age of thirty-two years and six months, and was buried at Proctorsville New Cemetery in Cavendish, Vermont.[1] PD'A

Inscriptions/Marks: Painted in script on the verso is "Charles Mortimer French/taken at 6 years old./Asahel Powers./Painter."; painted on cover of book hanging from a nail beside the sitter's left shoulder is "Price 18 cents/MY MOTHER/A/PRETTY GIFT/THE NURSSE" followed by three lines of an illegible inscription.

Condition: No record of previous conservation. The two-part panel has warped evenly to a convex surface. There are a few flyspecks in the lighter areas.

Provenance: Found in Ludlow, Vt.; Mr. and Mrs. Howard Lipman, Wilton, Conn.; Mr. Stephen C. Clark Sr., Cooperstown, N.Y.

Exhibited: Untitled exhibition, the Century Association, New York, N.Y., January-February, 1952; "Art of the Pioneer," M. Knoedler & Co. Gallery, New York, N.Y., April 11–May 5, 1956; "Asahel Powers: Painter of Vermont Faces," the Abby Aldrich Rockefeller Folk Art Collection, Williamsburg, Va., October 14–December 2, 1973, and exhibition catalog, pp. 8 and 9, and no. 5, p. 16, illus. with verso as fig. 5 on p. 17; "The Flowering of American Folk Art, 1776–1876," Whitney Museum of American Art, New York, N.Y., February 1–September 15, 1974; "American Folk Painters of Three Centuries," Whitney Museum of American Art, New York, N.Y., February 26–May 13, 1980.

Published: *Arts Magazine*, April 1956; Mary Black and Jean Lipman, *American Folk Painting* (New York, 1966), p. 57, illus. as fig. 74 on p. 78; Jean Lipman, "Asahel Powers, painter," *Antiques* LXXV (June 1959), illus. on p. 558; Jean Lipman and Tom Armstrong, eds., *American Folk Painters of Three Centuries* (New York, 1980), p. 155, illus. on p. 157 with verso illus. on p. 156; Jean Lipman, Elizabeth V. Warren and Robert Bishop, *Young America: A Folk-Art History* (New York, 1986), illus. as fig. 1.37 on p. 34; Jean Lipman and Alice Winchester, *The Flowering of American Folk Art, 1776–1876* (New York, 1974), illus. as fig. 59 on p. 49.

78. *Vermont Woman*

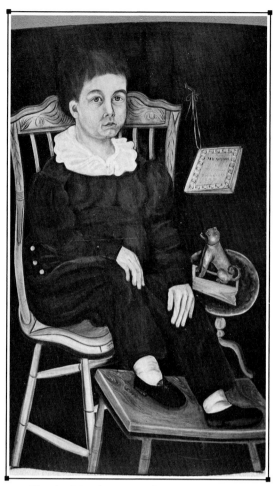

77. *Charles Mortimer French*

[1] Philip F. Elwert (Vermont Historical Society) to NYSHA, May 13, 1985. While Vermont Vital Records cite the death date as June 11, the subject's gravestone in the Proctorsville New Cemetery records the date as January 11, 1859. The identities of the parents of Charles Mortimer French have not been determined, although they are possibly Calvin D. (1799–1879) and Jerusha (1798–1829) French, who are buried in Cavendish, Vermont, beside Charles. Cavendish is a town adjacent to Ludlow, Vermont, where this portrait was found.

78. *Vermont Woman* N-40.61

This portrait of an unidentified woman is painted with the loose, fluid brush strokes, gray shading, and bold, dark outlines that mark Powers's early style. As in many of his portraits of adult subjects, the artist rendered the seated figure close to the picture plane in a three-quarter length pose.[1] Powers's interest in costume details is evident in the attention paid to the sheer fichu and large white cap. Her hands, folded in her lap, lighten the lower half of the picture and serve to balance the composition. PD'A

Condition: No record of previous conservation. The two-piece panel is severely warped into an even curve. The surface shows some signs of abrasion in the white fichu and pink ribbons. There are numerous flyspecks in the lighter areas.

Provenance: Found in Ludlow, Vt.; Mr. and Mrs. Howard Lipman, Wilton, Conn.; Mr. Stephen C. Clark Sr., Cooperstown, N.Y.

Exhibited: Untitled exhibition, The Century Association, New York, N.Y., January-February 1952; "Art of the Pioneer," M. Knoedler & Co. Gallery, New York, N.Y., April 11–May 5, 1956; "Asahel Powers: Painter of Vermont Faces," the Abby Aldrich Rockefeller Folk Art Collection, Williamsburg, Va., October 14–December 2, 1973, and exhibition catalog, pp. 8 and 9, and no. 6, p. 16, illus. as fig. 6 on p. 17.

Published: Jean Lipman, "Asahel Powers, painter," *Antiques* LXXV (June 1959), illus. on p. 558.

[1] Stylistic similarities with four signed likenesses dated 1832 which depict members of the Chase family of Springfield, Vermont suggest a similar date for this portrait. The Chase family portraits are owned by the Springfield Art and Historical Society, Springfield, Vt., and are illustrated in the catalog that accompanied the exhibition "Asahel Powers: Painter of Vermont Faces" (see *Exhibited*), on pp. 15 and 17.

❖ William Matthew Prior ❖
(1806–1873)

William Matthew Prior was one of the most prolific and influential nineteenth-century folk portrait painters. He is perhaps best known today for the large number of quick, inexpensive likenesses he painted, and for his possible influence on several other artists who compose what is known as the Prior-Hamblin School.

Prior was born in Bath, Maine, on May 16, 1806, the son of Captain William and Sarah Bryant Prior.[1] Although no record has surfaced to document Prior's artistic training, by the time he reached eighteen he was considered a professional portrait painter. A portrait inscribed "W. M. Prior, Painter/Formerly of Bath/1824/3 piece on cloth/Painted in C. Codman's Shop/Portland, Maine" raises the possibility that the young painter may have studied with the portrait, landscape and ornamental painter, Charles Codman (1800–1842).[2]

But portrait painting alone could not support a young and ambitious artist. Newspaper advertisements placed by Prior in the *Maine Inquirer* between 1827 and 1831 show that, in addition to portraits, Prior offered bronzing, oil gilding, varnishing, japanning, fancy, sign and ornamental painting, as well as reverse painting on looking glasses and clocks. On April 5, 1831, Prior placed an advertisement in the *Maine Inquirer* that concisely describes the works for which he is best known: "Persons wishing for a flat picture can have a likeness without shade or shadow at one quarter price." Although Prior was capable of producing an accomplished academic likeness, he developed a quick and efficient technique that allowed him to mass-produce his portraits.

Prior married Rosamond Clark Hamblin of Portland, Maine, in 1828. The Hamblins were known in Portland as a family with a long tradition as painters and glaziers. Prior, his wife, and their first two children settled in Portland sometime between 1831 and 1834. There, the artist developed a long-lasting professional relationship with several of his Hamblin in-laws who were also painters. By 1841, the Prior family and the brothers-in-law moved to Boston, where they lived with Nathaniel Hamblin at 12 Chambers Street. Prior would be listed in the Boston city directories for all but two of the next thirty-one years.[3] By 1852, Prior had moved to 36 Trenton Street which he referred to as the "Painting Garret."[4] Except for several sojourns to Baltimore, he lived in Boston for the remainder of his life. His productivity and his influence secured him a place as one of the most popular painters in that city.

The 1840s saw the rise in popularity of the daguerreotype, and Prior, like many other artists, sought to be competitive. The speed and assurance with which he painted

is documented by a label found affixed to a portrait from about 1848: "PORTRAITS/PAINTED IN THIS STYLE!/Done in about an hour's sitting./Price 2,92, including Frame, Glass, &c./Please call at Trenton Street/East Boston/WM.M.PRIOR."[5]

As the popularity of photography increased in the 1850s, Prior was forced to offer other kinds of paintings to supplement his dwindling portrait work. These late works include landscapes, numerous views of Washington's Tomb, imaginary scenes and, in the 1860s, reverse paintings on glass of historic portrait figures.

Prior's marketing techniques and his direct, appealing portraits of middle-class New Englanders provide a lively and colorful record of popular taste and fashion during the second quarter of the nineteenth century. RM

**Attributed to
William Matthew Prior**
United States, ca. 1835
Oil on canvas
24¾" × 20⅛"
(62.9 cm × 51.2 cm)

79. *William Whipper*

[1] Most of the biographical information is from Nina Fletcher Little, "William Matthew Prior, Traveling Artist, and His In-Laws, the Painting Hamblens," *Antiques* LII (January 1948), pp. 44–48, and Beatrix T. Rumford, ed., *American Folk Portraits: Paintings and Drawings from the Abby Aldrich Rockefeller Folk Art Center* (Boston, 1981), pp. 176–182.

[2] The portrait is privately owned and is listed in Sotheby Parke Bernet, Inc., *Americana*, catalog for sale no. 3134, lot no. 116, December 11–12, 1970.

[3] Prior is not listed for the years 1844–1845. He may have worked during this time as an itinerant.

[4] A stenciled notation that appears on work from the late 1840s reads: "Painting Garret/No. 36 Trenton Street/East Boston/W.M.Prior."

[5] Little, "William Matthew Prior," p. 45.

79. *William Whipper* N-246.61

William Matthew Prior is known for the sympathetic, dignified manner in which he portrayed blacks, a reflection of his own Abolitionist leanings.[1] He rendered this portrait of a black man with a greater degree of facial modeling than is seen in his "flat" style paintings, evidenced by the shading on and around the sitter's nose, under his eyes and below his mouth. However, the sitter's partially visible ear lacks definition, and his right thumb is awkwardly positioned. In his left hand he holds an open book similar in manner to a number of other portraits from the Prior-Hamblin School.[2] A modest amount of embellishment is evident in this portrait, such as the dabs of gold paint outlining the book, the subtle pattern of the vest and the subject's gold chain and rings.

The identification of the subject as William Whipper is based upon the family tradition which held that all of his personal belongings were labeled "W.W."[3] Whipper was one of the leading moral reformers of his time, a self-educated man who displayed his literary and oratory skills in numerous resolutions and addresses. He was born about

1804 in Little Britain township, Pennsylvania, the son of a successful white lumber merchant and a black house servant. He spent his young adulthood in Philadelphia, where he worked in a commercial laundry in 1828 and operated a "free labor and temperance grocery" in 1834. Whipper's most notable addresses were written during this time, including his "Address before the Colored Reading Society of Philadelphia" (1828) and his "Eulogy on William Wilberforce" (1833). His essay "Non-Resistance to Offensive Aggression," published in *Colored American* in 1837, preceded Henry David Thoreau's *Civil Disobedience* by twelve years. An active reformer, Whipper took part in numerous conventions of "free people of color" throughout the 1830s, 1840s and 1850s. He helped organize the American Moral Reform Society, dedicated to the principles of education, economy, temperance and universal liberty, and served as editor of their journal, the *National Reformer.* By 1835, Whipper was residing in Columbia, Pennsylvania, where he married Harriet L. L. Smith on March 10, 1836. He enjoyed a successful business partnership with the wealthy black lumber merchant, Stephen Smith, and spent thousands of dollars aiding fugitive slaves who passed through Columbia on their way north to freedom. Later in his life, Whipper served as cashier for the Philadelphia branch of the Freedmen's Savings Bank. He died in Philadelphia on March 9, 1876, and was buried in Olive Cemetery.[4] PD'A

Inscriptions/Marks: Painted in print on the cover of the book held in the sitter's left hand is "W.W."

Condition: Caroline and Sheldon Keck lined, cleaned and varnished this painting in 1959. This work corrected the distortion of the canvas and removed several stains, apparently caused by previous attempts to clean the surface. The lined canvas was placed on a new stretcher.

Provenance: Mr. and Mrs. William J. Gunn, Newtonville, Mass.; Miss Mary Allis, Fairfield, Conn.; Mr. Stephen C. Clark Sr., Cooperstown, N.Y.

Exhibited: NYSHA, "New-Found Folk Art of the Young Republic," 1960, and exhibition catalog, pp. 19–20, no. 29, illus. as fig. 29; untitled exhibition, The Century Association, New York, N.Y., January 2–February 15, 1961; untitled exhibition, Roberson Memorial Center for the Arts and Sciences, Binghamton, N.Y., November 1–December 15, 1961; untitled exhibition, Union College Art Gallery, Schenectady, N.Y., January-March 1962; "Folk Art from Cooperstown," Museum of American Folk Art, New York, N.Y., March 21–June 6, 1966; "The Portrayal of the Negro in American Painting," Forum Gallery, New York, N.Y., September 1–October 8, 1967, and exhibition catalog, illus. on p. 4; "Domestic Manners of the Americans," Museum of American Folk Art, New York, N.Y., December 5, 1967–February 4, 1968; "What is American in American Art," M. Knoedler & Co. Gallery, New York, N.Y., February 8–March 6, 1971.

Published: Louis C. Jones, "A Leader Ahead of His Times," *American Heritage* XIV (June 1963), illus. on p. 58.

[1] For examples of other portraits by Prior depicting black subjects, see the likenesses of Rev. W. Lawson and his wife Nancy, owned by the Shelburne Museum, Shelburne, Vt.

[2] See no. 52, the portrait *Three Children*, attributed to Sturtevant J. Hamblin.

[3] Leigh Whipper to NYSHA, April 4, 1960.

[4] Much of the biographical information on William Whipper is from Louis C. Jones, "A Leader Ahead of His Times," *American Heritage* XIV (June 1963), pp. 58–59, 83, and Betty Culpepper (Howard University) to NYSHA, June 19, 1985.

William Matthew Prior
Probably New England, 1844
Oil on cardboard
14¼″ × 10¼″
(36.2 cm × 26 cm)

81. *Mrs. G. Brightman*

80. *Mr. G. Brightman*

80. **Mr. G. Brightman** N-292.59
81. **Mrs. G. Brightman** N-293.59

Prior defined the facial features of these two subjects with the loose, nervous brushwork that characterizes his popular, least expensive painting style. The facial modeling is minimal; thick lines of brown paint outline the sitters' eyes, eyelids, noses and mouths. Ears, however, are sketchy and ill-defined. The creases in Mr. Brightman's forehead are actually grooves which Prior made in the wet design layer, allowing the lighter color of the underpaint to show. A light shade of salmon pink lends color to the subjects' cheeks and lips. Mrs. Brightman's dress is outlined with bold, dark lines, while her husband's black suit is defined by lightly applied lines of white pigment. PD'A

Inscriptions/Marks: Painted in script on wood backing board of no. 80 is "G. Brightman/AE 57 1844/By WM Prior/1844."

Condition: In 1986 the paint surface of no. 80 was lightly cleaned by the NYSHA conservator. A protective acid-free mat and backing were prepared.

There is no record of previous conservation on no. 81. The cardboard support is flat and the paint is undamaged. There is some uneven whitening of the dark background, probably just on the surface.

Provenance: Miss Anne Brightman, Syracuse, N.Y. (descendant of the sitters).

82. *Little Child with Big Dog* N-254.61

This portrait of an unidentified child standing beside a large dog is considerably more developed and complex than Prior's inexpensive painting style. The brushwork is tight and controlled, especially in the child's evenly painted face. White highlights and subtle

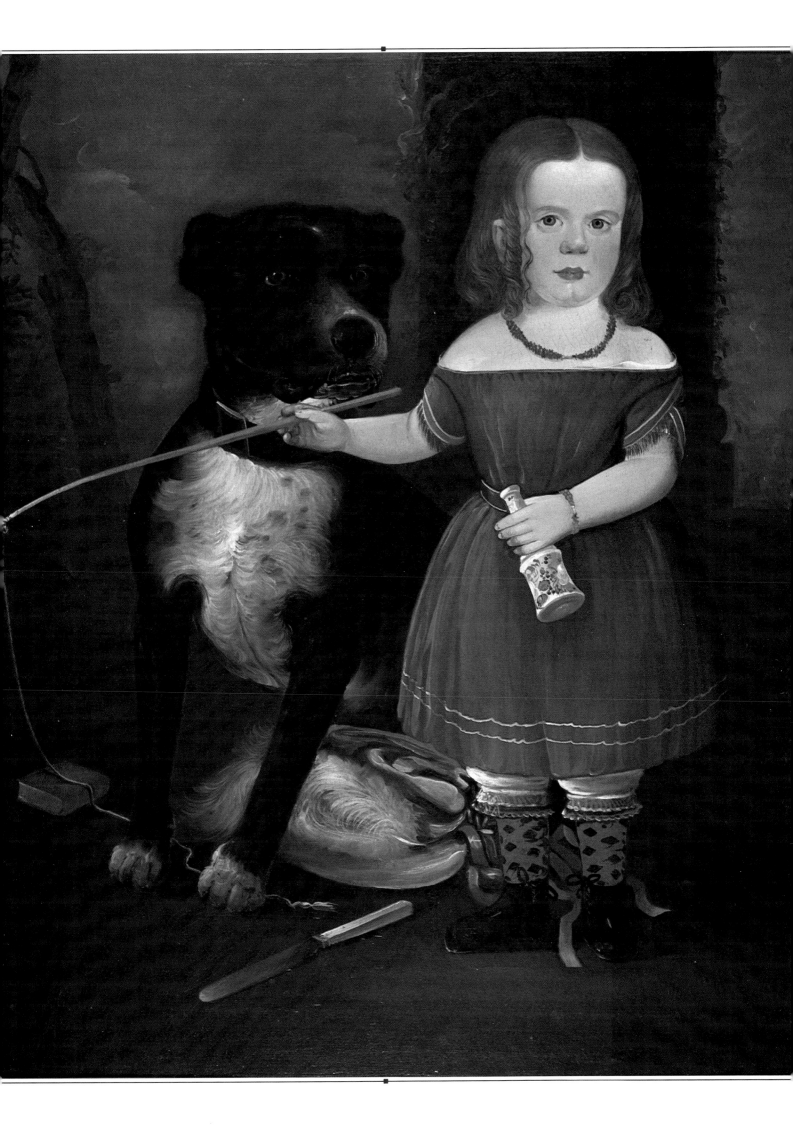

shading in the child's face and hands lend a naturalistic appearance that falls between the abstract quality of the artist's "flat" style and the realism of his more accomplished, academic technique. The dog is depicted in an alert, upright stance, and enjoys almost equal emphasis in this composition.

Prior includes many decorative yet personalizing accessories in this likeness, such as the whip and floral-decorated rattle held by the child, the coral necklace and bracelet, as well as the blue feathered hat, knife and book. He placed a dark, vine-covered column directly behind the sitter's head to direct the viewer's eye to the face, and added a darkened sky, tree trunk and leafy shrubbery to complete the outdoor setting. The child's gender is not known, as hair ringlets and dresses were common to both boys and girls at this time. However, the blue dress and the whip, considered a boy's toy, may indicate a young male child. PD'A

PAGE 137
82. *Little Child with Big Dog*
William Matthew Prior
Probably New England, 1848
Oil on canvas
35⅛" × 29"
(90.5 cm × 73.7 cm)

Inscriptions/Marks: Painted in script on the verso, now obscured by a lining canvas, is "Painted by W. M. Prior, 1848."

Condition: Treatment by Caroline and Sheldon Keck in 1959 included consolidating paint layers, lining with new fabric to remove dents, repairing two punctures, cleaning, filling and inpainting small losses. The painting was also placed on a new stretcher and varnished.

Provenance: Mr. and Mrs. William J. Gunn, Newtonville, Mass.; Miss Mary Allis, Fairfield, Conn.; Mr. Stephen C. Clark Sr., Cooperstown, N.Y.

Exhibited: NYSHA, "New-Found Folk Art of the Young Republic," 1960, and exhibition catalog, p. 33, no. 76, illus. as fig. 76; untitled exhibition, The Century Association, New York, N.Y., January 2–February 15, 1961; "American 19th Century Painting," Michigan State University, East Lansing, Mich., January 17–February 25, 1966; "The Animal Kingdom in American Art," Everson Museum of Art, Syracuse, N.Y., January 18–April 24, 1978, and exhibition catalog, illus. as fig. 3 on p. 9.

Published: George R. Clay, "Children of the Young Republic," *American Heritage* XI (April 1960), illus. on p. 53; Anita Schorsch, *Images of Childhood: An Illustrated Social History* (New York, 1979), illus. as Plate VII on p. 70.

83. *Charles E. and Octavia C. Adams* N-378.61

Prior painted this likeness of the young Adams children at about the same time he was advertising his ability to complete such "flat" portraits in a one-hour sitting. The loose, swirling brushwork and the thickly applied paint in this portrait suggest the rapid execution which allowed the artist to compete with the daguerreotype. However, Prior conveyed the childlike features of the pair in their pudgy, dimpled faces and large, expressive eyes. Their cheeks are faintly flushed in pink, and their faces exhibit Prior's characteristic white highlighting around the nose, mouth and eyes. Also typical of the artist's "flat" style are the sitters' hands, which are depicted as stubby, rounded forms with lines of brown paint defining individual fingers and nails. Prior used bright colors in their costumes and accessories to enliven this simple portrait, as Octavia's dress, coral necklace and bracelet are painted red and Charles's striped shirt is painted in green. Reddish-pink paint was used on the ribbon tied to Octavia's necklace, on the flower in the miniature basket, and along the cloud-like edge of the darker background color that vertically divides the canvas. A heavy impasto is visible on the lacy edges of Octavia's dress and Charles's collar, the pink flowers, the whip handle and the buttons on Charles's shirt. The subjects' identities have yet to be verified in genealogical records. PD'A

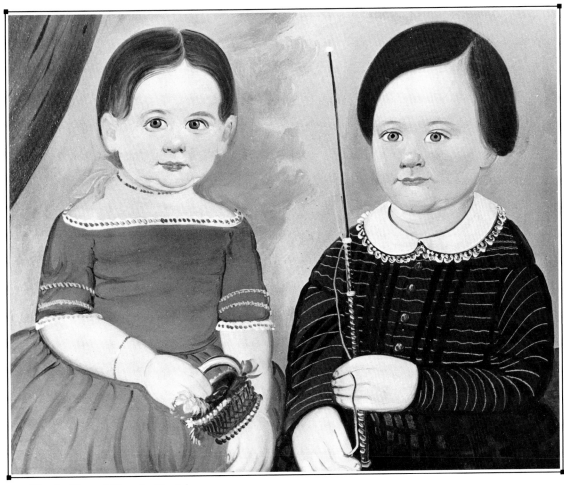

William Matthew Prior
Probably New England, 1848
Oil on cardboard
17″ × 23″
(43.2 cm × 58.4 cm)

83. *Charles E. and Octavia C. Adams*

Inscriptions/Marks: Painted in script on the verso, now obscured by mounting board, is "Charles E. Adams and Octavia C. Adams"; painted in script below Charles's name is "Age 3 years/by Wm. M. Prior 1848" and below Octavia's name, "aged 15 months."

Condition: The painting was treated by Caroline and Sheldon Keck in 1969. Examination revealed damaged edges and evidence that the left and right edges were cut down slightly. The warped card-board support was scored and infused with wax to flatten, then placed on a solid panel. The surface was cleaned, inpainted and varnished.

Provenance: Mr. and Mrs. William J. Gunn, Newtonville, Mass.; Miss Mary Allis, Fairfield, Conn.; Mr. Stephen C. Clark Sr., Cooperstown, N.Y.

Exhibited: "Primitive Art," Albion College, Albion, Mich., November 24–December 16, 1965.

84. *Possibly William Miller* N-33.60

Prior achieved one of his most penetrating character studies in this dark, somber likeness. His sophisticated modeling of the sitter's furrowed brow and the heavily shaded, wrinkled area around the eyes accentuates the man's piercing gaze. In addition, the stark lighting on the man's face and on the background directly behind his head create a dramatic presence.

A number of factors led to Nina Fletcher Little's tentative identification of this subject as the religious leader William Miller, the most compelling being the artist's as-

sociation with the preacher's following. William Miller (1782–1849) was a dynamic preacher and founder of the Adventist Movement who claimed to prove, by a prophetic chronology, that the second coming of Christ and the end of the world would occur between March 21, 1843 and March 21, 1844. Prior, along with his brother-in-law, Joseph G. Hamblin, was a fanatic Millerite. In March of 1840 Miller preached for thirteen days at the Casco Street Christian Church in Portland, Maine, and on October 13 of the same year he presided over a large gathering in Boston. These events coincided with Prior's move from Portland to Boston in the summer of 1840, raising the possibility that he attended both gatherings. Prior named a daughter, Balona Miller, after the charismatic preacher, and authored two books on the Adventist Movement. In 1862 he published *The King's Vesture, Evidence from Scripture and History Comparatively Applied to William Miller*, in which he attempted to prove that Miller was himself Christ in his second coming. Prior's 1868 publication, *The Empyrean Canopy*, discusses his rendering of a chronological chart for Miller and tells of his inspiration to paint the man's portrait.[1]

This likeness is sufficiently similar in appearance to descriptions and other portraits of William Miller to support Mrs. Little's contention. Contemporary accounts note Miller's penetrating eyes, white hair, wrinkles and his ever-present beaver hat. Known portraits of Miller exhibit the same broad nose and mouth, and strong jawline that is evident in this likeness. The sitter holds a volume labeled *Voltaire*, the philosopher whose work Miller studied prior to entering the public ministry. Interestingly, the volume's cover bears the date 1849, the year of Miller's death. The rings on the subject's right hand may be interpreted as a symbolic reference to the celestial phenomena, such as solar halos, observed by Miller and his followers in 1843 and 1844 and seen as signs of the prophesied second coming of Christ.

Prior's life-long devotion to Miller's teachings make it highly probable that he would have painted the prophet's likeness at least once. The inclusion of Miller's date of death on the book cover suggests that the portrait may have been rendered posthumously. Interestingly, Prior claimed visionary powers that allowed him to paint such likenesses "by spirit effect."[2] PD'A

Inscriptions/Marks: Painted in print on the spine of the book held by the sitter is "Voltaire" and, on the cover, "1849."

Condition: The canvas is taut on the strainer and apparently has never been treated in any way.

Provenance: Bertram K. and Nina Fletcher Little, Brookline, Mass.; Charles Childs, Boston, Mass.

Exhibited: "Folk Art," Roberson Center for the Arts and Sciences, Binghamton, N.Y., September 15, 1966–April 1, 1967.

Published: Nina Fletcher Little, "William M. Prior, Traveling Artist, And His In-Laws, the Painting Hamblens," *Antiques* LII (January 1948), illus. as fig. 5 on p. 46.

[1] Nina Fletcher Little, "William M. Prior, Traveling Artist, And His In-Laws, the Painting Hamblens," *Antiques* LII (January 1948), p. 44–48; Gerard C. Wertkin (Museum of American Folk Art) to NYSHA, July 1, 1985.

[2] Beatrix T. Rumford, ed., *American Folk Portraits: Paintings and Drawings from The Abby Aldrich Rockefeller Folk Art Center* (Boston, 1981), p. 177.

Attributed to
William Matthew Prior
Probably New England, ca. 1850
Oil on canvas
27″ × 22″
(68.6 cm × 55.9 cm)

84. *Possibly William Miller*

❖ Joseph Whiting Stock ❖
(1815–1855)

There are few folk painters whose careers can be documented as extensively as Joseph Whiting Stock, thanks to the survival of his seventy-three page handwritten journal which describes his activities during the years 1832 to 1846. The journal, compiled by Stock after

1846, from various unknown sources, lists over 900 portraits with their price, size and approximate date of execution. This document provides researchers with a resource of extraordinary value in the identification of the artist's portrait subjects. Additional information on Stock's career comes from newspaper advertisements, a will, an inventory of his estate and a lengthy letter written by Stock to his brother-in-law Otis Cooley in 1855.[1]

Stock was born in Springfield, Massachusetts on January 30, 1815, the third of twelve children in his family. At age eleven, he was accidentally crushed beneath an oxcart and was crippled. He learned to paint at the encouragement of his physician, Dr. William Loring. Franklin White, a former pupil of Chester Harding, taught Stock such technical aspects of painting as priming canvases and preparing a palette. His first portraits were successful likenesses, which led to more commissions from friends and relatives. With this early success Stock's spirits were boosted and his poor health improved. In 1834, Dr. James Swan of Springfield designed a wheelchair which allowed Stock the freedom of movement he needed to pursue his craft seriously and make it a profession. Dr. Swan soon became a steady patron, commissioning numerous anatomical and phrenological studies from Stock.[2]

Working from his Springfield studio for several years, Stock limited travels to nearby Massachusetts towns such as North Wilbraham, Chicopee and Westfield. In 1840, he traveled to Bristol and New Haven, Connecticut, and, in 1841, to New Bedford, Massachusetts and Warren, Rhode Island. He also journeyed to other towns in Connecticut and Massachusetts, painting portrait miniatures and landscapes. In 1844, he entered into a brief partnership to execute portraits and daguerreotypes with his brother-in-law, Otis Cooley, in Springfield. In 1852, the artist's travels took him westward to Middletown, Goshen and Port Jervis, New York, where he continued to paint portraits and miniatures. While in Port Jervis, he briefly became partners with another artist, Salmon W. Corwin. This partnership lasted less than a year, and was dissolved by January, 1855.[3] Shortly thereafter, Stock returned to Springfield where he died of tuberculosis on June 28, 1855.

Although best known for his portraits, Stock indicates in his journal that he was also painting landscapes and genre scenes, as well as drawing anatomical sketches and even decorating windowshades. No examples of his more varied artistic output have been found.

Stock's most memorable likenesses are his full-length portraits of children, which appear more pleasing to the modern eye than his adult subjects. In the children's portraits, he consistently employed bolder colors and more carefully rendered details. Youngsters are often shown in complex interior settings surrounded by a variety of accessories and occasionally pictured with a favorite pet. The delicate expressive faces of the children and the lively colored and patterned floor coverings, characteristically painted in vertical perspective, contribute greatly to the visual appeal of these likenesses. PD'A

[1] The biographical information on this artist is from Juliette Tomlinson, ed., *The Paintings and the Journal of Joseph Whiting Stock* (Middletown, Conn., 1976), preface and pp. 3–59.

[2] For information on Stock's anatomical and phrenological renderings produced for Dr. Swan, see Mary Black, "Phrenological Associations: Footnotes to the Biographies of Two Folk Artists," *The Clarion* (Fall 1984), pp. 44–52.

[3] A lithograph of Port Jervis, with the annotation "Published by Stock & Corwin Portrait Painters," is owned by The New-York Historical Society, New York, N.Y.

85. *Edward W. Gorham* N-266.61

This somber colored, posthumous portrait of a child seated on a floor and playfully driving tacks into a chair seat has long been known by the title *The Young Hammerer.* The child has been identified, however, as Edward W. Gorham of Springfield, Massachusetts. The portrait's inscribed death date of February 19, 1844 matches the known date of the Gorham boy's death, and corresponds with Stock's listing in his journal of a portrait of "J. W. Gorham's boy deceased" painted in Springfield in early 1844.[1] Edward W. Gorham was the son of Joseph W. and Laura N. Rogers Gorham of Springfield.[2] According to Stock's journal, Mr. Gorham paid the artist the sum of twelve dollars for this likeness of his deceased child.

Stock depicted the Gorham boy as a playful, energetic child, yet placed him in a dark, plain setting without the brightly patterned floor that typifies his portraits of children. Included in the composition are a number of characteristic props such as the boy's toy hammer and the ball and whip in the foreground. The piece of string loosely wound around the arm of the chair adds an air of informality to this likeness. PD'A

Inscriptions/Marks: Painted in script on the verso is "Feb. 19th 1844/Aged 1 yr. 8 mo. 2 da./Painted by J. W. Stock"; penciled in script to the left of "Feb. 19th 1844" is the barely legible word "died"; penciled in script to the lower right of the artist's signature is "Springfield, Mass."

Condition: Some inpainting was done before acquisition. In 1959, Caroline and Sheldon Keck lined the picture and put it on a new stretcher. The surface was cleaned. Fills and inpainting corrected damage at lower right, upper left and in the background.

Provenance: Mr. and Mrs. William J. Gunn, Newtonville, Mass.; Miss Mary Allis, Fairfield, Conn.; Mr. Stephen C. Clark Sr., Cooperstown, N.Y.

Exhibited: NYSHA, "New-Found Folk Art of the Young Republic," 1960, and exhibition catalog, p. 33, no. 78, illus. as fig. 78; untitled exhibition, The Century Association, New York, N.Y., January 2–February 15, 1961; "Joseph Whiting Stock," Smith College Museum of Art, Northampton, Mass., February 4–March 20, 1977, and exhibition catalog, p. 54, no. 23, illus. as fig. 23 on p. 29.

Published: George R. Clay, "Children of the Young Republic," *American Heritage* XI (April 1960), p. 52, illus. on p. 53; A. Bruce MacLeish, "Paintings in the New York State Historical Association," *Antiques* CXXVI (September 1984), p. 592, illus. as fig. 2 on p. 593; Juliette Tomlinson, ed., *The Paintings and the Journal of Joseph Whit-*

85. *Edward W. Gorham*

Joseph Whiting Stock
Springfield, Massachusetts, 1844
Oil on canvas
30⅛" × 25"
(76.5 cm × 63.5 cm)

ing Stock (Middletown, Conn., 1976), p. 66, no. 26, illus. as fig. I:26.

[1] Juliette Tomlinson, ed., *The Paintings and the Journal of Joseph Whiting Stock* (Middletown, Conn., 1976), p. 41.

[2] City Clerk's records, City Library, Springfield, Mass.

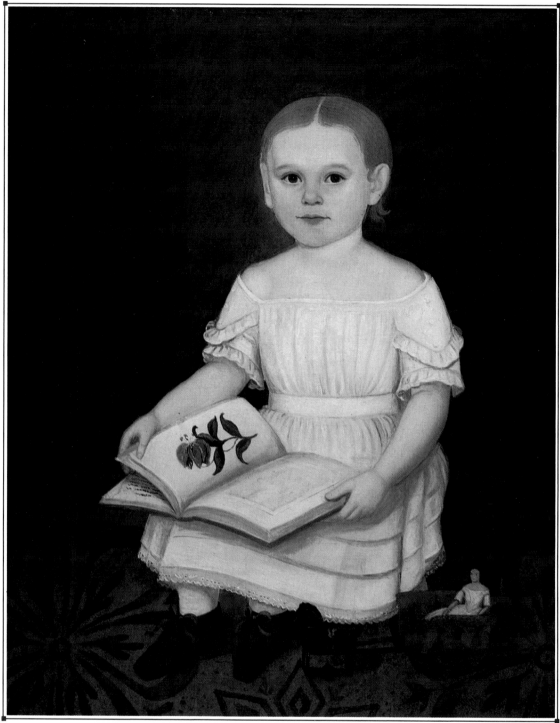

Attributed to
Joseph Whiting Stock
Probably Springfield,
Massachusetts, ca. 1845
Oil on canvas
33⅛″ × 27¼″
(84.2 cm × 69.3 cm)

86. *Little Child with Flower Book*

86. *Little Child with Flower Book* N-296.61

The attribution of this portrait to Joseph Whiting Stock is based on a stylistic comparison with the documented portrait of Helen Eddy.[1] These two likenesses display markedly similar facial features including prominent ears, large, dark eyes and dimples at the cor-

ners of the mouth. These details give many of Stock's children pleasingly innocent expressions. Also evident are the characteristic vertical floor covering, patterned in colors of reddish orange and green, as well as such decorative details as the toy horse and wagon, the doll, and the carefully rendered illustration of a lily in the child's open book. In this portrait, Stock departed from his usual method of placing children in detailed interior settings by depicting this young subject against a dark, neutral background. The resulting contrast with the child's white dress makes this a strong composition, enhanced by the large size of the canvas. No positive identification of this subject has yet been made from Stock's journal.[2] PD'A

Condition: At an unknown date, the canvas was fabric lined with very hard glue and some filling and inpainting were done. However, when Caroline and Sheldon Keck examined the picture in 1959, the fillings were falling out and the inpainting had darkened. The fills were replaced, the entire surface was cleaned, and the inpainting was renewed.

Provenance: Mr. and Mrs. William J. Gunn, Newtonville, Mass.; Miss Mary Allis, Fairfield, Conn.; Mr. Stephen C. Clark Sr., Cooperstown, N.Y.

Exhibited: NYSHA, "New-Found Folk Art of the Young Republic," 1960, and exhibition catalog, p. 21, no. 35, illus. as fig. 35; untitled exhibition, The Century Association, New York, N.Y., January 2–February 15, 1961; "Child's World," Schenectady Museum, Schenectady, N.Y., January 2–May 9, 1972.

[1] This portrait is privately owned and is illustrated in Juliette Tomlinson, ed., *The Paintings and the Journal of Joseph Whiting Stock* (Middletown, Conn., 1976), as fig. I:29.

[2] Betsey B. Jones (Smith College Museum of Art) to NYSHA, September 6, 1984. As the canvas dimensions, 33″ × 27″ were not very common for Stock, and there are few portraits of children listed in his journal with these dimensions it is possible that this child may be "Mrs. Robinson's girl deceased 27 + 33″ painted in 1846 for fifteen dollars and listed in *ibid.*, on p. 47.

❖ "Mr. Thompson" ❖
(active 1814–1819)

87. *John Berry* N-88.61

The twelve extant portraits by this hand have been attributed to an artist known only as "Mr. Thompson"—an attribution based on a fragmentary inscription on one of the portraits. These portraits range in date from 1814 to 1819, and nine of them depict members of families from Schraalenburgh, Polifly and other Dutch settlements near present-day Hackensack, New Jersey. A number of ties existed among these families in marriage, business and estate matters. Unfortunately, many of the subjects are children and their identities have proven difficult to trace. Using pale watercolors, this painter depicted subjects either standing or sitting in full-length or three-quarter length poses. The artist placed sitters in front of either a neutral background or one that was embellished with cloud-like shapes or swagged drapery. The sitters have sloping shoulders, tiny hands that are tapered to the index finger or curved in a claw-like fashion, puckered lips and large eyes, which give them alert, perky expressions. The artist often personalized portraits by including props such as books, flowers, animals or various types of chairs and floor coverings. Each portrait bears an inscription panel inscribed with the subject's birthdate and age in striped block letters.[1] PD'A

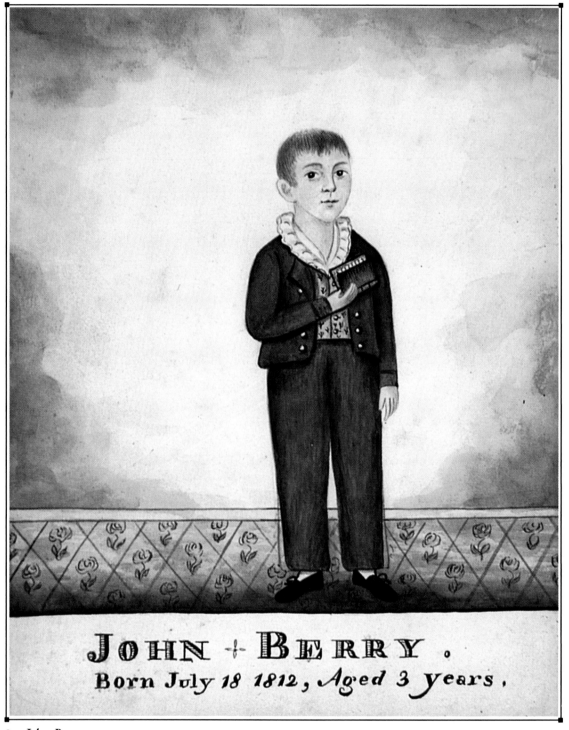

Attributed to
"Mr. Thompson"
Probably New Jersey, ca. 1815
Watercolor and pencil
on wove paper
10¼″ × 8⅛″
(26 cm × 20.7 cm)

87. *John Berry*

Inscriptions/Marks: Printed in watercolor in block letters in the margin below the portrait is "John Berry/Born July 18, 1812, Aged 3 Years." No watermark found.

Condition: Treatment was undertaken by the NYSHA conservator in 1976. The paper support, glued unevenly to a cardboard backing, was removed, adhesive residue and staining were washed out. Several small and two one-inch tears were mended with Japanese tissue and starch paste. Three oval brown stains could not be removed,

but were toned with pastel. A new mat and backing were prepared.

Provenance: Found in New England; Mr. and Mrs. Howard Lipman, Wilton, Conn.; Mr. Stephen C. Clark Sr., Cooperstown, N.Y.

Exhibited: "From the Cradle," The New-York Historical Society, New York, N.Y., November 1948; untitled exhibition, The Century Association, New York, N.Y., January-February 1952.

[1] See Beatrix T. Rumford, ed., *American Folk Portraits: Paintings and Drawings from the Abby Aldrich Rockefeller Folk Art*

Center (Boston, 1981), p. 189, cat no. 165. The portraits are: *Agnes Ackerman,* owned by the Philadelphia Museum of Art, Philadelphia, Pa.; *Sally Vreeland,* owned by the Abby Aldrich Rockefeller Folk Art Center, Williamsburg, Va.; *Rachel Brinkerhoff, John N. Outwater* and *Eliza N. Outwater,* owned by the Monmouth County Historical Association, Freehold, N.J.; *Lawrence Ackerman with a Canary, Lawrence Ackerman with a Cat, Sally Bogart* and *Charlotte Eliza Raub,* privately owned and illustrated in Sotheby Parke Bernet, Inc., *Americana* catalog for sale no. 3981, lot nos. 417–420, April 27, 29 and 30, 1977; and two privately owned portraits. The fragmentary inscription appears on an original backing paper for one of the privately owned portraits and reads "Thompson/. . .painter/has gone into the Country/. . .few days."

❖ Henry Walton ❖
(1804–1865)

The earliest documented works by the artist Henry Walton include mezzotints and lithographs dating from about 1820. These are landscapes and town views from the Finger Lakes Region of central New York state. The exacting linear quality of these drawings suggests that he may have received some formal training in architectural drawing. The artist was probably the son of Judge Henry Walton and Matilda Caroline Cruger Yates Walton of New York City, Saratoga Springs and Ballston Spa, New York, and was born on August 25, 1804 in Ballston Spa. The number of drawings by H. Walton illustrating buildings owned by Judge Walton in Saratoga Springs supports this theory.[1]

By 1836, Henry Walton was residing in Ithaca, New York, where he continued to work as a lithographer, but increasingly sought employment as a portrait painter. His subjects were residents of Ithaca and surrounding towns, including Geneva, Stockholm, Lodi, Hector and Ovid. Working in both watercolor and oil, he often presented sitters in interior scenes decorated with ornately designed carpeting and floral patterned table coverings. At other times, he drew subjects standing against rapidly receding landscape views filled with trees, shrubbery and an occasional house.

While Walton's lithographs and mezzotints are the work of a highly skilled trained craftsman, his early portraits in watercolor on paper, dating from 1836, and those in oil on canvas, dating from 1839, lack the same high level of artistic ability and technical knowledge. Faces are delineated with round eyes, cupid's-bow lips and full cheeks revealing little, if any, attempt by the artist to model their form. By 1842, Walton's work had become more accomplished. He began drawing faces with shadow and contour; hands became more true to life; bodies were rendered with a greater sense of weight and volume. He continued to paint landscapes and town views in oil and watercolor and made lithographs that revealed a technically proficient style.[2]

Henry Walton moved from New York to San Francisco, California in 1851. His last known renderings are a watercolor portrait drawn in 1853 of William D. Peck from the town of Rough and Ready, California, and a landscape scene of Grass Valley, California drawn four years later.[3] Soon thereafter, Walton retired to Cassopolis, Michigan where he died in 1865. CME

Henry Walton
Probably Lodi, New York,
probably 1836
Watercolor and ink
on heavy wove paper
8¾" × 6⅛"
(22.2 cm × 15.6 cm)

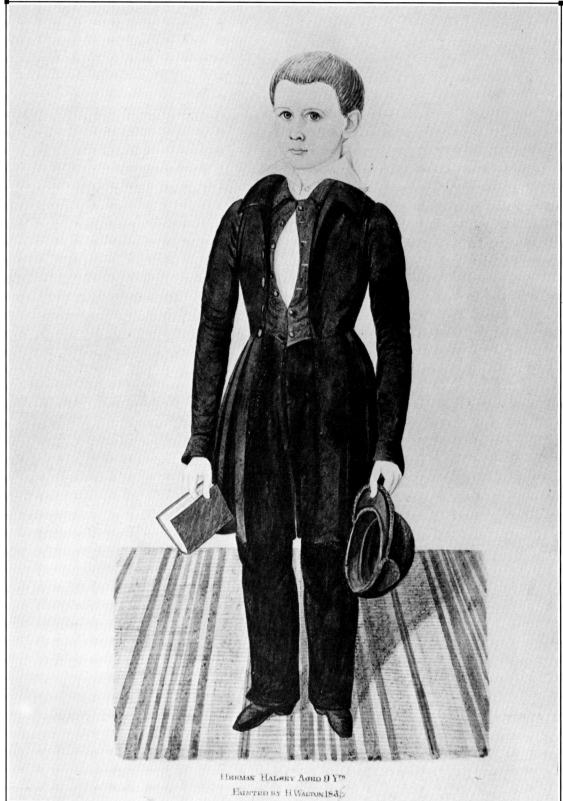

88. *Herman Halsey*

[1] All biographical information on the artist is from the catalog for the exhibition, "Henry Walton, 19th Century American Artist," Ithaca College Museum of Art, Ithaca, N.Y., December 9, 1968–January 4, 1969, pp. 9–13.

[2] Especially noteworthy is Walton's large and meticulously detailed firemen's parade banner. It depicts volunteer fire companies responding to the great fire which swept through Ithaca in 1840. The banner is illustrated in the catalog for the exhibition "Henry Walton, 19th Century American Artist," as fig. 54 on p. 49.

[3] The portrait of William D. Peck is privately owned; the landscape scene of Grass Valley, California is owned by the Society of California Pioneers, San Francisco, Calif. The Peck portrait and landscape scene are illustrated *ibid.*, 53 on p. 47; 67 on p. 62.

88. *Herman Halsey* N-213.70

This drawing of Herman Halsey dates from Henry Walton's earliest known period of portrait activity. Although Walton recorded the subject's facial features with the minute precision and skill of a competent draftsman, his earliest portraits betray an unfamiliarity with the precepts of modeling anatomical form. For example, Herman Halsey's coat, vest and trousers are all drawn in solid tones and darker strokes of color are applied to convey contour and shape; his face and hands appear flat and shallow. All of these features lack evidence of shading techniques employed by more experienced portraitists.

Herman Halsey was born in 1827, the son of Silas and Elizabeth Halsey of Lodi, New York. He married Sarah Meeker on June 11, 1857, and lived on a farm in Lodi where they raised two children. He died at the age of sixty-two on December 11, 1889.[1] CME

Inscriptions/Marks: Hand printed in ink in the lower margin below the portrait is "Herman Halsey Aged 9 Yrs./Painted by H. Walton 1836." The last number of the date "1836" has been inscribed in pencil in a different hand. No watermark found.

Condition: The portrait was rematted and backed with acid-free material at an unknown date. In 1983, the frame was cleaned and finish repaired by the NYSHA conservator.

Provenance: Albert W. Force, Ithaca, N.Y.

Exhibited: "Henry Walton, 19th Century American Artist," Ithaca College Museum of Art, Ithaca, N.Y., December 9, 1968–January 4, 1969, and exhibition catalog, illus. as no. 23 on p. 29.

Published: Leigh Rehner, "Henry Walton, American Artist," *Antiques* XCVII (March 1970), p. 146.

[1] Edith Brown to NYSHA, October 4, 1985; Betty Anten to NYSHA, August 4, 1985.

Henry Walton
New York state, 1836
Watercolor and ink
on heavy wove paper
8¾" × 6⅛"
(22.2 cm × 15.6 cm)

89. *Nancy Couch*

89. *Nancy Couch* N-215.70

The identity of Nancy Couch has not been determined in records where Henry Walton is known to have executed portraits. CME

Inscriptions/Marks: Hand-printed in ink in the lower margin below the portrait is "Nancy Couch/Drawn by [H?] Walton. 1836." No watermark found.

Condition: The paper is unevenly yellowed, with foxing above and around the head. There is an L-shaped tear (1" × ¼") above the head. Small white spots around the face appear to be abrasions

and there are tiny punctures in the paper at left center and bottom center. An acid-free mat and backing were placed in the frame in 1971.

Provenance: Albert W. Force, Ithaca, N.Y.

Exhibited: "Henry Walton, 19th Century American Artist," Ithaca College Museum of Art, Ithaca, N.Y., December 9, 1968–January 4, 1969, and exhibition catalog, illus. as no. 25 on p. 31.

Published: Albert W. Force, "H. Walton – Limner, Lithographer, and Map Maker," *Antiques* LXXXII (September 1962), illus. as fig. 1 on p. 284.

RIGHT
Henry Walton
Ithaca, New York, 1840
Watercolor on ivory
2⅜" × 1¹⁵⁄₁₆"
(6 cm × 4.9 cm)

FAR RIGHT
Henry Walton
Ithaca, New York, 1840
Watercolor with glazed highlights on ivory
2½" × 1¹⁵⁄₁₆"
(6.4 cm × 4.9 cm)

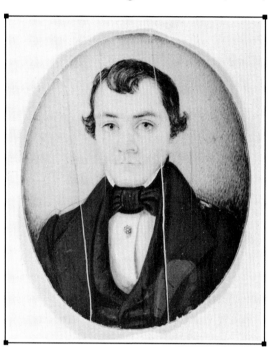

90. *Probably Joseph Curtiss Burritt*

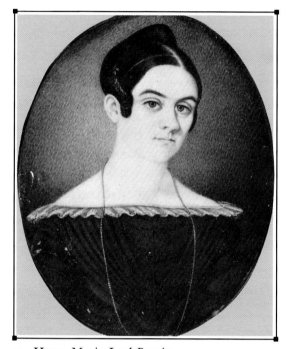

91. *Hettey Maria Lord Burritt*

90. *Probably Joseph Curtiss Burritt* N-211.70

Although the artist is known primarily for his portrait work in watercolor on paper and oil on canvas, Henry Walton also painted portrait miniatures in oil on ivory. Thus far, six examples of these have been found; two depict subjects from Ithaca, New York, and three are dated 1840.

The subject of this miniature may in fact be Joseph Curtiss Burritt, the husband of Hettey Maria Lord (see no. 91). Information in the NYSHA files indicate these two miniatures are a pair. A comparison between this portrait and two existing photographs of Burritt as an older man support this notation.[1]

Joseph C. Burritt was born on January 26, 1817 to Joseph and Asenath Curtiss Burritt of Ithaca, New York. In May of 1838, Burritt began working for his father's jewelry business which also offered watch repair services and eventually photographic supplies. He assumed control over the firm in the early 1860s. Influenced by local photographers who frequented his store, the mechanically inclined Burritt naturally became interested in the burgeoning field of photography and pursued it as a hobby. During the 1860s, Burritt took over four hundred photographs documenting the people, places and the countryside around Ithaca, thus establishing a local reputation as a prominent early photographer.[2]

Two years after his wife Hettey died in 1873, Burritt married Julia Atwater on January 7, 1875. He and his second wife had one son. Joseph C. Burritt died on May 22, 1889 after falling from a tree he was pruning. CME

Inscriptions/Marks: In ink in script on laid paper glued to ivory, "Painted by H. Walton/Ithaca 1840."

Condition: No record of previous conservation. The ivory support has been backed with paper, but it has warped and split into three pieces with additional cracks in the larger two. Except for the cracks, there is no damage to the paint.

Provenance: Albert W. Force, Ithaca, N.Y.

Exhibited: "Henry Walton, 19th Century American Artist," Ithaca College Museum of Art, Ithaca, N.Y., December 9, 1968–January 4, 1969, and exhibition catalog, illus. as fig. 31 on p. 34.

[1] See *With a Jeweler's Eye: The Photographs of Joseph C. Burritt* (Ithaca, 1980), frontispiece; and Mary L. Foster, *One Line of the Burritt Family* (Ithaca, 1898), between p. 12 and p. 13.

[2] The photographs are owned by the DeWitt Historical Society of Tompkins County, Ithaca, N.Y. All biographical information is from *Jeweler's Eye*, pp. 4–9, and Foster, p. 18.

91. *Hettey Maria Lord Burritt* N-212.70

It seems that Walton adapted well to drawing with watercolor on ivory as this likeness of Hettey Maria Lord Burritt reveals a level of artistic accomplishment not often found in his early portraits. Her round eyes, full nose and tightly pursed lips are all rendered with smooth, meticulous brushstrokes. Walton used to advantage the translucent quality of the ivory support to make the face and long neckline appear soft and delicate. He employed tonal contrasts in the stippled background of this portrait, thus separating the subject from it and lending depth to the composition.

Hettey Maria Lord Burritt was born on New Year's Day, 1819 to Harley and Hettey Smith Lord of Ithaca, New York.[1] She was the first wife of Joseph C. Burritt whom she married on January 30, 1839. The couple resided on North Albany Street in Ithaca, where they raised their four children.[2] Hettey died on January 5, 1873, at the age of fifty-four. CME

Inscriptions/Marks: In ink in script on laid paper glued to ivory backing is, "Painted by H. Walton./Ithaca 1840." Penciled in script on folded paper found inside between ivory and back of locket is, "My Beloved./J.C.B."

Condition: This miniature was treated by the NYSHA conservator in 1986. The slightly warped ivory support was lightly cleaned. The frame and glass were cleaned completely and the loose bezel repaired and polished.

Provenance: Albert W. Force, Ithaca, N.Y.

Exhibited: "Henry Walton, 19th Century American Artist," Ithaca College Museum of Art, Ithaca, N.Y., December 9, 1968–January 4, 1969, and exhibition catalog, illus. as fig. 30 on p. 34.

[1] Margaret Hobbie (DeWitt Historical Society of Tompkins County) to NYSHA, May 15, 1985; a second portrait of Hettey Maria Lord by an unidentified artist is owned by the historical society.

[2] *With a Jeweler's Eye: The Photographs of Joseph C. Burritt* (Ithaca, 1980), p. 9.

92. *De Mott Smith* N-214.70

In his portraits of children, as in this likeness of De Mott Smith, Henry Walton expressed a special fondness for patterned details rendered with strong, vibrant colors. With De Mott's bright blue suit and his violet-colored vest, decorated with dotted lines of red and white, Walton conveys a sense of youthful vitality. The green and red colors in the lively, patterned floor covering provide further evidence of Walton's understanding of complementary contrasts and their contribution to a dynamic portrait.

J. De Mott Smith was born in Lodi or Ovid, New York, on December 10, 1832.

Henry Walton
Lodi, New York, 1841
Watercolor, ink and pencil
on heavy wove paper
10 ¹⁵⁄₁₆″ × 6 ¹⁵⁄₁₆″
(27.8 cm × 17.7 cm)

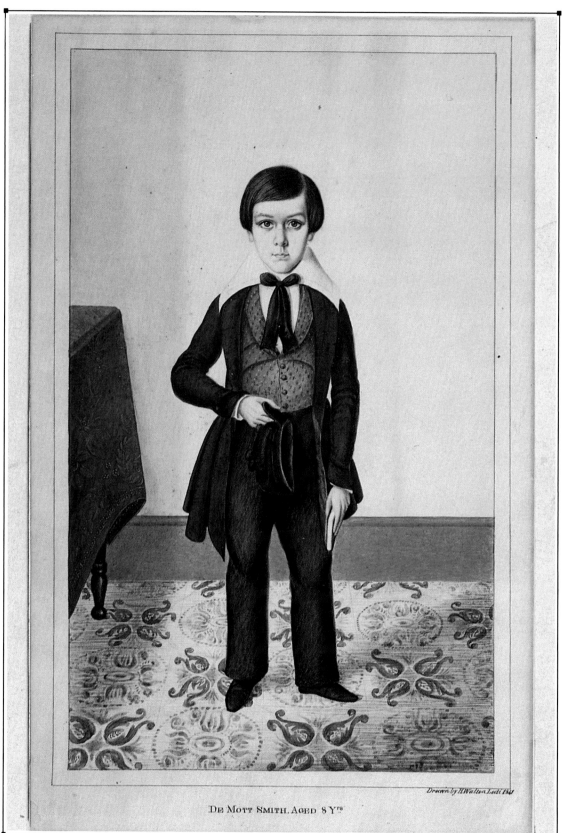

DE MOTT SMITH, AGED 8 Yʳˢ

Drawn by H.Walton Lodi 1841

92. *DeMott Smith*

He was the son of Eliza Ann Baker and Colonel Ralph Smith, a wealthy agriculturist and prominent military officer. J. De Mott is listed in the federal census records in 1860 as a lawyer, living in Ulysses, New York, with his wife Mary and children.[1] CME

Inscriptions/Marks: Hand printed in ink in the lower margin below the portrait is "De Mott Smith. Aged 8 y.rs./Drawn by H. Walton. Lodi 1841." Watermark in the primary support, "J. Whatm[an]/Turkey Mill" for the Maidstone, Kent, England firm operated by the Hollingworth brothers between 1806 and 1859.

Condition: The portrait was rematted and backed with acid-free material at an unknown date. In 1983, the frame was cleaned and finish repaired by the NYSHA conservator.

Provenance: Albert W. Force, Ithaca, N.Y.

Exhibited: NYSHA, "Rediscovered Painters of Up-state New York," June 14–September 15, 1958, and exhibition catalog, illus. as no. 73 on p. 75; "Henry Walton, 19th Century American Artist," Ithaca College Museum of Art, Ithaca, N.Y., December 9, 1968–January 4, 1969, and exhibition catalog, p. 24, and illus. as no. 18 on p. 25.

Published: Dorothy Adlow, "De Mott Smith: A Watercolor by Henry Walton," *Christian Science Monitor,* July 29, 1958, p. 8.

[1] Betty Anten to NYSHA, August 4, 1985.

93. *Almira H. Mapes* N-197.56

Almira H. Montgomery Mapes lived in Lodi, New York, with her husband James, who was a merchant. Together they had four daughters, three of whom died in infancy, although a fourth child, Frances, lived to adulthood (see no. 94). At the time that this portrait was drawn, Almira was only thirty-eight years old. However, the gaunt appearance of her face suggests a sickly disposition; her eyes seem heavy, cheeks sunken and her overall condition somewhat frail. Almira died on May 5, 1845, only a few years after this portrait was drawn.[1] CME

Inscriptions/Marks: Hand printed in ink in the lower margin below the portrait is "Almira H. Mapes. Aged. 38 Years./Drawn by H. Walton." Printed in watercolor on the cover of the book held in the subject's right hand is "AHM." Remnant of an erased erroneous modern penciled inscription on the verso is "married in 1856–Aged 38/Born 180[?]/died 1860–age 42." No watermark found.

Condition: The paper is slightly yellow. There is a 1" tear at left center. An acid-free mat and backing have been placed in the frame.

Provenance: E. Hayden Parks, Buffalo, N.Y.

Exhibited: "Henry Walton, 19th Century American Artist," Ithaca College Museum of Art, Ithaca, N.Y., December 9, 1968–January 4, 1969, and exhibition catalog, illus. as fig. 35 on p. 35.

[1] Betty Anten to NYSHA, August 4, 1985.

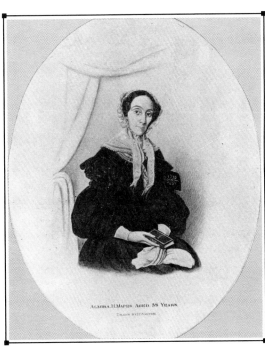

Henry Walton
Probably Lodi, New York, ca. 1841
Watercolor and ink on heavy wove paper
8¹³⁄₁₆″ × 6¹⁵⁄₁₆″
(22.4 cm × 17.7 cm)

93. *Almira H. Mapes*

94. *Frances E. Mapes* N-208.70

Frances Ellis Mapes was born to James and his first wife, Almira H. Mapes, on April 11, 1836 in Lodi, New York. On December 12, 1860, Frances married Charles M. Neeley, owner of a hardware and grocery store in Lodi. The couple had one child, Montgomery Neeley. Frances died on April 5, 1921, at the age of eighty-four.[1] CME

Attributed to
Henry Walton
Probably Lodi, New York,
ca. 1841
Watercolor and ink
on heavy wove paper
5⅝″ × 3½″
(14.3 cm × 8.9 cm)

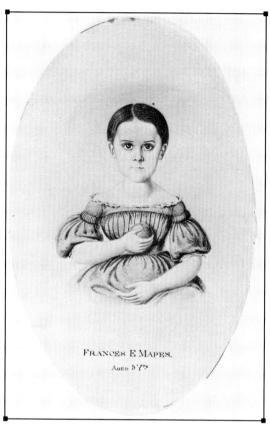

94. *Frances E. Mapes*

Inscriptions/Marks: Hand printed in ink in the lower margin of the primary support is "Frances E. Mapes./Aged 5 Yrs." No watermark found.

Condition: The paper support is slightly yellow. The top right area of the oval is somewhat ragged and there is a 1″ tear at the bottom, extending up through the inscription. In 1987 the NYSHA conservator repaired damage to the wood frame, mended the tear and reassembled the piece.

Provenance: Albert W. Force, Ithaca, N.Y.

Exhibited: "Henry Walton, 19th Century American Artist," Ithaca College Museum of Art, Ithaca, N.Y., December 9, 1968–January 4, 1969, and exhibition catalog, illus. as fig. 33 on p. 34.

[1] All biographical information on the subject is from Edith Brown to NYSHA, October 4, 1985. See Almira H. Mapes, no. 93.

95. *Theodore Squires* N-207.70

Walton depicted Theodore Squires as a businessman, posed at his desk with paper and pen in hand. Correspondence, stationery, bottles of ink, ledger and day books occupy the shelves and pigeonholes of the desk. Squires worked as a merchant in Hector, New York, where in 1847 he became a partner in the firm of Squires and Wilcox, a prominent mercantile business engaged in buying and selling produce for Hector and surrounding towns in Seneca and Schuyler counties.[1] Squires maintained this business with his partner Orrin Wilcox until about 1865 when federal census records begin listing him as a grain broker.

Theodore Squires was born to Selah Squires, a farmer, and his wife Rhoda on October 11, 1820 in Seneca County, now Schuyler County, New York. On December 18, 1851, he married Dora Elizabeth Wilson. The couple had two children, a son, Charles, and a daughter, Carrie. Squires died on April 17, 1888, at the age of sixty-one.[2] CME

Inscriptions/Marks: Hand printed in ink in the lower margin below the portrait is "Theodore Squires. Age [?]2 Yrs./Drawn by H. Walton. Hector. 1843." The books on the shelves beside Theodore Squires are titled LEGER and DAY BOO[K]. The first number inscribed for the subject's age is illegi-

ble. Squires would have been twenty-two years old prior to his birthday on October 11, 1843. Watermark in the primary support, "J. What[man]/Turkey [Mill]" for the Maidstone, Kent, England firm operated by the Hollingworth brothers between 1806 and 1859.

Condition: This watercolor was damaged in a fire before acquisition. It was superficially cleaned and backed with a piece of colored paper to hide paper loss at left center. In 1986, the NYSHA conservator removed some of the soot streaks from both sides and washed the paper to reduce more staining. The loss was mended and a new mat and backing were prepared.

Provenance: Albert W. Force, Ithaca, N.Y.

Exhibited: "Henry Walton, 19th Century American Artist," Ithaca College Museum of Art, Ithaca, N.Y., December 9, 1968–January 4, 1969, and exhibition catalog, p. 41, illus. as fig. 41 on p. 40.

Published: Albert W. Force, "H. Walton – Limner, Lithographer, and Map Maker," *Antiques* LXXXII (September 1962), illus. as fig. 2 on p. 284.

[1] Barbara H. Bell to NYSHA, September 30, 1985.

[2] Alice Wixson (Schuyler County Historical Society) to NYSHA, June 3, 1985.

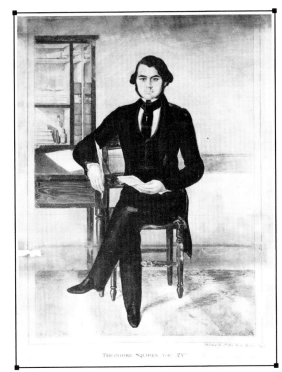

Henry Walton
Hector, New York, 1843
Watercolor with glazed highlights and ink on heavy wove paper
12″ × 9%6″
(30.5 cm × 24.3 cm)

95. *Theodore Squires*

96. *Ann E. Van Lew* N-210.70

This likeness of Ann E. Van Lew was copied by Henry Walton after a portrait of the subject rendered about 1837 when Anna was thirty-one years old. Anna Elizabeth Couch Van Lew was born on August 18, 1804, and was the daughter of Adam Couch. On December 30, 1829, she married Peter Van Lew of Lodi, New York, who was a tavern and mill owner. Anna died on April 17, 1841, seven days after the birth of her third son. A year after Anna died, her husband married Fanny Baker on June 26, 1842.[1] In 1843, Walton drew this posthumous portrait of Anna and a portrait of Peter's second wife, Fanny.[2] While Walton often varied his compositions and poses, the likenesses of the two Van Lew wives are virtually identical, with only their facial features differentiated. CME

Inscriptions/Marks: Hand printed in ink in the lower margin below the portrait is "Ann E. Van. Lew. Age. 31 yrs../Copied by H. Walton. 1843." Watermark in lower right of primary support, "J. Whatman/Turkey Mill" for the Maidstone, Kent, England firm operated by the Hollingworth brothers between 1806 and 1859.

Condition: The paper is slightly yellow and there are two light brown spots to the left and right of the head. An acid-free mat and backing have been placed in the frame.

Provenance: Albert W. Force, Ithaca, N.Y.

Exhibited: "Henry Walton, 19th Century American Artist," Ithaca College Museum of Art, Ithaca, N.Y., December 9, 1968–January 4, 1969, and exhibition catalog, illus. as fig. 43 on p. 41.

[1] Emerio R. Van Liew and W. Randolph Van Liew, *Van Liew, Van Lieu, Van Lew Genealogical and Historical Record* (Michigan, 1956); Betty Anten to NYSHA, August 4, 1985.

[2] The portrait of Fanny Baker is unlocated and is illustrated in Van Liew and Van Liew as Item N on p. 72.

FAR RIGHT
Henry Walton
Probably Lodi, New York, 1843
Watercolor with glazed
highlights and ink
on heavy wove paper
10″ × 7⅞″
(25.4 cm × 20 cm)

RIGHT
Henry Walton
Probably Groton, New York,
1845
Watercolor and ink
on heavy wove paper
10″ × 8″
(25.4 cm × 20.3 cm)

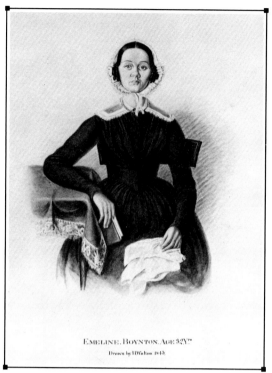

98. *Emeline Boynton*

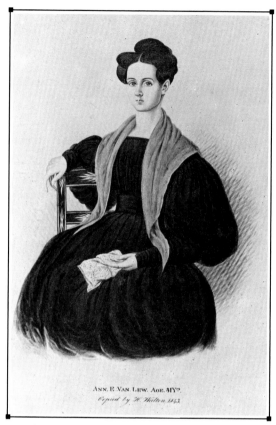

96. *Ann E. Van Lew*

97. ***Henry Boynton*** N-209.70
98. ***Emeline Boynton*** N-216.70

The Boynton portraits date from Walton's later period of watercolor portraiture. The subjects' facial features and hands are heavily shaded with strokes of brown to convey rounded form and soft contour. Mrs. Boynton's white ruffled bonnet and dress collar with delicate lace edges and the white handkerchief placed casually on her lap in rippling folds of material demonstrate Walton's ease in interpreting line and volume.

Henry Boynton and his family are cited in federal census records, dating from 1840 through 1870, as residents of Groton, Tompkins County, New York. These records indicate that Henry was born in Vermont and worked as a farmer and carpenter. His wife Emeline, and their two children Hannah and Harriet (see no. 99), were all born in Tompkins County. CME

Inscriptions/Marks: Hand printed in ink in the lower margin below the portrait of no. 97 is "Henry Boynton. Age. 39 Y.rs../Drawn by H. Walton. 1845." The title of the newspaper held in the subject's right hand is "New-Y[?]". Hand printed in ink in the lower margin below the portrait of no. 98 is "Emeline, Boynton. Age 32. Y.rs../Drawn by H. Walton. 1845." No watermarks found.

Condition: The paper is slightly yellow and there are brown stains and "tide lines" along the left and right sides of no. 97, apparently due to uneven wetting. The paper is slightly yellow, with small foxing spots scattered across the margins of no. 98. A faint "tide line" at bottom left is probably due to uneven wetting. Both portraits have had an acid-free mat and backing placed in the frame.

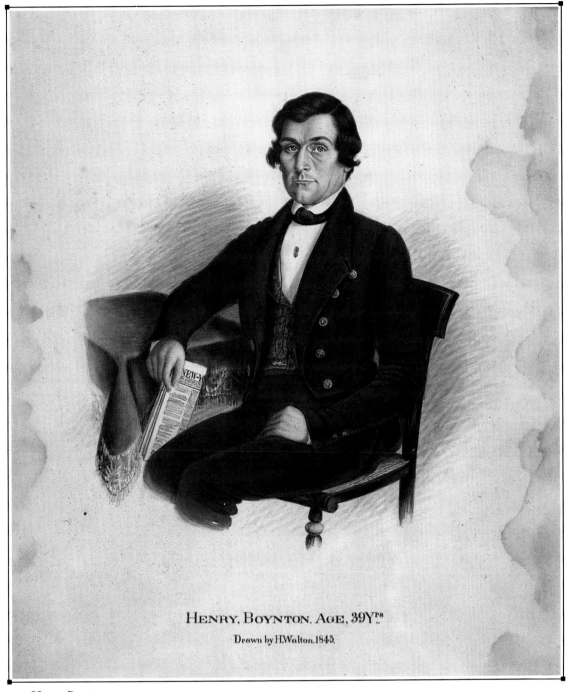

HENRY. BOYNTON. AGE, 39Y.ʳˢ

Drawn by H.Walton. 1845.

Henry Walton
Probably Groton, New York,
1845
Watercolor and ink
on heavy wove paper
10″ × 8″
(25.4 cm × 20.3 cm)

97. *Henry Boynton*

Provenance: Albert W. Force, Ithaca, N.Y.

Exhibited: NYSHA, "Rediscovered Painters of Up-state New York," June 14–September 15, 1958, and exhibition catalog, illus. as no. 70 on p. 74 and no. 72 on p. 75; "Henry Walton, 19th Century American Artist," Ithaca College Museum of Art, Ithaca, N.Y., December 9, 1968–January 4, 1969, and exhibition catalog, illus. as no. 46 and no. 47 on p. 43.

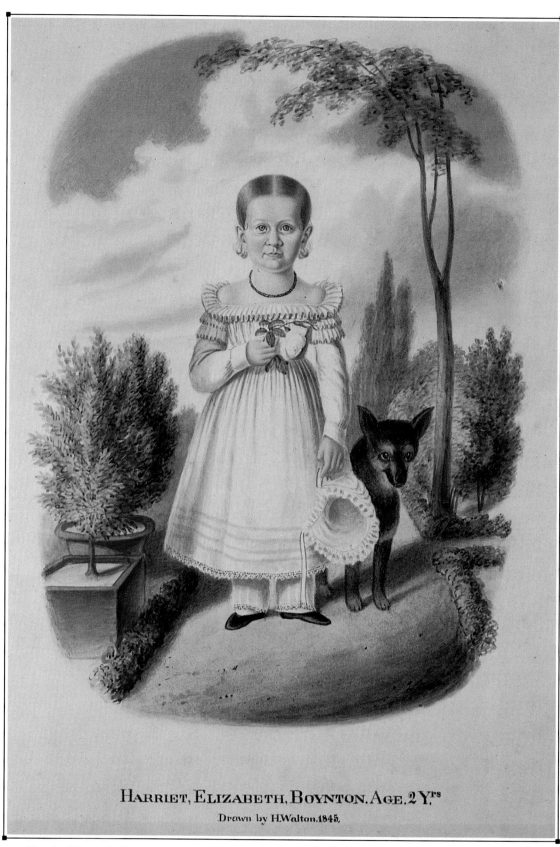

HARRIET, ELIZABETH, BOYNTON, AGE, 2 Y.rs

Drawn by H.Walton,1845,

99. *Harriet Elizabeth Boynton*

99. *Harriet Elizabeth Boynton* N-217.70

This winsome likeness of Harriet Elizabeth Boynton is one of Henry Walton's most appealing portraits. Using a lively palette, Walton drew Harriet and her dog standing on a garden path with brightly colored fall foliage. As in most of his portraits, the artist paid scrupulous attention to rendering the sitter's face, hands and hair with exacting detail and precision. The rose and bonnet in Harriet's hands are typical props that he employed to balance the composition and to demonstrate his ability at drawing hands in complex positions. CME

Inscriptions/Marks: Hand printed in ink below the lower margin below the portrait is "Harriet, Elizabeth, Boynton. Age. 2Y.rs/Drawn by H. Walton. 1845." No watermark found.

Condition: Conservation treatment by the NYSHA conservator in 1978 removed surface dirt and reduced foxing, spots and yellowing from the paper support. The watercolor was placed in a new mat and backing.

Provenance: Albert W. Force, Ithaca, N.Y.

Exhibited: NYSHA, "Rediscovered Painters of Upstate New York," June 14–September 15, 1958, and exhibition catalog, illus. as no. 71 on p. 74; "Henry C. Walton, 19th Century American Artist," Ithaca College Museum of Art, Ithaca, N.Y., December 9, 1968–January 4, 1969, and exhibition catalog, illus. as no. 45 on p. 42; "The Folk Arts and Crafts of the Susquehanna and Chenango River Valleys," Roberson Center for the Arts and Sciences, Binghamton, N.Y., February 22–June 11, 1978.

FACING PAGE
Henry Walton
Probably Groton, New York, 1845
Watercolor and ink on wove paper
10″ × 7¹⁵⁄₁₆″
(25 cm × 20.2 cm)

❖ Susan C. Waters ❖
(1823–1900)

During an artistic career that spanned almost sixty years, Susan Waters created two distinctly different bodies of work. Although she is best known for the naively rendered portraits produced at the beginning of her career, she became a successful still-life and animal painter in later life, displaying a level of proficiency rarely achieved by folk painters.

Susan Catherine Waters was born in Binghamton, New York, on May 18, 1823, the daughter of Lark and Sally Moore.[1] When she was young her family moved to Friendsville, Pennsylvania, a town southwest of Binghamton. While in Friendsville, Waters attended a female seminary with her sister. She earned their tuition by making drawings for her natural history class. She married William C. Waters, a Hicksite Quaker from Friendsville, on June 27, 1841. Encouraged by her husband, Susan pursued her artistic talents as a portrait painter.

From 1843 through 1846 Waters painted portraits in many small towns in the southern tier of New York state, including Cannonsville, Berkshire, Richford, Kelloggsville and Oxford. In the early 1850s she continued to paint and draw, and also taught art. She and her husband had some success as photographers, taking daguerreotypes and ambrotypes until the mid 1850s. They moved from Friendsville to Bordentown, New Jersey in 1852, and relocated again in 1855 to Mount Pleasant, Iowa. The couple resettled in Friendsville in 1859 and in 1866 returned to Bordentown.

In her later years Susan Waters was painting in a much more proficient manner, producing highly accomplished still-lifes and animal pictures to meet the public demand

for fashionable parlor ornaments. Waters also became involved in social and religious issues, engaging in heated religious debates and becoming active in the New Jersey Women's Suffrage Association. After her husband's death in 1893 she lived alone and devoted herself mainly to her paintings. In 1899 she moved to a Quaker home in Trenton, New Jersey, where she died on July 7, 1900.

Despite the rigors of itinerancy, Susan Waters created many memorable likenesses during her brief career as a portrait painter. She used the materials that were available to her in the rural areas in which she traveled. She painted on linen, cotton or mattress ticking stretched on simple butt-end strainers. She often nailed fabric loops to the upper member of the strainers to facilitate the hanging of her portraits.

Waters's half-length portraits of adults, rendered in somber colors of black and gray, are in marked contrast to her vibrant, full-length depictions of children. In all her portraits, however, she applied even flesh tones with few highlights, using thinly applied paint to create black shadows that model her sitter's features. This technique is particularly evident around the eyes, nose and corners of the mouth. She characteristically paid close attention to costume details, especially lace, which she described by applying small dots and thin lines of black and white over a thin layer of white paint. A noticeable change in Waters's portrait style is evident between 1844 and 1845, as the later paintings generally exhibit broader facial features and more fluid, confident outlines. PD'A

[1] The biographical information for this entry is from Colleen Heslip's catalog that accompanied the exhibition "Mrs. Susan C. Waters: 19th Century Itinerant Painter," Longwood Fine Arts Center, Longwood College, Farmville, Va., October 19–November 19, 1979.

Attributed to Susan Waters
Probably New York state,
ca. 1845
Oil on mattress ticking
Oil on canvas
30″ × 25″
(76.2 cm × 63.5 cm)

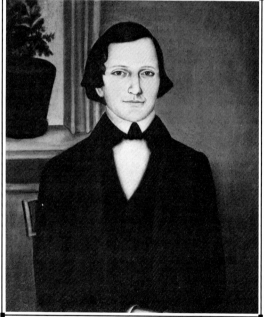

101. *Portrait of a Man*

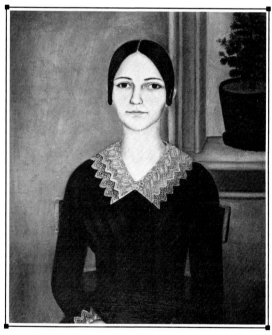

100. *Portrait of a Woman*

100. ***Portrait of a Woman*** N-61.50
101. ***Portrait of a Man*** N-62.50

The attribution of these portraits to Susan Waters is based on similarities to the signed and dated portrait of Helen Kingman.[1] They exhibit many of the stylistic features that

characterize Waters's portraits of adults. These include the firmly posed, upright figures which fill the canvas, the flat, broad shades of color in the couple's dark costumes and the gray interior walls, and the large potted plants on the windowsills. In the woman's portrait, the artist breaks up the solid areas of color by accentuating the delicate treatment of her lace collar and cuff, articulated in her usual manner of applying black dots and white highlights over a thin layer of white paint. As in Waters's other portraits executed after 1844, the sitters' faces are broader and the outlines of the figures more controlled than in her earlier work. PD'A

Condition: Conservation of these two portraits was done in 1962–1963 by Caroline and Sheldon Keck. Both had very irregular surfaces which were flattened. The woman's portrait had several old patches removed. The voids were filled with small canvas inserts. Both paintings were lined with new canvas and cleaned with organic solvents. Numerous small losses were filled and inpainted. Protective varnish was applied and the paintings were mounted on new expansion bolt stretchers.

Provenance: The Art Institute of Chicago, Chicago, Ill.

Exhibited: "The Folk Arts and Crafts of the Susquehanna and Chenango Valleys," Roberson Center for the Arts and Sciences, Binghamton, N.Y., February 22–June 11, 1978; "Mrs. Susan C. Waters: 19th Century Itinerant Painter," Longwood Fine Arts Center, Longwood College, Farmville, Va., October 19–November 19, 1979, and exhibition catalog, no. 26 and no. 27, illus. on p. 29.

Published: Colleen Cowles Heslip, "Susan C. Waters," *Antiques* CXV (April 1979), no. 100 only, p. 769, illus. as fig. 12 on p. 776.

[1] This portrait is privately owned and is illustrated in the exhibition catalog for "Mrs. Susan C. Waters: 19th Century Itinerant Painter" (see *Exhibited*), as no. 17 on p. 23. Painted in script on the verso of the portrait is "Helen Kingman/Aged 15 Years/1845/Painted by/Mrs. Susan C. Waters."

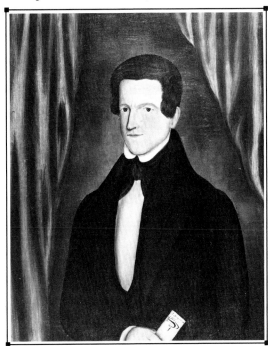

102. *A. Huggins*

Albertus D. Whitney
United States, 1839
Oil on poplar panel
29½" × 23⅛"
(75 cm × 58.7 cm)

❖ Albertus D. Whitney ❖
(active 1839)

102. *A. Huggins* N-37.60

The only known painting by the artist Albertus D. Whitney, this portrait of A. Huggins is rendered in an artistic shorthand that evinces a simplistic interpretation of the subject's appearance. Using a rather limited palette, Whitney painted the sitter's suit in black, the background in brown, and the drapery-like elements flanking Huggins in shades of brown with vertical lines of highlighted color. The pinched brow, bushy eyebrows, long nose and tightly pursed lips are features possibly more distinctive of the artist's hand than a revealing likeness of the sitter. CME

Inscriptions/Marks: Inscribed in pencil on the verso at the center is "Drawn by/Albertus D. Whitney/Dec. 1839." Inscribed in paint on the piece of paper held in the subject's right hand is "A. Huggins–/Note/Dec. 1839."

Condition: In 1960, Caroline and Sheldon Keck consolidated the cupped paint film on this panel with a synthetic resin. The surface was cleaned, losses were inpainted, and several protective coats of varnish were applied.

Provenance: Mrs. Lillian McGrath, Oswego, N.Y.

"Mr. Willson"
Amherst, New Hampshire, 1822
Watercolor and ink
on wove paper
19 ½″ × 15″
(49.5 cm × 38.1 cm)

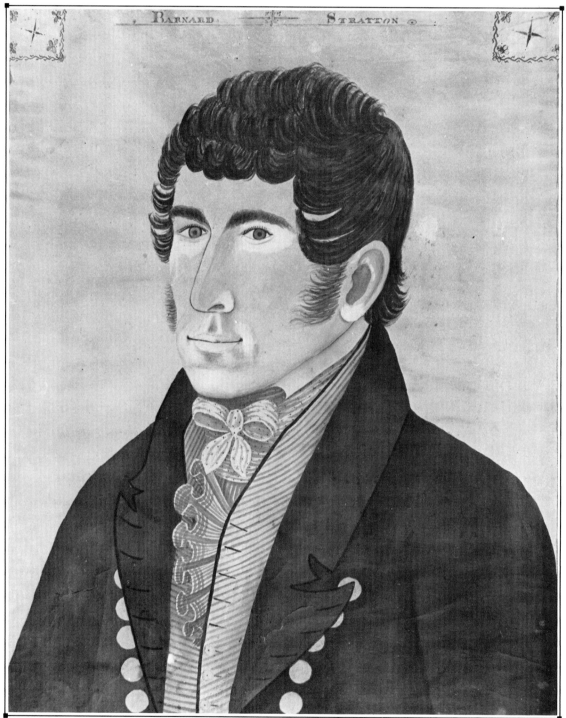

103. *Barnard Stratton*

❖ "Mr. Willson" ❖

(active 1822)

103. *Barnard Stratton* N-252.61

The signed portrait of Barnard Stratton forms the basis for attributing seven other likenesses to an elusive artist known only as "Mr. Willson." Three of these portraits have a New Hampshire provenance. Most of the subjects are depicted in bust-length, three-quarter view, with their bodies turned to the right, against a neutral background. Facial features—the profile nose, upper eyelid and mouth—are delineated with a single line of paint. Eyelashes are individually drawn in several examples and ears are rendered as oval shapes with a heavily shadowed inner ear. The artist often highlighted faces with white watercolor, which in the portrait of Barnard Stratton has become more visible against the aged paper support. Willson took special delight in the rhythmic qualities of contemporary hair styles as he transformed his subject's hair into sweeping lines and repetitive curls. He also paid close attention to costume detail, particularly the men's patterned vests, ruffled shirts and bow-tied cravats. Most sitters hold no props, although two are depicted with books, one holds a flower, another a key. Hands, when shown, are drawn stiffly and with stubby fingers. Barnard Stratton's likeness is the only instance where the artist added decorative corner blocks, and inscribed the subject's name along the upper margin of the paper.[1]

Barnard Stratton was born on August 25, 1796, the son of Jonas and Anna Barnard Stratton. On August 18, 1819, the sitter, then of Orange, Massachusetts, married Charlotte Boutelle of Amherst, New Hampshire. They settled in Amherst, and raised two children, Levi and Martha.[2] PD'A

Inscriptions/Marks: Printed in ink along the upper margin of the picture is "Barnard Stratton"; in ink in script along the lower margin of the picture is "Amherst, September, the 16. 1822 Drawn By, Mr. [] Willson. []. N.H." The primary support bears the watermark "S & C Wise/1815."

Condition: In 1967, Caroline and Sheldon Keck matted and rebacked this picture and cleaned the frame. A one inch, three-cornered tear in the coat at the bottom left was mended. The yellowing of the paper has resulted in the white highlights being much more noticeable than they were originally.

Provenance: Mr. and Mrs. William J. Gunn, Newtonville, Mass.; Miss Mary Allis, Fairfield, Conn.; Mr. Stephen C. Clark Sr., Cooperstown, N.Y.

Exhibited: NYSHA, "New-Found Folk Art of the Young Republic," 1960, and exhibition catalog, p. 34, no. 80, illus. as fig. 80; untitled exhibition, The Century Association, New York, N.Y., January 2–February 15, 1961; "The Decorative Arts of New Hampshire: 1700–1825," The Currier Gallery of Art, Manchester, N.H., July 1–September 6, 1964.

Published: Mary Black and Jean Lipman, *American Folk Painting* (New York, 1966), illus. as fig. 72 on p. 77.

[1] The recorded portraits are: the portrait of Gilman Dudley, privately owned and illus. in the catalog for the exhibition "Nineteenth Century Folk Painting: Our Spirited National Heritage, Works of Art from the Collection of Mr. and Mrs. Peter Tillou," William Benton Museum of Art, University of Connecticut, Storrs, Conn., April 23–June 3, 1973, as no. 38; the portrait of Mary Furber, owned by the Museum of Fine Arts, Boston, Mass.; the portrait of Levi Jones, owned by The Currier Gallery of Art, Manchester, N.H.; the unlocated portraits of Deacon John Searle and James N., no last name, illustrated in Sotheby Parke Bernet, Inc., *Fine Americana*, catalog for sale no. 4116, April 27–29, 1978, as lot no. 555 and lot no. 556; the portrait of a girl with corkscrew curls, owned by the Shelburne Museum, Shelburne, Vt.; the portrait of a man holding a key, privately owned; and the unlocated portrait of an unidentified gentleman, formerly in the collection of Colonel Edgar William and Bernice Chrysler Garbisch.

[2] Biographical information on the sitter is from NYSHA research files.

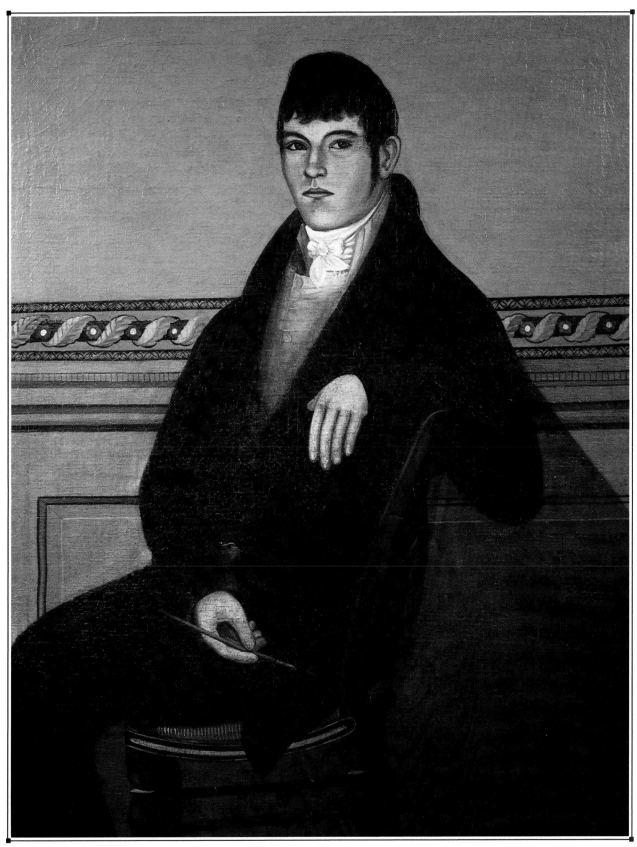

112. *The Artist*

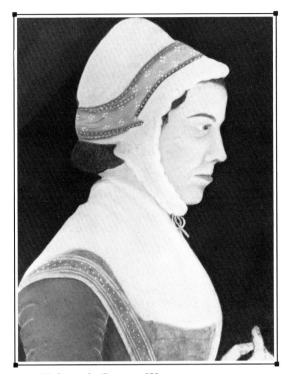

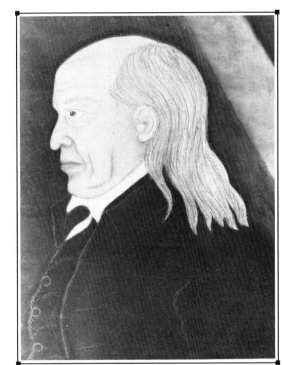

Artist unidentified
United States, ca. 1775–1800
Pastel on laid paper
24″ × 18⅞″
(61 cm × 48 cm)

105. *Eighteenth Century Woman*

104. *Eighteenth Century Man*

104. **Eighteenth Century Man** N-III.61(1)

105. **Eighteenth Century Woman** N-III.61(2)

A strong sense of character is captured by the artist in the stern, tight-lipped expressions and penetrating gazes of these sitters. However, the difficulties encountered by the portraitist in the definition of anatomical features are evident in the man's undersized ear, his oddly hooked nose, and the woman's stubby hand. Teardrop-shaped eyes with dilated pupils and the pale lines of color adding definition to costumes also seem to be distinctive stylistic traits of this unidentified hand. The man's long hair is given texture by the use of quickly drawn lines, while the woman's hair, tucked underneath her bonnet, is rendered in a tight, controlled manner. PD'A

Inscriptions/Marks: No watermarks found.

Condition: Both paper supports have been glued to gray cardboard sheets, and they are still firmly attached. Several brownish stains, probably related to the application of adhesive, were touched up by the NYSHA conservator in 1986. Acid-free mats were also placed in the frames.

Provenance: Found near Cambridge, Mass.; Mr. and Mrs. Howard Lipman, Wilton, Conn.; Mr. Stephen C. Clark Sr., Cooperstown, N.Y.

Exhibited: Untitled exhibition, The Century Association, New York, N.Y., January-February, 1952.

106. **John Wharf** N-280.61

There are at least four known stylistically related portraits of children by this hand, three of which are dated 1784.[1] In each, the subject is posed within a painted flat oval and is depicted with the left eye placed slightly higher than the right. When shown, the left ear is placed parallel to the picture plane. Other stylistic traits shared by this group in-

clude almond-shaped eyes, flat noses, small, pointed chins, cupid's-bow mouths and claw-like hands. Each subject is depicted with a personalizing accessory such as a single flower, a basket of flowers, a dog or toy bow and arrow. In the portrait of John Wharf, the paint is thickly applied throughout the entire surface, with a particularly heavy impasto employed as the white highlights of the sitter's costume. The inscriptions painted on three of these portraits cite the sitters' first and last initials in the upper corners, their ages in the lower corners and the date of execution of the portraits in the center of the lower margin. The lettering of these inscriptions suggests the work of an artist who may have had some experience or training in sign painting.

FACING PAGE
106. *John Wharf*
Artist unidentified
Probably Gloucester,
Massachusetts, 1784
Oil on fabric
24″ × 17″
(61 cm × 43.2 cm)

Although family tradition holds that this portrait was brought to Maine from Provincetown, Massachusetts, the sitter is believed to have been a member of the Wharf or Wharff family of Gloucester, Massachusetts. Vital records for Gloucester indicate that a son, Jonathan, was born to Jonathan and Priscilla Wharff on March 22, 1781, a birthdate consistent with the age cited on his portrait. This identification is substantiated by the existence of a stylistically related portrait of John Wharf's six-year-old sister Priscilla, which cites her correct age as six in 1784.[2] PD'A

Inscriptions/Marks: Printed in paint in the upper left and right corners are the letters "J." and "W.", respectively; printed in paint in the lower left and right corners are "Aged." and "3 Year", respectively; inscribed in paint at the center of the lower margin is "1784."; the name "John Whorf" reportedly appears on the strainer, which is not accessible for verification.

Condition: In 1958, Caroline and Sheldon Keck cleaned and revarnished this painting. The original strainer and frame which are attached directly with nails were retained.

Provenance: Found in Maine; Charles Buckley Smith, Worcester, Mass.; E.F. Coffin, Worcester, Mass.; Mr. and Mrs. William J. Gunn, Newtonville, Mass.; Miss Mary Allis, Fairfield, Conn.; Mr. Stephen C. Clark Sr., Cooperstown, N.Y.

Exhibited: Untitled exhibition, Albright-Knox Art Gallery, Buffalo, N.Y., May 8–15, 1959; NYSHA, "New-Found Folk Art of the Young Republic," 1960, and exhibition catalog, p. 13, no. 1, illus. as fig. 1.; untitled exhibition, The Century Association, New York, N.Y., January 2–February 15, 1961.

Published: Louis C. Jones, *Three Eyes on the Past: Exploring New York Folklife* (Syracuse, 1982), illus. on p. 149; Suzette Lane and Paul D'Ambrosio, "Folk art in the New York State Historical Association," *Antiques* CXXIV (September 1983), illus. as plate VIII on p. 524.

[1] Joyce Hill to NYSHA, March 26, 1984. The portrait of Priscilla Wharf was owned in 1960 by a descendant living in Nashua, N.H. The sitter is depicted holding a basket of flowers, and the portrait is inscribed "P.W./Aged 6 years/1784"; the portrait inscribed "J.B./Ag.d. 1 Year/1784.", representing a subject feeding a dog, is privately owned and is illus. in Sandra Brant and Elissa Cullman, *Small Folk: A Celebration of Childhood in America* (New York, 1980), as fig. 7 on p. 13; the portrait of Dorcus Lufkin is privately owned. All sitters are depicted in a three-quarter length pose, with a three-quarter view to their right. This stylistically related group of portraits is the subject of continuing research by Mrs. Hill.

[2] *Vital records of Gloucester, Massachusetts* (Salem, 1923), pp. 567, 755. Priscilla Wharf was born on September 23, 1778.

107. *Man in Blue Coat and Patterned Vest* N-19.68

The painter of this early miniature depicted the sitter with almond-shaped eyes, and defined the eyelids with a single line of black paint. The sitter's rich blue coat and light blue patterned vest contrast well with the gray-brown stippled background. PD'A

Condition: No record of previous conservation. The ivory support is slightly warped, but not broken. It has been attached to the inside of the case.

The coverglass is missing.

Provenance: Jane Marie Smith, Tucson, Ariz.

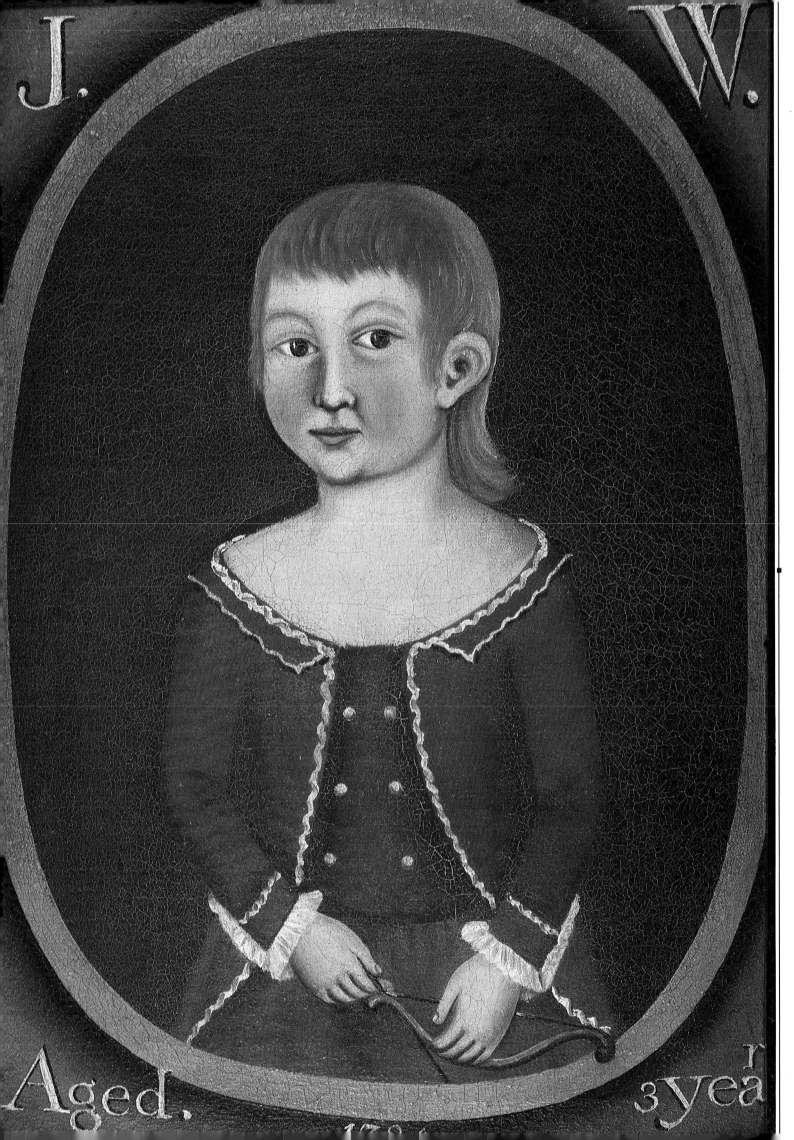

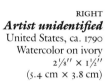

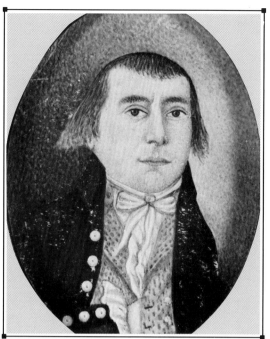

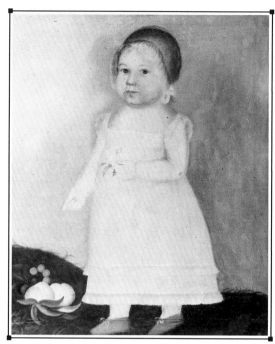

107. *Man in Blue Coat and Patterned Vest*

108. *Baby with Flowers and Fruit*

108. *Baby with Flowers and Fruit* N-251.61

This child's full cheeks and round, chubby arms suggest the artist's skill at rendering features of children's anatomy. In addition, the indented wrist and pronounced dimple at the bend of the elbow enhance the childlike appearance of this subject. However, the artist was not able to reconcile the relationship between the child's body, seen in a three-quarter view pose, and his feet, which are depicted in profile.

A colorful and visually appealing element of this portrait is the arrangement of fruit curiously located at the lower left of the composition, to which the child points. The peach, orange and purple hues of the fruit contrast well with the blue color of the originally green grassy knolls and background, and the fruit's rounded forms echo the fullness of the child's features. The child's shoes are drawn in bright orange and mark the only other area of bold color in this composition. PD'A

Inscriptions/Marks: No watermark found.

Condition: Surface dirt was removed with an air jet by the NYSHA conservator in 1983. One loose flap of paper was reattached to the fabric backing with methyl cellulose. The wood strainer was strengthened and a backing attached to it.

Provenance: Mr. and Mrs. William J. Gunn, Newtonville, Mass., Miss Mary Allis, Fairfield, Conn.; Mr. Stephen C. Clark Sr., Cooperstown, N.Y.

Exhibited: NYSHA, "New-Found Folk Art of the Young Republic," 1960, and exhibition catalog, p. 13, no. 5, illus. as fig. 5.

109. *That's My Doll* N-249.61

This picture is a rare example of depicting action and youthful mischief in non-academic portraiture of the nineteenth century. It has a lively, spontaneous quality, showing two

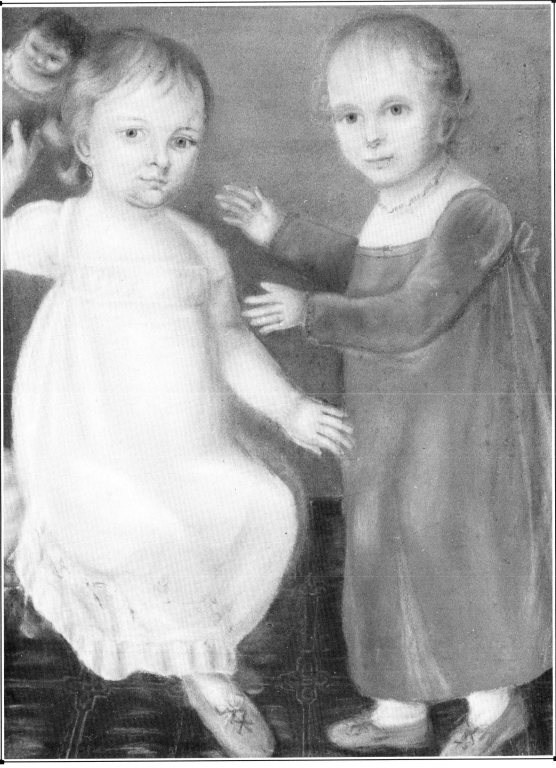

Artist unidentified
United States, ca. 1805–1810
Pastel on laid paper
30¼″ × 22½″
(76.8 cm × 57.2 cm)

109. *That's My Doll*

youngsters, who, despite their placid expressions, appear to be fighting vigorously for the possession of the doll seen in the upper left corner of the painting.

The artist skillfully drew the facial features of both youngsters, yet their poses and

gestures are stiffly rendered. The candid poses reflect an informality that may be useful in linking other portraits to this hand.[1] PD'A

Inscriptions/Marks: Penciled in script on the left member of the strainer is "Mrs. . . . Bingham/Garden St./Cambridge." No watermark found.

Condition: This piece was opened by the NYSHA conservator in 1982 because of apparent sticking of the paper to the non-glare glass. No sticking was found and virtually no pigment had been lost. Bits of dust were removed from the surface with a jet of air. The left edge of the fabric backing was reattached with copper tacks. A small amount of "inpainting" was done with new pastel over water stains along the top edge and in the hands. A new mat was inserted and new glass replaced the old "frosty" type.

Provenance: Mr. and Mrs. William J. Gunn, Newtonville, Mass.; Miss Mary Allis, Fairfield, Conn.; Mr. Stephen C. Clark Sr., Cooperstown, N.Y.

Exhibited: NYSHA, "New-Found Folk Art of the Young Republic," 1960, and exhibition catalog, p. 13, no. 4, illus. as fig. 4.

Published: Louis C. Jones, *Three Eyes on the Past: Exploring New York Folklife* (Syracuse, 1982), illus. on p. 154.

[1] A portrait titled *Children with Dog,* executed in oil, in which the poses of the children here are very nearly mirrored, is illustrated in *Antiques* CXIX (March 1981), on p. 547. Its present location is unknown. Another unlocated portrait which may prove vital to future research on this artist is a stylistically similar pastel portrait of Abby Ann Duchesne, signed by Margaret Byron Doyle and dated 1814. It is illustrated in an undated catalog for the George Schoellkopf Gallery, New York, N.Y. (Reproduced on the cover of this catalog is an oil painting titled *Little Girl with Rag Doll,* artist unidentified.) No body of work by Doyle is yet available for comparative study.

110. *The Mariner* N-299.61

FACING PAGE
110. *The Mariner*
Artist unidentified
United States, ca. 1810–25
Oil on canvas
30¼″ × 25¾″
(76.9 cm × 65.4 cm)

The telescope held in this man's left hand and the sailing vessel barely visible over his right shoulder are nautical symbols commonly employed in portraiture to convey a subject's seafaring occupation. A series of eye-pleasing designs are formed by the oval shapes that are repeated throughout the portrait, from the painted spandrels which create an oval niche for the sitter, to the outline of the subject's face, eyes and ear as well as the swagged drapery. This strong visual rhythm is enhanced by the rich red color of the drapery and the sitter's flushed cheeks. PD'A

Condition: This painting had several old mends, repaint, and a thick coat of dark yellow varnish when it was treated in 1959 by Caroline and Sheldon Keck. It was cleaned, lined, inpainted and put on a new stretcher. In 1967, the canvas was keyed out and revarnished.

Provenance: Mr. and Mrs. William J. Gunn, Newtonville, Mass.; Miss Mary Allis, Fairfield, Conn.; Mr. Stephen C. Clark Sr., Cooperstown, N.Y.

Exhibited: NYSHA, "New-Found Folk Art of the Young Republic," 1960, and exhibition catalog, p. 14, no. 10, illus. as fig. 10; untitled exhibition, The Century Association, New York, N.Y., January 2–February 15, 1961; untitled exhibition, Roberson Center for the Arts and Sciences, Binghamton, N.Y., November 1–December 15, 1961; untitled exhibition, Union College Art Gallery, Schenectady, N.Y., January-March 1962.

Published: A. Bruce MacLeish, "Paintings in the New York State Historical Association," *Antiques* CXXVI (September 1984), illus. as plate IV on p. 592.

111. *Mary P. Dakin* N-21.64

To date, at least eight other portraits by this hand have been recorded, including two found in New York state and five with a Pennsylvania provenance. All are painted on wood panel and depict the subjects in half-length profile. They are marked by delicate

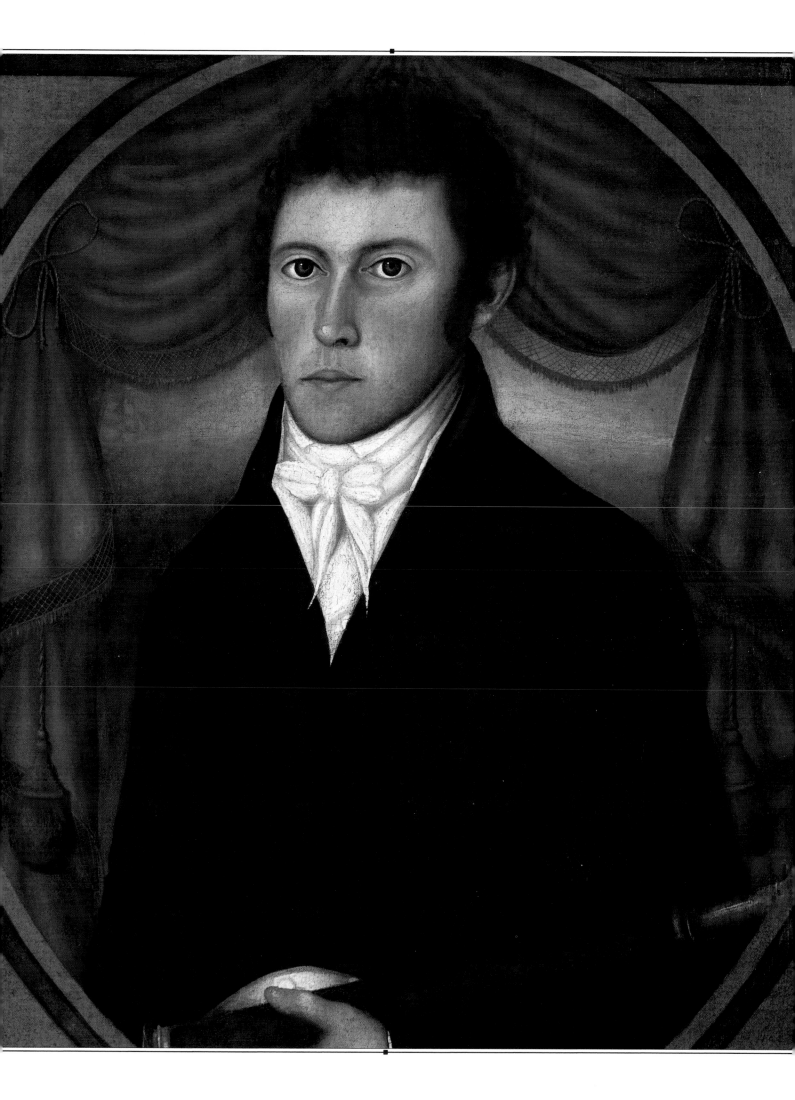

and precise brushwork in the faces and thickly painted, more quickly rendered costumes. Several of the paintings exhibit a similar sloppy treatment of the outside edge of the oval border evident in this portrait, an unfinished area no doubt intended to be covered by a spandrel frame or églomisé mat.[1]

The little girl in this portrait was born Mary Pierce Mumford on February 8, 1809 in Cayuga, New York. Mary's father, Thomas Mumford, was a surrogate judge in Onondaga County, New York, president of the Bank of Auburn and a land speculator in the Rochester area.[2]

In 1825, Mary attended Emma Willard's Female Seminary in Troy, New York. On September 6, 1827 she married Samuel Dana Dakin, a lawyer and member of a prominent Utica, New York, family. For many years, the couple lived in New York City where they raised five sons and one daughter. Following the death of her husband in 1853, Mary Pierce Dakin moved to Freeport, Illinois where she lived with her relatives. She died there on February 20, 1863 and was buried in Utica, New York.[3] PD'A

Inscriptions/Marks: Printed in pencil at lower left is "December 1811"; in penciled script at lower right is "Cayuga"; in penciled script on the verso at the upper left corner is "Mary P. Dakin."

Condition: In 1963, Caroline and Sheldon Keck cleaned the portrait and inpainted a few scratches and one paint loss. An additional support was loosely attached to the reverse of the very thin panel.

Provenance: Mrs. Katherine Dakin, Seattle, Wash. (descendant of the sitter).

Exhibited: "Early American Folk Art," Rensselaer County Historical Society, Troy, N.Y., October 2–November 28, 1967; "Remember the Ladies," Pilgrim Society, Plymouth, Mass., May 13, 1976–July 1, 1977.

[1] These include a portrait of the sitter's brother, Elihu Hubbard Smith Mumford, owned by the Wadsworth Atheneum, Hartford, Conn., similarly inscribed "December 1811" and "Cayuga, N.Y." and attributed to Jacob Eichholz; *Woman in Profile*, owned by the Abby Aldrich Rockefeller Folk Art Center, Williamsburg, Va.; *Lydia Thomas, Mrs. George Thomas* and *General George Thomas*, privately owned and illustrated in the catalog for the exhibition "Nineteenth Century Folk Painting: Our Spirited National Heritage, Works of Art from the Collection of Mr. and Mrs. Peter Tillou," William Benton Museum of Art, University of Connecticut, Storrs, Conn., April 23–June 3, 1973, as fig. 18, fig. 19 and fig. 20, and cited with a Pennsylvania provenance. These three portraits are illustrated without the spandrel frames in *Kennedy Quarterly* IX (December 1969), as no. 185, no. 186 and no. 187 on p. 190; an unidentified man and woman owned by the National Gallery of Art, Washington, D.C. and also with a Pennsylvania provenance; and a portrait of an unidentified woman illustrated in an advertisement for John Gordon Antiques and Fine Arts in *Connoisseur* (July 1970).

[2] James Gregory Mumford, M.D., *Mumford Memoirs* (Boston, 1900), p. 183; Jane Speakes Shadel, "Samuel Dana Dakin, Esq. 1802–1853," (M.A. Thesis, State University of New York College at Oneonta, 1965), p. 4.

[3] *Emma Willard and Her Pupils, or Fifty Years of the Troy Female Seminary, 1822–1872.* (New York, 1898), p. 85.

112. ***The Artist*** N-275.61 (1)
113. ***The Artist's Wife*** N-275.61 (2)

The variety of decoration included on the fancy Sheraton chairs and the expertly painted borders on the walls in these two portraits suggest the work of an ornamental painter using the medium of portraiture to convey his skill and versatility with the brush. This theory may explain the differences between the two portraits in the height of the chair rail, the style of the paneling and the wall texture. The lady's right arm was originally draped over the arm of the chair, but was repositioned by the artist, perhaps to show more of the painted embellishment.

These portraits clearly stand out in contrast to the more simple, straightforward likenesses of middle-class sitters commonly produced by untrained artists during this period. The bright yellow walls, the unusually large canvases, the stylish clothing of the

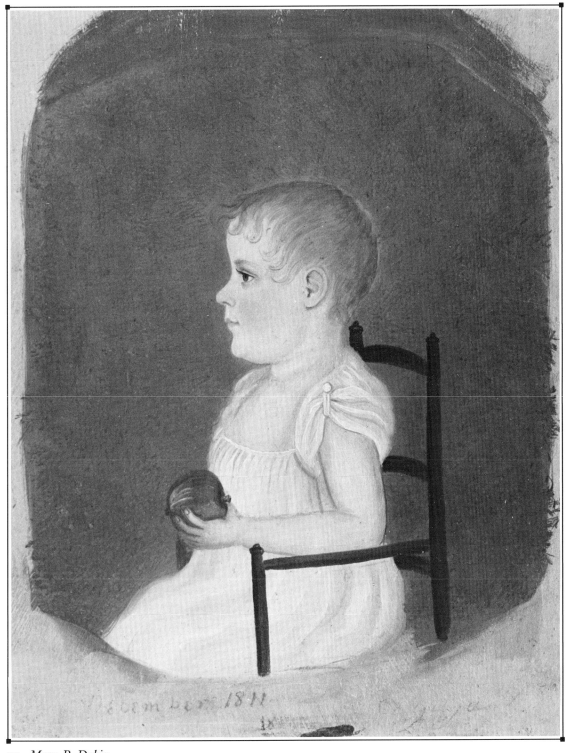

Artist unidentified
Probably Cayuga, New York,
1811
Oil on tulipwood panel
8⅛″ × 6¾″
(21.3 cm × 17.2 cm)

III. *Mary P. Dakin*

sitters and the look of condescension and arrogance on the man's face all lend a strong sense of presence and an air of opulence to these portrait compositions. PD'A

Condition: Restoration on no. 112 at an unknown date included repairing a large hole in the fore- head and mounting the canvas on a pressed wood panel with glue. There was extensive overpaint.

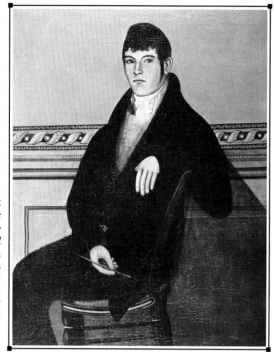

112. *The Artist*

RIGHT AND FACING PAGE
112. *The Artist*
113. *The Artist's Wife*
Artist unidentified
United States, ca. 1815
Oil on canvas
44½″ × 35″
(113 cm × 89 cm)
FULL COLOR REPRODUCTION OF
The Artist ON PAGE 165

In 1959, Caroline and Sheldon Keck strengthened the warped panel and cleaned, filled and inpainted losses. At some time before acquisition, no. 113 was lined with fabric and glue, punctures were mended, and the surface was cleaned and extensively inpainted, especially the background. In 1959, Caroline and Sheldon Keck replaced the lining with new fabric, cleaned the surface, and filled and inpainted losses to improve the appearance.

Provenance: Mr. and Mrs. William J. Gunn, Newtonville, Mass.; Miss Mary Allis, Fairfield, Conn.; Mr. Stephen C. Clark Sr., Cooperstown, N.Y.

Exhibited: NYSHA, "New-Found Folk Art of the Young Republic," 1960, and exhibition catalog, p. 13, no. 6 and no. 7, illus. as fig. 6 and fig. 7; untitled exhibition, The Century Association, New York, N.Y., January 2–February 15, 1961; "Folk Art from Cooperstown," Museum of American Folk Art, New York, N.Y., March 21-June 6, 1966; "The Flowering of American Folk Art, 1776–1876," Whitney Museum of American Art, New York, N.Y., February 1–September 15, 1974.

Published: Jean Lipman and Alice Winchester, *The Flowering of American Folk Art, 1776–1876* (New York, 1974), illus. as no. 16 and no. 17 on p. 27; A. Bruce MacLeish, "Paintings in the New York State Historical Association," *Antiques* CXXVI (September 1984), illus. as plate VII and plate VIII on p. 595.

114. *Mrs. Starke's Brother of Troy* N-253.61

Depicted in a nearly full-length pose, this child holds a toy hammer in his right hand while engaging the viewer with a direct frontal gaze. The original appearance of this portrait has changed over time, as the once subtle highlights on the sitter's face, wrists and fingernails have become more pronounced by the aging and yellowing of the paper support. The resulting white patches are visually pleasing and seem to compliment the bright orange and white colored garment worn by the child. In addition to the white highlighting, this unidentified artist's style is marked by a sensitive delineation of delicate facial features, rendering the subject with unusually large eyes, a full mouth, and a closed hand which tapers toward a pointed thumb. Although the specific identification of this sitter remains undetermined, one other portrait has been documented as probably by this same hand. This portrait of a male child is privately owned. PD'A

Inscriptions/Marks: Penciled in script on the upper member of the frame is "1820/Mrs. Starke's Brother of Troy." Also penciled in script on the upper member of the frame is "No./3110." No watermark found.

Condition: An acid-free mat and backing were placed in the frame by the NYSHA conservator in 1986.

Provenance: Mr. and Mrs. William J. Gunn, Newtonville, Mass.; Miss Mary Allis, Fairfield, Conn.; Mr. Stephen C. Clark Sr., Cooperstown, N.Y.

Exhibited: Untitled exhibition, Albright-Knox Art Gallery, Buffalo, N.Y., May 8–15, 1959; NYSHA, "New-Found Folk Art of the Young Republic," 1960, and exhibition catalog, p. 14, no. 9, illus. as

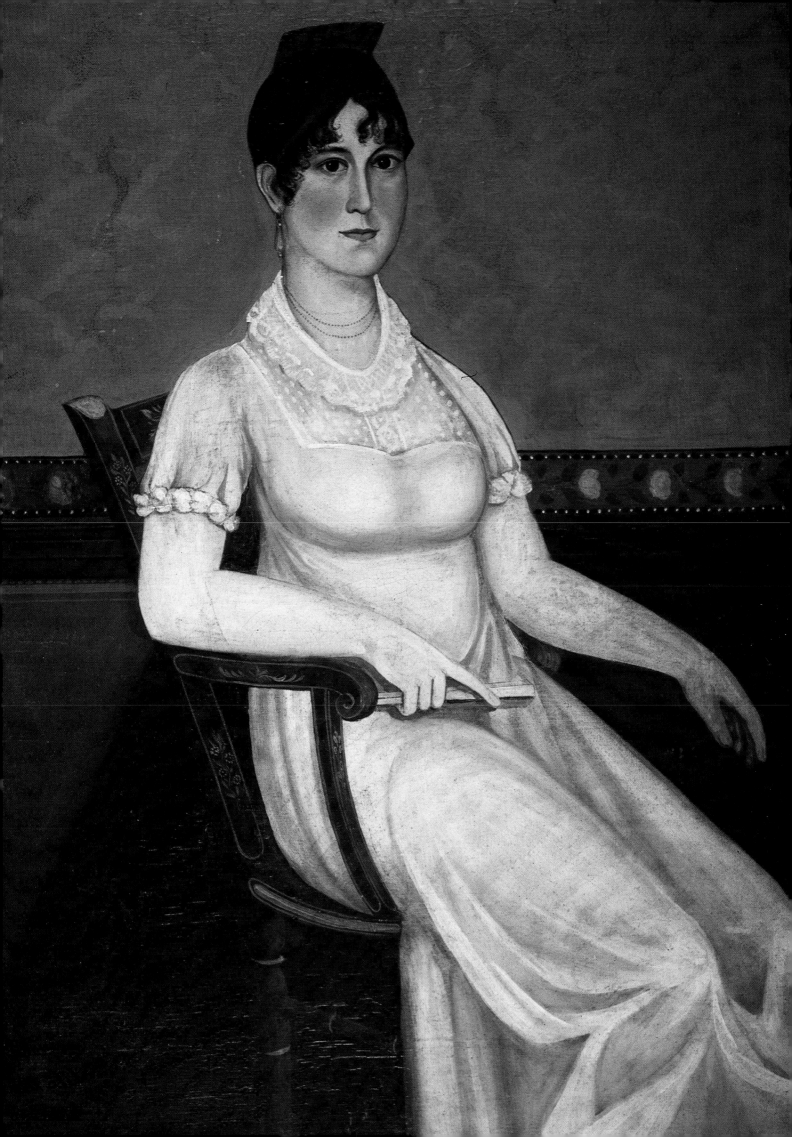

fig. 9; "Folk Art," Roberson Center for the Arts and Sciences, Binghamton, N.Y., September 15, 1966–April 1, 1967.

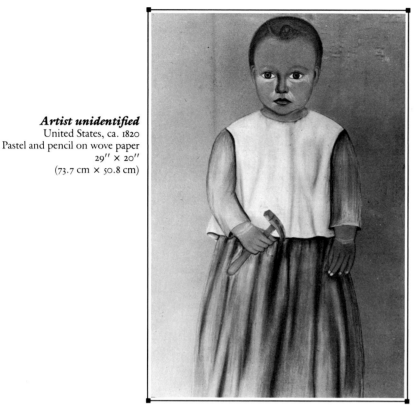

Artist unidentified
United States, ca. 1820
Pastel and pencil on wove paper
29″ × 20″
(73.7 cm × 50.8 cm)

114. *Mrs. Starke's Brother of Troy*

FACING PAGE
115. *Boy in Gray Suit with Dog*
Artist unidentified
United States, ca. 1820
Oil on canvas
44″ × 26⅜″
(111.7 cm × 67 cm)

115. *Boy in Gray Suit with Dog* N-270.61

This lively full-length portrait exhibits wonderful child-like impishness in the boy's facial expression and posture. The young subject stands next to a table in a dark interior scene, holds an open book in his right hand and grasps the ear of his playful dog with the left. His pudgy face, reddish flesh tones and slight smile evince a childishness rarely communicated in folk portraiture. The artist's inability to render anatomy realistically is evident in the boy's short neck, hunched shoulders and stiff legs, all of which happily contribute to the youthful exuberance of this figure. Adding to the portrait's visual appeal are the fashionable Titus or Brutus hair style and the gray pearlescent, high-waisted Empire suit, both features deriving from the popular French modes of the Napoleonic era in vogue during the early nineteenth century in America. Another attractive feature is the curious heart-shaped white spot on the dog's side. The artist clearly had some awareness of the properties of light, as the placement of shadows and the shiny reflections on the boy's shoes indicate a single light source emanating from the right side of the picture.[1] PD'A

Condition: Small tears were previously repaired by lining the painting with glue and canvas and overpainting the damaged edges. In 1958, Caroline and Sheldon Keck removed layers of dirt and very dark varnish. Some old inpainting was also removed and the areas of loss were filled and inpainted. The old lining and stretcher were judged sound and were left.

Provenance: Mr. and Mrs. William J. Gunn, Newtonville, Mass.; Miss Mary Allis, Fairfield, Conn.; Mr. Stephen C. Clark Sr., Cooperstown, N.Y.

Exhibited: Untitled exhibition, Albright-Knox Art Gallery, Buffalo, N.Y., May 8–15, 1959; NYSHA, "New-Found Folk Art of the Young Republic," 1960, and exhibition catalog, p. 14, no. 8, illus. as

fig. 8; untitled exhibition, The Century Association, New York, N.Y., January 2–February 15, 1961; "Childhood Long Ago," The IBM Gallery, New York, N.Y., February 1–March 6, 1965.

Published: George R. Clay, "Children of the Young Republic," *American Heritage* XI (April 1960), p. 46, illus. on p. 47.

[1] Stylistic similarities exist between this portrait and the work of artist Nathaniel Wales (active 1803–1815). Two signed portraits by Wales depicting Captain and Mrs. Nathan Sage are privately owned and are illustrated in Nina Fletcher Little, *Paintings by New England Provincial Artists 1775–1800* (Boston, 1976), on p. 171 and p. 173.

116. *Presenting Baby* N-55.61

Recent examination has led to the conclusion that this composition is basically original and intact, conflicting with the long-standing theory that the canvas was cut down from a larger picture. The composition itself seems to support this evidence, as the arms project so far into the scene that the woman holding the baby would have to be at full arm's length for her not to be included in this picture. Taken as it appears, this high-spirited portrait reflects a timeless sense of parental pride in the newest addition to the family. PD'A

Artist unidentified
United States, possibly Rhode Island, ca. 1825–1850
Oil on canvas (transferred)
20″ × 14″
(50.8 cm × 35.5 cm)

116. *Presenting Baby*

Condition: Extensive treatment and examination by Caroline and Sheldon Keck in 1965 revealed that this painting had been transferred to its present support from another canvas. A heavy coat of glossy varnish was removed, revealing extensive in-paint and overpaint. Original layers, where visible, seem to be extensively abraded and dirty. The painting was infused with wax-resin adhesive to consolidate the structure. No additional cleaning has been attempted. In 1983, X-radiographs were taken by the NYSHA conservator. These indicate that the painting was not cut down in width.

Provenance: Found in Rhode Island; Mr. and Mrs. Howard Lipman, Wilton, Conn.; Mr. Stephen C. Clark Sr., Cooperstown, N.Y.

Exhibited: "American Children," Harry Stone Gallery, New York, N.Y., 1943; "From the Cradle," The New-York Historical Society, New York, N.Y., November 1948, and exhibition catalog, illus. on cover.

Published: *American Collector,* August 1945; "The Paintings," [New York State Historical Association Issue], *Antiques* LXXV (February 1959), illus. on p. 172.

117. *Baby with a Miniature* N-532.61

The rich colors used in this modest portrait, particularly the blue and white of the costume and the orange of the child's hair, stand out against the gray-brown color of the background. In addition, a bluish tint is visible in the flesh tones and in the young sitter's eyes. Carefully rendered details include the attractive miniature profile portrait of

Artist unidentified
United States, ca. 1825–1850
Oil on wood panel
19¾″ × 16½″
(50.2 cm × 41.9 cm)

117. *Baby with a Miniature*

a man framed in a locket strung on a seemingly adult-size necklace, the red painted child's chair, and the meticulously worked lace on the edge of the child's apron. The artist's limited ability in handling perspective is suggested by the placement of the chair arms parallel to the picture plane. PD'A

Condition: In 1961, Caroline and Sheldon Keck cleaned the panel. A few small losses were filled and inpainted.

Provenance: Mr. and Mrs. William J. Gunn, Newtonville, Mass.; Miss Mary Allis, Fairfield, Conn.; Mr. Stephen C. Clark, Cooperstown, N.Y.

Artist unidentified
United States, ca. 1830
Watercolor and pencil
on laid paper
5¼″ × 4¼″
(13.4 cm × 10.9 cm)

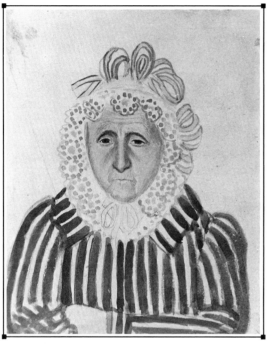 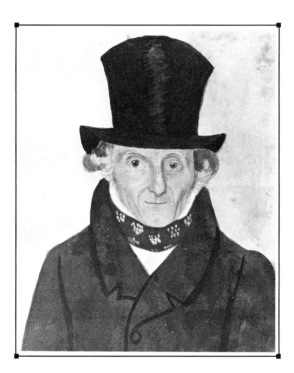

118. *Old Lady and Gentleman*

118. *Old Lady and Gentleman* N-353.61 a & b

These sitters' expressive faces are drawn with a level of skill that suggests a semi-trained artist. The subjects exhibit contrasting facial expressions; the gentleman's face is alert and smiling while the woman's is tired and drawn. Rapidly applied dots and lines of color were employed by the artist to decorate the portraits, as evident on the woman's brown dress and bonnet and the man's blue patterned stock. PD'A

Inscriptions/Marks: No watermarks found.

Condition: The NYSHA conservator cleaned the paper supports, which were dirty and stained, and put them into acid-free mats and backings in 1987. The paper is somewhat yellowed and there is a diagonal scratch on the lady's portrait, near the left edge.

Provenance: Mr. and Mrs. Howard Lipman, Wilton, Conn.; Mr. Stephen C. Clark Sr., Cooperstown, N.Y.

Exhibited: "Primitives," Union College Art Gallery, Schenectady, N.Y., March 1951.

119. *Gentleman in a Yellow Vest* N-1.62

A number of this portrait's stylistic attributes closely relate to the work of both Milton Hopkins and Noah North, raising the possibility that this portrait could have been executed by a painter who was familiar with the works of one or both artists. Strong similarities to Hopkins and North include the meticulous rendering of the floral pattern on the vest, the treatment of the enveloping shirt collar, and the thick white paint dabbed on the shirt buttons. Also, the bold colors of the man's reddish face and brightly pat-

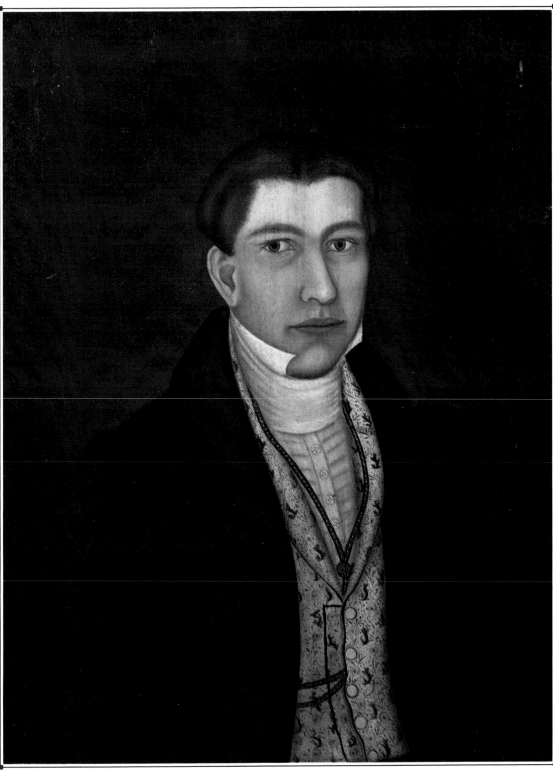

Artist unidentified
United States, ca. 1830
Oil on wood panel
27″ × 21⅛″
(68.6 cm × 53.7 cm)

119. *Gentleman in a Yellow Vest*

terned vest contrast with the dark brown background and black jacket in a manner that is reminiscent of both artists. The man's distorted facial features, particularly his eyes and mouth, are not consistent with the convincing natural form regularly attained by both Hopkins and North. In addition, the man's ear is not painted with the smoothly curving interior D-shaped area evident in the works of both artists. Further investigation is needed to determine whether or not this portrait can be linked stylistically with the work of other artists who were in contact with Hopkins or North. PD'A

Inscriptions/Marks: On the verso is a chalk sketch of a man.

Condition: The panel was cleaned in 1962 by Caroline and Sheldon Keck. Inpainting was done on a few scratches and some of the very extensive shrink-crackle which had developed on the surface. The reverse of the panel was coated to reduce reaction of the wood to changes in relative humidity.

Provenance: Mary Ellen Williams, Sidney, N.Y.

Artist unidentified
Probably Columbia,
Connecticut, ca. 1830–1835
Watercolor on wove paper
4″ × 3″
(10.2 cm × 7.6 cm)

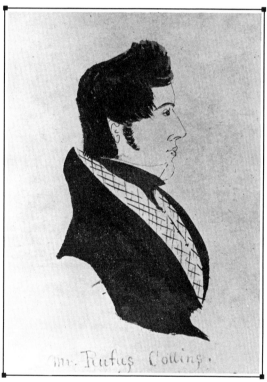

120. *Mr. Rufus Collins*

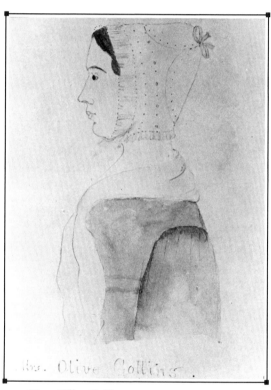

121. *Mrs. Olive Collins*

120. **Mr. Rufus Collins** N-90.61 (1)
121. **Mrs. Olive Collins** N-90.61 (2)

These miniatures display some carefully rendered details, such as Rufus Collins's patterned vest and his wife's white linen bonnet decorated with a combination of tiny black dots and circles and a ruffled edge. This artist utilized the same shade of pink in the two ribbons on Mrs. Collins's bonnet and scarf and in the delicately flushed cheeks and lips of both sitters. Rufus Collins was born probably in Columbia, Tolland County, Connecticut, around 1794. Olive Potter Collins was born on February 16, 1807 in Sterling,

Connecticut, the daughter of James and Esther Perry Potter. They were married in neighboring Plainfield on December 19, 1830. The 1850 federal census for Connecticut lists Rufus Collins as a farmer living in Columbia with his wife Olive and their six children. An 1832 cemetery inscription indicates that one other child died in infancy. Mr. Collins died on April 27, 1883, and Mrs. Collins on May 19, 1894. They are buried in Center Cemetery in Columbia.[1] PD'A

Inscriptions/Marks: In ink in script along the lower margin of no. 120 is "Mr. Rufus Collins"; in ink in script along the lower margin of no. 121 is "Mrs. Olive Collins." No watermarks found.

Condition: No record of previous conservation. The paper supports have yellowed slightly, in a mottled pattern.

Provenance: Found in eastern Connecticut; Mr. Frederick Fairchild Sherman, Westport, Conn.; Mr. and Mrs. Howard Lipman, Wilton, Conn.; Mr. Stephen C. Clark Sr., Cooperstown, N.Y.

Exhibited: Untitled exhibition, The Century Association, New York, N.Y., January-February, 1952;

untitled exhibition, Shakertown at Pleasant Hill, Harrodsburg, Ky., August 9–October 7, 1976.

Published: "American Antiques: Notes on Colonial and Early American Furniture, Silver, Needlework, Portraiture, Silhouettes, Pewter, Engravings, Glass, China and other Arts and Crafts," *Art in America* XI (June 1923), pp. 208–9, illus. on p. 209; Frederick Fairchild Sherman, "American Miniatures by Minor Artists," *Antiques* XVII (May 1930), illus. as fig. 6 and fig. 7 on p. 423.

[1] Judith Ellen Johnson (The Connecticut Historical Society) to NYSHA, December 12, 1985.

122. *Martha Read Warren* N-379.61
123. *Caroline Augusta Warren* N-380.61

These two young girls are seated at opposite ends of what appears to be the same sofa and are portrayed wearing identical red dresses with black aprons. The artist outlined the girls' eyes, noses and necks in heavy brown shading to add depth and softness to their features. In Martha's portrait the eyes are outlined by a single line of brown paint, while in both likenesses the shaded area around the eyes curls outward at the temple. A single line of dark brown paint gives definition to the lips and quickly applied dabs of yellow pigment highlight the belt buckles and the brass tacks along the edges of the sofa. Despite these distinctive characteristics, stylistic comparisons with other portraits have yielded only one other related work.[1]

The earrings, belt buckles and hand-held props embellishing this pair complement the bold linear patterns created by the ridges, lines and folds of the girls' costumes. The black aprons, with their zig-zag edges, add visual appeal to the portraits and provide a dark background against which the rose and cherries in the girls' hands stand out. The billowy sleeves of the dresses enhance the decorative quality of these portraits and provide a solution to the artistic problem of connecting the girls' arms convincingly to their shoulders. Research in genealogical records has not conclusively determined the identities of these girls.[2] PD'A

Inscriptions/Marks: Painted in script along the upper margin of the verso of no. 122 is "Martha Read Warren/AE 7 – 1834"; painted in script along the upper margin of the verso of no. 123 is "Caroline Augusta Warren. AE 10. 1833." Penciled in

script along the left member of the strainer of no. 123 is "$50.00 Mr. Moore's office."

Condition: No. 122 suffered from active cleavage of the paint layer when it was consolidated and

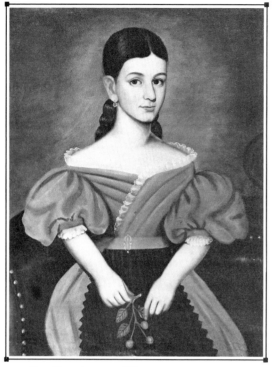

RIGHT AND FACING PAGE
Artist unidentified
United States, 1833–1834
Oil on canvas
30″ × 24″
(76.2 cm × 61 cm)

123. *Caroline Augusta Warren*

lined by Caroline and Sheldon Keck in 1967. The surface was cleaned, losses were filled and inpainted and it was placed on a new stretcher. In 1986, the NYSHA conservator cleaned and varnished no. 123. A large paint drip that ran across the top edge was removed.

Provenance: Mr. and Mrs. William J. Gunn, Newtonville, Mass.; Miss Mary Allis, Fairfield, Conn.; Mr. Stephen C. Clark Sr., Cooperstown, N.Y.

Exhibited: Untitled exhibition, New York State Teachers Association, Elnora, N.Y., March 27–April 1, 1967, no. 122 only.

[1] A similar portrait titled *Lady with a Yellow Bow* is unlocated and is illustrated in *The Old Print Shop Portfolio* 1, no. 8 (April 1942), as fig. 1 on p. 4.

[2] According to the records at the Mormon Genealogical Research Center in New York, N.Y., and Walter V. Hickey (Samuel S. Pollard Memorial Library) to NYSHA, September 18, 1986, Martha R. Warren married James W. Bailey on June 4, 1846 in Boston, Mass., and Caroline Augusta Warren married Benjamin Green Smith on June 22, 1843 in Townsend, Mass. However, these marriages cannot be located in Massachusetts vital records.

124. *Lucretia Stewart Brownson* N-122.57
125. *Simeon Brownson* N-123.57

These simple, straightforward likenesses include few details to distract the viewer's attention from the sitters' faces, which are modeled convincingly and clearly dominate the dark canvases.

According to information supplied by the donor, Lucretia Stewart Brownson (1799–1889) was born in Cooperstown, New York, the daughter of John and Phoebe Castle Stewart. She may have been the second wife of Simeon Brownson (1779–1852). However, this information cannot be verified in local genealogical or census records. PD'A

Condition: In 1976 the NYSHA conservator lined no. 124 with new canvas. The surface was cleaned and a few small losses were filled and inpainted. Protective coats of varnish were applied. The canvas of no. 125 is undamaged. The paint has nine tiny flake losses (left center, left of the face, in the hair and right center). The surface appears to be clean and unvarnished.

Provenance: Mrs. Florence Brownson Hays, Niagara Falls, N.Y. (descendant of the sitters).

126. *Enigmatic Foursome* N-257.61

Rarely in folk art does one find a group portrait that does not represent family members. The relationship in this odd assortment of individuals has not been established, although it has been suggested that they may have been a traveling theatrical troupe.[1] During the 1830s and 1840s, numerous small theatrical troupes, often including one black performer, traveled to America's cities and towns presenting plays and performing skits. Until more documentation concerning this painting is found, however, the connection to the theater remains speculative.

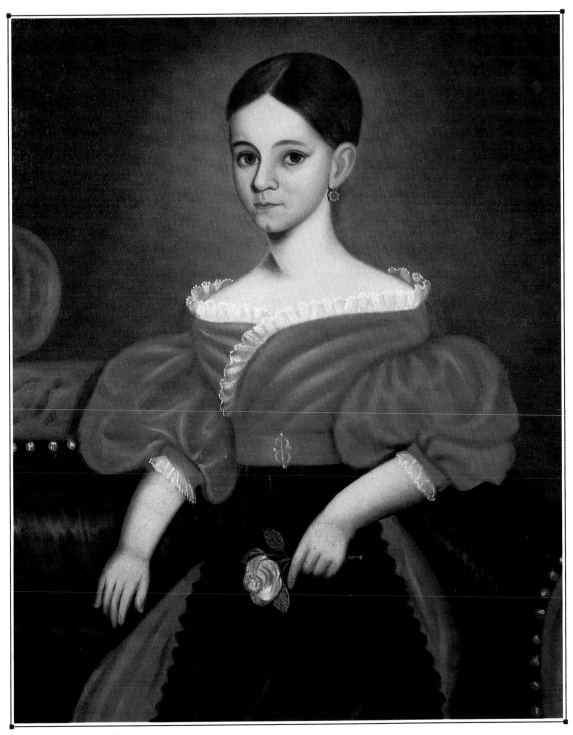

122. *Martha Read Warren*

In an era when the vast majority of portrait subjects were depicted with facial features expressing solemnity and seriousness, the exuberant expression of the laughing redheaded man stands out in contrast. This man's expression, the placement of the four heads in a circular composition, and the inclusion of the black man in the group all make this a mysterious and compelling picture. PD'A

Artist unidentified
Possibly New York state, ca. 1835
Oil on canvas
32¼″ × 26¼″
(82 cm × 66.7 cm)

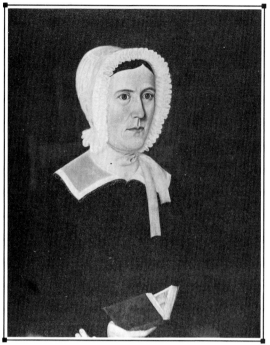

124. *Lucretia Stewart Brownson*

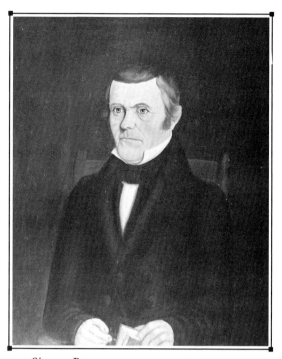

125. *Simeon Brownson*

Artist unidentified
United States, ca. 1835–50
Oil on canvas
28″ × 24¼″
(71.1 cm × 61.5 cm)

126. *Enigmatic Foursome*

Condition: Treatment in 1958 by Caroline and Sheldon Keck included repairing acute cracking, lining, filling and inpainting small losses.

Provenance: Mr. and Mrs. William J. Gunn, Newtonville, Mass.; Miss Mary Allis, Fairfield, Conn.; Mr. Stephen C. Clark Sr., Cooperstown, N.Y.

Exhibited: NYSHA,"New-Found Folk Art of the Young Republic," 1960, and exhibition catalog, p. 17, no. 20, illus. as fig. 20; untitled exhibition, Bowdoin College Museum of Art, Brunswick, Me., April–July 25, 1964, and exhibition catalog, no. 14; "Folk Art," Roberson Center for the Arts and Sciences, Binghamton, N.Y., September 15, 1966–April 1, 1967; "The Portrayal of the Negro in American Art," Forum Gallery, New York, N.Y., September 1–October 8, 1967, and exhibition catalog, no. 5.

[1] This idea was first articulated by Louis C. and Agnes Halsey Jones in the catalog for the NYSHA exhibition "New-Found Folk Art of the Young Republic," p. 17 (see *Exhibited*).

127. *Curls and Scallops* N-261.61

A strong rhythmic pattern is evident in the curves and folds of the child's dress, making this an eye-catching portrait. The large brown eyes and distinctively flat anatomical features and costume details may one day link other portraits to this hand. In addition, the artist exhibited an inability to render hands, as one is placed behind the rose leaf and the other is unconvincingly wrapped around and curled beneath the book. PD'A

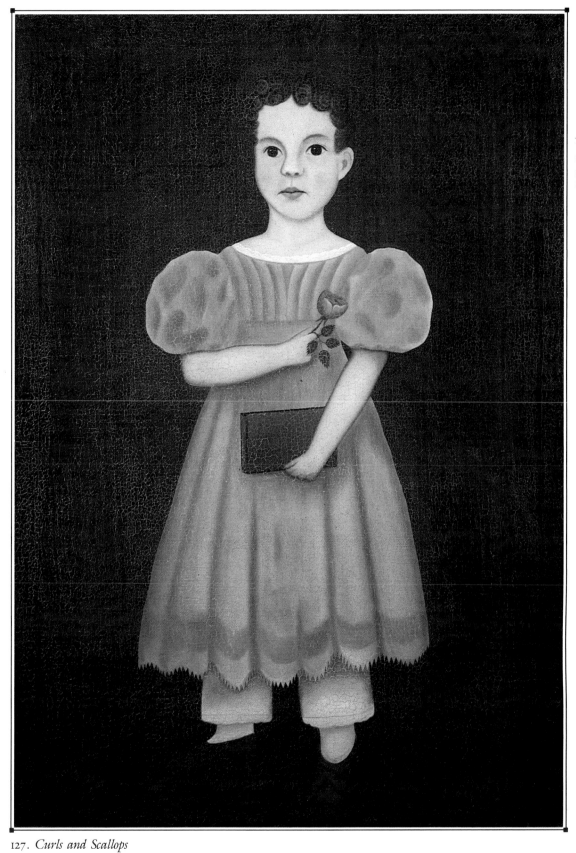

Artist unidentified
United States, ca. 1835
Oil on canvas
36″ × 26″
(91.5 cm × 66 cm)

127. *Curls and Scallops*

Condition: No record of previous conservation. The canvas is slightly slack on the strainer. There is a fine network of traction cracks over the entire surface, with the exception of the face. At an unknown date the surface was cleaned and varnished.

Provenance: Mr. and Mrs. William J. Gunn, Newtonville, Mass.; Miss Mary Allis, Fairfield, Conn.; Mr. Stephen C. Clark Sr., Cooperstown, N.Y.

Exhibited: NYSHA, "New-Found Folk Art of the Young Republic," 1960, and exhibition catalog, p. 17, no. 21, illus. as fig. 21; untitled exhibition, The Century Association, New York, N.Y., January 2–February 15, 1961; untitled exhibition, Briarcliff College Museum of Art, Briarcliff Manor, N.Y., October 2–November 1, 1974.

128. *Child in a Red Dress with Mother* N-435.61

The rippling lines on the frilly edged bonnets worn by this mother and child add visual movement to this attractive portrait. The white paint applied to define the decorative lacework on the bonnets serves to brighten the composition. The artist also uses dots of white on the woman's necklace to simulate light reflecting off her pearls. The wide-bridged noses, slightly turned mouths and short, stubby hands of the sitters appear to be stylistic traits of this artist's work. PD'A

Artist unidentified
United States, ca. 1835
Oil on fabric
27¾" × 23¾"
(70.5 cm × 60.4 cm)

128. *Child in a Red Dress with Mother*

Condition: The surface was cleaned and varnished by the NYSHA conservator in 1987.

Provenance: Mr. and Mrs. William J. Gunn, Newtonville, Mass.; Miss Mary Allis, Fairfield, Conn.; Mr. Stephen C. Clark Sr., Cooperstown, N.Y.

129. *Eliza Smith* N-34.61

FACING PAGE
129. *Eliza Smith*
Artist unidentified
Probably Providence, Rhode
Island, ca. 1836
Oil on canvas
36⅛" × 27"
(93 cm × 68.6 cm)

Rather than present the subject in a realistic interior setting, this artist created a personal, almost psychological vision. The young girl sits in a rocking chair, in an imaginary room that appears to float mysteriously over a murky landscape scene. The carpeted floor seems to be rendered in the shape of a large tray, with the front side visible as a strip of brown paint appearing along the lower margin of the canvas. This seemingly surrealistic interpretation creates an incongruous relationship between the interior setting and the landscape background. The structures depicted in the background of the portrait remain unidentified.

Information in NYSHA files indicates that a currently unlocated card once attached to the verso of the canvas records the artist as the Reverend Elijah W. Burrows, founder and first pastor of the Broad Street Christian Church in Providence, Rhode Island. Burrows resided in Providence from 1834 to 1836. His stay coincided with the death of Eliza's mother in 1836, which is believed to be why Eliza is depicted in black.

Eliza Smith was born on April 4, 1831. She was the youngest child of Alaston and Eliza Guild Smith who lived on Stewart Street in Providence, Rhode Island, and was the only one of their five children to survive infancy.[1] Eliza Smith was graduated from Rhode Island Normal School, and went on to teach classes in various local Providence school districts from 1860 to 1889. She consistently won praise from local school committees for her teaching abilities. Never married, Eliza died at the age of seventy on July 16, 1901, and is buried in the Smith family plot at Grace Church Cemetery in Providence. Her personal possessions, including this portrait, were willed to friends, as she had no descendents to inherit her property. PD'A

Inscriptions/Marks: Information in NYSHA research files indicates that after 1857 a card was attached to the verso of the canvas and inscribed "Eliza Smith Born Stuart St. Providence 1827./Taught for 40 years in the schools of Johnson, R.I./Painting by pastor of Broad Street Christian Church 1832."[2] This card is unlocated.

Condition: Records indicate that this painting was "cleaned by Hisgrove" in 1945. Treatment by the NYSHA conservator in 1979 included the removal of an adhesive tape patch, mending a small tear, infusion with wax-resin and lining with new canvas. The surface was cleaned, losses were filled and inpainted and synthetic resin varnish was applied.

Provenance: Mr. and Mrs. Howard Lipman, Wilton, Conn.; Mr. Stephen C. Clark Sr., Cooperstown, N.Y.

Exhibited: "Primitives," Harry Stone Gallery, New York, N.Y., 1942; "Folk Art From Cooperstown," Museum of American Folk Art, New York, N.Y., March 21–June 6, 1966; "Folk Art," Roberson Center for the Arts and Sciences, Binghamton, N.Y., September 15, 1966–April 1, 1967.

Published: Mary Black and Jean Lipman, *American Folk Painting* (New York, 1966), illus. as fig. 78 on p. 82; Jean Lipman, *American Primitive Painting* (London, 1942), p. 40, illus. as fig. 24; Jean Lipman, "American Primitive Portraiture: A Revaluation," *Antiques* XL (September 1941), illus. as fig. 1 on p. 142; *Middleburgh (Mass.) Antiquarian* XVIII (September 1977), illus. on cover; "The Paintings" [New York State Historical Association issue], *Antiques* LXXV (February 1959), illus. on p. 172; Elizabeth Jane Townsend, "Teaching the Three R's–Eliza Smith, Schoolmistress," *Rhode Island History* 37 (May 1978), illus on p. 46.

[1] All biographical information on the subject is from Elizabeth Jane Townsend, "Teaching the Three R's–Eliza Smith, Schoolmistress," *Rhode Island History* 37 (May 1978), illus. on p. 46.

[2] Clifford P. Monahan to NYSHA, January 16, 1957. From 1834 to 1857, the Broad Street Christian Church was known as the Pawtucket Street Christian Church. The card cited the post-1857 name, suggesting the information was written and attached to the painting sometime after that date.

130. *Erastus Cooke* N-47.41

According to unverified donor information, this subject was the husband of Lurissa Cooke, whose portrait by John Gall (see no. 46) is also in the Association's collection. Stylistically, this portrait bears some resemblance to the work of R. B. Crafft (active 1836–1866), a portrait painter who is believed to have worked in Indiana, Kentucky and Mississippi. This sitter is rendered with sharply defined facial features, thick, flattened lips and an elongated body. The skewed perspective of the book is similar to Crafft's treatment of

books in at least one other portrait.[1] However, the lack of sufficient biographical data for both Erastus Cooke and Crafft, and the absence of an established body of work for Crafft makes the connection tenuous. PD'A

Inscriptions/Marks: Penciled in script on the upper member of the stretcher is "1397."

Condition: No record of previous conservation. The canvas is slightly slack on the strainer, with wrinkles along the bottom edge, which has been attached to the strainer with glue for half its width. There are small punctures (two at bottom right, one at bottom center). Three large punctures (two at bottom left, one at top right) have been mended with tape patches on the reverse and the losses have been painted over. The surface is covered with a dark yellow varnish.

Provenance: Mrs. Bruce Phillips, Oneonta, N.Y.; Otsego County Historical Society, Cooperstown, N.Y.

Published: Clifford L. Lord, comp., *Handbook of the Museum and Art Gallery of the New York State Historical Association* (Cooperstown, 1942), illus. on p. 36.

[1] The portrait of *The Merchant,* signed by Crafft and dated 1836, is owned by the Abby Aldrich Rockefeller Folk Art Center, Williamsburg, Va.

Artist unidentified
United States, ca. 1840
Oil on canvas
34⅛″ × 27¼″
(86.7 cm × 69.2 cm)

130. *Erastus Cooke*

131. **Miniature of a Man** N-376.50

Several stylistic features of this miniature may prove helpful in identifying other works by the same artist. The man is rendered with a large head, a small, stylized body, a tiny mouth curled up at the corner, large eyes accentuated by thick eyebrows, long sideburns and an unusually long nose. The soft background color was achieved by applying blue, red and purple paint to the verso, thus taking advantage of the translucent quality of the ivory to create a mottled effect. The artist employed the same technique to suggest the shadow on the man's chin, and above his upper lip. Glazed highlights appear on the man's hair, vest, cravat and the edges of his coat. PD'A

Condition: No record of previous conservation. The ivory support is irregularly warped, but there are no breaks. A few very small flakes of black paint are missing. The glass has a 3/8″ chip at top right.

Provenance: R. W. Canfield, Glen Ellyn, Ill.

132. **Profile of a Man** N-48.55

This artist achieved a realistic likeness in the sitter's well-modeled face and accurately rendered ear. The portrait's only hints of color are the man's faint pink lips and cheeks. Accentuating the man's profile is a darkened pencil background along the edge of his face. PD'A

Inscriptions/Marks: No watermark found.

Condition: No record of previous conservation. The paper support is slightly yellow, and has been glued at three corners to a piece of gray cardboard.

Provenance: Mr. Stephen C. Clark Sr., Cooperstown, N.Y.

RIGHT
Artist unidentified
United States, ca. 1840
Watercolor with glazed highlights on ivory
2⅛" × 2³⁄₁₆"
(6.7 cm × 5.5 cm)

FAR RIGHT
Artist unidentified
United States, ca. 1840
Watercolor and pencil on wove paper
5½" × 5"
(14 cm × 12.7 cm)

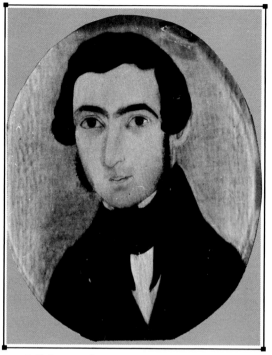

131. *Miniature of a Man*

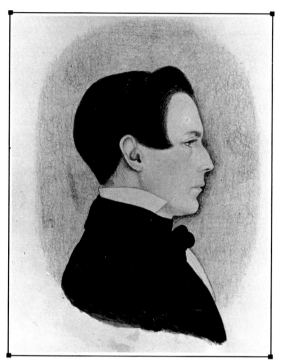

132. *Profile of a Man*

133. **Girl of the Fenton Family** N-17.58
134. **Woman and Child of the Fenton Family** N-18.58
·135. **Man of the Fenton Family** N-19.58
136. **Boy with Watch and Chain of the Fenton Family** N-20.58
137. **Boy of the Fenton Family** N-21.58

These five watercolor portraits are as unusual as they are enigmatic. The figures show considerable three-dimensional form, as the artist employed a dry-brush technique using color effectively to achieve depth. Brown, gray and black pigments dominate the pictures while delicately painted combinations of blue, orange and green accentuate the flesh tones. Another stylistic trait of this artist is the rendering of large, dark eyes, making his sitters look innocent and charming.

The portraits also exhibit a number of accessories no doubt included by the artist to individualize the likenesses. The younger boy (no. 136) holds a watch and chain in his right hand, while the girl (no. 133) is posed holding a fan. On the man's lap is a ledger providing some clue to his profession. Locks of hair are attached at the upper right of the man's portrait and on the woman's sleeve in her likeness, further personalizing these portraits. According to information given by the donor, the Fenton family lived in the Hudson River Valley. Interestingly, two other privately owned portraits by the same hand, depicting a man and a woman, have been found in the same general area. PD'A

Inscriptions/Marks: Penciled in script on possibly original wood backing board of no. 133 is "Miss Prudy/Fenton/Mch/1786"; penciled in script on reverse of lower member of frame of no. 135 is

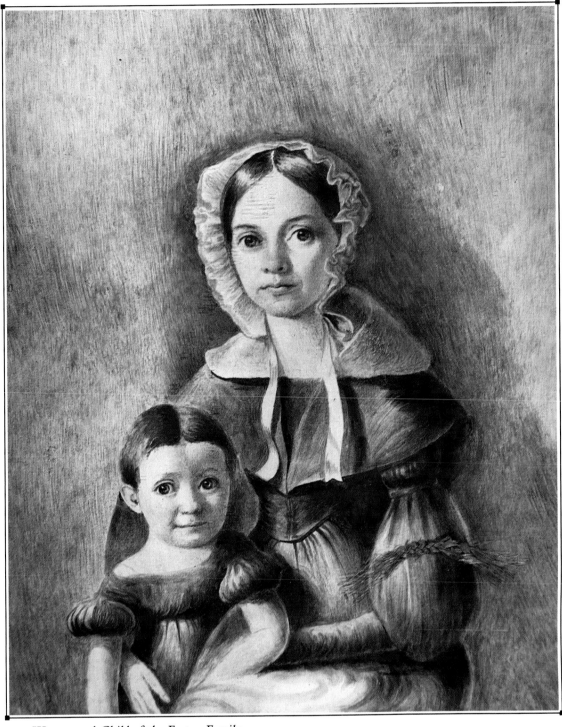

Artist unidentified
Possibly New York state or
Connecticut, ca. 1840
Watercolor on wove paper
9¾″ × 7⅞″
(24.8 cm × 20.1 cm)

134. *Woman and Child of the Fenton Family*

"McCoy"; printed in watercolor on the spine of the book held by the man in no. 135 is "LEDG..."; printed in script on reverse of upper member of frame of no. 136 is "McCoy". No watermarks found.

Condition: Surface dirt and rubber-based adhesive residue were removed from the paper support of no. 133 by the NYSHA conservator in 1983. At the same time, paper and wood backings were replaced with a mat and backing of acid-free material. Loose dust was brushed off and a loosely-attached backing and adhesive residue were removed from

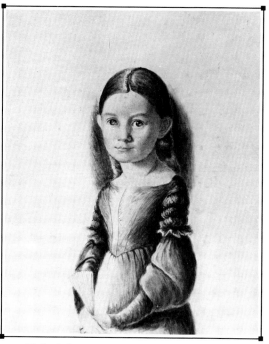

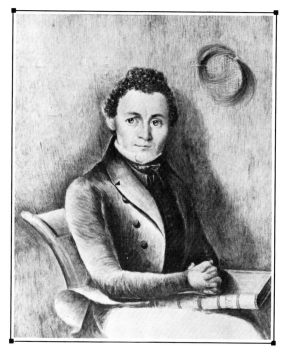

133. *Girl of the Fenton Family*

135. *Man of the Fenton Family*

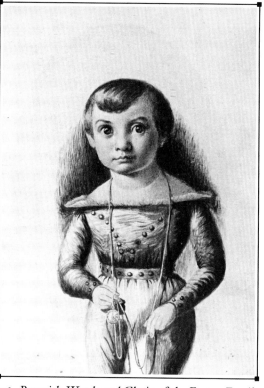

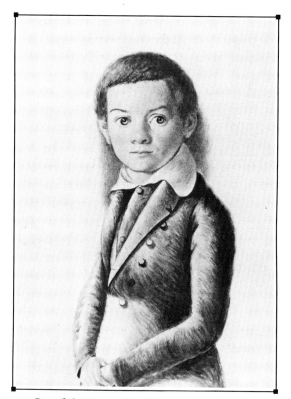

136. *Boy with Watch and Chain of the Fenton Family*

137. *Boy of the Fenton Family*

no. 134 by the NYSHA conservator in 1976. The painting was placed in a new acid-free mat and backing. Treatment on no. 135 by the NYSHA conservator in 1976 included removing cardboard

backing and yellowed adhesive residue and matting with acid-free material. Some foxing of the design area on no. 136 was recorded, but not treated in 1976 by the NYSHA conservator. A cardboard backing

was taken off, yellowed adhesive residue was removed from the back, and a new acid-free mat and backing were prepared. The paper support of no. 137 has some foxing and three small water stains. Rubber-based adhesive residue and surface dirt were removed by the NYSHA conservator in 1979 and the old paper and wood backings were replaced with an acid-free mat and backing.

Provenance: Found in Westport, Conn.; W. P. Emmons, Sanbornville, N.H.; Robert M. Light and Co., Cambridge, Mass.

Exhibited: "The Folk Art of New York State," the Abby Aldrich Rockefeller Folk Art Collection, Williamsburg, Va., March 15–May 20, 1959, and NYSHA, Cooperstown, N.Y., June 15–September 15, 1959; untitled exhibition, State University College, New Paltz, N.Y., September 25–November 1, 1959.

Published: "The Paintings" [New York State Historical Association issue], *Antiques* LXXV (February 1959), no. 134 only, illus. on p. 172.

138. *Boy with Hammer and Iron Pot* N-363.61

A rather curious likeness, this painting has been suggested as the work of Vermont artist Horace Bundy because of stylistic similarities to a currently unlocated portrait of Hale Holden believed to have been painted by Bundy.[1] In addition, a portrait similar to that of Hale Holden, entitled *Little Girl in a Red Dress,* is supposedly signed "Bundy."[2] Unfortunately, neither portrait has been located to verify this attribution. While *Boy with Hammer and Iron Pot* has been compared to a substantial body of work attributed to Horace Bundy, further investigation is required to conclusively determine the artist's identity. CME

Condition: In 1959, Caroline and Sheldon Keck consolidated the paint, canvas, and cleaned and inpainted small damaged areas. An old glue lining was left intact. A new stretcher replaced the old one. In 1985 an examination with infrared and X-rays failed to establish whether a signature is present on the reverse of the painting.

Provenance: Mr. and Mrs. William J. Gunn, Newtonville, Mass.; Miss Mary Allis, Fairfield, Conn.; Mr. Stephen C. Clark Sr., Cooperstown, N.Y.

Exhibited: NYSHA, "New-Found Folk Art of the Young Republic," 1960, and exhibition catalog, p. 20, no. 30, illus. on p. 66.

[1] The portrait was advertised for sale in 1966 by Thomas D. and Constance R. Williams, Litchfield, Conn., and is illustrated in *Antiques* XC (August 1966), p. 172.

[2] The portrait was advertised for sale in 1969 by Kennedy Galleries, New York, N.Y., and is illustrated in the *Kennedy Quarterly* IX (December 1969), as fig. 74 on p. 187. Lynn Bettmann (Kennedy Galleries) to NYSHA, August 4, 1986.

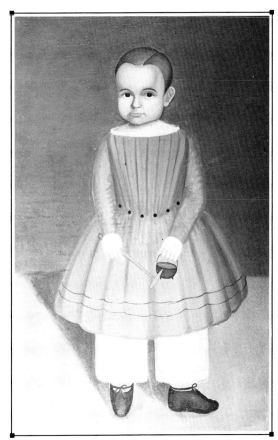

Artist unidentified
United States, ca. 1840
Oil on canvas
41⅜″ × 27⁵⁄₁₆″
(105.1 cm × 69.4 cm)

138. *Boy with Hammer and Iron Pot*

139. *Four Children and a Cat* N-397.61

The inclusion of nearly every one of these children's hands gives this painting an emotional unity that makes it much more than simply a crowded group portrait. The oldest child standing in the rear embraces his three younger siblings while the two children standing in the middle hold onto the baby in the foreground. The family pet playfully toying with the child's necklace in the lower left adds to the charm of this cheerful picture.

Noteworthy elements of this artist's style include the distinctively broad, round faces, large almond-shaped eyes and rosy colored cheeks. The detailing of the costumes and the naturalistic drapery treatment in the background also may serve to identify more portraits by this artist. PD'A

Artist unidentified
Probably United States, ca. 1840
Oil on canvas
33⅛″ × 27½″
(84.3 cm × 69.9 cm)

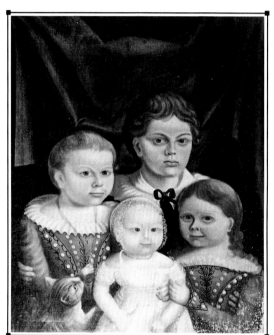

139. *Four Children and a Cat*

Condition: At an unknown date the canvas was lined with new fabric attached with paste or glue. The original tacking edges have been cut off. The canvas is slightly slack, but not distorted. There are a few flake losses along the bottom edge and a 4″ × 6″ area with flake losses at bottom right. The surface has been coated with a very glossy varnish.

Provenance: Mr. and Mrs. William J. Gunn, Newtonville, Mass.; Miss Mary Allis, Fairfield, Conn.; Mr. Stephen C. Clark Sr., Cooperstown, N.Y.

140. *Husband and Wife* N-260.50 a & b

This unidentified artist was evidently experienced, judging from the somewhat accomplished modeling of the sitters' faces and the man's hand. However, the artist was less successful with the man's arm, as it appears awkwardly foreshortened. The sitters' costumes are carefully defined, especially the woman's transparent and seemingly three-dimensional lace shawl. The sweeping arc of the man's lapel enhances his alert, upright posture. PD'A

Condition: Both canvases were treated by the NYSHA conservator in 1987. Flaking paint near the edges was set down, the surfaces were cleaned, losses were filled and inpainted and protective varnish was applied.

Provenance: Mrs. Rudyard Boulton; The Art Institute of Chicago, Chicago, Ill.

141. *Victorian Family* N-262.61

The accurate, realistic images offered by photography may have influenced the artist who rendered this painting with realistic perspective, anatomical modeling and surface tex-

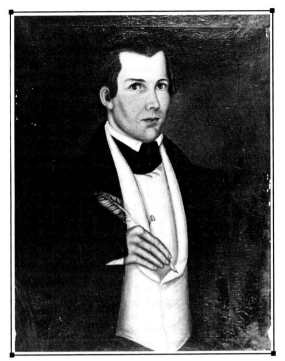 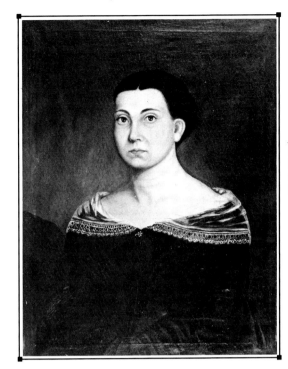

Artist unidentified
United States, ca. 1845
Oil on canvas
28¼″ × 22⅛″
(71.7 cm × 56.2 cm)

140. *Husband and Wife*

tures. Unlike the vast majority of folk portraits, these figures are placed firmly within a three-dimensional space. The naturalistic modeling of the sitters' faces, and the skillfully handled details such as the man's vest, the still-life arrangement on the table, and the floral decoration of the tablecloth all suggest the work of a technically proficient artist. In addition, the table and floor are rendered in convincing perspective, indicating some awareness of academic artistic principles. The formal appearance of the portrait is offset somewhat by the artist's insightful and sensitive rendering of the sitters' faces, revealing subtle differences in character among them. PD'A

Condition: In 1959, Caroline and Sheldon Keck replaced an earlier lining, treated flaking paint, filled and inpainted small losses, and put the painting on a new stretcher.

Provenance: Mr. and Mrs. William J. Gunn, Newtonville, Mass.; Miss Mary Allis, Fairfield, Conn.; Mr. Stephen C. Clark Sr., Cooperstown, N.Y.

Exhibited: NYSHA, "New-Found Folk Art of the Young Republic," 1960, and exhibition catalog, pp. 21–22, no. 37, illus. as fig. 37; untitled exhibition, The Century Association, New York, N.Y., January 2–February 15, 1961; untitled exhibition, Roberson Center for the Arts and Sciences, Binghamton, N.Y., November 1–December 15, 1961; untitled exhibition, Union College Art Gallery, Schenectady, N.Y., January-March 1962; "Domestic Manners of the Americans," Museum of American Folk Art, New York, N.Y., December 5, 1967–February 4, 1968; "Child's World," Schenectady Museum, Schenectady, N.Y., January 2–May 9, 1972.

142. **Two Girls in Blue Dresses** N-264.61
Using only blues and grays, the artist rendered this double portrait in a manner which probably reveals several stylistic characteristics of his portrait work. Eyes appear large, round and heavily shaded; heads are tilted as eyes glance sideways; while oval shaped forms at

RIGHT
Artist unidentified
United States, ca. 1845
Oil on canvas
36¼″ × 28¾″
(92 cm × 73.2 cm)

FAR RIGHT
Artist unidentified
United States, ca, 1845
Oil on bed ticking
46½″ × 34¾″
(118 cm × 88.3 cm)

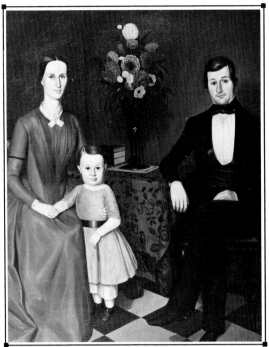

141. *Victorian Family*

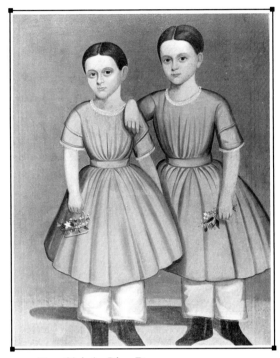

142. *Two Girls in Blue Dresses*

the feet of the sitters suggest shadow. The artist's obvious difficulty in rendering anatomical features is evident in the girl standing at the right, whose upper body is visibly misaligned with her legs. In addition, the hand that rests on her companion's shoulder is mysteriously independent of an arm. PD'A

Condition: In 1959, Caroline and Sheldon Keck repaired a rip in the canvas at lower left, reattached a small area of flaking paint, attached a lining, and put the picture on a new stretcher. Losses were inpainted and some streaks of gold frame paint near the eyes were overpainted.

Provenance: Mr. and Mrs. William J. Gunn, Newtonville, Mass.; Miss Mary Allis, Fairfield, Conn.; Mr. Stephen C. Clark Sr., Cooperstown, N.Y.

Exhibited: NYSHA, "New-Found Folk Art of the Young Republic," 1960, and exhibition catalog, p. 20, no. 31, illus. as plate 31; untitled exhibition, The Century Association, New York, N.Y., January 2–February 15, 1961; untitled exhibition, Roberson Center for the Arts and Sciences, Binghamton, N.Y., November 1–December 15, 1961; untitled exhibition, Union College Art Gallery, Schenectady, N.Y., January-March, 1962.

Published: George R. Clay, "Children of the Young Republic," *American Heritage* XI (April 1960), illus. on p. 48.

143. ***Two Boys in Green Tunics*** N-269.61

Judging from the expressive quality of the boys' faces and the skilled handling of the delicate lace shirts, collars and cuffs, the unidentified hand which produced this charming double portrait was probably an experienced one. The graceful pose is enhanced by the inclusion of the older boy's left hand wrapped around the elbow of his younger companion. Stylistic traits that may help to identify more portraits include soft, diffusely shaded facial features, fine hair, large eyes, rounded foreheads and sloping shoulders. Other details, such as the whip, cart and background landscape, are painted more economically and with less precision. PD'A

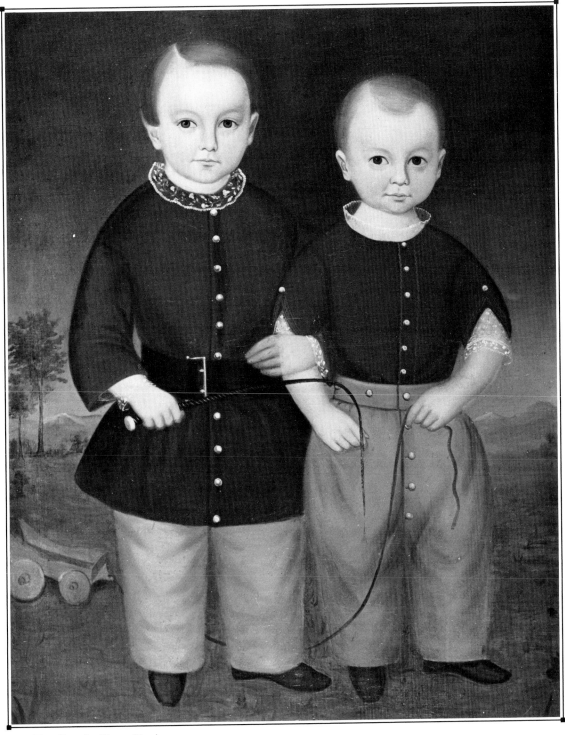

Artist unidentified
United States, ca. 1845
Oil on canvas
36⅜″ × 29¼″
(92.4 cm × 74.4 cm)

143. *Two Boys in Green Tunics*

Condition: No record of previous conservation. At an unknown date the painting was cleaned, minor losses inpainted, and varnished.

Provenance: Mr. and Mrs. William J. Gunn, Newtonville, Mass.; Miss Mary Allis, Fairfield,

Conn.; Mr. Stephen C. Clark Sr., Cooperstown, N.Y.

Exhibited: NYSHA, "New-Found Folk Art of the Young Republic," 1960, and exhibition catalog, p. 20, no. 34, illus. as fig. 34; untitled exhibition, The

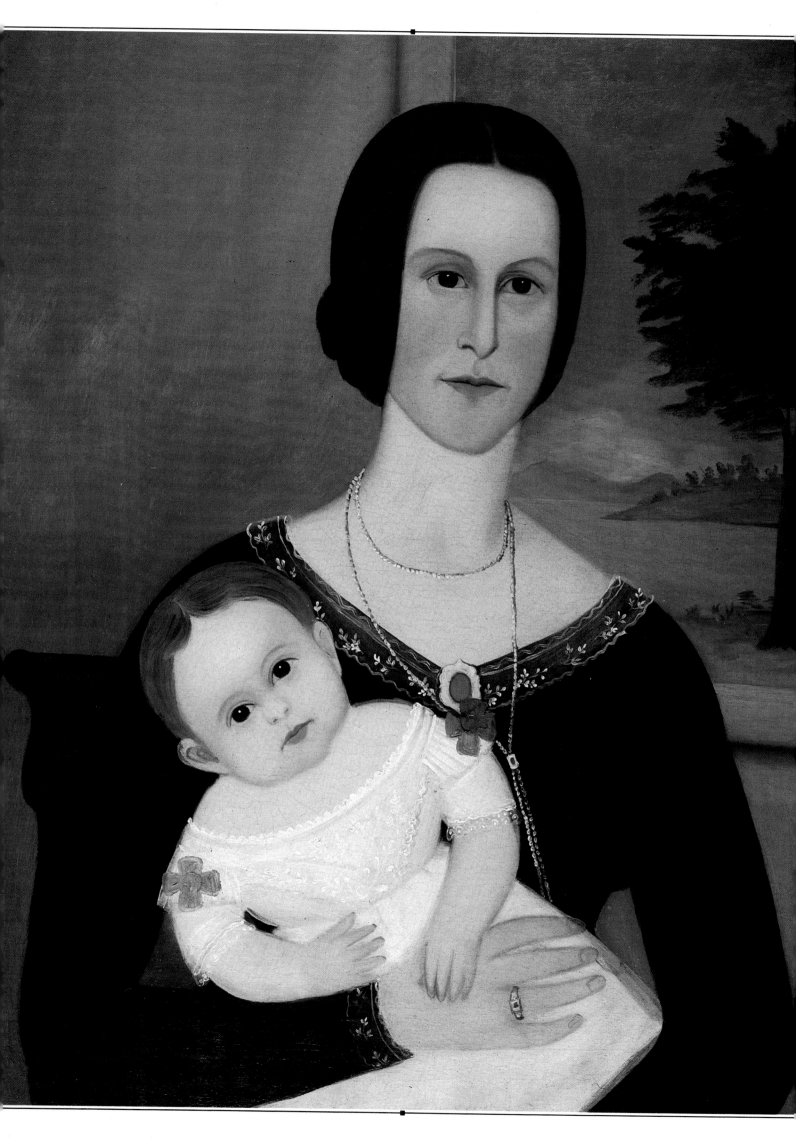

Century Association, New York, N.Y., January 2–February 15, 1961; untitled exhibition, Roberson Center for the Arts and Sciences, Binghamton, N.Y., November 1–December 15, 1961; untitled exhibition, Union College Art Gallery, Schenectady, N.Y., January–March 1962; "Treasure House: Museums of the Empire State 1979," Roberson Center for the Arts and Sciences, Binghamton, N.Y., June 27–September 4, 1979.

Published: George R. Clay, "Children of the Young Republic," *American Heritage* XI (April 1960), illus. on p. 51.

144. *American Madonna and Child* N-297.61

More so perhaps than any other portrait in the Association's collection, *American Madonna and Child* illustrates the simplicity and directness that characterize the most successful folk paintings. The overall flatness and solid areas of color focus the viewer's eye on the smooth, graceful outlines of the figures. This emphasis on line rather than form, the result of the artist's lack of training in academic principles, makes the baby appear to float weightlessly in its mother's arms. The sitters' serene faces are rendered with clarity and softness, and the artist achieved an appealing doll-like quality in the baby's large dark eyes and direct gaze. A number of carefully painted details embellish the picture, including the woman's necklace, brooch and ring, and the lace on her collar, sleeve and on the baby's dress. The sitters' hands and the landscape vista are loosely painted, yet remain effective in completing the unified composition.[1] PD'A

FACING PAGE
144. *American Madonna and Child*
Artist unidentified
United States, ca. 1845
Oil on canvas
27½" × 22⅛"
(69.9 cm × 56.3 cm)

Inscriptions/Marks: Stenciled on the verso is "Prepared/By/Hollis & Wheeler/59 Union St./Boston Mass" for the art supply firm of Charles Hollis and Asahel Wheeler which operated in Boston from 1844 to 1849.

Condition: Caroline and Sheldon Keck lined and cleaned the painting in 1958. A few tiny losses near the top edge were inpainted.

Provenance: Mr. and Mrs. William J. Gunn, Newtonville, Mass.; Miss Mary Allis, Fairfield, Conn.; Mr. Stephen C. Clark Sr., Cooperstown, N.Y.

Exhibited: Untitled exhibition, Albright-Knox Art Gallery, Buffalo, N.Y., May 8–15, 1959; NYSHA, "New-Found Folk Art of the Young Republic," 1960, and exhibition catalog, p. 22, illus. as fig. 40; untitled exhibition, The Century Association, New York, N.Y., January 2–February 15, 1961; "Folk Art From Cooperstown," Museum of American Folk Art, New York, N.Y., March 21–June 6, 1966.

Published: Suzette Lane and Paul D'Ambrosio, "Folk art in the New York State Historical Association," *Antiques* CXXIV (September 1983), illus. as fig. 4 on p. 522; Anita Schorsch, *Images of Childhood: An Illustrated Social History* (New York, 1979), illus. as fig. 37 on p. 59; Cynthia Sutherland, "The Elusive C. Balis," *The Clarion* (Fall 1984), illus. as fig. 6 on p. 58.

[1] A stylistically related portrait of a woman, also from the collection of Mr. and Mrs. William J. Gunn, is owned by The American Museum in Britain, Bath, England.

145. *Two Sisters in White and Yellow Dresses* N-377.61

The painter of this compelling double portrait was more successful at rendering the softly modeled features of the two young sitters than at giving their bodies a natural appearance. This is evident in the square-shouldered representation of the girl at the left, and particularly in the artist's awkward attempt to include her right hand holding a flower. However, the decorative quality of the portrait is enhanced by the carefully painted patterns of the dresses worn by the two girls, and the sensitive treatment of lace, jewelry and hair ribbons. PD'A

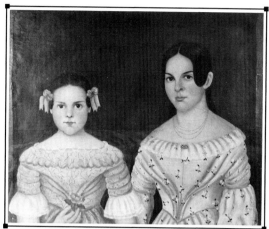

Condition: The surface has some surface dirt and slightly yellowed varnish. There are a few very small scratches around the edges.

Provenance: Mr. and Mrs. William J. Gunn, Newtonville, Mass.; Miss Mary Allis, Fairfield, Conn.; Mr. Stephen C. Clark Sr., Cooperstown, N.Y.

145. *Two Sisters in White and Yellow Dresses*

146. *Boy with Whip* N-386.61

This artist's inability to convey realistic anatomy and three-dimensional space results in an appealing, almost abstract likeness. Although the child's body appears stylized and stiffly drawn against a flat, neutral background, his face conveys individuality, as the artist carefully delineated each eyelash and delicately applied color to his cheeks. The flat linear design created by the artist's two-dimensional treatment of the standing figure and the calligraphic-like detailing on the surface of the child's coat add to the portrait's visual appeal. PD'A

Inscriptions/Marks: Penciled in script in modern hand on the verso at the right is "W.J. Gunn/173 Otis St./Newtonville."

Condition: In 1962, Caroline and Sheldon Keck cleaned the panel, and filled and inpainted small losses along a center split which had been mended previously. The reverse was coated to minimize wood's reaction to changes in relative humidity.

Provenance: Mr. and Mrs. William J. Gunn, Newtonville, Mass.; Miss Mary Allis, Fairfield, Conn.; Mr. Stephen C. Clark Sr., Cooperstown, N.Y.

Exhibited: "Child's World," Schenectady Museum, Schenectady, N.Y., January 2–May 9, 1972.

147. *Woman* N-399.61

The unidentified artist of this portrait added visual interest to an otherwise conventional composition by including details such as the woman's lace collar, jewelry and the small decorated boxes. PD'A

Condition: No record of previous conservation. The canvas is slightly slack on its strainer. The paint is very slightly cupped. There are three small scratches at left center. The painting is covered with a glossy varnish and there is some surface dirt.

Provenance: Mr. and Mrs. William J. Gunn, Newtonville, Mass.; Miss Mary Allis, Fairfield, Conn.; Mr. Stephen C. Clark Sr., Cooperstown, N.Y.

148. *Old Lady in a Decorated Rocker* N-425.61

This woman's unfocused eyes and sunken, possibly toothless mouth, illustrate the uncompromising honesty with which many naive painters depicted their subjects. How-

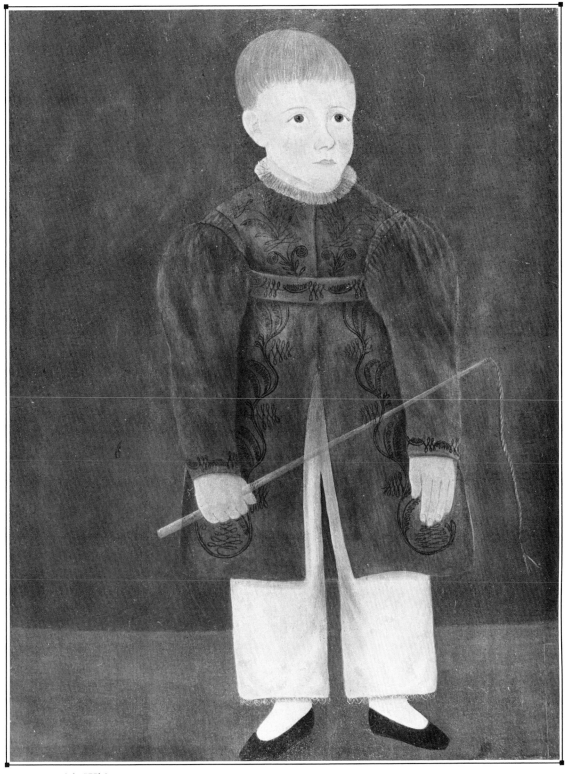

Artist unidentified
United States, ca. 1845
Oil on wood panel
29¼″ × 22¼″
(74.3 cm × 56.5 cm)

146. _Boy with Whip_

ever, the sophisticated handling of colors in the flesh tones of the woman's face and the pleasing sense of design formed by the outlined curves of the chair rail evince an experienced hand. The artist may have been capable of more polished work, but was per-

RIGHT
Artist unidentified
United States, ca. 1845
Oil on canvas
29¼″ × 24¾″
(74.3 cm × 62.8 cm)

FAR RIGHT
Artist unidentified
United States, ca. 1845
Oil on canvas
35⅞″ × 28⅞″
(91.2 cm × 73.3 cm)

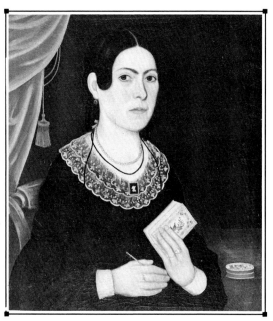

147. *Woman*

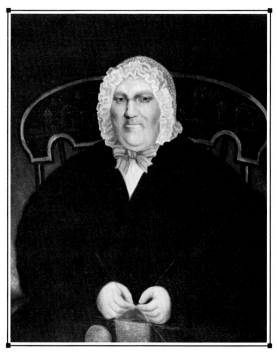

148. *Old Lady in a Decorated Rocker*

haps constrained to rapid execution in this portrait.

Adding to the portrait's aesthetic appeal are the picturesque landscape scene painted in gold on the panel of the decorated rocking chair and the inclusion, in the lower center of the picture, of the ball of yarn and three knitting needles forming the shapes of a triangle, circle and square. On an otherwise dark canvas, these highlighted areas balance the light colors of the woman's face and bonnet. PD'A

Condition: At an unknown date, the painting was lined, small losses filled and inpainted, and a protective coat of varnish was applied.

Provenance: Mr. and Mrs. William J. Gunn, Newtonville, Mass.; Miss Mary Allis, Fairfield, Conn.; Mr. Stephen C. Clark Sr., Cooperstown, N.Y.

149. *Boy with a Slate* N-426.61

The sitter's patterned shirt is the only area of bright color in this dark, somber portrait. Stylistic features which may help to link this likeness to others by the same hand include the shaded flesh tones, large, angled ears and the sketchily rendered hands. PD'A

Condition: Serious paint flaking was treated by Caroline and Sheldon Keck in 1959. The stretcher, attached to the canvas with glue, was removed. The original canvas was lined with new fabric and the surface was cleaned and varnished. It was placed on a new stretcher. The losses were not filled or inpainted.

Provenance: Mr. and Mrs. William J. Gunn, Newtonville, Mass.; Miss Mary Allis, Fairfield, Conn.; Mr. Stephen C. Clark Sr., Cooperstown, N.Y.

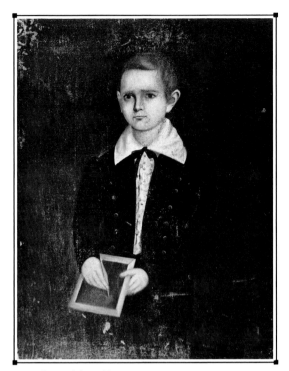

149. *Boy with a Slate*

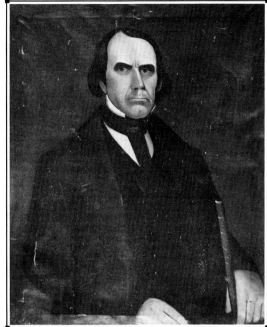

150. *Man Holding a Cane*

FAR LEFT
Artist unidentified
United States, ca. 1845
Oil on sized fabric
34¼″ × 27″
(87 cm × 68.6 cm)

LEFT
Artist unidentified
United States, ca. 1845
Oil on canvas
33″ × 27″
(83.8 cm × 68.6 cm)

150. *Man Holding a Cane* N-167.65

An imposing personality is conveyed in this rather quickly painted portrait, by the subject's riveting eyes, pursed forehead, and the artist's placement of the figure so close to the picture plane. The deeply modeled areas of the face, particularly around the nose and mouth, are in marked contrast to the subject's flat, glove-like hands which convey no sense of natural form.

A curious feature of this portrait is a diagonal distortion of the subject's head, as though the canvas had been stretched from the upper left and lower right corners. This artistic technique is also documented in the later works of Ammi Phillips (1788–1865). The appearance of two different sitters' heads on the verso (see *Inscriptions/Marks*) make this an interesting and unusual study piece, providing some evidence of this artist's preliminary work methods. PD'A

Inscriptions/Marks: Drawn in paint on the verso at the top center is an outline of a woman's head; drawn in paint at the bottom center is an upside-down outline of a child's head. Both images have been covered with a thin layer of paint.

Condition: No record of previous conservation. The canvas is very slack on the strainer and the surface is wrinkled, especially along the right side. There are two small punctures and a 3″ tear at bottom left. The surface is covered with a yellow varnish layer.

Provenance: Found near New Haven, Conn.; Mrs. Agnes Halsey Jones, Cooperstown, N.Y.

151. *Dr. Marion Nash* N-298.59

This modest likeness of Dr. Nash sitting next to a writing table with quill pen in hand is executed with sensitivity and skill despite the awkwardly foreshortened arm draped over the chair. The patterned drapery at the left side of the picture adds decoration to

this otherwise plain and monochromatic portrait. The artist captured a distinctive feature of this sitter when he drew the continuous line of eyebrow across the subject's forehead.

Dr. Marion Nash married Frances Bestrick on June 4, 1857 in Denmark, Lewis County, New York.[1] He became a well-known citizen of nearby Martinsburgh, where he served the community as a physician, member of the board of supervisors and county treasurer. He died there on June 8, 1888 at the age of sixty years, four months and two days. His obituary states that he had been a resident of the village for twenty-eight years, and was survived by a wife, son and daughter.[2] PD'A

Artist unidentified
Probably New York state,
ca. 1850
Charcoal, chalk and pencil
on wove paper
16⅝″ × 13″
(42.3 cm × 33 cm)

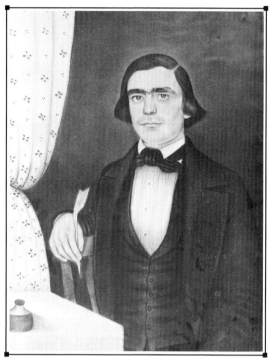

151. *Dr. Marion Nash*

Inscriptions/Marks: No watermark found.

Condition: No record of previous conservation. The paper is very yellow, with stains from an old wood backing on the reverse.

Provenance: Mr. Leonard Pelton.

[1] Reference files, Mormon Genealogical Research Center, New York, N.Y.

[2] Virginia K. Burrow (Lewis County Historical Society) to NYSHA, August 18, 1986.

152. *Maine Family* N-98.61

This family portrait is reminiscent of the work of the watercolorists Joseph H. Davis and J. Evans (see nos. 27–30 and 43). In a similar manner to those painters this unidentified artist rendered this composition as an interior scene, probably deriving elements from English conversation pieces and silhouette groups.[1]

The individual personalities of the sitters, difficult to convey in profile portraiture, are somewhat evident here. The parents flank their four children and give an emotional as well as compositional unity to the scene. This sense of communication is also apparent in the attention bestowed on the baby by both the mother and the child at her side. With an eye toward accuracy, the artist carefully included details such as the cast-iron wheels on the pull toy at the bottom center of the picture, the well outlined drawings in the geography book held by the oldest boy and the meticulously rendered pieces of furniture. The brilliant blue costumes of the two children standing in the center of the scene are complemented by the red color of the baby's dress, pull toys and upholstery of the unoccupied chair and footstool. PD'A

Inscriptions/Marks: No watermarks found.

Condition: The paper is slightly cockled. There are a few yellow spots at top left. An acid-free mat and backing were placed in the frame and lining strips were removed from the left and right edges by the NYSHA conservator in 1985.

Provenance: Found in Rockland, Me.; Mr. and Mrs. Howard Lipman, Wilton, Conn.; Mr. Stephen C. Clark Sr., Cooperstown, N.Y.

Exhibited: Untitled exhibition, The Century Association, New York, N.Y., January-February 1952.

Published: Anita Schorsch, *Images of Childhood: An Illustrated Social History* (New York, 1979), illus. as fig. 34 on p. 56.

[1] See the catalog for the exhibition "Three New England Watercolor Painters," The Art Institute of Chicago, Chicago, Ill., November 16, 1974–September 1, 1975, p. 7.

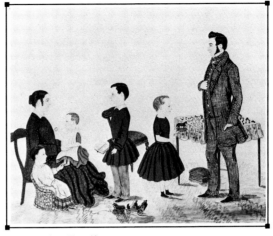

Artist unidentified
Possibly Maine, ca. 1850
Watercolor on wove paper
12¼" × 15¼"
(31 cm × 38.7 cm)

152. *Maine Family*

153. *Girl in Blue* N-100.61

The alert perky expression on this sitter's face, and the technique of rendering the entire likeness in blue, including the oval border, may be helpful in identifying other works by this unidentified miniaturist. PD'A

Inscriptions/Marks: No watermark found.

Condition: No record of previous conservation. The paper is unevenly yellowed.

Provenance: Found in Philadelphia, Pa.; Mr. and Mrs. Howard Lipman, Wilton, Conn.; Mr. Stephen C. Clark Sr., Cooperstown, N.Y.

Exhibited: "From the Cradle," The New-York Historical Society, New York, N.Y., November 1948; untitled exhibition, The Century Association, New York, N.Y., January-February, 1952.

Artist unidentified
United States, ca. 1850
Watercolor on wove paper
3⅜" × 3⅝" (8.6 cm × 9.2 cm)

153. *Girl in Blue*

154. *Anna Hunsicker* N-104.61
155. *Christian Hunsicker* N-105.61
156. *Jonathan Hunsicker* N-106.61
157. *Amalie Brechbill* N-107.61

These portraits belong to a group of over twenty-five stylistically related watercolors executed between 1835 and 1850 in Berks, Lebanon and Lancaster counties, Pennsylvania, by an unidentified portraitist referred to in recent years as "The Reading Artist."[1] The sitters in this group were probably all of Germanic extraction and are usually depicted

Artist unidentified
Bethel Township, Lebanon
County, Pennsylvania, 1850
Watercolor, pencil and ink
on wove paper
11½" × 7⅞"
(29.2 cm × 20 cm)

156. *Jonathan Hunsicker*

in one of two loose variations on this artist's basic formula: standing or seated outdoors next to a stone building or picket fence or seated in an interior setting next to a window and surrounded by patterned walls and floors. The works are stylistically marked by a robust and intense treatment of facial features, stiff, upright postures and quickly but

Artist unidentified
Bethel Township, Lebanon
County, Pennsylvania, 1850
Watercolor, pencil and ink
on wove paper
11½″ × 7⅞″
(29.2 cm × 20 cm)

154. *Anna Hunsicker*

157. *Amalie Brechbill*

effectively painted backgrounds. Many of these portraits are accompanied by cardboard frames grain-painted to simulate wood.

Also typical of these works is the broken gothic script along the lower margin of the paper below the outlined border of the picture, usually citing the sitter's name and the date of execution and, in several instances, the sitter's date and place of birth.[2] Anna Hunsicker, according to the inscription on her portrait, was born on October 5, 1817. However, her gravestone places her birth on February 5 of that same year. Genealogical records identify her as Anna Brechbill, born December 6, 1817. She married Jonathan Hunsicker (1813–1869) and had two children named Jonathan and Christian.[3] The two portraits of Jonathan and Christian B. Hunsicker probably depict her sons. Jonathan was born December 9, 1848, and died March 21, 1857. Christian Hunsicker's dates in the genealogical records are given simply as 1835–1908. All three subjects are buried in Wolfs Union Cemetery in Bethel Township, Lebanon County, Pennsylvania. Amalie Brechbill has not yet been positively identified but may be Anna's mother. PD'A

Inscriptions/Marks: Each portrait has a cardboard "strap" at the top of the frame reinforced on the reverse by irregularly sized pieces of lined paper on which fragmentary copybook inscriptions appear. In ink in script along the lower margin of no. 154 is "Anna Hunsicker 1850/geboren den 5 October 1817. Bethel Towschip./Libanon County Pa." Paper fragment on reverse, adhered to possibly original cardboard backing, includes the partial inscription in ink in script "...The days that are..." repeated eight times. In ink in script along the lower margin of no. 155 is "Christian Hunsicker/geboren den 24 November 1835. Bethel

Town/schip Libanon County Pa. gemast 1850." Paper fragment on reverse, adhered to possibly original cardboard backing, includes the partial inscription in ink in script "...in the way..." repeated three times, and "...the seats of the scornful..." repeated four times. Also on this paper fragment is penciled in script "Christian Hunsicker" and another short penciled inscription in script that is illegible. An embossed seal in the primary support, depicting a dove in an oval medallion, reads "George King/York Pa." In ink in script along the lower margin of no. 156 is "Jonathan Hunsicker/geboren den 9 December 1848 Bethel

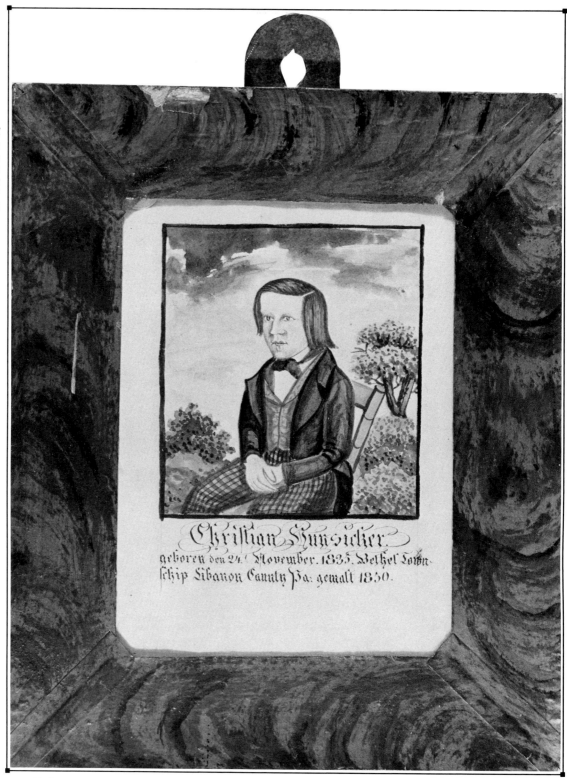

Artist unidentified
Bethel Township, Lebanon
County, Pennsylvania, 1850
Watercolor, pencil and ink
on wove paper
11½″ × 7⅞″
(29.2 cm × 20 cm)

155. *Christian Hunsicker*

Town/schip Libanon County Pa: gemast 1850."
Paper fragment on reverse, adhered to possibly
original cardboard backing, includes the partial

inscription in ink in script ". . .be careful to. . ."
repeated nine times and the inscription in ink in
script "Christian Hun. . . ." In ink in script along

the lower margin of no. 157 is "Amalie Brechbill." Paper fragment on reverse, adhered to modern replacement cardboard backing, includes the partial inscription in ink in script ". . .with. . ." repeated eight times. Other marks include light pencil tracings made with a straight edge as a guide for the lettering along the lower margin of each picture. No watermarks found.

Condition: No record of previous conservation. The paper supports are only slightly yellowed. There are some small damages to the paper frames and backings.

Provenance: Titus Geesey, Wilmington, Del.; Mr. and Mrs. Howard Lipman, Wilton, Conn.; Mr. Stephen C. Clark Sr., Cooperstown, N.Y.

Exhibited: "From the Cradle," New-York Historical Society, New York, N.Y., November 1948, no. 156 only.

Published: Donald A. Shelley, *The Fraktur Writing or Illuminated Manuscripts of the Pennsylvania Germans* (Pennsylvania German Folklore Society, 1961), no. 155 only, illus. as no. 81.

[1] Donald R. Walters (Abby Aldrich Rockefeller Folk Art Center) to NYSHA, February 26, 1976. A possibly related portrait of David Kistler owned by the Chrysler Museum in Norfolk, Va. is inscribed "F. Bischoff pinx invenit[?]." However, the identification of this person as the artist has not been verified. The only Bischoff known to have painted in the Reading area, Frederick Christopher Bischoff (1771–1834) died well before many of these portraits were painted. See Alfred Shoemaker, "Reading's First Artist, A Painter of Butterflies,"

Historical Review of Berks County (April 1948), pp. 89–90. Other portraits signed by Bischoff, owned by the Historical Society of Berks County, Reading, Pa., are not attributable to this group, as they bear a closer resemblance to the works of Jacob Maentel (ca. 1763–1863).

[2] NYSHA research files. The unlocated portrait of James Sands is inscribed with the sitter's birthdate, birthplace, the name of the baptising Reverend, date of baptism, the names of the witnesses and the names of the sitter's parents.

[3] Genealogical information is from Wolfs Union Cemetery records and the Reverend E. D. Brechbill to NYSHA, October 26, 1983.

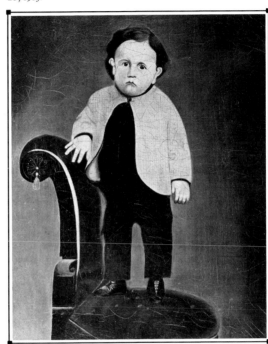

Artist unidentified
United States, ca. 1860
Oil on canvas
24″ × 20″
(61 cm × 50.8 cm)

158. *Boy Standing on a Chair*

158. *Boy Standing on a Chair* N-536.48

In the years that followed the emergence of photography as a popular means for recording one's likeness, painted portrait commissions diminished particularly among those middle class patrons who preferred inexpensive accurate likenesses. Many portrait painters abandoned their craft and independently took up the camera, while others joined photography studios and produced painted versions of daguerreotype images for this growing new market.

This rendering may very well be a portrait painted from a daguerreotype. The visual effect of photography on this composition is evident as the subject lacks the vitality created by the linear forms and bold colors previously employed by the untrained artists who were painting subjects from life. PD'A

Condition: At an unknown date the painting was lined with new fabric attached with glue. The paint has traction crackle which is evident in the light areas. There are two spots with tenting paint at right center.

Provenance: Mr. Stephen C. Clark Sr., Cooperstown, N.Y.

Exhibited: "Child's World," Schenectady Museum, Schenectady, N.Y., January 2–May 9, 1972.

INDEX